The Libyan Desert:

Natural Resources and Cultural Heritage

Edited by
David Mattingly, Sue McLaren, Elizabeth Savage,
Yahya al-Fasatwi, Khaled Gadgood

The Society for Libyan Studies

The Libyan Desert:

Natural Resources and Cultural Heritage

Edited by
David Mattingly, Sue McLaren, Elizabeth Savage,
Yahya al-Fasatwi, Khaled Gadgood

Society for Libyan Studies Monograph number 6

Published by

THE SOCIETY FOR LIBYAN STUDIES

on behalf of

THE BIRUNI REMOTE SENSING CENTRE

ENVIRONMENTAL GENERAL AUTHORITY

ACADEMY OF GRADUATE STUDIES

THE BRITISH COUNCIL

The Libyan Desert: Natural Resources and Cultural Heritage

Society for Libyan Studies Monograph number 6

The Society for Libyan Studies
31-34 Gordon Square
London, WC1H 0PP

www.britac.ac.uk/institutes/libya/index.html

ISBN 1-900971-04 6

Designed and typeset in Garamond
by Primavera Quantrill
www.quantrillmedia.com

Printed by Lanes Printers, Broadstairs, Kent

Front cover image: Artistic impression of a Saharan oil-drilling site (Ian Reeds)

Back cover image: The lake and spectacular dune backdrop at Gabr 'Awn in the Ubari Sand Sea (photo: David Mattingly)

Contents

Introduction

Theme 1: Natural Resources (Oil and Water)

Theme 2: Prehistory

Theme 3: Ecology and Environment

Figures

Tables

Introduction

1. Resources and Heritage of the Libyan Desert

By David Mattingly,[1] Sue McLaren,[2] Elizabeth Savage,[3] Yahya al-Fasatwi,[4] Khaled Gadgood [5]

The Natural Resources and Cultural Heritage Conference

The Society for Libyan Studies (SLS), in concert with the Libyan Environmental General Authority (EGA), the Biruni Remote Sensing Agency, the British Council and the British Embassy, Tripoli, organised a major international and interdisciplinary conference on the Sahara desert, held in Tripoli and southern Libya in December 2002. The overall theme of the conference was "Natural Resources and Cultural Heritage of the Libyan Desert" and brought together experts from a wide range of fields, including geology, geography, hydrology, environmental and urban planning, history, tourism, archaeology. A total of 44 papers were presented to the conference: 21 by Libyans, one by a pair of Libyan/UK authors and 22 by UK or overseas contributors. In addition to two days of plenary papers and conference sessions in Tripoli attended by several hundred people, the conference also involved a fieldtrip for a core group of over 60 Libyan and expatriate delegates, which covered a substantial part of Fazzan.

The Sahara is Libya's outstanding landscape feature and is the source for most of its significant natural resources. This desert region is also extraordinarily rich in historical and cultural heritage that is in itself another valuable resource, through exploitation by the tourism industry. The conference drew attention to the link between benefiting from the Sahara's resources (oil, gas, water, minerals and tourism) and the need to safeguard and record aspects of its cultural heritage. Another objective of the conference was to raise awareness of problems of conservation of the natural and cultural heritage of the Sahara at both national and regional levels of government and in particular to engage with the local agencies in Fazzan about measures they themselves could undertake to preserve this heritage for the benefit of future generations. These issues are not unique to Libya, but are common throughout the Saharan region (Keenan 2005).

A further aim of the conference was to promote contacts between Libyan and foreign scholars across a wide spectrum of subjects. In particular, it sought to encourage new research partnerships between British and Libyan academics. It is hoped that the event has indeed marked a series of new beginnings as well as the enrichment of existing links.

The Tripoli part of the conference was organised around two plenary lectures (see Appendix 1 for full programme). The first was on natural resources by Professor Amin Missalati; and the second on archaeology and heritage by Professor Graeme Barker. These were followed by three

[1] School of Archaeology and Ancient History, University of Leicester
[2] Department of Geography, University of Leicester
[3] Sanders Research Associates, Great Gaddesden
[4] Biruni Remote Sensing Centre
[5] Environmental General Authority, Tripoli

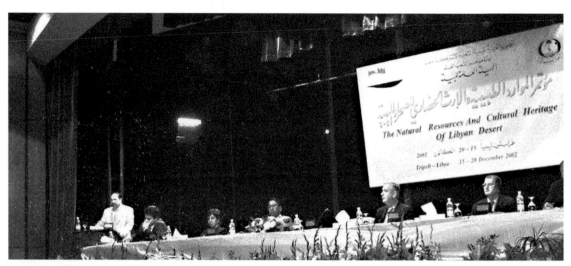

Figure 1.1. Plenary session of the main conference session in Tripoli being addressed by Dr Ehtuish F. Ehtuish.

pairs of parallel sessions on "Natural Resources", "Prehistory", "Ecology and Environment", "Historical Archaeology", "Tourism, development and conservation", "Historical and documentary sources". A final plenary session, to which session chairs reported on the main points arising from each session, concluded with the drafting of a first set of conference resolutions (Fig. 1.1).

Following the end of the Plenary session closing out the Tripoli conference, 65 of the delegates, including virtually all of the speakers and the British Ambassador, flew directly to Sabha (for itinerary of tour, see Appendix 2). Dr Habib el-Hesnawi presented a third Plenary lecture, on "The History of Fazzan", at the University of Sabha. This marked the start of an extraordinary tour of many key areas and sites of Fazzan (Fig. 1.2), with enthusiastic support from the local government agencies (*sha'abiyat*). At all the main towns, notably Sabha, Zuwila, Traghan, Murzuq, Jarma/Ubari and Ghat, the delegates were warmly received. Townspeople were eager to debate and discuss the finding of the conference. We visited historic towns with important monuments of Garamantian and Islamic date (with Dr Ali Abdusalam (Department of Antiquities) and David Mattingly as the main guides and contributions from many others), a 'lost' oasis city in plain desert and sites of rock art and prehistoric settlements and cemeteries (led by David Mattingly, Tim Reynolds and Graeme Barker). The geographical research of the Fazzan project was highlighted by a visit to a palaeolake in the Ubari Sand Sea and springline deposits near Jarma (led by Nick Drake and Sue McLaren). Andrew Wilson gave us a concise introduction to the Garamantian irrigation systems (foggaras) in the landscape near Jarma and Francesca Merighi to the work of the Italian team

Figure 1.2. The desert tour in progress.

around Ghat. The field trip made it possible for experts to question their colleagues (Fig. 1.3) and to carry on discussions en route to the next location.

Whilst it is clear that efficient exploitation of oil and water are vital to Libya's economic future, desert tourism is another vital resource and one of particular value to southern communities. However, it was apparent that the challenges of conservation and management must first be tackled to protect the Saharan heritage and environment which underpins the tourism market. A final plenary discussion summed up the delegates' views on conservation and exploitation and focused on:

The impact of urban and social development
- recommended alternatives for city rubbish disposal,
- encouraged interest and education in local history,
- considered best practice for conservation and consolidation of historic sites and buildings,
- raised the subject of conserving invisible below-ground archaeology.

The problems caused by the extractive industries
- oil, gas, water drilling and pumping sites,
- extraction of aggregates,
- seismic survey,
- road and pipeline construction,
- pylon installation.

Figure 1.3. David Mattingly in discussion with a group of Libyan colleagues during the tour.

Problems related to rock art conservation
• urgent need to see that rock art is linked with other archaeological evidence: stone tools, pottery, trapping stones, tombs and other cairns,
• problems with defacement and graffiti,
• damage by rock art enthusiasts and collectors (fading, enhancement, looting, taking moulds or casts).

Problems related to the palaeolakes
• vulnerability to disturbance by vehicles,
• vulnerability to looting of stone tools, etc..

The potential for tourism development
• key historic sites – Jarma, Zuwila, Murzuq,
• need for tighter control of foreign tourists,
• need for improved regulation of some local companies.

The creation of a national park in southern Libya
• to provide an umbrella for a range of conservation and management measures,
• linked to the introduction of a code of practice for all inhabitants and users of the Sahara,
• to serve as a focus for new education programmes.

These problems – by no means unique to Libya – are faced by all modern countries balancing development needs against conservation measures. Nor are the problems insoluble ones and practical suggestions arose through both the papers and the field observations. At the end of the tour, a further set of Conference Resolutions was drafted which encapsulated both the first-hand experience of the group in the desert and the subsequent discussions.

Organisation of this Volume

Many of the papers presented at the conference have been included for publication here, with the entire proceedings being translated and edited for separate printing in English and Arabic editions. The balance of the papers included reflects the greater success of the UK editors in collecting final versions of papers that had been delivered. The conference structure has been broadly followed in the arrangement of this book, though the order and location of some papers has been adjusted to provide the best fit between content and section. The six conference sessions have been retained as the main subdivisions of the book in the following order: "Natural Resources", "Ecology and Environment", "Prehistory", "Historical Archaeology", "Historical and Documentary Sources", "Tourism, Development and Conservation". The keynote paper by Professor Graeme Barker is published here as an introductory contribution as it spans several of the themes.

It is hoped that the assembled papers will prove of great interest to a wide readership. They offer a new interpretation and vision of many aspects of Libya's environmental and cultural

heritage and include some suggestions for improvements to the current management situation. Some of these, such as the creation of a National Park in south-west Fazzan (Liverani, this volume), merit consideration at the highest levels of local and national government. The concluding section of the volume gathers together the two sets of conference resolutions and some draft ideas of a Sahara Code for Libya. These are additional ideas for future consideration at both regional and national levels in Libya.

Above all, it is hoped that the conference and this volume have demonstrated the necessary and close links between the exploitation of natural resources of the Sahara and the conservation/preservation of its uniquely important environments, flora and fauna, archaeology, history and cultural traditions for the benefit of Libya today and tomorrow.

Acknowledgements

The Sahara Conference marked the culmination of two years' planning and preparation. On the Libyan side, the organising committee was chaired by Dr Ehtuish F. Ehtuish (then Secretary of Natural Resources, Environment and Urban Planning or Environmental General Authority [EGA]), with the main organisational work being carried out by Dr Khaled Gadgood and Dr Ahmed Tawangi of the EGA, along with Dr Yahya Fasatwi of the Biruni Remote Sensing Centre. Other members of the Libyan Organising Committee included: Ali Khadouri, Dr Giuma Anag and Mustapha Turjman (Department of Antiquities); Dr Mustapha Salem (Al-Fatah University); Dr Habib el-Hesnawi (Jihad Historical Centre); Dr Salem el-Barudi and Dr Abdul Latif (NOC); Haddi Hinshir (Water Authority); Dr Ahmed Fituri (ACARTSOD).

The conference received strong backing from successive British Ambassadors, Richard Dalton and Anthony Layden, and the role of Tony Jones, British Council Director in Tripoli was crucial in finalising all the practical arrangements. Anthony and Josephine Layden kindly hosted a reception to welcome conference delegates on 14th December. The British Council and British Embassy also provided financial support towards travel costs of external speakers and the hire of facilities in Tripoli. Additional sponsorship for the conference was received from Shell, BAE Systems, the Arab-British Chamber of Commerce. British Council staff worked tirelessly during the conference to ensure close liaison with our Libyan hosts, particular mention must be made to the work of Salah Subhi, Sherif Shibani and Awatef Shawish. The southern tour received considerable practical support from the local government agencies (sha'abiyat) in Fazzan, notably in Sabha, Zuwila, Traghan, Murzuq, Ubari, al-Birkit and Ghat. Fluent translation of presentations at the scheduled stops on the fieldtrip was mainly provided by Ahmed al-Hawat (University of Gar Yunis) and Salah Subhi (British Council). Thanks are also due to Salah Subhi for the photographs of the Conference and tour used in the Introduction and Conclusion sections.

The EGA arranged and funded the translation of all papers English to Arabic in Tripoli, with additional support provided by the Libyan Academy of Graduate Studies through the good offices of Milad Saad Milad. The translations of Arabic to English were undertaken by Dr Faraj Najem in London.

References

Keenan, J. (ed.). 2005. The Sahara: Past, Present and Future, London (*Journal of North African Studies* 10.3-4, autumn-winter 2005).

2. The Archaeology and Heritage of the Sahara

By Graeme Barker[1]

Abstract

The rich and varied archaeological heritage of the Sahara is an enormous cultural asset. As the *Natural Resources and Cultural Heritage of the Libyan Sahara* conference affirmed, it has profound potential for its present-day inhabitants as an important economic resource for tourism, and for the symbolic links it provides people with their past, and their sense of place. However, it also provides eloquent testimony to the lives of past peoples, and how they helped shaped the landscapes of today for good or ill. Over a fifth of the world's population lives in drylands, and over a third in arid and semi-arid lands combined, yet there are many gaps in our understanding about how fragile or resilient these regions are for human settlement. To fill these gaps we need to answer questions that are likely to be of very great significance for the global community in the present century. Many dryland regions such as the Sahara have abundant archaeological remains of ancient settlement, implying that these now degraded landscapes were once fertile and populous lands. Scholars have long speculated on the possible reasons for the 'desertification' evident in such regions: were changes in climate the prime cause of environmental deterioration? Or did past societies create deserts by their own unwise actions as farmers or herders? Or did perhaps climate and people sometimes form a perverse partnership to degrade the environment (as may be the case in the context of global warming today)? One of the problems with much research on desert settlement history has been the lack of inter-disciplinary work. Research by geographers, or historians, or archaeologists has yielded important information about climate, or environment, or human settlement, but hardly ever about all three within the same study area. The result has usually been deceptively attractive and straightforward models of change. In this paper, by contrast, I take examples especially from recent work in Libya to illustrate how inter-disciplinary research programmes in 'landscape archaeology', which integrate the methodologies of archaeology and environmental science in regional studies of long-term ecological and cultural history, have made significant contributions to understanding the complexity of human behaviour in dryland regions in the past. These findings sometimes have significant implications for current debates about the present and future stability of drylands.

Introduction

Archaeology is normally defined as the study of the human past through the material remains left by past societies, to distinguish it from history, the study of the human past through written records (Barker 1999). 'Material remains', as far as modern archaeology is concerned, encompasses everything created by or affected by people, an enormous variety of forms of evidence: humanly-made objects such as tools, weapons, jewellery, inscriptions, paintings, sculpture, mosaics, and so on; humanly-created structures of every size, shape and type, both buried and standing, from rubbish pits to palaces, shrines to great cathedrals and mosques; biological evidence such as human skeletons and the many forms of microscopic and macroscopic residues of the animals and plants associated with humans; and the sediments and soils and other components of the environment in which humans lived, and which they changed through their activities. Archaeology concerns itself with all periods of the past, from the origins of our

[1] McDonald Institute for Archaeological Research, University of Cambridge

species several million years ago to the archaeology of a generation ago. It concerns itself with all types of human society, in all parts of the world. And we are interested in all scales of human behaviour, from global histories such as the colonisation of the world by Ice-Age hunter-gatherers, or the development of farming, or urban life, to the actions of individuals, whether the actions and motives of an unknown prehistoric hunter in painting an animal on a cave wall or making a stone axe, or of the Roman emperor Septimius Severus in beautifying his home city Lepcis Magna. As archaeologists we are interested in writing all these histories.

The archaeological resource of the Sahara is enormously rich. There are caves with deep archaeological stratigraphies of profound importance as 'archaeological histories' spanning many thousands of years. There are major stone monuments, variously ceremonial, funerary, agricultural, domestic, and industrial: prehistoric megalithic tombs; Roman, Arab, and Italian military forts; prehistoric, Roman-period, and later farms; stone quarrying and metal mining and smelting sites; churches and mosques; wells and irrigation systems; and much more besides. There are many thousands of rock paintings, carvings, and inscriptions. Traditional vehicle-based archaeological surveys can locate, visit, and record such visible archaeological monuments. It is also an archaeology that is reasonably easy for governments and their national antiquities authorities to protect from damage, physically with fences and guards, and legally through placing identified monuments on a national antiquities list of protected archaeological sites and monuments, as well as through educational programmes teaching local people to respect, value, and protect their local archaeological heritage.

However, it is increasingly recognised by Saharan archaeologists that this is just one part of the archaeological record. Studies of modern pastoralist and hunter-gatherer societies have indicated how they frequently do not create 'sites' in the sense of dense concentrations of material culture: a Kalahari hunter-gatherer band, for example, might visit the same waterhole in the same season of the year each year, but they will simply camp in its vicinity, on higher ground, so that they can watch (and be away from) the game coming to drink. The archaeology created by these hunter-gatherer visits over the years usually consists of a discontinuous spread of artefacts over hundreds of metres, what archaeologists have come to call 'off-site' or 'non-site' archaeology (Foley 1981). In virtually every square kilometre of the Sahara there is this kind of small-scale ephemeral archaeology: small spreads or piles of stones, the traces of tent-footings, burial cairns, animal pens, and field walls; and untold numbers of stone tools and other artefacts - fragments of pottery, grindstones, shell beads and so on (Aumassip 1987; Barker 1996; Gabriel 1987; and see Reynolds this volume). This archaeology is the material culture that has been discarded or lost by past peoples living mobile or nomadic ways of life, from the initial colonisation of the region by early humans to the beginnings of pastoralism and farming and the subsequent history of the Saharan desert dwellers who emerge into history as the present-day Berber and Tuareg peoples. Vehicle-based archaeological survey is poorly suited to locate and study it. The 'off-site' nature of much Saharan pastoralist archaeology means that its significance only be established following its investigation by intensive work on foot involving systematic planning and grid collecting. Furthermore, without detailed geomorphological survey alongside, and integrated with, archaeological survey, it is still more difficult to understand why we find what we find

in some locations and not in others, and what it means, because processes such as erosion, alluviation and colluviation may variously destroy archaeological remains, or cover them, or move them from one place to another (Barker 1991; Cremaschi and di Lernia 1998a; and see papers by McLaren *et al.* and White *et al.* this volume). It is an archaeology that is difficult to map, interpret, and protect; and it is also an archaeology vulnerable to damage or disturbance by travellers and vehicle traffic, mostly from lack of awareness of its potential importance (Keenan, this volume).

In the rest of this paper I discuss the contribution of recent archaeological research in Libya to two major themes: the transition from foraging (hunting and gathering) to pastoralism and farming; and the debates about the possible roles of farmers and shepherds in causing the presently degraded landscapes of the Sahara, the process called 'desertification'. In both cases the archaeological heritage of Libya is not only proving critical for understanding the history of the Sahara, but is also providing major insights into debates world-wide about forager-farmer transitions and desertification processes.

Saharan Prehistory: from Foraging to Pastoralism

Modern humans colonised North Africa in the Pleistocene (the so-called 'Ice Ages') perhaps 100,000 years ago, moving northwards from south of the Sahara in the expansion of our species that took us to Europe by *c.*40,000 years ago, across Eurasia to Australia by *c.*50,000 years ago, and into the Americas by *c.*15,000 years ago. At the climax of cold conditions, the Last Glacial Maximum *c.*20,000 years ago when enormous glaciers covered much of the northern latitudes and world sea levels were over 100 m below their present levels, North Africa was not just very cold but also hyper-arid (Petit-Maire 1991; and see Drake *et al.* this volume). The interior was uninhabitable, and humans abandoned the Sahara entirely, moving east to the Nile valley, north and west to the coasts (to the cave of Haua Fteah in Cyrenaica, for example: McBurney 1967), and south to the Sahel, which was 500 km further south than today. With the end of the Pleistocene and beginning of the Holocene or Postglacial 10,000 years ago, world temperatures warmed. In Africa the southern monsoonal belts shifted northwards, resulting in rainfall levels in the Sahara estimated variously at between five and fifteen times modern levels, and lakes in places 100 m higher than they are today (Grove 1993; Hassan 1998). Sahelian fauna and flora rapidly colonised the Sahara, and people followed them. The antiquity of Saharan culture effectively goes back to this time.

Some of the best evidence in North Africa for the lives of this initial population has come from an outstanding programme of inter-disciplinary excavations and surveys by Italian teams in the Tadrart Akakus mountains (Barich 1987; 1998; Cremaschi and di Lernia 1998b; di Lernia 1999; di Lernia and Manzi 1998; di Lernia and Merighi, this volume; Fig. 2.1). This work is a good example of a modern field archaeological investigation at its best: focussed on clearly defined research problems; theoretically informed and methodologically comprehensive; and integrating archaeological studies with relevant other disciplines in genuinely inter-disciplinary – rather than simply multi-disciplinary – studies. The excavations in the Uan Afuda cave (Fig. 2.2) showed how these first Holocene colonists lived as hunters, fishers, and gatherers, setting

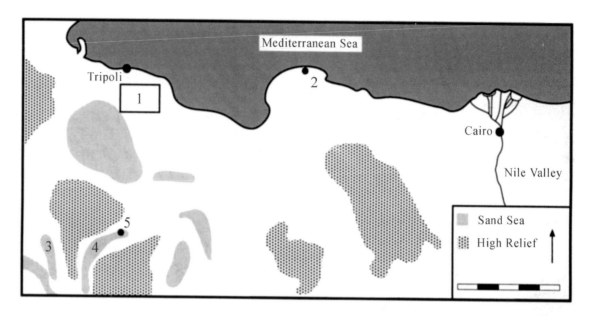

Figure 2.1. Central and eastern North Africa, showing the principal regions and archaeological sites in Libya mentioned in the text: 1. the survey area of the UNESCO Libyan Valley Survey; 2. Haua Fteah; 3. Tadrart Akakus; 4. Massak Sattafat; 5. Wadi al-Ajal and Jarma.

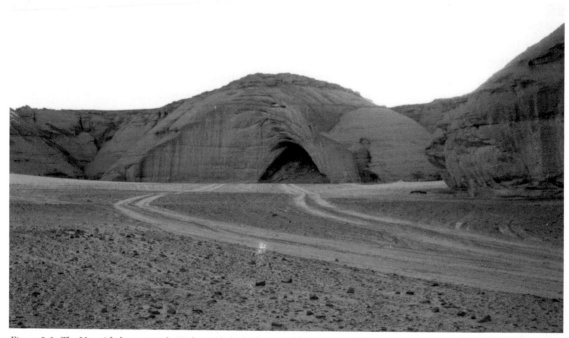

Figure 2.2. The Uan Afuda cave in the Tadrart Akakus (Photograph: Graeme Barker).

up their base camps in the better-watered highlands, and ranging from these onto the scrub and seasonal grassland beyond, where there is now rock or sand desert (Fig. 2.3). There were streams and pools in the mountains, where people were able to hunt animals like crocodile,

Figure 2.3. The Tadrart Akakus mountains (Photograph: Graeme Barker).

hippopotamus, and turtles, as well as fish and kill waterfowl. Out on the steppes they hunted large and small antelopes and wild cattle, though probably their main source of meat was the Barbary sheep (*Ammotragus lervia*), the indigenous wild sheep of North Africa (Fig. 2.4). They also collected plants – fruits, nuts, bulbs and grasses, including wild sorghum and millet, processing them with grindstones and mortars and storing them in simple pots.

The traditional theory for the beginnings of farming in North Africa has been that farming was invented first in the Near East *c.*10,000 BC, Neolithic farmers spread southwards to the Nile valley by *c.*6000 BC, and then moved westwards across the Sahara *c.*4000 BC, taking with them domesticated cereals (wheat and barley) and domesticated animals (cattle, sheep and goat in particular) and, it was assumed, replacing the indigenous hunter-gatherers with their superior technologies and forms of subsistence (Clark 1962; Hugot 1968; Muzzolini 1993; Smith 1984). The Uan Afuda cave, however, tells a very different story. During the seventh millennium BC, there was a sharp climatic change to much

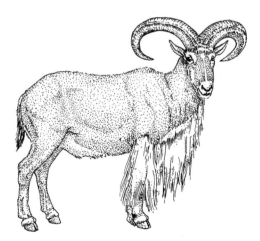

*Figure 2.4. The Barbary sheep (*Ammotragus lervia*) (after Barker* et al. *1996a, fig. 8.11).*

13

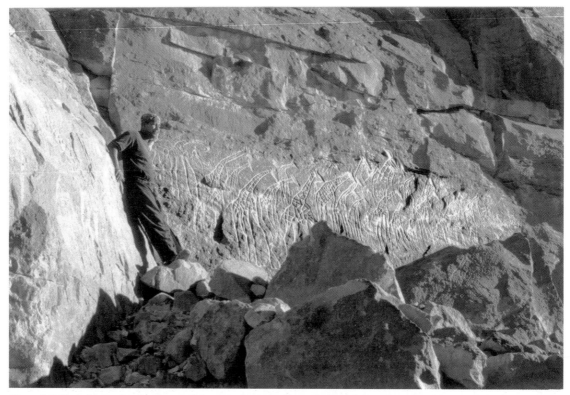

Figure 2.5. Typical examples of prehistoric Saharan rock art: giraffes in the Massak Sattafat, Libya (Photograph: Graeme Barker).

drier conditions. The people using the cave built pens inside it, and micromorphological analysis of the dung in the pens shows that the animals being kept were the native wild Barbary sheep. Grass seeds in the dung had been partially processed by grinding. Domestic animals are not found here or elsewhere in the Sahara until 1000 years or so later, so it appears on the Uan Afuda evidence that Saharan hunter-gatherers were experimenting with controlling – in effect, domesticating – wild Barbary sheep and providing them with fodder (di Lernia 1998; 1999). The pollen in the dung shows they were being looked after in the late winter and spring, the driest part of the year. A few hundred years later the climate returned to wetter conditions as before, and people returned to hunting the Barbary sheep and other game. Scholars studying the origins of agriculture tend to assume that the new way of life only began in a few core 'hearths of domestication' and then spread to other regions by the movement of people and/or of ideas. The Uan Afuda evidence for some kind of close herding or management of what we now regard as wild animals before the normally accepted date for domestication chimes with growing evidence for similarly ambiguous 'pre-domestication domestication' processes in several other parts of the world. Such evidence is requiring archaeologists to rethink many of their long-standing assumptions about the nature and complexity of pre-farming societies, and the kinds of 'world views' or 'cognitive maps' they had about the natural world and their place within it.

During the fifth and fourth millennia BC the climate shifted once more towards aridity, the beginning of the trend towards the modern Saharan climate that had certainly developed by

*c.*3000 BC (see papers by Cremaschi *et al.*, and Drake *et al.* this volume). This was the context in which we can discern pastoralist societies widespread in the Sahara, with domestic cattle, sheep and goat found for example at sites such as Uan Muhuggiag in the Tadrart Akakus (Chenal-Vélardé 1998; Clutton-Brock 1993; Corridi 1998). Though the traditional thesis has been that these were new people who originated from the Nile valley, the evidence for marked continuity in technologies at sites with long occupations spanning the period, and for pastoralism at these sites being practised alongside hunting and gathering rather than simply replacing it, suggests that what we are witnessing was primarily a process of internal subsistence change and acculturation (the transference of cultural elements between different ethnic groups) by the indigenous hunter-gatherers rather than colonisation by Neolithic people from the Nile valley as envisaged in the traditional model. It is noteworthy that DNA studies of modern cattle populations likewise indicate that processes of domestication in North Africa were separate from those in the Near East (Bradley and Loftus 2000).

In most hunter-gatherer societies today, hunters get prestige by demonstrating prowess in the hunt and generosity in distributing their kills to the rest of the bands, whereas in pastoralist societies prestige comes from accumulating live animals and using them in competitive arrangements of gift-giving for bridewealth and the like (Ingold 1988). The development of a commitment to herding animals amongst Saharan hunter-gatherers must surely have involved major transformations in the social relations of production and the ideology of prestige. This

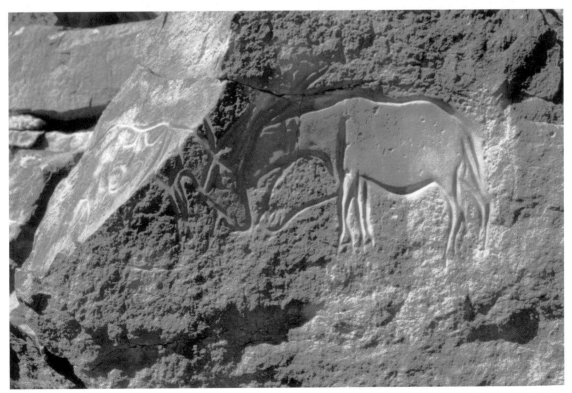

Figure 2.6. Typical examples of prehistoric Saharan rock art: sheep in the Massak Sattafat, Libya (Photograph: Graeme Barker).

is probably the primary context in which much of the classic 'big game', 'round head' and 'pastoralist' rock art of the Sahara was produced (Lutz and Lutz 1995; Mori 1960, 1965; Muzzolini 1986; Le Quellec 1987; Fig. 2.5-2.6). A commitment to pastoralism as a mechanism to cope with an increasingly hostile environment meant new ways of looking at the natural world and one's place within it, and new kinds of social relationships. Some scholars have argued that much Saharan pastoralist rock art may have been produced by shamans in altered states of consciousness, perhaps in relation to initiation ceremonies of the kind undergone by young male Fulani pastoralists in recent times (Smith 1993a; 1993b; and see Barnett this volume). Though the precise significance of Saharan rock art must elude us, these debates underscore how critical it is not just to protect rock art sites today but to be able to situate them within the regional archaeological context of the people who made them in the course of their seasonal movements.

Archaeology and Desertification

The term 'desertification' refers to the deterioration of arid lands into semi-deserts or deserts as a result of climatic change (aridification) or adverse human actions (Beaumont 1993; Thomas and Middleton 1994). Climate and people can of course work in tandem to degrade dryland environments, as may be the case in the context of global warming today. Drylands support over a fifth of the world's population, and arid and semi-arid lands together support over a third, so understanding the long-term effects of climate and people on arid lands is certainly critical for the future well-being of a large proportion of the world's population. The rich archaeology of many of the world's drylands has commonly been brought into debates about the causes of desertification, because many arid and degraded regions now sparsely occupied by mobile or semi-mobile pastoralists have archaeological remains suggesting that these same landscapes must once have supported settlement of a very different order of intensity (Barker and Gilbertson 2000a). Following on from the speculations of early European travellers and explorers, scholars have frequently debated the implications of spectacular archaeological ruins in desert regions for understanding processes of environmental change. Was the 'greening of the desert' by past societies essentially a matter of new know-how, of the introduction of sophisticated technologies and cropping systems? Or was climatic change the key factor, more abundant rainfall allowing crops to be grown by farmers in areas where this is impossible today? What then caused the green fields of antiquity to become the denuded landscapes of today? Had a return to aridity caused arable farming to be abandoned? Had people sowed the seeds of their own destruction through their greed and stupidity, stripping the landscape for building timber and fuelwood and/or allowing their animals to overgraze the vegetation? Did moral or economic decline cause ancient societies to abandon maintaining their land in good order? Had unsuitable or over-intensive systems of irrigation ruined soil fertility through salinisation?

One of the problems with much research on desert settlement history has been the lack of inter-disciplinary work. Research by geographers, or historians, or archaeologists has yielded important information about climate, or environment, or human settlement, but hardly ever about all three within the same study area. The result has usually been deceptively attractive

and straightforward models of change in which agency can be clearly recognised as *either* climatic change *or* 'human impact'. Characterisations of ancient farmers or pastoralists as either ecologically benign or ecologically destructive are grist to the mill of popular media treatments of desert history, many of which have sometimes reflected modern political agendas more than anything else (Barker and Gilbertson 2000b). Yet these histories of dryland settlement contrast strikingly with the emphasis of modern ecological theory on the complexity of drylands today and ecologists' active debates about the inevitability or avoidability of humanly-induced desertification (Millington and Pye 1994; Mortimore 1998; Tiffen *et al.* 1994).

Landscape archaeology integrates the methodologies of the archaeological, social, and environmental sciences at the regional scale and over long timescales. Hence it has the potential to address human-environment-climate interactions in the distant past: to identify past societies' solutions and choices (both good and bad) for living in drylands, to ascertain in what circumstances human settlement was sustainable, when it caused damage from which the landscape was able to recover, and when it degraded arid and semi-arid lands to the point of no return. Recent work in Libya shows how landscape archaeologists can provide answers to such questions and so contribute fruitfully to understanding processes of desertification in the past, and to the desertification debate more generally.

Garamantian Oasis Settlement: the Fazzan Project

Pastoralism appears to have been the dominant lifestyle in the Saharan region through the fourth, third and second millennia BC, during which period the modern arid climate and environment of the Sahara were firmly established. The first evidence for significant agricultural intensification in the central Sahara is not until the beginning of the first millennium BC, when the Fazzan oases (the Wadi al-Ajal especially) became the focus for dense settlement by people we can later identify from the classical writers as the Garamantes (Fig. 2.1). Like the Tadrart Akakus studies described earlier, the Fazzan Project is a good example of the power of modern inter-disciplinary archaeology to write the long-term landscape archaeology and history of the Sahara, informing us in this case not just about the lives of past peoples in this challenging landscape, but also about the process of desertification (Mattingly 2000; Mattingly *et al.* 2003; and see Mattingly this volume).

During the climax centuries of the Garamantian state, *c.*500 BC to AD 500, the Wadi al-Ajal was densely settled: on either side of the large urban centre of Garama (Jarma) there were regularly-spaced village settlements all along the valley, the density of population at this time further indicated by the tens of thousands of Garamantian graves along the valley margins. This state-level society, the project has shown, was sustained by irrigation farming using *foggara* technology, the underground channels once thought to date in origin to the Islamic period; hundreds of *foggaras* were tunnelled into the hillsides by Garamantian farmers to trap the groundwaters and channel them to their fields on the oases floor (Fig. 2.7. See also Wilson, this volume and Fig. 18.2).

In the late Garamantian and early Islamic period some of the Garamantian villages were embellished with castle-like structures of mud brick, but over time the number of villages declined

GARAMANTIAN 900 BC - AD 500

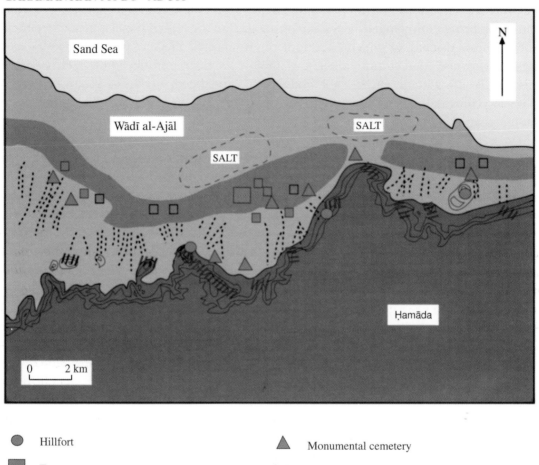

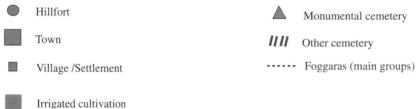

Figure 2.7. Model of evolved Garamantian landscape around Jarma, with its urban centre, satellite villages, numerous cemeteries, and extensive irrigation systems based on foggara technology (after Mattingly 2000, fig. 9.6).

markedly. The underlying reason seems to have been the long-term damaging effects of *foggara* technology, which drastically lowered the water table. The cultivated area of the Wadi al-Ajal shrank drastically compared with what it had been in the Garamantian period, together with the population it supported, as agriculture had to be refocused around deep wells dug down to reach the diminishing water supplies. When the earliest European travellers penetrated into the Sahara in the late eighteenth and early nineteenth centuries, they found the Wadi al-Ajal a desperately impoverished region. In recent decades the agricultural basis has been revived by the sinking of deep artesian wells, but these are also causing the water table to drop at a rapid

rate, suggesting that future agricultural activity will have to concentrate around a few deep-bore artesian wells serving clusters of 'crop circles', the *c*.300 metre-diameter irrigated zones developed elsewhere in the Sahara for exploiting fossil water supplies deep below the Sahara. As David Mattingly has commented (2000: 175), "the Fazzan Project cannot offer solutions to the problem of where water is to come from next, but it has graphically illustrated the human consequences of past changes in water availability in the desert. Whilst we may take pride in human ingenuity in finding ways to live in the desert, we may also reflect on the environmental costs that such a 'mastery' brings in its wake. Garamantian development of the *foggara* irrigation systems may, in the long term, have been a key factor leading to the decline of their civilisation as a result of over-extraction from a non-renewable groundwater source".

Roman Tripolitania: the UNESCO Libyan Valleys Survey

My final example is from Tripolitania in north-west Libya. The UNESCO Libyan Valleys Survey was an inter-disciplinary study of desert-edge settlement and land use here. The fieldwork took place between 1979 and 1989, the results being published in over 30 papers in *Libyan Studies* and then in final form as two volumes entitled *Farming the Desert: the UNESCO Libyan Valleys Archaeological Survey* (Barker *et al.* 1996a; 1996b). It was coordinated by myself and the late Professor Barri Jones, with significant input in particular from David Mattingly and David Gilbertson, as well as numerous specialist contributions in archaeology and environmental science.

With annual rainfall today diminishing rapidly from about 100 mm at the northern edge of this 'pre-desert' zone to less than 25 mm, the area investigated by the project was traditionally inhabited by transhumant pastoralists who camped here in the summer and wintered to the south much further into the Sahara. These people were highly mobile, relying on flocks and herds (sheep, goats, camels) and cultivating small patches of cereals on the floors of the dry valleys or wadis after the autumn rains. However, it was known from studies in the 1950s and 1960s by Olwen Brogan, Richard Goodchild, and John Ward-Perkins that this area had been densely settled in classical antiquity on the evidence of hundreds of fortified farms (Arabic: *gsur*) of broadly Roman date. Our project was developed at the invitation of the Libyan government and UNESCO, to investigate the archaeology in order to try to understand the reasons for such dense and apparently sedentary settlement in an area traditionally used by mobile pastoralists.

Our study was able to establish that, until the late first century AD, settlement in the pre-desert was small-scale and mobile, much as in recent centuries, but at that point there was a dramatic transformation to the landscape with the appearance of hundreds of stone-built farms (Fig 2.8). These were built in a recognisably Roman design and style (with the *opus Africanum* system of masonry, for example), but inscriptions demonstrated that their builders were indigenous Libyans, 'Romano-Libyans' as we termed them. During the course of the third century AD these people abandoned the courtyard farms in favour of fortified versions, the *gsur* (Fig. 2.9). In the most arid southern regions the fortified farms were generally abandoned in the fifth century AD, but elsewhere most continued in occupation into the sixth or seventh centuries, whilst in the northernmost (wetter) part of the study area some of the farms were only abandoned

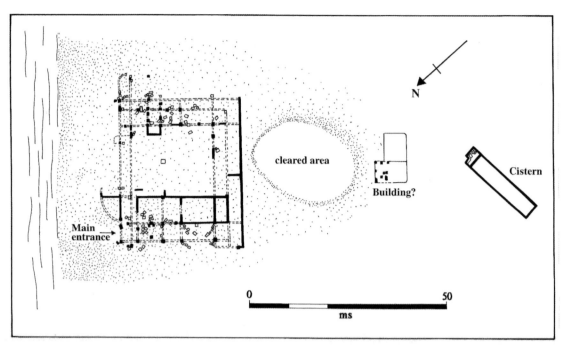

*Figure 2.8. The UNESCO Libyan Valleys Survey in Tripolitania, north-west Libya, plan of a typical open (*opus Africanum*) farm (after Barker et al. 1996a, fig. 5.9).*

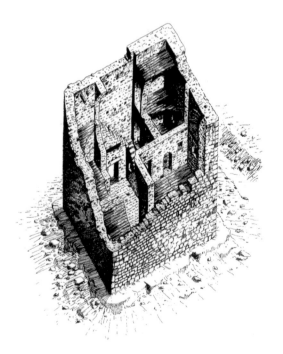

Figure 2.9. The UNESCO Libyan Valleys Survey in Tripolitania, north-west Libya, isometric reconstruction of a typical tower-like gasr *or fortifed farm (after Barker et al. 1996a, fig. 5.17).*

very recently. Detailed field and laboratory studies in geomorphology and palaeoecology by the project team established that the climate of the Tripolitanian pre-desert over the past 3000 years has been essentially the same as today (apart from a wetter episode that may equate with the Little Ice Age in medieval Europe). Hence climatic change clearly cannot be cited as a primary reason either for the greening of the Tripolitanian pre-desert in the first century AD, or for the piecemeal abandonment of farms in ensuing centuries. We were able to demonstrate, however, that Romano-Libyan farmers practised rather sophisticated floodwater farming (Fig. 2.10). By building elaborate systems of dry-stone walls to divert surface runoff after seasonal storms, they were able to channel the runoff into fields they laid out on the wadi floors. By collecting the rainwater from a large area into these fields,

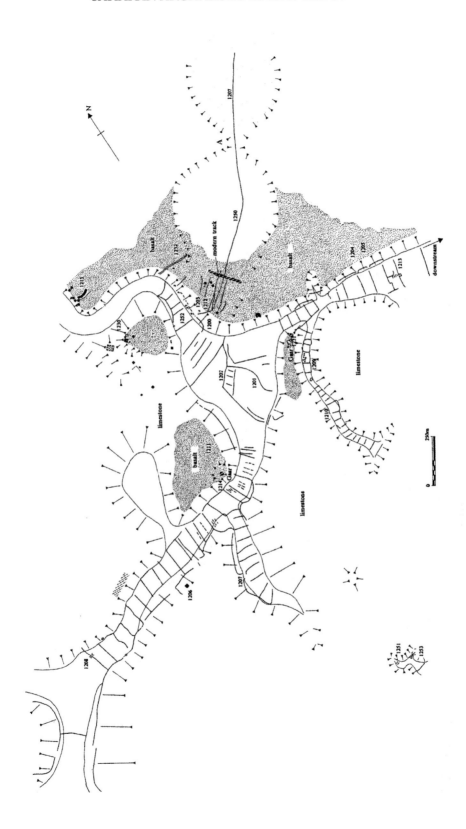

Figure 2.10. The UNESCO Libyan Valleys Survey in Tripolitania, northwest Libya: Romano-Libyan wall systems at a wadi confluence in the Wadi Gobbeen (after Barker et al. 1996a, fig. 7.6).

they were able to grow a wide range of crops that needed much more water than was available in terms of annual rainfall levels. These crops, analysed by the archaeobotanist Marijke van der Veen, included three cereals (barley, durum or hard wheat, and bread wheat), three pulse crops (lentil, pea, grass pea), four oil plants (olive, safflower, linseed or flax, and castor), five Mediterranean fruits (grape, fig, pomegranate, almond, peach), and African fruits including date palm and water melon (see also van der Veen this volume). Many farms have stone pressing structures for making oil and wine, and vat capacities indicate that most farms were producing a surplus well beyond the needs of the inhabitants. Animal husbandry, by contrast, appears to have been small scale on the evidence of the bone fragments studied by the archaeozoologist Annie Grant: the principal animals kept were sheep and goats, their dung indicating that they were stalled part of the year on the farms (see also Grant this volume). Their water and pasture needs would have been competing with those of the people and crops, and the abundance of wild animals such as gazelle in the farm middens suggests that they were hunted as much for their meat as to protect the vulnerable crops on the wadi floors.

Our conclusion was that indigenous Libyan elites in the pre-desert switched from subsistence to cash-crop farming in response to the opportunities of Romanisation in the first century AD, supplying agricultural products (olive oil especially) to local Roman garrisons in forts such as Bu Njem and to the burgeoning urban populations of the coastal cities. The shift to fortified farms in the third century AD reflected the internal social tensions and competitive behaviours amongst these elites. People in the most marginal locations soon returned to traditional lifestyles, but elsewhere intensive farming continued in response to Roman markets, and in certain wadis local warlords appear to have retained control over their peasant farmers and maintained their floodwater-farming systems until the Arab conquest and beyond.

The study of sediments associated with several farms, for example in midden deposits, building infills, and cistern conduits, found indicators for local landscape erosion at a few sites that might reflect the pressures of overgrazing and fuelwood collection. However, there was no evidence to suggest that environmental degradation was on such a scale as to have been a significant factor in the decline of the system and the return to traditional pastoral lifestyles. In fact, there are several indicators that many Romano-Libyan desert farmers in Tripolitania were well aware of the need for conservation strategies: some sluices had been blocked, presumably so that smaller quantities of floodwater could enter the fields; stalling was presumably in part for the production of manure to fertilise the fields; and the concurrence of evidence for stalling and for active vegetation growth in some sediment sequences indicates awareness of the relationship between animals and vegetation, and of steps being taken to maintain it to the farmers' advantage.

Conclusion

British television at the moment is full of archaeological programmes, by far the most popular of which is called *Time Team*. In that programme, a group of enthusiastic archaeologists manage to solve an archaeological problem apparently (as it is presented to the public) in a weekend of frantic fieldwork. These archaeologists have become household names, each character larger than

life and getting larger with every series of programmes as their individual fan clubs grow. Their efforts are aided and abetted by a supporting cast of white-coated archaeological scientists, who perform wonders of specialist analysis in their laboratories, but who in general are expected to be rather earnest introspective figures compared with the field team. The programme is hugely popular in Britain, especially with the young. *Time Team* conveys very accurately two major aspects of archaeology: that it can be hugely enjoyable and rewarding for those who do it, as a team activity *par excellence*; and that its practice in the field and the laboratory involves highly specialised skills rooted variously in the humanities, social sciences, and sciences. At the same time, of course, it fails to convey that real archaeology takes a long time, that fieldwork takes weeks or months, and that the ensuing study of the data months or years, and that as a rule of thumb the post-fieldwork study and interpretation of the material – without which the fieldwork is valueless, simply vandalism by another name – will normally cost six to ten times the cost of the fieldwork. Even more seriously from my perspective, though, many of the programmes that appear night after night on British television either about (or apparently meant to be about) archaeology, fail to convey that, whilst it may often be fun and is certainly difficult to do, real archaeology should relate to important questions about our past that are worth answering.

The three projects I have described here, in the Tadrart Akakus, the Fazzan oases, and the Tripolitanian pre-desert, are all exemplars of modern archaeological investigation at its most imaginative and effective. First, all three projects were developed in order to address important research questions about past societies. Second, a multi-disciplinary group of scholars was assembled with the appropriate mix of archaeological and non-archaeological specialisms to address those questions, and welded into an inter-disciplinary team so that the results in each case have been far more valuable than the sum of the individual components. Third, a staged programme of fieldwork and allied laboratory study was pursued by the team, with approaches and methodologies amended as interpretations changed, and as answers to particular questions defined further questions. Finally, results and interpretations have been disseminated to the public promptly in detailed articles and books, as well as exhibitions and the popular media. Saharan people deserve no less than this in how their archaeological heritage should be studied.

Certainly the archaeological heritage of the Sahara is a priceless cultural asset, for three reasons. First, as the Fazzan and Tripolitania desertification studies show, we can learn a great deal from the past of direct relevance to the present and future. Modern desertification theory can learn a great deal from such archaeological case studies. There was no simple evolutionary development from simple to complex, or extensive to intensive systems of irrigation or floodwater farming. There were no straightforward correlations between particular human activities and particular environmental impacts. In the Wadi al-Ajal it seems highly likely that Garamantian farmers would have noticed falling groundwater levels, but the intensity of exploitation meant they had no room for manoeuvre, no strategies for remedial action. In the Tripolitanian pre-desert, by contrast, there is no significant evidence for humanly-induced environmental degradation, and indeed several indicators of attempts by Roman-Libyan farmers to practice sustainable systems of land management. The two case studies emphasise above all the complexity of ancient societies' perceptions of marginal and precarious environments, of their responses to the constraints and

G. BARKER

opportunities presented to them, and of the manner in which their activities impacted on the landscape.

Second, as many of the papers in the conference explore, the archaeological heritage has significant potential for the present-day inhabitants of countries such as Libya as an important economic resource for tourism. The best known and most accessible of the monuments, and the magnificent desert landscapes in which they are situated, are major stopping points for tourist groups. Such cultural and ecological tourism in a country such as Libya is small scale at present, and could clearly be expanded greatly. However, enlargement will need exceptionally careful management if it is not to impact detrimentally on the prehistoric and historic monuments, prehistoric and historic landscapes, and present-day desert cultures that are the reasons for the tourism in the first place. As Jeremy Keenan demonstrates so eloquently in his paper, it will have to be managed with sensitivity and firmness to stay 'sustainable green tourism'. There are many examples of badly managed tourism in archaeologically-rich developing countries that has created and in turn ruined archaeological 'honey pot' sites, commonly in the process concentrating tourist income into the hands of the few, especially the multinational chains and the indigenous wealthy elite who own the hotels, tour companies, and the other key components of the tourism infrastructure. Properly managed cultural or green tourism, on the other hand, spreads impacts wider, both environmental and economic, generating broad-based employment and income outwards from the national airlines, big tour companies, and hotel chains to the cultural administrative authorities, regional and national antiquities institutions, local museum staff, site guards, 4WD driver-guides, village stores and hostels, the makers and sellers of craft goods, and so on.

Finally, we must remember that the archaeological heritage matters not just as a laboratory for learning about the Sahara's natural and cultural history, and as an economic resource for tourism, but for the more abstract but no less real role it has in linking Saharan people to their common past, and thus to their sense of place, their sense of belonging. The human species is unique, as far as we can tell, in its consciousness of past, present, and future. The past is important for us all because, in telling us where we have come from, it shapes our ideas about who we are and where we are going. In Africa no less than in any other region in the world, understanding the complexity, distinctiveness and diversity of past cultures is one of the planks on which modern multi-cultural societies have to be built.

References

Aumassip, G. 1987. Neolithic of the basin of the Great Eastern Erg, in A.E. Close (ed.) *Prehistory of Arid North Africa,* Dallas: 235-58.

Barich, B.E. 1987. *Archaeology and Environment in the Libyan Sahara: the Excavations in the Tadrart Acacus 1978-1983*, Oxford, British Archaeological Reports, International Series 368.

Barich, B.E. 1998. *People, Water and Grain: the Beginnings of Domestication in the Sahara and the Nile Valley*, Rome.

Barker, G. 1991. Approaches to archaeological survey, in G. Barker and J. Lloyd (eds), *Roman Landscapes: Archaeological Survey in the Mediterranean,* London, British School at Rome, Archaeological Monographs 2: 1-9.

Barker, G. 1996. Prehistoric settlement, in Barker *et al.* 1996a: 83-109.

Barker, G. 1999. General introduction, in G. Barker (ed.), *Companion Encyclopedia of Archaeology,* London: xxxiii-xlv.

Barker, G. and Gilbertson, D. 2000a. *The Archaeology of Drylands: Living at the Margin.* London, One World Archaeology 39.

Barker, G. and Gilbertson, D. 2000b. Themes in the archaeology of drylands, in Barker and Gilbertson 2000a: 3-18.

Barker, G., Gilbertson, D., Jones, B., and Mattingly, D. 1996a. *Farming the Desert: the UNESCO Libyan Valleys Archaeological Survey: Volume One, Synthesis,* (ed. G. Barker), Paris/London/ Tripoli.

Barker, G., Gilbertson, D., Jones, B., and Mattingly, D. 1996b. *Farming the Desert: the UNESCO Libyan Valleys Archaeological Survey: Volume Two, Gazetteer and Pottery,* (ed. D. Mattingly), Paris/London/Tripoli.

Beaumont, P. 1993. *Drylands: Environmental Management and Development,* London.

Bradley, D. and Loftus, R. 2000. Two Eves for *taurus*? Bovine mitochondrial DNA and African cattle domestication, in R. M. Blench and K. C. MacDonald (eds), *The Origins and Dispersal of African Livestock: Archaeology, Genetics, Linguistics, and Ethnography,* London: 244-50.

Caligari, G. (ed.). 1993. *L'Arte e l'Ambiente del Sahara Preistorico: Dati e Interpretazioni,* Milan, Memorie della Società Italiana di Scienze Naturali e del Museo Civico di Storia Naturale de Milano 26, Fascicolo II.

Chenal-Vélardé, I. 1998. Les premières traces de boeuf domestique en Afrique du Nord: état de le recherché centré sur les données archéozoologiques, in A. Gautier (ed.), *Animals and People in the Holocene of North Africa,* Grenoble: 11-40.

Clark, J.D. 1962. The spread of food production in sub-Saharan Africa. *Journal of African History* 3: 211-28.

Clutton-Brock, J. 1993. The spread of domestic animals in Africa, in Shaw *et al.* 1993: 61-70.

Corridi, C. 1998. Faunal remains from Holocene archaeological sites of the Tadrart Acacus and surroundings (Libyan Sahara), in Cremaschi and di Lernia 1998a: 89-94.

Cremaschi, M. and di Lernia, S. 1998a. (eds) Wadi Teshuinat: Palaeoenvironment and Prehistory in South-western Fezzan (Libyan Sahara), Florence: Insegna del Giglio.

Cremaschi, M. and di Lernia, S. 1998b. The geoarchaeological survey in central Tadrart Acacus and surroundings (Libyan Sahara): environment and cultures, in Cremaschi and di Lernia 1998a: 243-96.

di Lernia, S. 1998. Cultural control over wild animals during the early Holocene: the case of Barbary sheep in central Sahara, in S. di Lernia and G. Manzi (eds), *Before Food Production in North Africa,* Forlì: 113-26.

di Lernia, S. (ed.). 1999. *The Uan Afuda Cave (Tadrart Acacus, Libyan Sahara). Hunter-gatherer societies of Central Sahara,* (Arid Zone Archaeology, Monographs 1), Firenze.

di Lernia, S. and Manzi, G. (eds). 1998. *Before Food Production in North Africa.* Forlì, Abaco.

Foley, R. 1981. Off-site archaeology: an alternative approach for the short-sited, in N. Hammond, I. Hodder, and G. Isaac (eds) Patterns of the Past: Studies in Memory of David Clarke, Cambridge, Cambridge University Press: 157-83.

Gabriel, B. 1987. Palaeoecological evidence from Neolithic fireplaces in the Sahara. African Archaeological Review 5: 93-103.

Grove, A.T. 1993. Africa's climate in the Holocene, in T. Shaw, P. Sinclair, B. Andah, and A. Okpoko (eds) The Archaeology of Africa: Food, Metals, and Towns. London, Routledge, One World Archaeology 20: 32-42.

Hassan, F. 1998. Holocene climatic change and riverine dynamics in the Nile valley, in S. di Lernia and G. Manzi (eds), Before Food Production in North Africa, Forlì, Abaco: 43-51.

Hugot, H. 1968. The origins of agriculture: Sahara. Current Anthropology 9: 483-9.

Ingold, T. 1988. Notes on the foraging mode of production, in T. Ingold, D. Riches and J. Woodburn (eds), Hunters and Gatherers: History, Evolution, and Social Change, Oxford, Berg: 269-85.

Lutz, R. and Lutz, G. 1995. *The Secret of the Sahara*, Innsbruck.

Mattingly, D. 2000. Twelve thousand years of human adaptation in Fezzan (Libyan Sahara), in Barker and Gilbertson 2000a: 160-79.

Mattingly, D.J., Daniels, C.M. Dore, J.N., Edwards, D. and Hawthorne, J. 2003. *The Archaeology of Fazzan. Volume 1, Synthesis,* London.

McBurney, C.B.M. 1967. *The Haua Fteah in Cyrenaica*, Cambridge, Cambridge University Press.

Millington, A.C., and Pye, K. (eds). 1994. *Environmental Change in Drylands: Biogeographical and Geomorphological Perspectives*, Chichester.

Mori, F. 1960. *Arte Preistorica del Sahara Libico*, Rome.

Mori, F. 1965. *Tadrart Acacus*, Turin.

Mortimore, M. 1998. *Roots in the African Dust: Sustaining the Drylands,* Cambridge.

Muzzolini, A. 1986. *L'Art Rupestre Préhistorique des Massifs Centraux Sahariens,* Oxford, British Archaeological Reports, International Series 318.

Muzzolini, A. 1993. The emergence of a food-producing economy in the Sahara, in Shaw *et al.* 1993: 227-39.

Petit-Maire, N. 1991. Recent Quaternary climatic change and Man in the Sahara. *Journal of African Earth Sciences* 12 (1-2): 125-32.

Le Quellec, J.-L. 1987. *L'art rupestre du Fezzan (Septentrional), Libye): Widyan Zreda et Tarut (Wadi Esh-Shati),* Oxford, British Archaeological Reports, International Series 365.

Shaw, T., Sinclair, P., Andah, B. and Okpoko, A. (eds). 1993. *The Archaeology of Africa: Food, Metals and Towns,* London, One World Archaeology 20.

Smith, A.B. 1984. Origins of the Neolithic in the Sahara, in J. D. Clark and S. A. Brandt (eds), *From Hunters to Farmers: the Causes and Consequences of Food Production in Africa,* Los Angeles: 84-92.

Smith, A.B. 1993a. New approaches to Saharan rock art, in Caligari 1993: 467-8.

Smith, A.B. 1993b. New approaches to Saharan rock art of the Bovidian period, in L. Krzyzaniak, M. Kobusiewicz, and J. Alexander (eds), *Environmental Change and Human Culture in the Nile Basin and Northern Africa until the Second Millennium BC,* Poznan: 77-89.

Thomas, D.S.G., and Middleton, N.J. 1994. *Desertification: Exploding the Myth*, Chichester.

Tiffen, M., Mortimore, M., and Gichuki, F. 1994. *More People, Less Erosion: Environmental Recovery in Kenya*, Chichester.

Theme 1

Natural Resources
(Oil and Water)

3. Managing Libya's water security in a world of changing technologies: the Saharan contribution

By Salem El Maiar[1] and J.A. [Tony] Allan[2]

Abstract

The main purpose of the study is to show that the Libyan economy has the capacity to meet its water resource needs. The Saharan groundwater is an important strategic element in the achievement of Libya's current and future water security. It is argued that it is only one of a number of sources of national economic security. A second purpose is to show that perspectives on how to allocate and manage water resources change through time as economies develop and technologies improve. The case of Libya is particularly interesting as it has been able to construct advanced civil structures to transport freshwater from the central Sahara to the coast. The Great Man-made River Project (GMRP) was conceived at a time when strategic and economic factors combined to make the water carrier option both feasible and appropriate. The recent advances in desalination technologies have so reduced the costs of desalination that countries such a Libya have been able to diversify and enhance their water security by deploying a range of water providing technologies. The two and a half decades since the initiation of the GMRP have shown that Libya has enjoyed the significant security of ready access to low priced staple foods on the international market which has reduced the urgency of mobilising freshwater for food production in Libya. The study includes details of the Great Man-made River Project (GMRP), its design capacity and the past and current phases.

Introduction

Libya's strategic location is, in a sense, its most important asset because it has easy access to the Mediterranean to trade its valuable export, oil, to readily accessible markets. It can also easily import the commodities, which its own resource base does not provide. Water is the main strategic natural resource deficit. Libya is for the most part a vast desert country with a long Mediterranean coastline. Throughout history Libya has been involved in an eternal struggle between sand and water. With a total area of 1,750,00 square kilometers, Libya is the fourth largest in Africa and among the world's fifteen largest countries, yet its population of about six million (2003 estimate) is amongst the smallest in the world (Fig. 3.1).

The climate of Libya is influenced by both the Mediterranean and the Sahara and varies from north to south. It can be classified into four climatic zones. Subtropical: limited to a very small area of the Jabal Akhdar in the north-west, Semi-Mediterranean: limited to areas along the coast, Steppe: covering the southern slopes of the Jabal Akhdar in the north-east, the western Jafara Plain and the Jabal Nafusah in the north-west. Most of this zone receives rainfall of more than 300 mm per year. Finally, the desert zone covers the greater part of the country and receives as little as 10 mm per year.

The majority of the population (more than 90 percent) is concentrated on the coastal tracts of the north-east and north-west representing less than seven percent of the total surface area

[1]School of Oriental and African Studies, University of London
[2]School of Oriental and African Studies, King's College London

Figure 3.1. Libya's international boundaries.

of the country. The soils are relatively fertile in these coastal tracts and most economic and social activities are concentrated in these favoured regions.

The concentration of population and economic activity in the coastal regions has brought urbanisation, industrialisation as well as an intensification of agriculture. The additional population has needed water and food. Libya ran out of water to raise its food requirements in the 1950s. Food imports rose rapidly in the 1960s and in line with population increases thereafter. (Allan 1981) Like most Middle Eastern and North African countries Libya has ostensibly pursued a food self-sufficiency policy.

Libya's Water Resources

Quantifying the water resources of countries where water is scarce is always a challenge. There are numerous interested parties and they have different messages to convey. Farmers and politicians do not want to concede that water resources are inadequate for the production of current and future food needs. The mass of people living in water scarce economies also like to be reassured about the status of their water resources. The problem is particularly compounded in the case of Libya because the major freshwater resources of Libya, say 600 billion cubic metres of, albeit expensive, fossil groundwater, lie beneath Libya's southern Sahara. There is a natural coalition of interested parties in Libya wanting to project the idea that the water resources are secure.

Libya's coastal renewable freshwater resources amount to less than 1 billion cubic metres per year. In addition the coastal tracts receive about 200 million cubic metres of effective rainfall each year. In the last five years of the twentieth century about 1 billion cubic meters per year of freshwater were being pumped and conveyed from the Sahara to the coast each year. The pressing perceived need for food security and self-sufficiency has led to the overexploitation and abuse of the non-renewable coastal aquifers. These detrimental excessive abstractions lowered the water table and caused saline sea-water to intrude resulting in the degradation of the vulnerable coastal groundwater. The most affected area is the Gefara Plain where more than 50 percent of Libya's population reside, where the main industrial establishments exist and where intensive agricultural activities and developments are taking place.

During drilling exploration for oil in the 1960s, massive reserves of fresh water were discovered in the sedimentary basins of Kufrah, Sarir, Hamada and Murzuk. These four basins extend across the Libyan Sahara for over one million square kilometres covering almost 60 percent of the overall surface area of the country. From the early 1970s the Libyan authorities were aware of the newly discovered southern water and a number of geo-technical and preliminary studies were conducted to determine the best way the Libyan people could benefit from the Saharan water.

Ambitious development projects in the early 1970s, addressing both the goals of productive irrigated agriculture and settlement, were established *in situ* notably at Kufrah and Sarir. By the mid 1970s such projects were using 0.5 billion cubic metres per year. But there were transportation obstacles associated with the southern agricultural projects, together with severe management and labour supply problems, these problems made the schemes both technically challenging and economically non-viable (Allan 1988).

The major problem however proved to be a social issue. The schemes were isolated and could not provide their staff with the same level of social infrastructure, schools, hospitals, cultural and entertainment facilities that are available at the coast. Even settler farmers from the southern nomadic tribes have similarly chosen the coastal areas rather than remain in the interior. The national strategy for the development of the vast fossil water resources of the Sahara, therefore shifted in the second half of the 1970s to bringing water to the people rather than taking the people to the water. This trend eventually culminated in what is known as the Great Man-made River Project [GMRP].

On October 1983 the Libyan government established an autonomous body known as the Great Man-made River Authority (GMRA) to implement and manage one of the largest civil engineering and water supply schemes currently under construction in the world. After careful detailed studies and consultations, it was decided to transport the Saharan groundwater in buried pre-stressed concrete cylinder pipes (PCCPs), up to four metres diameter, and manufactured in plants specially built for the project at Brega and Sarir. These type of pipes have been used across the US and Canada on projects totalling 30,000 kilometres in length. Some of the pipelines have been in place for nearly 60 years. More than 200 million people in North America rely on PCCP structures to deliver a large portion of their primary water supply (AWWA 2002). Once installed the pipelines would convey Saharan water on a journey that could take up to nine days to reach the user's gate on the northern coast.

As part of the national strategy towards water security, the GMRP project was conceived to exploit the four basins and to bulk transfer good quality water to the coastal strip to service the population centres and to provide water for municipal, agricultural and industrial developments. The project consists of four main stages as indicated on Figure 3.2.

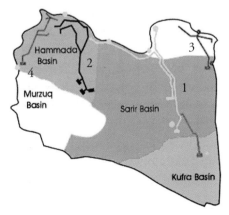

Water Development Trajectories and Social Theory

Libya began to encounter water supply problems in the 1960s. Its population, concentrated at the coast, had been growing rapidly for over half a century. The coastal groundwater resources were more than adequate to meet domestic water and industrial needs but the food needs of the rising population could not be met on the basis of coastal rainfed agriculture plus supplementary irrigation. Over-use of the coastal aquifers became evident by the mid-1960s. (Pallas 1976, Allan 1971)

Figure 3.2. The groundwater basins of Libya and phases of the Great Man-made River project.

Since then there has been a constant debate on how best to address the food insecurity issue. In practice the growing food deficit has been met by importing food grown in well-watered tracts in other continents. The impact of this widely adopted food-importing practice on the water situation in deficit economies across the Middle East and North Africa is economically invisible and politically silent. As a result the debates on national water deficits, such as those of Libya, have been only partially-informed. (Allan 2002) Most policy debates are only partially informed.

With the water deficit safely addressed by the 'virtual water' embedded in the easily affordable food imports (Allan 2003) it was possible to debate Libya's water predicament with whatever assumptions the interested parties wanted to adopt. Those who believed that technology could be effectively and economically brought to bear to move the economy towards water self-sufficiency could be persuasive. They argued that the serious risk was vulnerability to market circumstances beyond their control. Those who argued that a judicious food import policy was preferable to a risky, punishing and lengthy level of investment to achieve water and food self-sufficiency could be, and were, overwhelmed. The water self-sufficiency advocates perceived the major risk to be the weakening of the national economy by dependence on unreliable international forces. Those who advocated a calculated dependence on imported food commodities wanted to avoid an unnecessary project that would require an economy-distorting investment regime and would in addition have negative environmental impacts.

As is often the case the outcome has been different from both of the identified scenarios. The water developed from the Saharan fossil water resources has not been much used to raise food. Rather it has been mainly used to meet the domestic and industrial needs of the urban populations of Tripoli, Benghazi and other coastal cities. The rising food consumption has in practice been met by imports, which have reduced the need to mobilise water for irrigated farming. The Saharan water has been needed but has not comprehensively underpinned the food and water security of Libya. At the national level the policy discourse has been intense but it has not predicted actual outcomes.

Where does the GMRP fit in the international discourse on water resource management in economies located in semi-arid and arid regions? Approaches to the use of freshwater resources have been subject to significant change in the past half-century. In addition the approaches have had different trajectories in the economies of the industrialised semi-arid North compared with those in the less or less-industrialised semi-arid south. There are major economies in the semi-arid North that have progressively prospered despite a serious deterioration in the availability of water per head of population. California, Arizona and other western US states are extremely water short but prosperous. Australia is poorly endowed with freshwater and has also prospered. These economies witnessed a dramatic change in approach to the use of water in the late 1970s and the early 1980s. (Reisner 1984, Carter 1982, Allan 2001) The certainties, that more civil structures should be built to control water for use in agriculture, at the expense of the environment and the national economy, were successfully confronted by the environmental (green) social movement. Major US institutions, the US Bureau of Reclamation and the US Corps of Engineers were both reorientated and drastically reduced in influence by the Reagan

government of the early 1980s. Dam building and the construction of water conveyance structures virtually stopped. Dams have even been dismantled. (Reisner 1984, Allan 2002).

These unprecedented shifts of focus in the North in the decade, 1975-1985, was by chance the period when water resources were the subject of major review and evaluation in Libya. The development of the Saharan groundwater resources was a major element of that review. There was a convergence of circumstances, which favoured a radical solution to Libya's future water resources problems. First, in the 1975-1980 period Libya enjoyed high and buoyant oil revenues. First, the Libyan gross domestic product had risen to US$ 23 billion in 1980. Secondly, the big international names in US water infrastructure consulting and contracting, such as Bechtel, Halliburton, and Brown and Root, needed to compensate for the loss of business in North America as a result of the greening of US policies. They were predictably adaptive. Brown and Root, a subsidiary of Halliburton, moved from Houston to Surrey in the UK, following the serious rift in US-Libyan diplomatic relations after the bombing of Tripoli and Benghazi in 1986. Halliburton founded its Halliburton Environment subsidiary in the 1980s in response to the pressure on the US Government by environmental NGOs. It was Brown and Root that the Libyan authorities contracted to supervise the construction of the GMRP in 1980. Thirdly, Libya, like all the other economies in the semi-arid and arid South, regarded the development of their freshwater resources as an urgent national priority in order to achieve the levels of development enjoyed by the political economies of the North. Libya was in the company of governments allocating freshwater resources to major hydraulic projects involving well over 70 percent of the world's population and for 98 percent of the population of the Middle East and North Africa. A fourth factor which caused the Libyan leadership to opt for the development of Saharan freshwater was the experience of the first five or six years of managing the Libyan economy after the revolution of 1969. Addressing the problems of increasing the agricultural production and productivity of the Gefara Plain in the vicinity of Tripoli had been unrewarding. Those who had warned that groundwater was scarce had been shown to be right. At the same time measures to control groundwater use to raise water intensive crops such as tomatoes and citrus had been shown to be controversial and politically costly. (Allan 1981).

The trajectory defined by the decision to invest in the phases of the GMRP in 1979/80 have determined Libya's hydraulic mission approach to developing its freshwater resources since the mid-1970s. This trajectory has been sustained, albeit with a lower gradient than planned as a result of the very seriously reduced oil revenues of the 1980s. Projects planned for completion in less than a decade have still not been completed after 25 years. The reduced, but still very impressive trajectory, has been sustained by purchasing the technologies developed in California and built via contracts with Korean construction companies and consulting services based in the UK. This arrangement kept the substantial financial transactions at fiscal and diplomatic arm's length. Exceptional measures were needed to initiate and sustain the project. The success of the Saharan projects was too important for all the players – the Libyan leadership, international consulting services and the international contractors.

The policy of mobilising Saharan groundwater has been implemented at the same time as water use on the Gefara Plain has continued to increase. Libyan policy-makers and water-users

assume that the arrival of the Saharan water would solve their water problems and bring water and food self-sufficiency. In practice the approximately two billion cubic metres per year of GMRP water, which will be available when the project will be completed, can provide only about one third of the water needed by the economy for food self-sufficiency and to meet its domestic and industrial water needs. Another one sixth is available in the renewable coastal groundwater resources. The remaining 50 percent can only be economically accessed as virtual water in imported water intensive commodities.

The Political Economy of the GMRP

No major national decision to allocate or reallocate resources is based on economic and environmental fundamentals alone. Allocative decisions are made in historical and cultural contexts mediated by political processes. The Libyan leadership decided to build the GMRP at a point in its economic history when its budget prospects were favourable. At the same time all the economies of the South were committed to the 'certainties' of the hydraulic mission. The advocates of water and food security spoke louder, and had more political clout than those who favoured economic and environmental security. In any event the symbolic and emotional pull of food self-sufficiency fitted the beliefs and expectations of the population in general.

What were in practice the underlying fundamentals of the options which Libya had in the late 1970s? What were the risks and costs of the three major options? First, there was the GMRP option, which was believed to be a way to gain total water and food security and avoid dependence on the unpredictable global economy. In practice, while there is sufficient water in the Sahara the cost of pumping it, and conveying all that was needed to achieve food self-sufficiency via coastal agricultural production to the coast, was not viable. No verified cost per cubic metre of Saharan water has been formally published. The Centre for Data, Studies and Research of the Great Man-made River Authority, in making comments on Alghariani (2003) provided the following estimates for sections of the GMR: al-Jaghboub-Tobruk $0.296/m^3$, Adjdabiyah-Tobruk $0.274/m^3$, Ghadames-Zwara-Zawia $0.330/m^3$, al-Kufra-Tazerbo $0.171/m^3$. Unpublished figures of between 50 US cents and US$ 1.00 per cubic metre have been suggested. At US$ 1.00 per cubic metre the water could only be used economically for domestic and industrial use. At 50 US cents per cubic metre some water could be used to raise high value crops. In practice the volumes of water conveyed from the Sahara could only have met one third of Libya's needs in the first decade of the twenty-first century. The Saharan water has not been devoted to food production. The needs of the municipal, industrial and services sectors have taken priority. Current and future increases in food needs can only be met through the import of water intensive commodities.

A second option would have been to continue the existing policy of using some of the Saharan water in situ in the South for agricultural purposes and to allow food imports to increase to meet rising food demands. Both the first and the second options would have required moderation of the use of the coastal aquifers for irrigation because they were progressively deteriorating.

A third option would have been a hybrid strategy. This approach would have optimised the

use of reduced levels of coastal groundwater, the use of some in situ irrigation in the Sahara region, and the conveyance of about one billion cubic metres per year of affordable water from the Sahara to the coast to secure domestic and industrial water needs. In addition the security of domestic and industrial water supplies would have been achieved by initiating a major desalination programme to manufacture water.

National security was the major priority addressed in the late 1970s. The argument was driven by the mix of anxiety and belief alluded to above. The GMRP was judged to provide a more secure way forward for Libya. The manufacture of the GMRP four metre diameter pipes, the excavation of the pipe alignments and the installation of the pipes themselves would all be carried out in Libya. By contrast it was believed that the desalination option was both expensive as well as totally dependent on overseas technology. It was believed that a desalination programme would expose Libya to the manipulation of international suppliers whose interests could easily diverge from those of Libya (Centre of Data 2003). In practice Libya was just as exposed to the inefficiencies of the GMRP international suppliers and contractors and their inefficiencies and problems. There was a serious problem in the development of one the major well-fields in the late 1980s. And an expensive repair to corroded pipes had to be dealt with after it became evident in the year 1999.

The decision to adopt the GMRP technology was made easier because in the late 1970s as the cost of desalinating a cubic metre of water was between US$ 2 and US$ 3 depending on circumstances. Such costs made the comparative cost of delivering GMRP freshwater very much more favourable. The figures in currency for GMRP water were between US $ 0.5 and US$ 1.0 per cubic metre. The economics of desalination changed in the late 1990s and by 2001 figures of US$ 0.53 were being quoted for plants in the eastern Mediterranean and in Florida. As a result the debate over the role of desalination in Libya's future water-policy gained a high profile.

The cost of the original GMR project according to 1979/80 estimates amounted to over US$ 12 billion. This sum was about half of the Libyan national GDP at the time of the estimate and affordable if scheduled over a decade. The investment was huge but proportionate to the GDP being enjoyed at the end of the 1970s. Within two years Libya's GDP fell to about US$ 5 billion and fluctuated between that level and US$ 10 billion during the 1980s and the first half of the 1990s. Only in the late 1990s did oil revenues recover to provide Libya with US dollar incomes similar to those of the late 1970s.

The underlying fundamentals of the economy did not drive the water managing policy of Libya in the last two decades of the twentieth century. The vision of water and food security drove the commitment to the development of Saharan groundwater via the GMRP. But in the way of that political visions usually impact economies Libya's water policy has achieved some of the goals while at the same time as leaving in place much that was already there. About 50 percent of the planned Saharan annual supply was being delivered via the GMRP system by 2002. Meanwhile the coastal aquifers were still being progressively depleted. Most interesting of all scarcely any of the Saharan water conveyed to the coast was being devoted to crop production.

Alternative Technologies and Plural Global Solutions:
an Economic and Security Perspective on Libya's Water Policy.

Libyan policy makers have been exposed to a number of pressures, which led them to an understandable adoption of the GMRP outlined above. The first was the popular consensus that Libya should be water and food self-sufficient. The second was the widespread belief across the countries of the South that the conventional and new technologies that had enabled the industrialised economies to become strong and diverse should also be deployed by Southern economies where they could be afforded. Even non-oil economies were enabled to invest in major civil works as a result of financial support form agencies such as the World Bank. Where Cold War politics intervened to prevent such investment then bilateral funds could be mobilised. Egypt's High Dam, built between 1960 and 1972 was an example of the hydraulic mission given substance in the Middle East through Soviet support.

All technologies that attempt to harness natural resources are hostages to environmental and economic forces as well as to the fallibility of the technologies themselves. These forces and frailties are very hard to predict. The predicament of Libya is not that it is short of water. The fossil groundwaters beneath the Sahara, estimated to be about 600 billion cubic metres (600 cubic kilometres), are sufficient to meet the five out of six billion cubic metres per year needed by the Libyan economy now, and higher amounts in due course, for water and food self-sufficiency for about 100 years. The other one billion cubic metres per year could be met from the recharge of the coastal aquifers and the effective rainfall enjoyed at the coast. The problem for Libya is that utilising the Saharan water *in situ* has proved to be too challenging. The delivered cost of GMRP water at the coast means that such water is only suitable for high value activities, which do not include agriculture.

Economic and secure remedies to the water predicament of Libya require a mixed sourcing of water. Security has in practice been achieved over the past half century by sourcing water diversely. Some sources have more capacity and, more important, they are more flexibly available than others. Future security will depend increasingly on such diversity and flexibility. The sources and their characteristics of availability, reliability and flexibility are shown in the Table 3.1.

The analysis in Table 3.1 shows why Libya has adopted a policy which accesses water from plural sources. It will be confirmed as the most appropriate policy to achieve affordable security even if the actual sourcing is not currently recognised publicly by the water policy making community in Libya. Libya's soil water and low cost freshwater resources can only supply about 20 percent of Libya's water needs in good rainfall years. When rains are poor the proportion supplied would be less. The GMRP can supply between 1.5 and 2.2 billion cubic metres per year. The volume of GMRP water supplied can be varied from year to year but the Saharan water could not be regarded as an economic source of water for irrigated farming.

There are three potential sources of water from non-indigenous sources: desalination, imports by tanker or bag, and virtual water in water-intensive imported commodities. Two provide expensive water. The third is extraordinarily advantageous because it makes it unnecessary to mobilise the high volumes of water for irrigated farming at zero-cost in terms of water inputs.

Type of water	Availability bn m³/year	Capacity to meet demand for water for		Cost US$/m³	Flexible availability of affordable large volumes
		food	domestic/ industry		
soil water i.e effective rainfall	0.05-0.10 [insecure]	very very poor	n/a	negligible	no
coastal groundwater	1.00 [insecure]	very very poor	substantial	c.0.1	no
GMRP water	1.50-2.00 [secure]	inadequate	complete or partial	0.5-1.0 [cost limits avail- ability]	no
imports by sea	0.0-0.10 [secure]	inadequate	partial	c.0.5	no
desalination	0.20-0.50	inadequate	partial	0.5	no
treated waste water	0.01-0.30	inadequate	partial	0.5-1.0	no
virtual water	limitless	total	n/a	negligible / subsidised by exporters	very

Table 3.1. Libya's sources of water (soil water and freshwater) and their characteristics – level of secure availability, cost, capacity to meet demand and flexibility of availability. n/a = not applicable. (Source: Pallas 1976 and authors' estimates based on discussions with Libyan professionals.)

Meanwhile, desalination has become affordable for domestic and industrial water uses at about 50 US cents per cubic metre.

Water imports by tanker or bag will be competitive in terms of cost from sources such as Turkey during the coming decades for domestic and industrial uses. Neither of these high cost sources, however, has the capacity to meet the water needed to raise Libya's food needs. It is only virtual water in the global economic system that has the capacity, in terms of volume and even more important in terms of flexibility, to meet Libya's food needs (Hoekstra and Hung 2002).

Environmental and Heritage Impacts

The impact of the GMRP has to be evaluated against the long term trends in the status of Libya's water resources and heritage resources. Libya has no permanent streams. Its groundwater resources have been well documented and all studies of the renewable coastal aquifers record the serious deterioration of these important freshwater resources. The coastal aquifers have been over-exploited to meet the demands of agricultural users. They have also been degraded in quality through the intrusion of seawater as a consequence of over-pumping.

In a study implemented by the General Water Authority (GWA), between 1972 and 1997, of the Quaternary-Miocene Aquifer, the main groundwater supply for the Tripoli area, it was

found that water levels in the lower unconfined aquifer dropped by 38 metres. The decline was 43 metres in the upper Quaternary aquifer. In some central parts of the Jefara Plain the water level decline was over 50 metres and a number of the old wells were further deepened to maintain the supply of water (Alghariani 1998). Despite these trends, in 2002 the General Water Authority (GWA) was issuing around 100 drilling licences on a weekly basis. (Salem 2002) The well drilling was an attempt to compensate farmers for their water deficits. In practice these new wells further lowered the water table and exacerbated seawater intrusion.

The Saharan groundwater is a fossil resource. Any recharge is very small indeed. The development of the Sahara aquifers is a mining activity. Once used the Saharan groundwaters are in effect permanently impacted. Such is the volume available in these aquifers that the withdrawal of two cubic kilometres per year, or even five per year, will not seriously deplete the estimated 600 cubic kilometers which geologists retained by the Libyan government have calculated to be available. As already shown it is the cost of developing and transporting the Saharan waters that limits their use rather than the volume available.

The Saharan groundwaters have inherent quality problems. The major problem relates to the nitrate levels in the western Saharan groundwaters. Average nitrate concentration in Phase II water, exceeds the permissible WHO standards of 60 parts per million. Blending the high nitrate Saharan water with desalinated seawater is an option. This practice could enable the distribution of satisfactory water and reduce negative health and environmental impacts.

Any project as large as the GMRP must have environmental and heritage impacts. In the case of this Libyan project the environmental impact has been limited. The majority of the pipeline routes cross very sparsely vegetated and unpopulated regions. The grazing use along the alignment was and remains very low or zero. The wild-life populations were and remain very low indeed. The decision to excavate the pipeline routes and then back fill means that the final outcome in terms of surface disturbance has been minimal. Also the civil works do not create barriers to traditional land using practices nor to the movements of livestock or wild-life.

It is not possible to cite detailed environmental impact studies as these have not been completed. It was not until the early 1990s, when the western pipeline was being evaluated and planned, that there was a brief period, of between one and two months, when intensive environmental and heritage impact studies were completed. They were necessary because Libya was at the time exploring the option of negotiating a loan from the African Development Bank to part-finance the Western Pipeline. The African Development Bank required such surveys as a condition of providing finance. The EIA study of Phase II, the Western Pipeline, was conducted by Halliburton NUS Environmental Limited. This company and Brown and Root are both associated with the Halliburton parent company. The study clearly concluded that the project had been well conceived and would make an invaluable contribution to Libya's water security and development (Brown and Root 1992). In the event the western project went ahead without external finance.

There is one impact of the GMRP which will be environmentally favourable. The import of up to two cubic kilometres per year of high quality freshwater to the water-scarce coast will not only solve the domestic and industrial needs of the residents of these tracts. It will also have a

favourable impact on the coastal aquifers. Water used for domestic, municipal and industrial purposes is not consumed in the same way as plants and crops consume water. As much as 70 percent of the water used for domestic and industrial purposes is returned to the hydrological system. Most of the water used for flushing toilets, for washing and bathing, for cleaning the house and for washing the car return to a water collection system or leak to the ground. The water collected can be treated and reused. Much water leaks to the ground from all distribution systems, not just those in Libya. It is difficult to estimate the scale of the impact of the recharge of the coastal aquifers. It will be substantial. But it will always be difficult to estimate accurately while the current levels of groundwater use in agriculture prevail. Any actual allocation of Saharan water to irrigation at the coast will also have a positive impact on the health of the coastal aquifers. In due course, provided, agricultural use is regulated, the arrival of sustained volumes of Saharan water could even reverse the trend in seawater intrusion.

The only potentially serious impact of the GMRP has been in the northern section of the Western Pipeline. The alignment traverses the 'pre-desert' region in which there was significant human activity during pre-history as well as in the classical eras and during the Islamic periods. No detailed surveys have been carried out during the period of excavation nor subsequently so the heritage impact cannot be reviewed. In practice the impacts will be limited as the levels of prehistoric and more recent occupations were not intensive. Any serious disturbance of archaeological remains of intensive classical and Islamic settlement have been the result of activity unrelated to the GMRP project. It is the scale and pace of the expansion of the cities of the coastal regions in the Gefara Plain and in the Benghazi area that has been many times more significant than anything caused by the GMRP.

The Great Man-made River Project(GMRP): Phases of the Project

The $5.25billion Phase I of nearly 1,600 km, awarded to Dong Ah Consortium of South Korea as contractor and Brown and Root (Houston) as consultant, kicked off in 1983 and was completed in 1993. It was designed to convey 2.0 million cubic metres per day from the Sarir and Tazerbo well-fields to a holding reservoir at Ajdabiyah The reservoir has a storage capacity of 4.0 million cubic metres. Water was pumped from Ajdabiyah to the end reservoirs at Benghazi and Sirt. It was operating at less than 50 percent of its maximum capacity in 2003. Phase I is known by the acronym SS/TB.

The $7.4 billion phase II of nearly 2,155 km, was awarded to the same contractor and consultant (UK branch). It was started in 1986 and completed in 1996. It was designed to carry 2.5 million cubic metres per day from East and North East Jebel Hasounah wellfields to the fertile Gefara Plain including the city of Tripoli. It was operating at 50 percent of its potential capacity in 2003. Phase I and II are already supplying water to the main cities of Tripoli and Benghazi plus the population centres along the routes of the pipelines.

The $6 billion phase III is the connection from Sirt to Sedadah approximately 390 km and was under construction in 2003, almost by Libyans, This phase also includes a link from Kufrah to Tazerbo designed to supplement phase one with 1.6 million cubic metres per day. This augmentation was originally part of phase one.

The final stage of the project consists of two separate water supply systems, one in the extreme west from Ghadames to Zawarah and Zawiyah at a cost of approximately $500 million, for which a drilling contract was awarded in 2003. The second system will be in the extreme east from Jaghboub to Tobruk at a cost of nearly $560 million. This project was at the stage of preliminary geo-technical studies and investigation in 2003.

The aim of the Great Man-made River Project is to bring water to the people and to provide water for municipal, industrial and agricultural uses. As in most countries of the Middle East and North African region, by far the largest volume of freshwater is devoted to irrigation and agricultural development in their coastal tracts. The planned allocation of water has changed

Phase	Municipal	Agricultural	Industrial	Total
Phase I	410,170	1,506,030	83,800	2,000,000
Phase II	1,316,090	1,175,660	8,250	2,500,000
Phase III	253,000	1,427,000	0	1,680,000
Total	1,979,260 (32%)	4,108,990 (66%)	92,050 2%)	6,180,000 (100%)

Table 3.2: Approximate allocation of water to the three main sectors (source: GMRA 2001)

in the 25 years of the project. The volume of Saharan water officially scheduled for agriculture in 2001 had fallen to 66 percent as indicated in Table 3.2.

When all phases are completed, Libya will enjoy the availability of extra 2.0 billion cubic metres per year added from the Sahara to its existing under 1.0 billion renewable cubic metres per year from coastal aquifers and rainwater capture plus desalinated water and waste water treatment will give it in the region of 4.0 billion cubic metres per year as indicated by Table 3.3 below.

Water resource available for utilisation	(Mm³/yr)
Ground (non-renewable)	3,000
Renewable	650
Surface	250
Desalination	65
Waste water	35
Total	4000

Table 3.3: Estimates of affordable available water when GMRP is completed (source: authors' estimates)

The demand for water will always rise as a result of growth of population, urbanisation and improvement in the standard of living. Libya's food self-sufficiency will require well over 6.0

billion cubic meters per year to achieve this target and more when the population increases further. As far as the project is concerned the key policy issue remains is the allocation of water to agriculture. Allocations to irrigated agriculture will either shorten or lengthen the life span of the project. A very careful and detailed analysis is needed of the political, hydrological, economical and social impacts of the project.

Libya can avail itself of recent developments in desalinating sea-water and in treating municipal waste water. There has been a significant decline in the cost of sea-water desalination. An average cost of one cubic metre of desalinated in operational plants built in the Middle East in the 1970s and 1980s was between US$ 1.5 and US$ 3.0. In new plants under construction in the Middle East and the United States the price will be between US$ 0.50 – 1.00 per m³. So far transporting water via the GMRP is still cheaper than any other alternative. Libya's security interests lie in gaining access to as many sources as possible and by creating demand in order to develop competitive markets, thus enhancing the options available and ensuring the advantage of keen prices. It has been suggested that by 2025 the price of a desalinated cubic metre could come down to 15-25 cents per cubic metre (Jefferson 2002).

Another important option is to utilise water bags to deliver good quality water to the Libyan coast from northern Mediterranean countries such as Turkey, Albania or Croatia. These bags have a discharge capabilities of 250,000 metres per day at a cost of less than US$ 0.20 per metre. This cost makes the water unusable in agriculture, but is very favourable for supplies for coastal urban cities and industrial complexes. Libya is well placed to lead the Mediterranean in this technology as it has the dry climate to manufacture the bags (Savage 2003).

Wastewater treatment would be a very useful option especially that more than 70 percent of the water can be recovered from municipal systems. In the first decade of the twenty-first century, every litre delivered to a municipality today is literally lost for tomorrow. Wastewater conserves water for the highest-value uses. Such developments will also reduce environmental impacts, enhance food production and reduce the need to import artificial fertilisers because of the nutrients contained in the treated water (Faruqi *et al.* 2001).

Conclusion

In can be concluded that the Great Man-made River Project has proved to be technically feasible and politically successful. Though economically burdensome it is, on balance, viable as well as socially beneficial. The GMRP project has proved to be technically feasible in the installation of the latest hydraulic management solutions, deploying engineering and material and communication sciences. It is an impressive Middle Eastern precedent for water transportation schemes in arid and semi-arid regions. Others are being planned such as the Dissi/Amman project in Jordan.

The GMRP has had a political impact in the sense that it has contributed to a filling of the geopolitical vacuum between Tripoli and Benghazi. It has played a pivotal role in joining and uniting the most important populous parts of the country (Alghariani 1997).

Most importantly the project's water became an important symbol of national security being delivered at a time when Libya was politically isolated and enduring punishing US bombing in

1986 as well as US trade sanctions and severe and unjust UN sanctions imposed in 1992.

The project is economically viable in the sense that it delivers Saharan water to coastal water users more cheaply than any other alternative at least at the time of design in the late 1970s. (Stauffer 1997). The concept of pipes seemed very sound (Allan 1997) since the Pre-stressed Concrete Cylinder Pipes (PCCPs) utilised for all phases of the project have been manufactured domestically. The GMRP has not been able to deliver sufficient freshwater to meet the rising needs for low quality water for irrigated agriculture. As such it is a necessary but not a sufficient contributor to Libyan water security. A secure Libyan political economy in the area of water requires a marshalling of the full range of water supply options and a flexible approach to mobilising them according to evolving technologies and markets.

The project is clearly socially beneficial because it is brings abundant potable water to the citizens of Libya. Many Libyan families endured twenty years of water supply problems until the Sahara water came on stream in the early 1990s in the east and in the late 1990s in the west. In addition the environmental and heritage impacts of the project have been minimal (Brown and Root 1992).

The Great Man-made River Project has mobilised significant volumes of the vast Saharan groundwater resource. But it is by no means a permanent solution to the amelioration of Libya's challenging water resource status (Bakhbakhi and Salem 1999). However, if its water is allocated and managed in an economically rational and environmentally sustainable manner, Saharan water will be a vital element in securing the prosperity of Libya. The Saharan water will act as a buffer and is already giving Libya a breathing space. The length of time that the GMRP will make this contribution will depend on internal hydro-politics, water allocation policies, and the rate of extraction.

References

Alghariani, S. 1997. Managing Water Scarcity Through Man-made Rivers, *Proceedings of the XXV11 Congress of IAHR/ASCE,* San Francesco, CA: 607-14.

Alghariani, S.A. 1998. Remediation of Ground Mining in North-western Libya, *Proceedings of the International Water Resources Symposium,* ASCE, Memphis, TN: 183-90.

Alghariani, S. A. 2003. *Water transfer versus desalination in North Africa: sustainability and cost comparison,* Occasional Paper 49, SOAS, University of London. See www.soas.ac.uk/waterissues/

Allan, J.A. 1971. *The Economic Use of Land and Water in the Tripoli Region of Libya,* Unpublished PhD thesis, London University: SOAA.

Allan, J.A. 1981. *Libya: the experience of oil,* London: Croom-Helm.

Allan, J.A. 1988. The Great Man-made River: progress and prospects of Libya's great water carrier. *Libyan Studies* 19: 141-146.

Allan, J.A. 2001. *The Middle East Water Question, hydropolitics and the global economy,* London: I B Tauris.

Allan, J.A. 2002. Hydro-peace in the Middle East: why no water wars? A case study of the Jordan River Basin, *SAIS Review* 22.2, Summer-Fall 2002: 255-272.

Allan, J.A. 2003. Virtual water: useful concept or misleading metaphor? *Water International* 28.1: 4-11; 28.2: 255-272.

AWWA [American Water Works Association], 2002. *Manual of Water Supply Practices,* Denver.

Bakhbakhi, M. and Salem, O. 1999. Why The Great Man-made River Project, *Proceedings of the International Conference of IAH,* Tripoli: 112-24.

Brown and Root 1992. *Great Man-made River Project: Environmental Impacts Assessment – Main Report*. Leatherhead [UK]: Brown and Root.

Carter, J. 1982. *Keeping Faith: memories of a president,* New York: Bantam Books.

Center of Data, Studies and Researches. 2004 . *Comments on Occasional Paper 49*, Center of Data, Studies and Researches of the Great Man-made River Authority, Libya, published at SOAS, University of London. See www.soas.ac.uk/waterissues/

Faruqi, N., Biswas, A. and Bino, M. 2001. *Water Management in Islam*, Tokyo.

Gowing, J., Konishi, T. and Kupitz, J. 1998. *Nuclear and Fossil Seawater Desalination - General Considerations and Economic Evaluation*. Vienna: IAEA.

Hoekstra, A. and Hung, P. Q. 2002. Virtual water trade: a quantification of the flows of virtual water between nations in relation to international crop trade, *Value of Water Research Report No. 11,* Delft, The Netherlands: IHE: 55-60.

Jefferson, M. 2002. Report of the Thematic Panel on Energy Technology and its Implications for Water Resources, *World Water Vision*. The Hague: The World Water Council for the Second Global Water Forum: 277-84.

Pallas, P. 1976. Water resources of Libya, in M.J. Salem and M.T. Busrewil (eds), *The Geology of Libya,* Vol II, London: AcademicPress: 539-594.

Reisner, M. 1982. *Cadillac Desert*, New York: Penguin Books. Reprinted 1993.

Salem, O. 2002. General Director of the General Water Authority GWA (Personal communication, Tripoli, May 20th, 2002).

Savage, C. 2003. Executive Director of AquaMarine International Limited (Personal communication, London, March 2003).

Stauffer, T. 1997. Libya's water management options, *The Christian Science Monitor*. Issue No 29: 3-5.

4. Libya's Saharan Groundwater: Occurrence, Origins and Outlook

By W.M. Edmunds[1]

Abstract

The vast proportion of available groundwater in Libya is non-renewable and originated during past millennia when the climate was much wetter than today. The history of the exploration of groundwater during the twentieth century is presented, including the 'discovery' of freshwater in parallel with the oil exploration during the 1960s. Groundwater is contained in a series of overlapping sedimentary basins, which range in age from the Cambrian to the Quaternary and the hydrogeology of the main basins is discussed in terms of their sedimentary characteristics and recent exploitation. The main reserves of freshwater are in the south of the country, contained in sandstones and other continental sediments, which may reach over 3000 m in thickness. Brackish and saline groundwaters are found mainly in the north of the country where the continental sediments are overstepped by marine deposits. The recharge history of the groundwater is described using stable isotopes in groundwaters of known age. This shows that major recharge episodes occurred prior to 20 kyr BP from Atlantic westerly moisture sources. A period of aridity is recorded from 20-12 kyr BP corresponding to the ice age maximum. After this there is evidence of intense wet periods leading to groundwater recharge, especially in the south (both locally and from large rivers). These are partly related to the intensification of the Atlantic monsoon, which moved northwards. The present day arid climate with recharge to aquifers restricted to the northern coasts, dates from about 4.5 kyr BP.

In just over a quarter of a century major exploitation of these non-renewable freshwater reserves has led to water table decline and quality deterioration. A scientific basis is needed to create a deeper understanding of the nature of the water resource so that informed decisions can be made for future conservation and careful management.

Introduction

Libya is highly favoured amongst the desert states of the world in having large reserves of freshwater of high quality in relation to its population. Unlike its population, however, the reserves of groundwater are non-renewable. In this paper some of the evidence is reviewed which demonstrates that, except for a tiny fraction, Libya's groundwater is overwhelmingly an inheritance from the past. It represents a resource more valuable than the oil, since unlike the oil, water is essential for life.

There is ample evidence that wetter climates than today occurred in Libya, as well as over much of northern Africa prior to a general aridification some 4000 years before the present. Palaeoenvironmental evidence from fluvial and lake sediments provide a record of major river and palaeolake systems, which extended across the region during the early Holocene and during much of the late Pleistocene (Pachur 1980; Petit-Maire *et al.* 1980; Gasse 2000). The archaeological record provides ample evidence of prolonged subtropical humid climates during the Holocene from the rock graffiti which depict large mammals, as well as evidence of the progressive change to the present day arid climate. Groundwater emerging as springs determined sites of the first settlements and became a focus for migrating populations. Groundwater issuing mysteriously from the rock had been a source of reverence from the earliest of recorded history. The word

[1] Oxford University Centre for the Environment, University of Oxford

ain in arabic is both the word for 'spring' and for 'eye' and it is suggested that this may reflect the belief that springs were the "eyes of the gods" (Issar 1990).

The general piezometric decline in the late Holocene led to a decline in the flow of springs and a contraction of their discharge areas. Shallow wells were constructed and deepened to chase the lowering of the water tables. The first settled communities in Libya also constructed foggara to intercept the water tables in piedmont areas (Wilson, this volume). Flowing springs may still be found at the present day, although over most of Libya the springs, their associated discharge areas and ecosystems are under threat from the rapid recent developments of groundwater.

In this paper the occurrence and origins of the groundwater in Libya are reappraised. This commences with a review of the early groundwater exploration work in Libya. The scientific stages in defining the non-renewable status of the groundwater reserves are then considered. The paper ends with a review of the groundwater quality, the problems already faced by the recent exploitation and a consideration of the options for exploitation as well as conservation of the vast palaeowater reserves.

Discovery of Libya's Groundwater Resources

The first scientific work on groundwater dates from the late 1920s with the first expeditions and geological exploration of the Libyan Desert. The findings of the early explorers were put together by Ball (1927) who created the first water level contour map covering modern Libya, Egypt and Sudan and who proposed sources for the groundwater from the Erdi, Ennedi and Tibesti mountain regions. These studies extended from earlier work on the oases of Kharga and Dakhla. Continuity of an aquifer system linking the oases of the Libyan Desert was first suggested by the German explorer Gerhard Rohlfs in the nineteenth century. It was Hellstrom (1940), who took and extended the data compiled by Ball, and conducted the first hydrogeological interpretation of the aquifer system. His maps show carefully drawn flow lines separating flows into the Egyptian oases and across into Libya. Using porosity and permeability data from outcrop samples of the Nubian sandstone he was able to calculate transmissivities of the aquifer and compute gradients and flow velocities. He was also the first to draw attention to the likely age of the groundwater, which, he calculated, with a velocity of 15 m per annum would take 100,000 years to reach the Quattara depression from its source. These pioneering studies assumed an annual recharge of 10 mm/year and also drew attention to the large amounts of water 'wasted' by evaporation in the Quattara depression; some of the flow calculations and piezometric measurements were marred by low resolution topographic data (still a problem until recent years), but this study set the scene for the dramatic discoveries and developments of the next half century.

The discovery of vast groundwater reserves in the late 1960s and early 1970s took place on the back of the detailed geological exploration of the country and the search for hydrocarbons by Italian, German and American scientists. Following the pioneering geological work of Desio (see Desio 1970), further regional structural geological interpretation helped to define the main sedimentary basins (Klitsch 1970). However it was the systematic geological exploration and extensive deep drilling, conducted by international oil companies that defined the basin structures, the results of which were summarised in the renowned map and memoir of the US

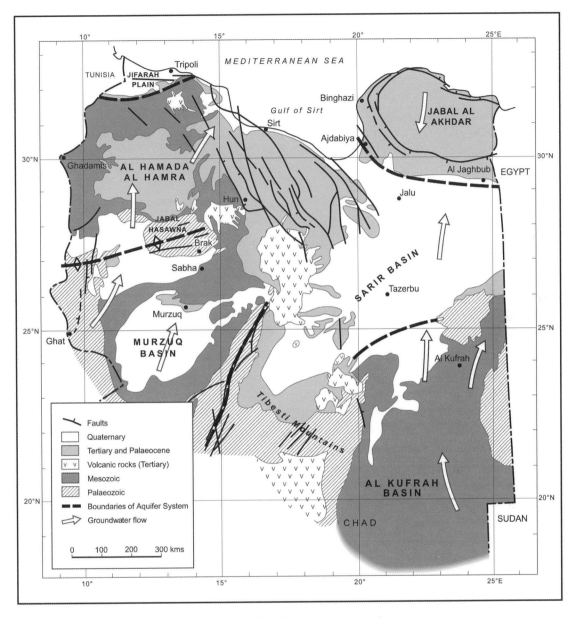

Figure 4.1. Map of the principal sedimentary basins in Libya showing the main aquifers.

Geological Survey (Conant and Goudarzi 1964).

Each oil exploration site requires on average two water supply wells. This provided a means for ancillary groundwater exploration. The USGS produced the first reconnaissance groundwater maps (Jones 1964), and in the late 1960s the British Geological Survey (BGS) with Occidental of Libya carried out the first detailed surveys in the Sirt and Kufra basins for British Petroleum (Wright and Edmunds 1970) and the Kufra Agricultural Company. This work continued during and after the 1st September revolution of 1969 with subsequent aquifer testing, sedimentological,

geochemical and modelling work in the Jalu and Sarir regions producing unpublished reports for the Kufra and Sarir Authority (see Wright *et al.* 1982).

The scientific basis for the Great Man-made River project drew from these early studies in the Sarir and Kufra basins as well as from later work in Fazzan. The countrywide appraisal of groundwater resources owes much to the synthesis carried out as a report to the Secretariat of Dams and Water Resources by Pallas (1978) and published in 1980 (Pallas 1980). Details of the construction and main characteristics of the GMMR are given by Pim and Binsariti (1994), and most recently by Salem and Pallas (2001).

Groundwater Occurrence in Libya

Basins and hydrogeological setting
Some 90 percent of Libya is comprised of sedimentary formations, ranging in age from the Cambrian to the Quaternary, which give rise to some of the largest aquifer systems in the world. Five major systems may be recognised (Fig. 4.1) which are more or less independent of each other: the Western aquifer system (including the sub-basins of Murzuq, Jabal Hasawna and Al Hamada al Hamra); the Kufrah (Nubian Sandstone) aquifer; the Sarir Basin; the Djefara Plain and the Jabal Al Akhdar. The last two regions are the only ones where measurable modern aquifer recharge is taking place, whilst the first three contain entirely non-renewable waters (palaeowaters). The occurrence of groundwater in these sedimentary basins as well as the main landscape elements are summarised conceptually in Figure 4.2. There are four main systems that are important for hosting groundwater: i) sedimentary basins of Palaeozoic age; ii) sedimentary basins of Mesozoic age; iii) sedimentary basins of Tertiary age; iv) Quaternary sediments forming shallow groundwater systems, notably in the Djefara plain. North to south cross sections through these basins, illustrating the likely pathways of groundwater movement, are contained in Pallas (1981).

The Western Aquifer system
This area includes the Murzuq basin and the area to the north, which includes the al Hamada al Hamra Basin system and the recently exploited Jabal Hasawnah aquifer.

a) The Murzuq Basin
The Murzuq Basin is well delineated by the Cambro-Ordovician outcrops, the extent of which are clearly visible from satellite images. The inner basin is delineated by the Mesozoic sandstone outcrops which are covered by extensive Quaternary sands. The two older sedimentary formations form major aquifer systems. The Cambro-Ordovician sandstones (Lower Aquifer) also show hydraulic continuity with Silurian sandstones in the north of the Basin.

The main flow of groundwater in the Lower Aquifer is from south to north, although it is uncertain whether there is hydraulic continuity across the basin from Ghat in the south to Wadi ash-Shati, or, whether there is uninterrupted flow through to the al Hamada al Hamra area. It must be assumed that the present piezometric gradient has been in overall decline since the Holocene wet phases. Important natural discharge areas from the Lower Aquifer include those

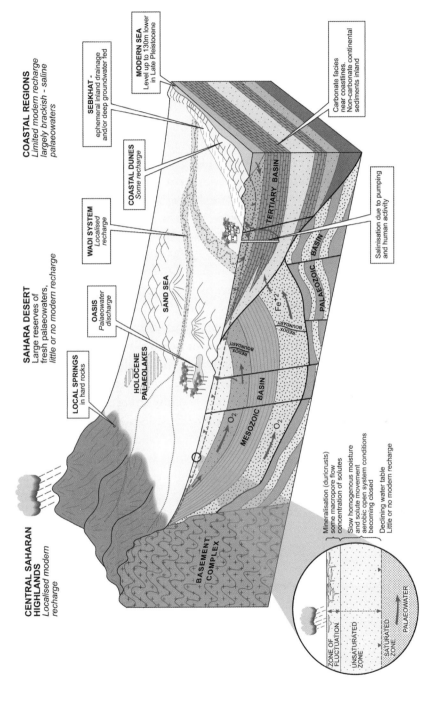

Figure 4.2. Groundwater occurrence in Libya. Schematic block diagram of the sedimentary basins, from the Lower Palaeozoic to the Recent, containing groundwater. The main landscape features are also shown with inset showing the movement of water through the unsaturated zone.

at Brak (Wadi ash-Shati) and at Ghat. The water is overall of excellent quality, ranging from 150-500 mg/l total mineralisation, the only saline water being restricted to the north-west of the basin. Extraction has taken place through a number of projects especially private farming, since the 1970s. These have caused a piezometric decline of up to 40 m in the Wadi ash-Shati, mainly at the expense of the discharge to the Sebkhats, but not without some environmental damage. The new GMMR Phase 2 development at Jabal Hasawna comprises two wellfields expected ultimately to produce some 2.5 Mm³/day for Tripoli and the coastal towns. The first phase now in operation comprises 90 wells each of 500 m depth and producing 50 l/s.

In the upper reservoir groundwater flow is also from south to north with important natural discharge zones in Wadi Ajal, the Murzuq, and Wadi Ash-Sharquyah basins. Some leakage northwards to the al Hamada al Hamra basin is likely. The aquifer is an inter-bedded sandstone/shale sequence, although it is likely that it functions as a single hydraulic unit. The water quality also is good with concentrations typically not exceeding 200 mg/l total mineralisation, although around the discharge zones saline groundwater may be a hazard. A number of private farms around Sebha were implemented in the Upper Aquifer in the 1970s, but many of these are now in decline. In the area of Murzuq away from the discharge zones (e.g. Wadi Barjuj), the rate of water table decline is lower.

b) The Hamada Basin

The northern aquifer system, centred on the Al Hamada al Hamra, is composed of a succession of different water-bearing formations, which are in hydraulic continuity. The deepest aquifers (around Jabal Fazzan, north of Brak) are of Cambro-Ordovician to Devonian in age. Further to the north the water flows transgressively through Lower Mesozoic sandstones into limestones of Upper Cretaceous age and then laterally into mainly sandy sediments of Tertiary age. The Upper Cretaceous sandstones (Kikla formation) form the most important regional aquifer, although most recently the Cambro-Ordovician sandstones of the Jabal Hasawna area are being exploited within the GMMR project (Phase 2). The overall flow is from south to north or north-east. Water quality in groundwaters of the basin is usually excellent, but brackish conditions are found where limestones occur.

The Eastern Aquifer System

a) The Kufra Basin

The Kufra Basin is the largest aquifer system in Libya. Its main unit, the Mesozoic sandstones forms part of the Nubian sandstone aquifer, which extends into Egypt, Sudan and Chad. The basin is more than 3000 m thick at its centre and contains huge reserves of fresh groundwater (total mineralisation 100-400 mg/l). The main development in this area has been the Kufra Production Project, the first large-scale groundwater development in Libya, initiated in 1972 and irrigating 100 hectares. Over 160 boreholes have now been drilled to depths ranging from 350-480 m and with an average production of 75 l/s. The water table decline is estimated at between 15-25 m over the 30 year period of operation, although monitoring is unreliable (Pallas and Salem 2000). Further development is now taking place at Tazerbu in the north of the Basin.

b) The Sarir Basin

The stratigraphy of the Sarir Basin is well known as a result of the oil exploration as well as from detailed hydrogeological studies (Wright *et al.* 1982). The early Tertiary formations up to the Oligocene are mostly marine, in contrast to the underlying Cretaceous formations. The main aquifers of the Sarir Basin are found in sediments of the Lower and Middle Miocene (Marada Formation). A major deposition of continental sediments also took place post-Middle Miocene corresponding to the Messinian event which lowered the Mediterranean Sea. The sediments in these two formations form the major aquifer of the Sarir Basin, There is a significant transition from continental to marine facies in these late Tertiary formations between 28 and 29°N (Fig. 4.2) and this gives rise to a gradation from fresh to saline waters.

There are two main well fields in the Sarir Basin: the Sarir Production Project (SPP), completed in the 1970s and the Sarir Water Transport, in operation since 1993 as Phase 1 of the GMMR project. The former comprises 240 wells for centre pivot irrigation (although only half of these were in operation in 1999) showing a drawdown of between 4-8 m over the 25 years of operation. The Water Transport Project consists of 126 wells, capable of producing 96 l/s almost exclusively for domestic use in the coastal towns and was operating at 25 percent of capacity in 1999 (Pallas and Salem 2000).

The Djefarah Plain

The maximum rainfall in the Djefarah Plain is around 300 mm/yr allowing some groundwater recharge. The main aquifer is formed of Quaternary to upper Miocene sediments which also are in hydraulic continuity at depth with sandstones of Jurassic to Triassic age and Miocene calcarenites. This aquifer, traditionally important for agriculture is seriously overexploited with saline intrusion stretching inland for several kilometres and with water levels depressed by a maximum of 60 m.

The Jabal al Akhdar

Groundwater is contained in fractured carbonate rocks of Eocene and Miocene age. This is largely a karstic aquifer system, which is replenished by modern rainfall (200-600 mm/yr). Runoff takes place to the coast and also towards the south into the Sebkhats. The area is used both for private agricultural projects as well as for urban use; water levels show significant decline suggestive of a significant overexploitation (Salem and Pallas 2000).

Groundwater Origins and Past Recharge Conditions

Methods of characterisation

The chemical and isotopic composition of groundwater contains important clues as to the waters' origin as well as the types of rock through which it has passed along flow lines. This information may directly indicate when periods of high rainfall took place from the evidence contained in dateable groundwater. Groundwater archive information may directly complement that from other environmental records such as lake sediments (Gasse 2000). Tracers used in groundwater investigations may be divided into two groups (Table 4.1), which are discussed further in Herczeg and Edmunds (2001):

Inert tracers

Inert tracers mainly record the inputs from rain and soil water. These may record past temperatures, rainfall sources and intensity, vegetation cover and other environmental history at the time of recharge. In this paper emphasis is placed on Cl, $\delta^{18}O$, δ^2H and nitrate.

Reactive tracers

Reactive tracers give evidence of the types of rocks through which the water has passed as well as giving information on the main properties for water use. Radiocarbon is of special importance in groundwaters for indicating residence times. Since it is also a reactive tracer knowledge of the carbonate system as a whole is required before ^{14}C can be used for absolute age determination; to facilitate this ^{13}C may be used. In the present study some radiocarbon results were corrected using suitable geochemical models (Clark and Fritz 1997), but for other purposes the raw data expressed as percentage modern carbon (pmc) were used to indicate age bands. The resolution of groundwater ages is usually within ±1000 years due to mixing and reaction.

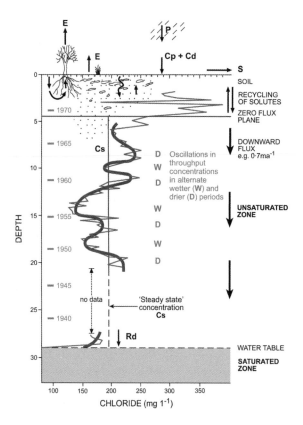

Figure 4.3. The estimation of groundwater recharge from chloride concentrations in unsaturated zone moisture – based on a profile from Akrotiri, Cyprus. The direct recharge rate at the point source (R_d) is calculated from the formula: $P.C_p/C_s$, where P is the mean annual precipitation. C_p (or $C_p + C_d$) is the total Cl in rainfall (and dry deposition), and where C_s is the steady state concentration of chloride in the unsaturated zone (below the zero flux plane). It is assumed that surface runoff is zero. NB oscillations in the Cl profile may be correlated with wet and dry years.

Aquifer recharge rates

Recharge rates may be determined from the chemistry of water in the unsaturated zone, specifically from the chloride compositions which are proportional to recharge amounts. Although no work has been conducted in Libya, examples from neighbouring countries may be used as illustration. One example from Cyprus, based on profiles through 30 m sand provides an illustration of the situation that may exist elsewhere along the Mediterranean coast, where sandy deposits

occur. The recharge rate can be calculated if the rainfall amount, the rainfall Cl composition and the mean composition (Cs) of Cl in the profile are known (Fig. 4.3). Water undergoes seasonal cycling in the upper 2-3 m before any excess passes through the unsaturated zone to the water table. The degree of enrichment in Cl is then proportional to the recharge amount. The steady-state value (Cs) of chloride in the profile demonstrates that active recharge is occurring. If no recharge is taking place then the profile would be saline. Moreover the oscillations shown in the profile correspond under conditions of piston flow to climatic oscillations (here at the decadal scale), with low Cl indicating higher periods of recharge.

This method of recharge assessment has been applied in several countries in Africa and wider afield. The long time intervals over which the recharge rates are recorded provide robust estimates for water balance estimation. In northern Senegal, where the mean annual rainfall is 290 mm, the average concentration of Cl in the unsaturated zone profiles is 82 mg/l Cl (Gaye and Edmunds 1996) giving a mean recharge rate of 13 mm/yr. The spatial variability across an area may be obtained if the chloride concentrations of groundwater at the immediate water table can be used alongside the profile estimates. Using this approach the regional mean recharge rates in the Quaternary sands of NW Senegal were estimated at between <1 and 20 mm/yr, comparable with the profile estimates (Edmunds and Gaye 1994).

Samples were also taken during digging of a 70m hand-dug well through sand-dominated deposits from Niger (Bromley *et al.* 1997) where the mean annual precipitation is 564 mm yr^{-1}. In this profile the recharge rate was 12.8 mm/yr and it takes about 760 years for rainfall recharge to reach the water table.

Using these and similar profile information from Africa and other regions, it is possible to obtain fairly accurate estimates of the modern recharge rates in semi-arid and arid parts of the world with sandy or similar permeable soils (Edmunds 2003). It is found that in any single location recharge rates are highly variable for a given amount of rainfall. The rates are especially dependent on the soil type and thickness as well as vegetation cover. For example the results from 7 profiles in southern Cyprus, where the mean rainfall is 400 mm, range from 10-95 mm yr^{-1}. It is evident that recharge is negligible in all regions below a threshold of approx. 200 mm recharge.

The implications for Libya at the present day are that any diffuse recharge is restricted to a few mm per annum in the northern coastal regions and is negligible below 30°N. Locally however significant local recharge could occur along wadis, especially from large-scale flash flood events taking place at the decadal scale. Nomadic farmers, however, even in the most arid regions, know ephemeral sources of local rainfall recharge.

Recharge history of Libya's groundwaters
In Figure 4.4 all available dated groundwaters from Libya, Egypt and Sudan are shown, expressed in terms of percentage modern carbon (pmc) with their corresponding oxygen isotope values ($\delta^{18}O$). Age bands are distinguished for the Holocene and late Pleistocene waters and some general conclusions may be drawn (Edmunds *et al.* 2003):

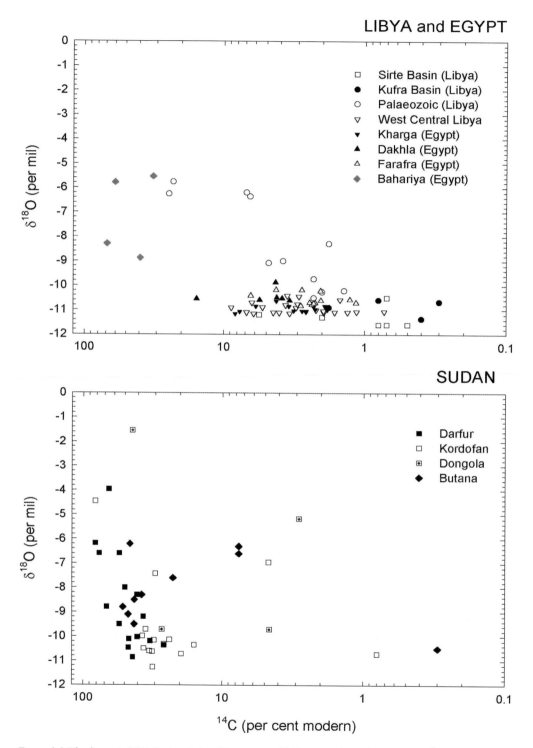

Figure 4.4. The change in δ¹⁸O during the late Pleistocene and Holocene as shown by dated groundwaters (¹⁴C as percent modern carbon): a) Libya and Egypt b) Sudan.

i) Within the late Pleistocene palaeowaters of North Africa distinct trends may be recognised on a north to south basis, seen most clearly in the groundwaters in Libya and Egypt (Fig. 4.4a). All these waters are isotopically light (i.e. have more negative values) as compared with modern groundwaters. Groundwater in the Kufra Basin (Nubian Sandstone) is isotopically the lightest recorded in North Africa (-11.5‰ $\delta^{18}O$) and this compares with the Sirt Basin to the north where the palaeowaters are some 3‰ more enriched (Edmunds and Wright 1979). Thus, each sedimentary basin seems to have a distinctive composition, which supports the likelihood of local recharge and local evolution of groundwaters, rather than long distance travel (as well as the lack of hydraulic continuity between the Al Kufra and Sirt basins). Groundwaters from the Egyptian oases (Thorweihe 1982) lie within the range -10 to -11‰, distinct from the Sirt Basin at the same latitude and comparable to the Kufra Basin compositions. It is most likely that these compositions demonstrate a 'continental effect', where lighter compositions are found in residual rains as air masses move across Africa, (first depositing the isotopically heavier rain). This could have led to the easternmost enrichments as seen in Libya and Egypt, although the vast reserves of freshwater are anomalous in that they are found at the extreme of the evolution of the Atlantic air mass source where lower rainfall amounts might be expected. An additional possibility is that in Libya some recharge took place from the south-west where isotopically lighter compositions (altitude effect) may have resulted from rainfall and surface runoff from the Tibesti mountains. The effects of the mountain areas elsewhere in northern Africa may also have contributed to isotopically light runoff.

ii) A gap in the record exists for groundwaters with ^{14}C of approximately 5-15 pmc. This was first noticed for North African ^{14}C data sets by Geyh and Jäkel (1974) and suggested for groundwaters by Sonntag et al. (1978). This period is interpreted as an arid interlude, coinciding with the Last Glacial Maximum (LGM) in Europe, during which time no recharge took place.

In contrast to Libya, in Sudan very few waters from the late Pleistocene are found (due mainly to the smaller size of the sedimentary basins, although where data exist, these are also isotopically light (Fig. 4.4b). In Sudan groundwaters of Holocene age predominate and these also are isotopically very light. These compositions are similar to some occasional very heavy monsoon rains at the present day and are interpreted as evidence of greater rainfall intensities during the Holocene climate. The monsoon rainfall belt has been shown from several lines of evidence to have reached some 500 km north of its present day limit during the mid Holocene and may have extended into Libya. With the aridification at the end of the Holocene pluvials the isotopic trends show a convergence towards the modern rainfall compositions measured in Khartoum.

The late Pleistocene and Holocene climates providing the groundwater recharge to the major aquifers can be summarised. During the colder Pleistocene with ice cover over Europe the westerly belt induced wetter conditions and wide scale recharge across the modern Sahara, until the onset of a cooler arid period coinciding with the LGM in Europe. During the Holocene the Atlantic monsoon gained in intensity and for a few thousand years shifted to the north coinciding with rapid warming, sea level rise and unstable climatic conditions.

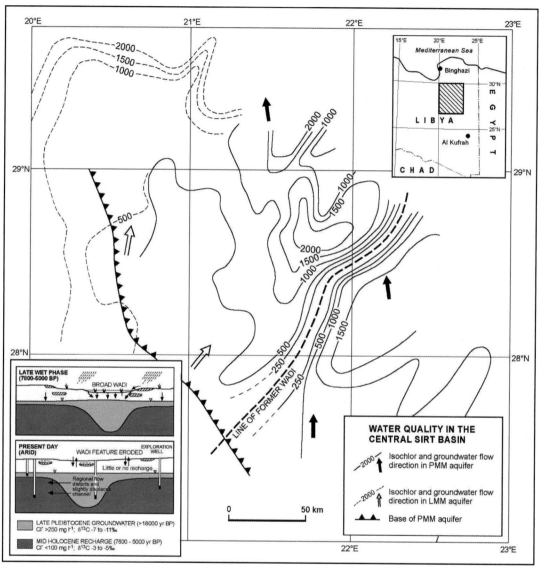

Figure 4.5. Fresh and saline water occurrence in the Sirt and Kufra basins. The overall distribution of fresh groundwater is shown south of 29°N; to the north of this brackish or saline water is found, mainly as a result of marine sedimentary facies. A distinct freshwater channel cross cuts the main body of freshwater – representing the recharge from a former large river, extending south to Tibesti.

Holocene Groundwater Recharge in Libya

Evidence is found in some unconfined aquifers in the Sahara and Sahel that groundwater at the immediate water table is of Holocene age (Fontes *et al.* 1993). A good example of this is provided in the Sirt Basin in east-central Libya (Edmunds and Wright 1979). During exploration studies in the mainly unconfined post-Middle Miocene (PMM) aquifer a distinct body of very fresh groundwater (<50 mg l⁻¹ Cl) around 100m saturated thickness was found cross-cutting

the general north-west – south-east trend of salinity increase (Fig. 4.5). Because of the good coverage of hydrocarbon exploration wells (water supply wells) in this region a three-dimensional impression could be gained of the water quality. This feature, around 10 km in width, and where the depth to the water table is currently around 30-50 m, may be traced in a roughly north-east – south-west direction for around 130 km. It is clear that this feature marks the line of recharge from a former wadi, inactive since the end of the Holocene wet period some 4500 years BP.

No obvious traces of this major river channel were found at the surface in this area, due to significant erosion, although neolithic artefacts and other remains testified to human settlement in the same area during the Holocene. Charred ostrich egg shells, associated with hearth sites were dated to 8465 yr BP and other shells from the open serir (gravel desert) were dated at 4170 yr BP. Whereas the regional, more mineralised, groundwaters gave radiocarbon values of 0.7-5.4 pmc, the fresh waters of the former wadi gave values from 37.6-51.2 pmc and also were distinctive in their hydrogeochemistry. Values (quoted as pmc) for younger waters corresponded to ages ranging from 5000-7800 years (uncorrected ages since it was argued that any reaction with the solid phase would probably have taken place with contemporaneous active carbonates in the soil zone or with calcretes).

Evidence from shallow wells not far from the fresh water channel (Fig. 4.5) proved that fresh water, some of which dated to the same period, was also present at the immediate water table. This indicates that, simultaneously with the river flows, direct recharge was occurring at a regional scale. The groundwater radiocarbon ages from the area increase in general with depth (Edmunds and Wright 1979).

Coinciding with the hydrogeological work, palaeoenvironmental studies traced the line of a large, now-inactive river system from the Tibesti mountains (Pachur 1974, 1980), which is shown in Figure 4.5. Both the surface and subsurface expressions of the former drainage network align well and indicate that continuous flow took place to the Gulf of Sirt (or later to the coastal Sebkhats). Recharge to the aquifer and perennial river flow probably only continued until around 4500 yr BP. Palaeontological evidence including that of large mammals shows that the wadi system was active until at least 3500 BP (Pachur 1975), after which time the present arid conditions (<20mm yr) commenced. Groundwater modelling of the water table aquifer, based on the measured aquifer properties, has indicated that the measured fall in the water table is consistent with a cessation of recharge some 5000 years before present but with some lateral flow taking place from the southern margin of the basin. There is, therefore, concordance between the radiocarbon ages, inferred palaeoclimate and the aquifer hydraulics.

Groundwater recharge, as indicated by [14]C data, may also have occurred during the Holocene from flooding as the result of higher river levels or from rivers changing their courses more frequently, elsewhere in Libya and the Sahara. This is also the case for tributaries to the Nile valley in northern Sudan, as suggested by Pachur and Kröpelein (1987). Similarly there is evidence of a northern extension of the Niger river in Mali during the Holocene and radiocarbon evidence confirms that this led to groundwater recharge (Fontes et al.; 1991) to a distance of some 150 km northwest of the present Niger River bend.

Groundwater Quality

Natural groundwater quality and salinity

In the major aquifers of southern Libya the groundwater, recharged during the late Pleistocene and Holocene is generally of excellent quality. This is a reflection both of the properties of the basins' sedimentary facies as well as the relatively high recharge rates during the pluvial episodes. Most parts of the Sahara south of latitude 28°N comprise continental sediments whereas to the north, marine facies are found (Fig. 4.2) which contain formation waters and evaporite minerals, which contribute to the salinity (Edmunds 2001). Significant changes in water quality occur along flow lines, especially in the confined aquifer, as a result of time-dependent water-rock interactions. Important changes in quality result from dissolution of carbonate and non-carbonate minerals, ion exchange reactions which alter the proportions of the major cations, redox reactions as well as mixing due to cross formational flow (see general illustration Fig. 4.2). The evolution in chemical quality (increasing salinity, ionic ratios such as increasing Na/Cl, Mg/Ca, build up of some trace elements such as F, Sr, Cr) is matched by changing isotopic ratios indicative of increasing age and climatic record.

Although much of Libya's groundwater is fresh, major problems for development may occur where saline waters occur adjacent to the freshwaters, especially, where salinity has built up near the surface. Thus, at Kufra oasis (Fig. 4.6) freshwater with a total salinity of 0.3 g/l from the Nubian sandstone discharged until quite recently into two lakes with salinities of 350 g/l total dissolved solids with halite crystals floating on the surface. The distribution of near-surface groundwater salinity in arid and semi-arid zones is closely related to past and present climate. Solutes of atmospheric origin are concentrated

Figure 4.6. Kufra oasis West Lake. The lake (which is now dry) is fed by fresh water springs but has a salinity of 330 g/l.

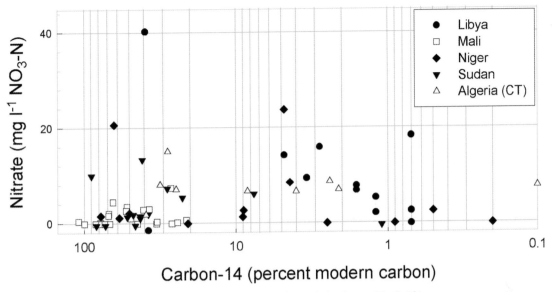

Figure 4.7. Nitrate concentrations in dated groundwaters from Libya and elsewhere in North Africa.

by evaporation may be brought to the surface and evaporated in groundwater discharge zones, forming saline lakes and Sebkhats. The present day distribution therefore is mainly a legacy from the onset of periods of aridity specifically during the past 4000 years. Some stratification in salinity in near-surface aquifers is a natural and common occurrence in discharge areas. The recognition and understanding of such stratification is an important requirement for the management of fragile groundwater resources on semi-arid regions. Well fields and groundwater pumping rates need to be designed, to avoid draw-down of the saline water and the contamination of the fresh water. Unfortunately, water table decline, observed in many oasis areas, including in Libya, has been accompanied by saline encroachment, water quality deterioration, loss of palms and traditional agricultural areas. Such salinisation is irreversible.

Pastoral activities, including the clearance of vegetation, over recent millennia may have also led to slow changes in the salinity of shallow groundwaters and these effects are clearly seen in some unsaturated zone records at the present day. Where vegetation has been cleared this can have the effect of increasing recharge rates, releasing salinity stored in the unsaturated zone and raising groundwater salinity. This is demonstrated most clearly in the dryland salinity build-up in Australia and other semi-arid countries following clearance of native vegetation for farmland (Cook *et al.* 1994; Ghassemi *et al.* 1995). In arid areas with shallow water tables the effect of clearance may also lead to salinity increase due to rising water tables and increase in evaporative discharge.

High nitrate and the redox-related build up of inorganic ions
The organic purity and highly oxidised nature of the sandstones and related sediments forming the major Libyan aquifers favours the persistence of oxygen in the groundwater. Under these

oxidising conditions nitrate remains inert. Thus, the groundwater may retain the signature of the environmental conditions at the time of recharge, as well as remaining a possible water quality problem during development. In the Sirt Basin NO_3-N sometimes in excess of 30 mg l^{-1} was originally considered (Wright and Edmunds 1969) to have resulted from contact with nitrate-rich shales (Hume 1915). However the widespread distribution of high nitrate groundwater concentrations in Libya and also in other countries, later prompted the view that palaeo-environmental factors, related to former vegetation cover, were responsible (Edmunds and Gaye 1997. In the Kalahari, aerobic groundwaters contain between 4.8 and 37 mg l^{-1} NO_3-N (Heaton *et al.* 1983) and are explained by a natural origin from the soil. High concentrations of nitrate have also been found in desert soils in America (Marrett *et al.* 1990; Hunter *et al.* 1982) associated with vegetation and in Australia (Barnes *et al.* 1992) where nitrate fixation by cyanobacteria in soil crusts and bacteria in termite mounds are proposed as the most likely explanation. Naturally high nitrate therefore seems to be a common feature of groundwaters not only in North Africa but also in other arid and semi-arid areas low in organic carbon where aerobic conditions have persisted.

All dated groundwaters from Libya with nitrate analyses (Edmunds and Wright 1979) and from elsewhere in North Africa are shown in Figure 4.7; Niger (Andrews *et al.* 1994); Sudan (Edmunds *et al.* 1992); Mali (Fontes *et al.* 1991) and Algeria (Edmunds *et al.* 2003). Many of these contain nitrate close to or above the 11.3 mg l^{-1} NO_3-N drinking water limit (WHO 1993). The frequency of occurrence of high nitrate groundwaters appears to be regular through the Late Pleistocene and Holocene. These high concentrations have been explained by leguminous (N-fixing) vegetation in the past with no major changes in plant communities over time. These concentrations are also close to the baseline values observed elsewhere in North Africa in modern groundwaters, (Edmunds and Gaye 1997). Thus it seems that the high nitrate concentrations are an intrinsic property of aerobic groundwaters from most arid zones. This may have implications for water quality standards in these regions, although it might be argued that desert populations must have adapted to the higher background concentrations.

In contrast to the concentrations of high nitrate, the persistent aerobic conditions maintain very low concentrations of dissolved iron. However, long residence times under aerobic conditions may favour the mobility of those elements, such as As, Se, Mo, V, U, Cr, which can form oxy-anion complexes such as MoO_4^-, CrO_3^{2-} and complexes with carbonate such as $UO_2(CO_3)^{2-}$. Although no specific studies are known from Libya, recent work from Algeria/Tunisia (Edmunds *et al.* 2003) shows high concentrations of U and Cr in the aerobic Continental Intercalaire aquifer of similar age to the Nubian Sandstone. These possible high concentrations, restricted to the aerobic section need to be taken into account for drinking water standards and point to the need to consider a wide range of chemical parameters in evaluating waters from similar aquifers. In the deeper groundwaters the complete reaction of oxygen leads to reducing conditions under which nitrate is unstable and reacts to form harmless N_2. Although in the deeper anaerobic groundwaters high iron may present a problem, most other metals are less likely to form a hazard.

Human impacts and groundwater protection

It should be clear that present day rates of movement through the unsaturated zone of the mainly sandy sediments (which occur for example in the coastal plains of Libya) are low and thereby a degree of protection is afforded against diffuse or point source pollution of the palaeowaters. On the other hand, under the widespread aerobic conditions at shallow depths, little attenuation capacity is provided and thus any contamination from nitrogen-based fertilisers and other agrochemicals will tend to accumulate. Significant threats come however from irrigation where return waters may increase salinity, and from wastewater discharges above aquifers, where transit times are likely to be rapid. In Libya, it is probable that pollution plumes containing hydrocarbons and saline formation waters may be found related to oil field development and which may pose a local threat to unconfined aquifers. It is beyond the scope of this paper to discuss the various forms of pollution, but it must be emphasised that groundwater protection policies in arid and semi-arid regions may require separate consideration to those being formulated in temperate regions.

Salinity changes in stratified aquifers, noted above pose an additional problem for which chemical and isotopic studies are of particular diagnostic value (Edmunds and Droubi 1998). Fresh water lenses or layers only a few metres thick, related to modern recharge represent a renewable resource (in some coastal areas for example) and for their sustainable development require careful well design and water quality monitoring. Similar problems are a feature of oases and Sebkhat areas where shallow groundwater development is very vulnerable to salinisation.

Key Issues for the Present and the Future

The present day issues relating to Libya's groundwater development have been discussed and summarised by Salem and Pallas (2001). These provide an up-to-date assessment of the range of problems:

• There has been rapid development of water from private farms since 1970s using traditional irrigation methods (now 2964 Mm^3 yr^{-1} or 46.4 percent of total water use), leading to over-abstraction in several areas.

• Agricultural projects dominate the water use and amount to 710 Mm^3 yr^{-1} or 11.2 percent of total use.

• The rapid development along the coast as well as the intensively developed inland areas have suffered from a universal lowering of the water table.

• There has been uncontrolled development of the coastal aquifers (far in excess of annual recharge).

• Sea water intrusion and up-coning of saline water has led to (almost) irreversible damage in northern aquifers: it is estimated that it would take 75 years to recover to original levels if allowed from now, with little improvement in the water quality.

• Domestic and industrial use is small, amounting to 6.0 percent of the total.

• Several pioneering agricultural projects – in Kufra and Fazzan for example – still survive. However these show signs of water level decline, well corrosion and uncontrolled leakage and

salinity increase, with some abandonment. There is some loss of vegetation and habitat in these areas.

• The Great Man-made River Project moves towards completion and this will result in an eventual total available water of 6.4 km^3 yr^{-1}, providing water of excellent quality to coastal regions. This however is unlikely to provide for much more than 50 percent of the projected water requirements to meet basic food self-sufficiency and to meet the domestic water demand.

Thus the very rapid development over the past quarter of a century has led to significant problems despite the apparent abundance of groundwater. There will need to be a greater awareness of the non-renewable nature of the groundwater at all levels of society in order to conserve the valuable stocks for future generations and provide a stabilisation of the rate of water-table decline. The basis of any improvement has to be a reform of the agricultural sector to greater water use efficiency.

References

Andrews, J.N., Fontes, J Ch., Edmunds, W.M., Guerre, A. and Travi, Y. 1994. The evolution of alkaline groundwaters in the Continental Intercalaire aquifer of the Irhazer Plain, Niger. *Water Resources Research* 40:45-61.

Ball, J. 1927. Problems of the Libyan desert. *Geographical Journal* 70: 21-34.

Barnes, C.J., Jacobson, G. and Smith, G.D. 1992. The origin of high-nitrate groundwaters in the Australian arid zone. *Journal of Hydrology* 137: 181-197.

Bromley, J., Edmunds, W.M., Fellman, E., Brouwer, J., Gaze, S. Sudlow, J. and Taupin, J-D. 1997. Rainfall inputs and direct recharge to the deep unsaturated zone of southern Niger. *Journal of Hydrology*, 188: 139-154.

Clark, I. and Fritz, P. 1997. *Environmental Isotopes in Hydrogeology*, Lewis. Boca Raton.

Conant, L.C. and Goudarzi, G.H. 1967. Stratigraphic and tectonic framework of Libya. *Bulletin of the American Association of Petroleum Geologists* 51: 719-730.

Cook, P.G., Jolly, I.D., Leaney, F.W., Walker, G.R., Allan, G.L., Fifield, L.K. and Allison, G.B. 1994. Unsaturated zone tritium and chlorine-36 profiles from southern Australia: their use as tracers of soil water movement. *Water Resources Research* 30: 1709-1719.

Custodio, E. 1992. Hydrogeological and hydrochemical aspects of aquifer overexploitation, in I. Simmers,Villarroya, F. and Rebollo, R.F. (eds), *Selected papers on Overexploitatio*n. International Association of Hydrogeologists. Selected Papers. Vol. 3. Verlag Heinz Heise, Hanover, Germany: 3-27.

Edmunds, W.M. 1980. The hydrogeochemical characteristics of groundwaters in the Sirte Basin, using strontium and other elements, in M.J. Salem and M.T. Busrewil (eds.), *Geology of Libya*, Vol.2, (University of Tripoli): 703-714.

Edmunds, W.M. 2000. Integrated geochemical and isotopic evaluation of regional aquifer systems in arid zones, in *Regional Aquifer Systems in Arid Zones: Managing Non-renewable Resources*. Proceedings of the International Conference, Tripoli, Libya, (1999), UNESCO. Paris: 107-118.

Edmunds, W.M. 2003. Renewable and non-renewable groundwater in semi-arid and arid regions, in A.S. Alsharhan and W. W. Wood (eds), *Water Resources Perspectives: Evaluation, Management and Policy*. Elsevier: 265-81.

Edmunds, W.M. and Droubi, A. 1998. Groundwater salinity and environmental change. In *Isotope Techniques in the Study of Environmental Change, 1997*, Vienna. IAEA: 508-518.

Edmunds, W.M. and Wright, E.P. 1979. Groundwater recharge and palaeoclimate in the Sirte and Kufra basins, Libya. *Journal of Hydrology* 40: 215-241.

Edmunds, W.M. and Gaye, C.B. 1994. Estimating the spatial variability of groundwater recharge in the Sahel using chloride. *Journal of Hydrology* 156:47-59.

Edmunds, W.M. and Gaye, C.B. 1997. High nitrate baseline concentrations in groundwaters from the Sahel. *Journal of Environmental Quality* 26: 1231-1239.

Edmunds, W.M., Guendouz, A. H., Mamou, A., Moulla, A. S, Shand, P. and Zouari, K. 2003. Geochemical evolution of groundwaters in the Continental Intercalaire aquifer of southern Algeria and Tunisia. *Applied Geochemistry*, 18: 805-822.

Edmunds, W.M., Dodo, A., Djoret, D., Gasse, F., Gaye, C.B., Goni, I.B, Travi, Y., Zouari, K. and Zuppi, G.M. 2003. Groundwater as an archive of climatic and environmental change. The PEP-III traverse, in R. W. Battarbee, F. Gasse and C.E. Stickley (eds), *Past Climate Variability through Europe and Africa*, Developments in Palaeoenvironmental Research series: Kluwer Dordrecht: 279-306.

Fontes, J.-Ch., Andrews, J.N., Edmunds, W.M., Guerre, A. and Travi, Y. 1991. Palaeorecharge by the Niger River (Mali) deduced from groundwater chemistry. *Water Resources Research* 27:199-214.

Fontes, J.-Ch., Gasse, F. & Andrews, J.N. 1993. Climatic conditions of Holocene groundwater recharge in the Sahel zone of Africa, in: *Isotopic techniques in the study of past and current environmental changes in the hydrosphere and the atmosphere,* Vienna: IAEA: 231-248.

Gasse, F. 2000. Hydrological changes in the African tropics since the Last Glacial Maximum. *Quaternary Science Reviews* 19: 189-211.

Gaye, C.B., and Edmunds, W.M. 1996. Intercomparison between physical, geochemical and isotopic methods for estimating groundwater recharge in north-western Senegal. *Environmental Geology* 27: 246-251.

Geyh, M.A. and Jäkel, D. 1974. Spätpleistozäne und Holozäne Klimageschichte der Sahara aufgrund zugänglicher [14]C Daten. *Zeitschrift Geomorphologie* 18: 82-98.

Ghassemi, F., Jakeman, A. J. and Nix, H. A. 1993. *Salinisation of Land and Water Resources: Human causes, extent, management and case studies*: Sydney, Univ. New South Wales Press and Wallingford, CAB International.

Heaton, T.H.E. 1984. Sources of nitrate in phreatic groundwater in the western Kalahari. *Journal of Hydrology*, 67: 249-259.

Hellstrom, B. 1940. The subterranean water in the Libyan Desert. *Geografi ska Annaler*, 206-239.

Herczeg, A.L. and Edmunds, W.M. 1999. Dissolved ions as tracers in subsurface hydrology, in P. G. Cook and A. L. Herczeg (eds.), *Tracers in Groundwater Hydrology,* Kluwer. Amsterdam.

Hume, W.F. 1915. The nitrate shales of Egypt. *Memoires de Institute d'Egypt,* 8: 146-169.

Hunter, R.B., Romney, E.M., and Wallace, A. 1982. Nitrate distribution in Mojave desert soils. *Soil Science* 134: 22-29.

Issar, A. S. 1990. *Water Shall Flow from the Rock: hydrology and climate in the lands of the Bible.* Springer-Verlag. Berlin.

Jones, J.R. 1963. *Groundwater Maps of the Kingdom of Libya.* Open File Report, US Geological Survey, 11pp.

Klitsch, E. 1969. The structural development of parts of North Africa since Cambrian time, in C. Gray (ed.), *Proceedings of the Symposium on the Geology of Libya*, Tripoli: 253-262.

Marrett, D.J., Khattak, R.A., Elseewi, A.A. and Page, A.L. 1990. Elevated nitrate levels in soils of the eastern Mojave desert. *Journal of Environmental Quality* 19: 658-663.

Pachur, H.-J. 1974. Geomorphologische Untersuchungen im Raum der Serir Tibesti (Zentralsahara). *Berliner Geographische Abhandlungen* 17: 58.

Pachur, H.-J. 1975. Zur spätpleostozäne und holozäne Formung auf der Nordabdachung des Tibest-Gebirge. *Die Erde* 106: 21-46.

Pachur, H.-J. 1980. Climatic history in the Late Quaternary in southern Libya and the western Libyan desert, in M.J. Salem and M.T. Busrewil (eds.), *The Geology of Libya,* London: Academic Press: 781-788.

Pachur, H.-J. and Kröpelin, S. 1987. Wadi Howar: Palaeoclimatic evidence from an extinct river system in the southeastern Sahara. *Science* 237: 298-300.

Pallas, P. 1980. Water resources of the Socialist Peoples Libyan Arab Jamahiriya, in M.J. Salem and M.T. Busrewil (eds.), *The Geology of Libya.* London: Academic Press: 539-593.

Pallas, P. and Salem, O. 2000. Water resources utilisation and management of the Socialist People Arab Jamahiriya. In *Regional Aquifer Systems in Arid Zones: managing non-renewable resources: Proceedings of the International Conference, Tripoli, Libya, 1999.* UNESCO. Paris: 147-172 (on CD-rom).

Petit Maire, N., Delibrias, G. & Gaven, C. 1980. Pleistocene lakes in the ash-Shati area, Fazzan, in M. Sarthein, E. Seibold, and P. Rognon (eds.), *Sahara and the Surrounding Seas, Palaeoecology of Africa* 12: 289-295.

Pim, R.H. and Binsariti, A. 1994. The Libyan Great Man-made River Project. Paper 2. The water resource. *Proceedings Institution of Civil Engineers Water, Maritime & Energy* 106: 123-145.

Thorweihe, U. 1982. Hydrogeologie des Dakhla Beckens (Ägypten). *Berliner geowissenschaftlicher Abhandlungen* A38: 1-58.

Sonntag, C., Klitsch, E., Löhnert, E.P., Münnich, K.O., Junghans, C., Thorweihe, U., Weistroffer, K. and Swailem, F.M. 1978. Palaeoclimatic information from deuterium and oxygen-18 in ^{14}C-dated north-saharan groundwaters; groundwater formation in the past. *Isotope Hydrology 1978*, Vienna: IAEA: 569-581.

WHO (World Health Organisation). 1993. *Guidelines for Drinking Water Quality.* World Health Organisation (Geneva).

Wright, E.P. and Edmunds, W.M. 1969. Distribution and origin of nitrate in the groundwaters. *Hydrogeological Studies in Central Cyrenaica, Kingdom of Libya.* Unpublished Report to the Libyan Government.

Wright, E.P. and Edmunds, W.M. 1971. Hydrogeological studies in Central Cyrenaica, Libya. In C. Gray (ed.), *Proceedings of the Symposium on the Geology of Libya*, Tripoli: 459-481.

Wright, E.P., Benfield, A.C., Edmunds, W.M. and Kitching, R. 1982. Hydrogeology of the Kufra and Sirte basins, eastern Libya. *Quarterly Journal of Engineering Geology London* 15: 83-103.

5. Geology and Petroleum Exploration of the Libyan Sahara Desert

By Peter Turner[1]

Abstract

The Saharan Platform is one of the world's most significant hydrocarbon provinces and the exploration and production industry dominates the economies of Libya and Algeria. There are a number of different petroleum systems and great variety of play types in Libya. The most important petroleum systems are the Palaeozoic Ghadames-Tanezzuft System and the Mesozoic-Tertiary Sirte Basin System, which are both described in this paper. Libya has proven reserves of over 30 bn bbl of liquids and 60 tcf of gas whilst Algeria has significantly larger known reserves of gas (150 tcf) but lesser volumes of liquids (16 bn bbl). These differences reflect the fact that the oil-prone Mesozoic-Tertiary petroleum system is present only in Libya. Both countries gain the vast majority of their foreign earnings from the export of hydrocarbons and both are well placed to supply gas by pipeline to major European markets. Since up to 95 percent of Libya's foreign earnings come from the sale of hydrocarbons, the conservation and sustainable development of these natural resources is clearly crucial to their future economic development. Also their exploitation must be undertaken hand in hand with the conservation of other archaeological and natural resources.

Economic growth in Libya will be dependent on future exploration and development of hydrocarbon resources which will benefit from the collaborative research activities that can take place between the Libyan authorities, international oil companies and Libyan and UK academic institutions. In particular, scientific training in geophysics, petroleum geology and sedimentological/stratigraphical studies can help to find more significant discoveries and ensure the efficient development and management of existing reserves.

Introduction

The geological conditions needed for the accumulation of hydrocarbons in commercial quantities include source rocks, porous reservoir rocks and an impermeable seal that prevents migration of the hydrocarbons. In addition there needs to be some sort of structural or stratigraphic trap which is in place at the time that hydrocarbons are generated in the source rock and migrate into the reservoir. The combination of these factors is generally referred to as a *Petroleum System*. Source rocks are typically organic-rich shales with total organic content (TOC) between 1-12 percent. Such rocks generate liquid hydrocarbons when they are heated (buried) to temperatures between (60-140°C). In practical terms this means burial depths of some 2-5 km. Libya has two world-class source rocks, the Silurian Tanezzuft Shale and the Cretaceous Sirte Shale.

Reservoir rocks are porous rocks that can hold large quantities of hydrocarbons and a great variety of different types occur. The two main groups are clastic rocks (sandstones) with well-developed intergranular porosity and carbonate rocks (limestones and dolomites), which may have intergranular porosity but are typified by the development of mouldic porosity formed by the dissolution of fossilised biotic remains such as shells and coral fragments. In Libya there are a variety of clastic and carbonate reservoirs.

[1]School of Geography, Earth & Environmental Sciences, The University of Birmingham

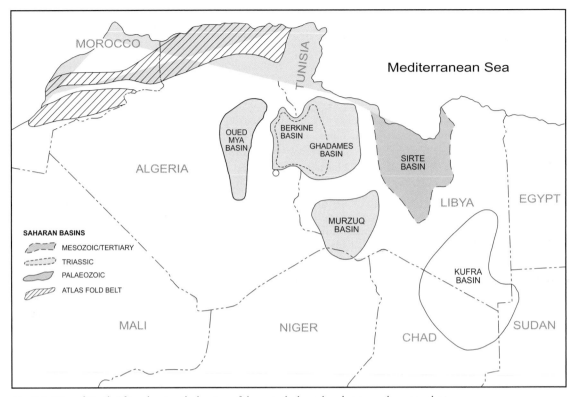

Fig. 5.1. Map of North Africa showing the location of the main hydrocarbon-bearing sedimentary basins.

The Saharan Platform is a geologically diverse area and presents a range of geological challenges in exploration and production. The platform contains a large number of different sedimentary basins, which are associated with a number of petroleum systems combining the essential ingredients of source rocks, reservoirs and seals. In addition, the timing of petroleum maturation and the formation of valid traps are crucial to the generation of economic accumulations. The Sahara Desert consists of a Precambrian basement cut by north-north-east, north and north-north-west lineaments, which divide the area into a series of Palaeozoic basins and ridges. Some of these ridges like the Hassi Messouad Ridge are the sites of giant oil fields that have been reactivated during later orogenic episodes, particularly the Hercynian (~280 Ma), Austrian (~120 Ma) and Alpine (~50 Ma). In Libya there are four main onshore basins: the Ghadames, Murzuq, Sirte and Khufra. Key elements of the Lower Palaeozoic basins (Illizi Basin in Algeria; Ghadames and Murzuq Basins of Libya) included Ordovician glacial sediments (North Africa was near the South Pole at this time) and the deposition of the Tanezzuft shale, a world class Llandovery-aged petroleum source rock. In the Upper Palaeozoic, shelfal sequences were deposited under the influence of contemporary relative sea level changes, with reservoir rocks deposited particularly during Devonian lowstands and further significant source rocks during Upper Devonian (Frasnian) times. The Hercynian Orogeny at the end of the Carboniferous was the first major tectonic event forming structural traps in these Palaeozoic basins. The most important of these Palaeozoic basins are the Illizi basin, with over 4.6 bn bbl of petroleum liquids,

45 tcf of gas and 0.9 bn of condensate, and the huge Ghadames-Hamra basin which occupies much of the central part of the Saharan platform and is the focus of much current exploration activity. The location of the principal Libyan hydrocarbon-bearing basins is shown in Figure 5.1.

Mesozoic rifting, associated with the opening of the North Atlantic and Palaeo-Tethys Oceans, was initiated in the Triassic and continued into the mid-Cretaceous. Triassic basins include the Qued Mya and Berkine Basins (Algeria) which have fluvial reservoirs concentrated along Panafrican basement structures which were reactivated during the Cretaceous forming complex structural traps. Mesozoic rifting was also responsible for the Sirte Basin (Libya) which is a world class petroleum province with known reserves of over 37 bn bbl of oil, 38 tcf gas and 0.1 bn bbl of condensate. The basin originated during early Cretaceous crustal extension and consists of a whole series of half grabens filled by syn-rift Early Cretaceous-Eocene and post-rift

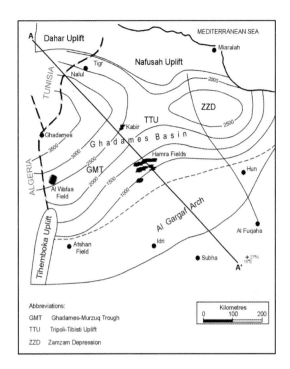

Fig. 5.2. Outline map of the Ghadames basin (modifi edfrom Hallett 2002). The line A-A' corresponds to the cross section shown in Figure 5.5.

Oligo-Miocene sediments. The main reservoir is the Early Cretaceous Sarir Sandstone which occurs primarily on horst blocks and was sourced by the more deeply buried Upper Cretaceous Sirte Shale, which matured in intervening troughs.

Palaeozoic Petroleum Systems

Palaeozoic reservoirs occur in the Ghadames-Hamra, Murzuq and Khufra Basins. The Ghadames basin is a huge intracratonic basin which straddles Algeria, Tunisia and western Libya, extending over an area of 350,000 km^2, and containing a thickness of up to 6 km of Palaeozoic and Mesozoic sediments. The Ghadames basin contains known recoverable reserves of over 4000 million barrels of oil and there is much future potential especially in the central part of the basin which is largely under-explored (Fig. 5.2)

The Murzuq basin is an intracratonic basin which is bounded by the Hoggar Massif to the south, the Tibesti mountains to the south east and the Gargaf Uplifts to the north (Fig. 5.3). The main reservoirs occur in the Ordovician glacial sediments, for example, in the newly developed Elephant Field and the Murzuq Basin is currently the focus of much petroleum exploration activity. Younger reservoir horizons are compromised by the fact that the sections are very sandy and good quality seals are largely absent.

The Khufra basin is a large intracratonic basin in eastern Libya, bounded by the Tibesti Plateau

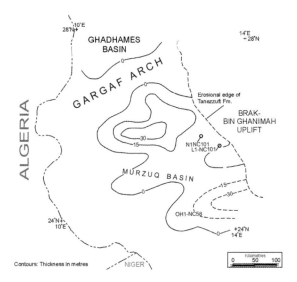

Fig. 5.3. Outline map of the Murzuq basin. The contours show the thickness of the Tanezzuft 'hot shale' (modifi edfrom Hallett 2002).

to the west and the Jebel Awaynat High to the east (Gumati *et al.* 1996). Although the Khufra basin is largely unexplored it is considered to have only limited hydrocarbon potential. This is because the main source rock, the Tanezzuft, is very sandy and difficult to distinguish from the overlying Acacus. Furthermore, because of relatively shallow burial, the Tanezzuft is likely to be mature only in the central part of the basin.

The Ghadames Basin is bounded by the Amguid-El-Biod high to the west, the Dahar high to the north and the Gargaf uplift to the east. The southern margin of the basin is more complicated and includes elements of the Tin Fouye, Tihembouka and Al Hamra Highs (Fig. 5.2). It was initiated during the reactivation of Pan-African faults and accumulated a thick Palaeozoic succession.

The present day Ghadames basin is the product of a number of different structural events. The earliest of these was the Ordovician Taconic compression which peaked during Llandeilo times and caused the creation of a series of broad folds and erosional troughs filled with periglacial sediments. Subsequently there were two phases of deformation which correspond to the Hercynian; the absence of the earliest Carboniferous sediments (early Tournaisian) over the whole of the Ghadames basin indicates a regional event at this time. During the late Carboniferous-Permian there was a major erosive event with rocks as old as Cambrian being eroded. This Hercynian Unconformity is overlain by Triassic and Jurassic sediments and represents a key regional surface in the Ghadames Basin.

The stratigraphy of the Ghadames basin is shown in Figure 5.4. Potential reservoirs occur in the Ordovician, Silurian, Lower Devonian, and the Middle-Upper Devonian (a cross-section of the basin is shown in Fig. 5.5).

Ordovician and Silurian Reservoirs

In Libya the Ordovician has been penetrated in a relatively small number of wells and most of these finish in the Caradocian-aged Memouniat Formation. In general the stratigraphy shows sandy periglacial deposits which fill glacial topography passing up into quartzitic sandstones and marine shales which are well represented in the central part of the basin. The Ordovician is characterised by rapid facies changes, consistent with the periglacial setting. There are two cycles of glacial advance and retreat which probably lasted only about 100,000 years (Sutcliffe *et al.* 2000). The facies include ice-proximal fluvio-glacial deposits, high density turbidites and upwards coarsening shoreface deposits). Reservoirs are therefore complex and accumulations are

System	STAGE	GHADAMES (BERKINE) AND HAMRA BASINS	GENERAL LITHOLOGY	DESCRIPTION
				Hercynian Unconformity
Carboniferous	Stephanian	Dembaba		Mudstone, limestone and gypsum
Carboniferous	Westphalian	Dembaba		Limestone, gypsum and mudstone
Carboniferous	Namurian	Assed Jeffar		Limestone and sandstone
Carboniferous	Visean	Mrar		Limestone and sandstone with concretions
Carboniferous	Visean	Mrar		Mudstone and sandstone
Carboniferous	Tournaisian	Mrar		Limestone and mudstone
Devonian	Strunian	Tahara (Shatti)		Sandstone
Devonian	Famen-Frasnian	Aouinet Ouenine		Mudstone Frasnian Unconformity
Devonian	Givetian-Eifelian	Aouinet Ouenine		Sandstone
Devonian	Givetian-Eifelian	Ouan Kasa		Mudstone and limestone
Devonian	Emsian	Ouan Kasa		Mudstone and sandstone
Devonian	Siegenian-Gedinnian	Tadrart		Sandstone
				Late Silurian-Early Devonian Unconformity
Silurian		Acacus		Sandstone and mudstone
Silurian		Tanezzuft		Black mudstone with graptolites
Silurian		Tanezzuft		Sandstone
Silurian		Bir Tlacsin		Microconglomeratic mudstone Glacial Unconformity
Ordovician	Caradocian	Memouniat		Limestone, sandstone and mudstone
Ordovician	Llandeilian-Llanvirnian	Melez Chograne		Silty black mudstone
Ordovician	Arenigian	Haouaz		Sandstone
Ordovician	Tremadocian	Haouaz		Sandstone and mudstone
Ordovician	Tremadocian	Achebyat		Mudstone
Ordovician	Cambrian-Ordovician	Achebyat		Sandstone and mudstone
Cambrian		Hassaouna and Mourizidle		Sandstone
Cambrian		Hassaouna and Mourizidle		Sandstone and conglomerate
				Pan-African Unconformity
Infra-Cambrian		Infra Tassilian/ Mourizidle		Metamorphic and magmatic rocks

Fig. 5.4. Stratigraphy of the Ghadames basin (modified from Klett 2000).

69

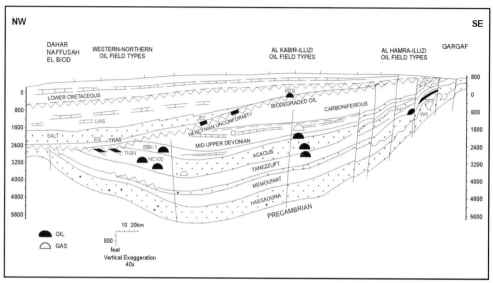

Fig. 5.5. Cross section showing the general structure of the Ghadames basin and the location of the major oil fields (after Echikh 1998).

smaller than the large Sirte basin pools. In the Elephant Field on the western flank of the Murzuq basin Ordovician glacial channel deposits are the main reservoir. These can be seen at outcrops around the village of Ghat. In Algeria where the Ordovician is deeper and more widely explored it has been divided into a number of different reservoir-bearing formations. These are generally gas reservoirs with oil rims and the reservoir quality is relatively poor, often due to pervasive quartz cementation.

A glacial microconglomeratic mudstone marks the transgressive unconformity between the Ordovician and the Silurian. The Silurian includes the Llandovery-aged Tanezzuft black mudstone, which is a world-class petroleum source rock responsible for much of the hydrocarbon generation in Libya and Algeria. The Tanezzuft is a typical marine, transgressive black shale which is locally discontinuous (Luning *et al.* 2000), partly because it fills the pre-existing glacial topography. It accounts for over 80 percent of the Palaeozoic derived hydrocarbons in North Africa. The Tanezzuft is overlain by the Acacus Formation a succession of interbedded sandstones and mudstones which progressively fine towards the north and the basin centre. The Acacus Formation comprises a sequence of stacked upwards-coarsening parasequences which represent episodes of north and north-west shoreface progradation. In the Wadi Tanezzuft there are spectacular exposures of the whole sequence from the Ordovician glacial sediments, the Tanezzuft Shale and the Acacus Formation along the eastern front of the Acacus Mountains (Fig. 5.6). On seismic sections these can be traced over 250 km across the Ghadames basin shelf indicating that global sea level was relatively high at this time (Massa 1988). The Lower Acacus is a productive reservoir in Libya especially in the south of the basin where reservoir quality is much better (with porosities up to 20-25 percent). In the northern area reservoir quality deteriorates (10-15 percent porosity) along with the net:gross sand ratio.

Lower Devonian Reservoirs

The Lower Devonian reservoirs in Libya are the Tadrart and the Uan Kasa Formations. The Tadrart is equivalent to the F6 in Algeria. It comprises laterally extensive, clean medium-coarse grained sandstones deposited in fluvial and shallow marine sandstones. The Tadrart represents the Low Stand Systems Tract which followed the relatively high sea level conditions of the Tanezzuft and the Acacus. Reservoir properties are variable largely due to the variation in diagenesis.

Fig. 5.6. Photograph of Wadi Tanezzuft. The floor of the Wadi coincides with the top surface of the Ordovician, the base of the cliff is the Tanezzuft Shale and the main part of the cliff shallow marine sandstones and shales of the Silurian Acacus formation.

Pervasive quartz cementation strongly reduces porosity in the central part of the basin and most of the productive oil fields lie nearer the basin margins, e.g. on the al Hamra and in the Illizi basin of Algeria.

The Uan Kasa is more variable than the Tadrart and comprises thinly bedded sandstones and shales with thin carbonates. This unit is more difficult to correlate across the basin, not least because of the mid-Devonian (Frasnian) unconformity which cuts out the Uan Kasa over the Ahara and Tihemboka Highs where Middle and Upper Devonian strata sit directly on the Acacus. The Uan Kasa is not so important as an oil reservoir largely because of the overall poor reservoir quality.

Middle-Upper Devonian Reservoirs

The Middle and Upper Devonian of the Ghadames Basin are more regionally restricted compared to the Acacus and the Tadrart. They tend to occur near the basin margin over the al Hamra, Tihemboka and Ahara Highs. Facies are generally variable with mixed sequences of thin sandstones, shales and limestones and are more productive in Algeria than Libya. In Algeria the F4 is an important oil reservoir in the Illizi Basin and the F2 is a regionally significant gas reservoir. The F4 equivalent in Libya, the Aaouinet Formation is a significant oil producer in the al Hamra area.

The Triassic Petroleum System

In the Ghadames Basin of Algeria, Tunisia and Libya, the Palaeozoic succession is overlain by a sequence of predominantly fluvial Triassic sandstones and mudstones which host significant hydrocarbon reservoirs in Algeria and have significant potential in Libya (Ras Hamia Formation) and Tunisia (Kirchaou Formation). Genetically, the Triassic sequences are quite distinct from the underlying Palaeozoic and in Algeria have been attributed to the Berkine basin, an intra- or peri-cratonic basin that developed during the Middle to Late Triassic extension of the Saharan platform. The basin lies to the east of the north-south trending Hassi Messaoud Ridge which separates it from the Oued Mya Basin to the west. The structure of the Triassic basins is largely controlled by reactivation of north-east to south-west, north-west to south-east, Panafrican

and late Palaeozoic basement lineaments. The Middle Cretaceous extensional reactivation of the north-west to south-east cross-cutting faults play a key role in the formation of a number of giant TAG-I (Upper Triassic Argilo-Gréseux Inférieur) reservoir oil fields. Late Cretaceous/ early Tertiary compressional inversion accounts for a number of other fields. A key question concerns the extent of Triassic extension in the Berkine Basin. Although seismic sections indicate that Triassic intrabasinal faults are rare or absent, the presence of syn-depositional volcanics to the east and west of the Hassi Messoud Ridge indicates that contemporaneous rifting was active in this area.

The principal hydrocarbon reservoir is the Upper Triassic Argilo-Gréseux Inférieur (TAG-I) which is Carnian to Norian in age. It was sourced by Tanezzuft black shales and also Devonian (Frasnian) hot shales. The TAG-I reservoirs are sealed by the overlying marine Triassic Carbonate and a series (S_1-S_4) evaporates.

The TAG-I sits unconformably on Palaeozoic basement rocks and with the basal Lower Carbonate comprises a laterally and vertically variable sequence which has been sub-divided

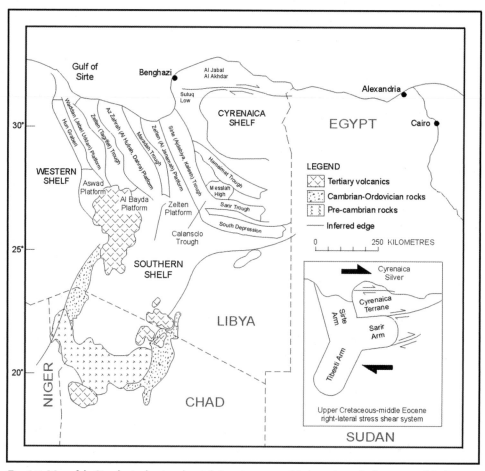

Fig. 5.7. Map of the Sirte basin showing the triple junction system. The inset shows the formation of the basins in right lateral shear system (based on Ahlbrandt 2001).

into four depositional sequences (Turner *et al.* 2001):

• Sequence 1 is an unconformity-bounded, ephemeral fluvial interval that fills palaeorelief on the Hercynian unconformity;

• Sequence 2 is an initially upward-fining, and subsequently upward-coarsening package of perennial fluvial sandstones and floodbasin shales with thin crevasse splay elements and interfluve palaeosols;

• Sequence 3 is an erosively based, fluvio-lacustrine section characterised by fluvial sandstones with associated crevasse sandstones and floodbasin/lacustrine shales. This sequence is the main hydrocarbon reservoir section and is divided into two main packages 3A and 3B; the base of 3B is distinguished by basin-wide fluvial incision and the widespread channel sand deposition;

• Sequence 4 (Lower Carbonate) is a coastal plain and shallow marine system comprising shales, sabkha-type evaporites and bay-fill sandstones.

The four depositional sequences reflect differences in depositional style resulting from base level shifts, tectonics and climate throughout TAG-I times. The overall increase in relative sea level was interrupted by periods of incision which may relate to periods of rifting and erosion of the rift shoulders of the Berkine Basin. The initial valley fill (Sequence 1) was deposited under relatively arid or semi-arid conditions. During Sequences 2 and 3A perennial fluvial systems with anastomosed channels and floodplain lakes became dominant and the climate increasingly humid. At this time a major longitudinal drainage divide developed due to intrabasinal rifting. The basin was ultimately flooded by the transgressive systems tract of Sequence 4.

Mesozoic and Tertiary Petroleum Systems

The Sirte basin is Libya's principal petroleum province with reserves probably in excess of 37 bn bbl of oil, 38 tcf gas and 0.1 bn bbl of condensate. The basin formed as a continental triple junction system, bordered to the north by the Gulf of Sirte in the Mediterranean Sea and to the south by the Nubian uplift. The system forms part of the Tethyan Rift System (Guirard and Bosworth 1997) and developed during Upper Cretaceous to middle Eocene right lateral shear of the northern part of the Saharan Platform. It comprises the Sirte, Sarir and Tibesti arms (Fig. 5.7) although all the main oilfields occur in the northern Sirte and Sarir arms.

The tectonic history of the Sirte basin is complex. The region originally formed part of the Sirte Arch (Bellini and Massa 1980; van Houten 1980; Anketell 1996) which may have formed in response to the Hercynian Orogeny at the end of Carboniferous times but was more likely associated with the Cretaceous rifting event. Most of the Palaeozoic section has been eroded over the crest of the Sirte Arch and it seems more likely that it formed as a result of doming over a mantle plume (Guirard and Bosworth 1997) which was linked to a triple junction system and Cretaceous extension. The extension was initiated in early Cretaceous times and terminated in the early Tertiary. Peak extension in late Cretaceous times resulted in the triple junction system and a series of north-west trending half graben and horst blocks, which step downwards towards the east and the deepest part of the basin (Harding 1984). From west to east the horst blocks or platforms are the Waddan, Al Hufrah and Zaltan platforms, whilst the intervening troughs (half

graben) are the Zallah, Maradah, and Ajdabiya (Sirte) Troughs. The stratigraphic fill of the Sirte basin is up to 7500 m thick and includes a syn-rift sequence of Triassic to Lower Cretaceous clastic continental sediments and a post-rift sequence of Upper Cretaceous evaporites, shales and carbonates (Fig. 5.8). In general the successions are thicker in the troughs and thin over the structural highs. A variety of petroleum traps occur on these highs which were filled with hydrocarbons formed from the Upper Cretaceous (Campanian) Sirte Shale. This organic-rich shale is the main petroleum source rock in the Sirte Basin and generated hydrocarbons in the more deeply buried troughs which migrated up-dip onto the highs (McGregor and Moody 1998). Peak generation was in the Oligo-Miocene and some areas are still generating hydrocarbons,

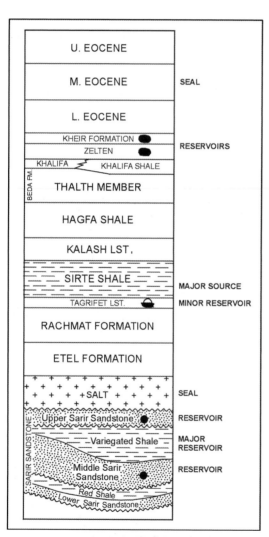

Fig. 5.8. Stratigraphy of the southern part of the Sirte basin showing the location of major reservoirs and seals.

however some of the more deeply buried areas have been heated to temperatures which were too high for oil generation and are now considered overmature.

Reservoirs occur in both the syn-rift clastic rocks and the post-rift carbonates. Both structural and stratigraphic traps occur. The syn-rift includes the Sarir (Nubian) Sandstone, which comprises two sandstone-dominated members separated by thick shales, which may act as both source rocks and seals (e.g. Variegated Shale Member) (Ambrose 2000). The Sarir Sandstone is beautifully exposed around the margins of the Murzuq basin (Figs 5.9 and 5.10) and forms the prominent escarpment of the Messak Mustafit. In this region the Sarir has abundant quartz cement and the durability of the rock enables it to be used for rock engravings, for example in Wadi Madkandoush, and as a building stone such as at the Gharamantian hill top settlement at Zinkekra.

The main fields occur on the Zelten and Meslah Highs. These have been charged with hydrocarbons which formed from the Sirte shale in the intervening troughs. These include the Sarir C field, a structural trap, the Messlah Field, a stratigraphic trap and the Calanscio Field, a horst block trap. In this area the downthrown side of fault blocks (hanging wall fault plays) are also important and there is still considerable exploration potential in this part of the Sirte basin.

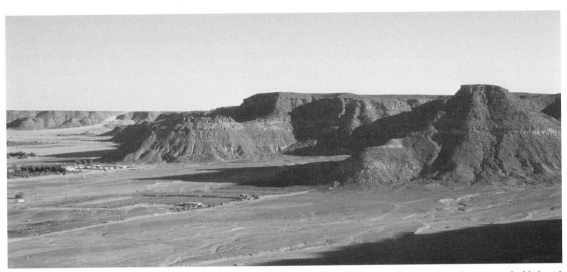

Fig. 5.9. Photograph of the Sarir sandstone near Jarma. Here the Sarir comprises fluvial channel sandstones interbedded with floodplain mudstones and shales.

Fig. 5.10. Details of the Sarir Sandstone. The main sedimentary structures are planar tabular and trough cross bedding.

The second most important oil fields in the Sirte basin are associated with Cretaceous and Paleogene carbonates on the Zelten Platform. Here the post-rift succession includes coral reefs, bioherms and associated bioclastic shoals which form good quality reservoirs (porosity 20-25 percent). Carbonate reservoirs continue up into the Eocene. Nummulitic limestones form excellent reservoirs in the Middle Eocene and some of them are very substantial accumulations. The giant Gialo Field has known reserves of 14 million barrels and these large fields are known to continue offshore close to the Libyan-Tunisian border (Bouri Field). Later sedimentation is dominated by sandstones and shales but known accumulations at this level are only minor although there is considerable unexplored potential, especially in offshore areas.

Conclusions: Future Exploration Potential

Libya is Africa's largest oil producer with about 75 percent going to Italy, Germany, Spain and France. It generally has low production costs and the oilfields are close to the European markets and refineries. Of the existing onshore fields 12 have reserves of over 1 bn barrels and at least two have reserves of 0.5-1 bn barrels. The average life of these fields is about 33 years and the National Oil Company (NOC) fields are depleting at the rate of about 7-8 percent each year. The ability to increase revenues is thus dependent on extending the life of existing fields and also exploring for new fields. In existing fields life expectancy can be increased by using enhanced oil recovery (EOR) in existing reservoirs and also by extended drilling to incorporate deeper oil accumulations. The priority for onshore exploration includes the Sirte, Ghadames and Murzuq basins; whilst offshore the priority is the offshore Sirte Basin where the giant al-Bouri field may contain up to 5 bn barrels of oil.

To meet these new challenges increased geological, geophysical and petroleum engineering expertise will be required. Cooperation between the international oil companies, the UK and Libya can prove vital in this regard. International oil companies can provide experience and new technologies. The training of Libyan nationals will provide the most efficient way of sustaining the development of such a precious natural resource.

References

Ahlbrandt, T. S. 2001. The Sirte Basin province of Libya-Sirte-Zelten Total Petroleum System, *US Geological Survey Bulletin* 2202-F: 29pp. Only available online at: http://pubs.usgs.gov/bul/b2202-a/

Ambrose, G. 2000. The geology and hydrocarbon habitat of the Sarir Sandstone, SE Sirt basin, Libya *Journal of Petroleum Geology* 23: 165-192.

Anketell, J.M., 1996. Structural history of the Sirt Basin and its relationships to the Sabratah Basin and Cyrenaican Platform, Northern Libya, in M.J. Salem, A.S El-Hawat, and A.W. Stieta (eds.), *The Geology of Sirt Basin, Volume 3*, Amsterdam: 57-88.

Bellini, E., and Massa, D. 1980. A stratigraphic contribution to the Palaeozoic of the southern basins of Libya, in M.J. Salem and M.T. Busrewil, (eds.), *The Geology of Libya* 3, London: 3-57.

Echikh, K. 1998. Geology and hydrocarbon occurrences in the Ghadames Basin, Algeria, Tunisia, Libya, in D.S. MacGregor, R.T.J. Moody and D.D. Clark-Lowes, (eds.), *Petroleum Geology of North Africa*: Geological Society, Special Publication 132: 109-129.

Guiraud, R., and Bosworth, W. 1997. Senonian basin inversion and rejuvenation of rifting in Africa and Arabia-Synthesis and implication to plate-scale tectonics. *Tectonophysics*, 282: 39-82.

Gumati, Y.D., Kanes, W.R. and Schamel, S. 1996. An evaluation of the hydrocarbon potential of the sedimentary basins of Libya. *Journal* of *Petroleum Geology* 19: 95-112.

Hallett, D. 2002. *Petroleum Geology of Libya*, Amsterdam.

Harding, T.P. 1984. Graben hydrocarbon occurrences and structural styles. *American Association of Petroleum Geologists Bulletin*, 68: 333-362.

Klett, T.R. 2000. Total Petroleum Systems of the Illizi Province, Algeria and Libya-Tanezzuft-Illizi, *US Geological Survey Bulletin* 2202-A: 15pp, only available online at: http://pubs.usgs.gov/bul/b2202-f/

Luning, S., Craig, J., Loydell, D.K., Storch, P. and Fitches, B. 2000. Lower Silurian 'hot shales' in North Africa and Arabia: regional distribution and depositional model. *Earth-Science Review* 49: 121-200.

MacGregor, D.S., and Moody, R.T.J. 1998. Mesozoic and Cenozoic petroleum systems of North Africa', in D.S. MacGregor, R.T.J. Moody and D.D. Clark-Lowes (eds.), *Petroleum Geology of North Africa*: Geological Society, *Special Publication* 132: 201-216.

Massa, D. 1988. *Paléozoique de Libye occidentale: stratigraphie et paléogéographie.* PhD thesis, Universite de Nice.

Sutcliffe, O.E, Dowdeswell, J.A., Whittington, R.J., Theron, J.N. and Craig, J. 2000. Orbitally induced change in the volume of the late Ordovician ice sheet in Gondwana. *Geology* 28: 967-970.

Turner, P., Pilling, D., Walker, D., Exton, J., Binnie, J. and Sabaou, N. 2001. Sequence stratigraphy and sedimentology of the late Triassic TAG-I (Blocks 401/402, Berkine Basin, Algeria). *Marine and Petroleum Geology:* 18: 959-981.

Van Houten, F.B. 1980. Latest Jurassic-Early Cretaceous regressive facies, northeast Africa Craton. *American Association of Petroleum Geologists Bulletin*, 64: 857-867.

Theme 2

Prehistory

6. The Importance of Saharan Lithic Assemblages

By Tim Reynolds[1]

Abstract

The most frequent form of evidence for the thousands of years of prehistory in the Libyan Desert is lithic scatters. These often ephemeral and easily overlooked spreads of material are potentially a mine of information about the behaviour and adaptation of prehistoric peoples. Lithic technology is dominated by the reduction of larger pieces by flaking into smaller, useable elements. Recording lithic scatters over surfaces and through depths of sand can, therefore, provide a direct picture of the use of raw materials over the lifetime of a site, it can inform on mobility patterns and on the nature of economy. Study of lithic scatters in Fazzan can be compared with that in the Akakus and the Egyptian Western Desert to identify the changing use of the landscape over long time periods.

Introduction

It is often said that the Stone Age is important because it represents 98 percent of human history, but this misses two vital points. Firstly, it is not simply human history that is being studied but the very processes that created the species we call human. The adaptations and behaviours that fed human evolution are one of the principal elements in the study of prehistory. The recent discovery of a 7 million year-old skull in the Djurab desert in Chad should remind us that this story is neither simple nor well understood and that unexplored desert regions may still have a significant contribution to make (Brunet *et al.* 2002; Vignaud *et al.* 2002). Secondly, it must be remembered that it is not history that is studied. Written records of behaviour, intent and motivation are lacking, it is the application of method and theory to try to reconstruct and interpret action in the past that is the challenge of prehistory.

The nature of the archaeological record for prehistory is dependent upon preservation and it is, therefore, unsurprising that much of the prehistoric record is dominated by stone tools. As one of the most durable artefacts they represent one of the major data sources. It should be remembered, however, that their dominance in the record is not simply an archaeological convenience. Human groups were moving stone resources large distances, even across open sea, by 28,000 BP and the first flint mines are known from Egypt at the same time (Vermeersch *et al.* 1984). Investment in raw materials and organising the logistics of supply and demand across the landscape is surely one of the factors in developing human intelligence, requiring planning depth, skills of prediction and understanding of the details of landscape. These skills can be seen to develop as humankind evolves but are equally crucial to later, fully modern humans, particularly in challenging landscapes such as the Sahara.

Traditionally, prehistorians have used typology to create pattern and a picture of activity through time, but the nature of lithic technology is such that greater understanding can be achieved from examination of the patterns of raw material extraction, use and discard. These

[1]Faculty of Continuing Education, Birkbeck College, London

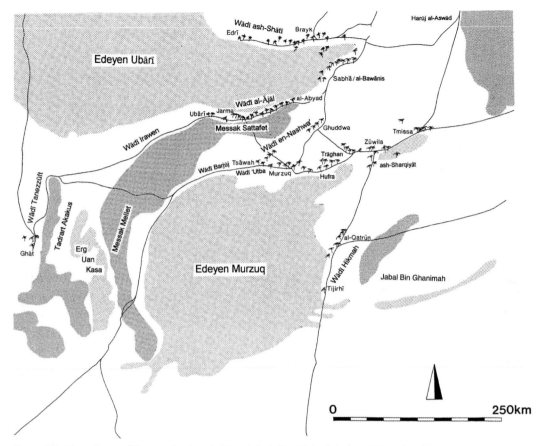

Figure 6.1. General map of Fazzan, showing the Massak Sattafat, Wadi al-Ajal and Ubari Sand Sea.

can be recovered from a more inclusive study. Whilst typology identifies tool types and pattern, technological study can be applied to all pieces recovered. It is the nature of lithic technology that artefacts are created by reduction – striking pieces off (a process known as 'knapping'). As such, each blow leaves its record on the original piece and creates a new item. Recovered assemblages of struck artefacts can then be used to reconstruct past behaviour by refitting the pieces back together again. In a similar fashion to playing a motion picture backwards, it is possible to see the actions and intent of the prehistoric knapper. It is important that the method of recovery allows such techniques to be applied, for experimental work has permitted us to learn much about how materials scatter during knapping, what sorts of technique create a given pattern and how use of a tool can create specific damage patterns.

The importance of lithic scatters in Saharan prehistory is that they represent the actions of humans across a vast amount of time and space. Equally important is the fact that the space was not a static background to human activity but was itself dynamic and changing (Schild *et al.* 1992; Ziegert 1966). This means that the lithic scatters studied reflect human responses to a varied landscape at fixed points in its development. It is possible to see the interplay between people and landscape through time. This does not mean that the environment was determining

all human action for different responses could be produced in similar environments. Indeed, as environments change cyclically, one can see different responses to a similar environment in the same place but at different times.

We can now examine some of these issues using the material recovered by the Fazzan Project (Mattingly *et al.* 2003). The project involved a landscape survey which has collected from a number of lithic scatters. The material was collected in several ways, on an encounter basis, as part of gridded survey and as gridded collections from a single site. Material has been limited to surface finds and the integrity of context cannot always be assured. Many of the sites studied were palimpsests of material from a number of events and times and so understanding each event can be complicated. An additional problem is that material may have been removed by collectors in the area which will preferentially select the distinctive 'type fossils' and so will have the effect of homogenising sites into collections of knapping debris. Caution should, therefore, be exercised in making interpretations from this data.

The Fazzan Project has used lithics to monitor human activity in an upland area (the Massak Sattafat) adjacent to a series of palaeolakes and around those lakes themselves (the Wadi al-Ajal) and the Ubari Sand Sea (Fig. 6.1). It has identified activity spanning the time from at least the Middle Pleistocene to the mid-Holocene. In the interpretation of dating for material it has been assumed that it is preferable to assign younger dates rather than older ones. During the time monitored, the environment has varied significantly with large lakes forming, drying out and reforming (White *et al.* this volume). Coupled to this were changes in the flora and fauna of the area that could be exploited by human populations.

Pleistocene Lithics

The earliest material comprises Acheulean bifaces. These are frequently found lying on the surface of the uplands, more occasionally along the fringes of the uplands, on the edge of palaeolakes and in one instance in the Ubari Sand Sea. These bifaces represent a multi-purpose tool adapted to a highly mobile lifestyle which has, elsewhere, been associated with exploitation of large game (whether this is through hunting or by scavenging has been debated). The bifaces are all made on raw materials local to the uplands – quartzite, and the frequency of their discard on the surface of the uplands may reflect the ready availability of replacements. The biface allows a number of tasks to be undertaken and liberates the user from being tied to raw material sources because it represents a portable source of material itself should its own edges not offer the suitable action.

It is important to remember that lithic tool types should not be seen as the fixed forms we are familiar with today. Whilst we would recognise specialised artefacts such as a set of knives – a steak, fish, butter, bread knife, and so on – lithic tools can be rapidly modified to suit a task. The forms we have are simply the last element in what could have been a complex and varied use life. The biface is a characteristic example of the flexible approach to tool use. The wealth of suitable raw materials on the upland also allowed use of Levallois technique in late Acheulean times. It is wasteful of raw material but shows a more developed skill in material use and planning. In addition to the bifaces, two flake cleavers were recovered from the Wadi

area, one of these was made on a Levallois flake. Dating these collections is problematic as the schemes for chronology are dependent upon tool morphology and stratigraphy in the circum-Mediterranean region (Alimen 1979; Biberson 1961) but such artefacts almost certainly represent the pre-modern humans of the area. It is likely, given the highly mobile nature of populations and the shifting patterns of environmental resources, that these peoples were not resident in the area permanently throughout the whole of the Middle and early Upper Pleistocene but came and went with resource availability and with growth and success of their population. The presence of a biface with trimming flakes in the Ubari Sand Sea demonstrates the degree to which environments have changed. The raw material for the biface derives from the Massak Sattafat several miles away and must have been taken to the site in the form of a rough-out or completed tool as only final trimming stages of biface production are represented. The trimming could be simple reworking of a worn or damaged edge rather than tool production itself.

The origins and spread of modern humans between 200,000 and 40,000 BP is a key debate in prehistory and the lithic scatters of the Sahara have a contribution to make to it. The end of the Acheulean and use of various Middle Palaeolithic industries is part of the adaptive range of behaviours of peoples at this time (Bar Yosef 1998). In Fazzan, it can be seen that there are at least three types of industry present through this period (Wendorf and Schild 1992).

The first is a continuation of the Acheulean using Levallois technique. It is found on the Massak Sattafat, its fringes and across the wadi floor. It uses the local quartzites. The second is a Middle Palaeolithic industry unique to North Africa (but with suggestions of links with Spain) – the Aterian (Clark 1993). This is a flake-based industry in which the tanging of tools is common. As such it may be seen that the role of hafting and tool curation have become a significant factor in stone tool use. This industry is rare on the Massak Sattafat but is found on the fringes of the palaeolakes in contrast to the distribution in the Akakus (di Lernia 1999). It is mostly made on local quartzites but a few more exotic raw materials are also used. Levallois technique is still used occasionally but disc cores are the most frequent form of core. The Aterian technology has a larger blade component than the other Middle Palaeolithic industries and Aterian tools are often made on blades. The most frequent Aterian tool collected by the Fazzan Project is the tanged blade.

The third industry is similar but lacking the tanged element and is known as the Mousterian (Bordes 1961). In the Mousterian sidescrapers are the most common tool type with denticulates and Mousterian points next most frequent. Again raw material use is mostly locally based but a few exotics occur. The Mousterian shares a distribution with the Aterian but is more widespread in the uplands. At one quartzite outcrop on the plateau of the Massak Sattafat we were able to recognise where two Mousterian knappers had sat and manufactured Levallois products over 60,000 years ago. It is possible to refit the waste flakes and see cores roughed out by one knapper being passed to a companion for blank production. Aterian pieces are usually more heavily weathered than Mousterian ones. Traditionally, it is believed that the Aterian is younger than the Mousterian and Acheulean and so this greater wear probably represents a change to harsher climatic conditions during or at the end of the Aterian phase. The Aterian has been dated to between 90,000 – 69,000 BP in the Akakus (di Lernia 1999).

There is another industry, characterised by massive blades made in quartzite that is undated but could represent an early incursion of blade-using modern humans into the area. It occurs in similar condition to the Mousterian industries and so could be approximately contemporary. The large blades are localised upon the upland but elements of these blades do appear to have been used in the Wadi base area. It may be that the blades were being used as a means of making raw material more easily portable and blanks were then being snapped off them in the Wadi area. Large blades have been found by the Italian Mission to the Tadrart Akakus but there they are thought to be Holocene in date. More detailed studies on the distribution, use wear patterns and reduction methods of these pieces are needed. Indeed, the dates of these different industries, their different use of raw materials and technology all require a more detailed study that cannot, as yet, fulfil the potential for understanding Pleistocene succession in the region.

Holocene Lithics

There is then a gap in human use of the area until the Holocene. At this point the palaeolakes had been re-established and hunter-gatherer populations were able to move back into the area, followed shortly afterwards by pastoralists. Much of the dating and interpretation of this evidence depends upon the detailed work and excavations by Cremaschi and di Lernia in the Akakus (Cremaschi and di Lernia 1995, 1996a/b; 1999: di Lernia 1999; di Lernia and Cremaschi 1996a/b, 1997; di Lernia and Garcea 1997; di Lernia et al. 1997) following that of Barich (Barich 1984, 1987a/b) and work on the lithics in Fazzan would be severely restricted were it not for this comprehensive work.

The pre-pastoralist phase probably began in the tenth millennium BP and we find backed blades on local raw materials in the palaeolake area. There are a number of broad blade- and flake-based endscrapers found across the Wadi area that resemble items described as Epipalaeolithic in the Libyan Valleys study (Barker 1996) but are not illustrated in the Akakus work of the Italian Missions. They may indeed be of this date but once again the limitations of general survey allow only putative dating to early/middle Holocene. It is possible to use the dated artefacts from the Akakus to suggest dates for finds from Fazzan: There are a number of projectile points that could be referred to the Early-Middle Pastoralist phase (7,400 – 5,000 BP). These include bifacial points and segments. The majority of points are either foliate or triangular in shape, some have tangs and some are both barbed and tanged. All these finds come from the Wadi floor and palaeolake shores. None have been found on the surface of the Massak Sattafat.

The Late Pastoral phase is also present and represented by tool types such as polished stone tools, and predynastic knives. The latter are not wholly bifacial but have the edge form and retouch type of predynastic knives from the eastern Sahara and so are regarded as a local variant based on poorer raw materials. In the Akakus such forms are termed 'exotic tools' and are believed to be used for plant processing. There are also two flaked stone axes and a flaked pick from the Massak Sattafat. The tools listed here are, however, rare across the survey area. There is an increase in both exotic raw materials and tool form diversity. This probably reflects increased population mobility in response to the increasing aridity of the time.

Figure 6.2. Location map of lithic sites studied in the vicinity of Jarma.

Collections from Palaeolakes in Ubari Sand Sea

It is not possible in a general landscape survey to examine specific sites in detail to identify all the behavioural information available but during the Fazzan Project it was possible to undertake a more detailed collection of material at a small number of sites to test the potential for more detailed work at a later date. A total of six sites, all located on the northern edge of the Wadi al-Ajal were investigated (Fig. 6.2). These sites were all lakeside camps where archaeological material has been exposed on the surface, probably by deflation. The sites were gridded and collected in multiples of five metre square boxes (5 x 5m). All material collected was planned so that distributions could be plotted and to support refitting studies. In addition to stone artefacts, some small pottery fragments, grinding stone pieces and ostrich eggshell (both worked and unworked) was recovered from some of the sites. None of the collections was particularly large and all sites could represent very short-term stops by small numbers of people. I will briefly describe some of these.

GER 37

This is an area of 15 x 5 m that yielded a single biface, two Levallois flakes, a Tayac point and a retouched blade. There were also two Levallois cores and four disc cores. This site shows a small amount of knapping taking place at the edge of a relatively early palaeolake shore. The relatively high number of cores is striking when the size of the collection is considered. Either a large amount of material remained buried (but this was not obvious to surface studies) or a significant amount of blanks were taken off site for use elsewhere.

GER 33

The collection came from an area of 35 x 15 m with a total of 374 flaked pieces. Pottery and ostrich eggshell were also present. Two stone perforators were recovered that fit with fragments

Figure 6.3. Detailed plot of lithics and other materials on site GER 34 in the Ubari Sand Sea.

of ostrich eggshell suggesting that eggshell beads were being manufactured here. There were also four microliths, two segments and a tanged projectile point. The material would date from early Holocene and Early/Middle Pastoralist times and so probably represents number of short visits over time. A small number of Mousterian artefacts were collected, including a sidescraper and a denticulate. Some of the Mousterian material had been reworked during the Holocene. All the raw materials used were quartzites which could have come from the Massak Sattafat.

GER 34

This is actually two adjacent areas of scatter on a deflation surface associated with a palaeolake. One area was 25 x 15 m and the other 30 x 15 m (Fig. 6.3). A significant number of tools was present including a Mousterian sidescraper. The Holocene tools included a number of projectile points of sixth millennium date, plus a number of backed blades and a microlithic point which could all be earlier. There were also two burin spalls showing manufacture of burins on site and possibly allowing a further inference that bone working also took place here. There was also a single flake from a polished stone axe indicating a Late Pastoralist presence. The absence of other polished pieces might suggest that a broken axe was being reused as a core and was taken

from the site. The frequency of projectile points might indicate that retooling was taking place with the removal of old points and their replacement by new ones but no impact damage was visible on the discarded points. Burins have been associated elsewhere with this type of retooling (Barton 1992) and it may be that it is the hafting that is being repaired rather than the point itself needing change. A number of perforators and a collection of worked ostrich eggshell pieces again suggest the on-site production of eggshell beads. Seventeen cores were recovered, three were on flint for which a source is unknown, the rest were on quartzite. This site is probably a palimpsest of material from at least two and probably several visits by Pastoralists between the seventh and fourth millennia BP.

GER 35

This site had a collection area of 15 x 5 m and lacked pottery. Grinding stone and ostrich eggshell were present. A single Mousterian sidescraper was collected and the Holocene tools included a segment, a burin spall, a backed blade fragment, a backed bladelet fragment and a truncated flake. This list would best fit within an Early/Middle Pastoralist date and once again suggests an element of retooling taking place. The notable element at this site was the frequency of cores: 27 in total. Four cores were of fossil wood, three of flint and the rest were quartzite. A significant element of core reduction and discard is present here. It would seem that raw material was being reduced as much as possible and the cores were then discarded. The fossil wood and quartzite could both derive from the Massak Sattafat. This site may be regarded as a retooling station at a position where the use of stone raw materials has reached the point where a significant number of cores had reached the end of their use.

It is significant that all the palaeolake shore sites have traces of Middle Palaeolithic activity, site GER 37 being the clearest without later, Holocene disturbance. It is possible that it is the Palaeolithic material which is deciding the choice of camp site; the older Palaeolithic sites being used as raw material sources for retooling. Although refitting of the collected material was attempted cursorily, no refits were found and so it is not possible to reconstruct Middle Palaeolithic tools from Holocene ones. It is, however, clear that some Palaeolithic material was being reworked. The superimposition of other, later, prehistoric activities over each other also confirms this pattern of selection of earlier sites for reoccupation. This is not something unexpected, work in the Eastern Sahara by Close (1990; 1992) has shown how important raw material exploitation was in patterning the materials found at scatter sites throughout the Holocene. Organisation of supply to meet the demands of a mobile population is crucial in the Sahara and this evidence suggests that in terms of lithic raw materials it had an early origin. The collections of the Fazzan Project indicate the potential of lithic scatters in reconstructing the behaviour and organisation of human groups across a large time span. Further, more detailed analysis and collection are now needed to realise this potential. It is clear, however, that lithic scatters have an essential part to play in the reconstruction of Saharan prehistory.

References

Alimen, H. 1978. *L'evolution de l'Acheuléen au Sahara Nord-Occidental (Saoura, Ougarta, Tabellala),* Meudon.

Barich, B.E. 1984. The Epipalaeolithic – ceramic groups of Libyan sahara: notes for an economic model of the cultural development in the West-Central Sahara, in L. Zrzyzaniak and M. Kobusiewicz (eds), *Origin and Early Development of Food Producing Cultures in North-Eastern Africa,* Polish Academy of Sciences, Poznan: 399-410.

Barich, B.E. (ed.). 1987a. *Archaeology and Environment in the Libyan Sahara. The Excavations in the Tadrart Acacus, 1978–1983,* Cambridge Monographs in African Archaeology 23/British Archaeological Reports International Series 368, Oxford.

Barich, B.E. 1987b. The two caves shelter: an early Holocene site in the north-eastern Acacus, in Barich 1987a: 13-61

Barker, G. 1996. Prehistoric Settlement, in G. Barker, D. Gilbertson, B. Jones and D. Mattingly, *Farming the Desert. The UNESCO Libyan Valleys Archaeological Survey, vol. 1 Synthesis,* (editor G. Barker), Paris and London: 83-109.

Barton, R.N.E. 1992. *Hengistbury Head, Dorset. Volume 2: The Late Upper Palaeolithic and Early Mesolithic Sites,* Oxford University Committee for Archaeology, Monograph No. 34, Oxford.

Bar-Yosef, O. 1998. The chronology of the Middle Palaeolithic of the Levant, in Akazawa, T. Aoki, K. & Bar Yosef, O. (eds), *Neanderthals and Modern Humans in Western Asia,* London: 39-56

Biberson, P. 1961. *Le paleolithique inferieur du Maroc Atlantique,* Service des Antiquities du Maroc, 17.

Bordes, F. 1961. *Typologie du paleolithique ancien et moyen.* Cahiers du Quaternaire 1, CNRS, Paris.

Brunet, M., Guy, F, Pilbeam, D, Mackaye, H., Likius, A., Ahounta, D., Beauvilain, A., Blondel, C., Bocherens, H., Boisserie, J-R., De Bois, L., Coppens, Y., Dejax, J., Denys, C., Duringer, P., Eisemann, V., Fanone, G., Fronty, P., Geraads, D., Lehmann, T., Lihoreau, F., Louchart, A., Mahamat, A., Merceron, G., Mouchelin, G., Otero, O., Pelaez Campomantes, P., Ponce De Leon, M., Rage, J.-C., Sapanet, M., Shuster, M., Sudre, J., Tassy, P., Valentin, X., Vignaud, P., Viriot, L., Zazzo, A., & Zollikofer, C. 2002 A new hominid from the Upper Miocene of Chad, Central Africa. *Nature* 418: 145-151

Clark, J.D. 1992. The earlier stone age/Lower Palaeolithic in North Africa and the Sahara, in Klees and Kuper 1992: 17-37.

Clark, J.D. 1993. The Aterian of the Central Sahara, In Krzyaniak, L., Kobusiewicz, M., & Alexander, J. (eds), Environmental Change and Human Culture in the Nile Basin and Northern Africa until the Second Millennium BC, *Studies in African Archaeology* 4, Poznan: 49-67

Close, A.E. 1990. Living on the edge: Neolithic herders in the Eastern Sahara. *Antiquity* 64: 79-96

Close, A.E. 1992. Holocene occupation of the Eastern Sahara. In Klees and Kuper 1992: 155-183

Cremaschi, M. and di Lernia, S. 1995. The transition between Late Pleistocene and Early Holocene in the Uan Afuda Cave (Tadrart Acacus, Libyan Sahara). Environmental changes and human occupation. *Quaternaria* 6: 173-189

Cremaschi, M. and di Lernia, S. 1996a. Climatic changes and human adaptive strategies in the central Saharan massifs: the Tadrart Acacus and Messak Settafet perspective (Fazzan, Libya), in Pwiti and Soper 1996: 39-51.

Cremaschi, M. and di Lernia, S. 1996b. Current research on the prehistory of the Tadrart Acacus (Libyan Sahara). Survey and excavations 1991–1995. *Nyame Akuma* 45: 50-59

Cremaschi, M. and di Lernia, S. 1999. Holocene climatic changes and cultural dynamics in the Libyan Sahara. *African Archaeological Review* 16.4: 211-238.

Cremaschi, M, di Lernia, S., & Trombino, L. 1996. From taming to pastoralism in a drying environment. Site formation processes in the shelters of the Tadrart Acacus Massif (Libya, Central Sahara), in L. Castelletti and M. Cremaschi (eds), *Micromorphology of deposits of anthropogenic origin*, [XIII Congress, UISPP, Colloquium VI, Vol. 3]: 87-106.

di Lernia, S. (ed.). 1999. *The Uan Afuda Cave. Hunter-Gatherer Societies of Central Sahara.* Arid Zone Archaeology Monograph 1, Firenze.

di Lernia, S. and Cremaschi, M. 1996a. Analysis of the Pleistocene Holocene transition in the Central Sahara: culture and environment in the Uan Afuda cave (Tadrart Acacus, Libya), in Pwiti and Soper 1996: 221-233.

di Lernia, S. and Cremaschi, M. 1996b. Taming Barbary sheep: wild animal management by Early Holocene hunter-gatherers at Uan Afuda (Libyan Sahara). *Nyame Akuma* 46: 43-54 .

di Lernia, S. and Cremaschi, M. 1997. Processing quartzite in central Sahara: a case study from In Habeter IIIA – Wadi Mathendusc (Messak Settafat, Libya), in Schild and Sulgotowska 1997: 225-232.

di Lernia, S. and Garcea, E.A.A. 1997. Some remarks on the Saharan terminology. Pre-Pastoral archaeology from the Libyan Sahara and the Middle Nile Valley. *Libya Antiqua* n.s. 3: 4-12

di Lernia, S., Cremaschi, M. & Notapietro, A. 1997. Procurement, exploitation and circulation of raw material: analysis of the early and middle Holocene lithic complexes from Fazzan, Southern Libya (Tadrart Acacus and Messak Settafet), in Schild and Sulgotowska 1997: 233-242.

Klees, F. and Kuper, R. (eds). 1992. *New Light on the Northeast African Past. Current Prehistoric Research*, Heinrich Barth Institut, Cologne.

Mattingly, D.J., Daniels, C.M., Dore, J.N., Edwards, D. and Hawthorne, J. 2003. *The Archaeology of Fazzan. Volume 2, Synthesis,* London.

Pwiti, G. and Soper, R. (eds) 1996. *Aspects of African Archaeology. Papers from the 10th Congress of the Pan African Association for Prehistory and Related Studies*, University of Zimbabwe Publications, Harare.

Schild, R. and Sulgotowska, Z (eds). 1997. *Man and Flint. Proceedings of the VIIth International Flint Symposium,* Institute of Archaeology and Ethnology, Polish Academy of Sciences, Warsaw.

Schild, R., Wendorf, F. & Close, A. 1992. Northern and eastern African climate changes between 140 and 12 thousand years ago, in Klees and Kuper 1992: 81-96.

Vermeersch, P. M. 1992. The Upper and Late Palaeolithic of Northern and Eastern Africa, in Klees and Kuper 1992: 99-153.

Vermeersch, P.M., Paulissen, E., Gijselings, G., Otte, M., Thoma, A., Van Peer, P. & Lauwess, R. 1984. 33,000-year old mining site and related Homo in the Eygptian Nile Valley. *Nature* 309: 342-344.

Vignaud, P., Duringer, P., MacKayne, H.T., Likius, A., Blondel, C., Boisserie, J-R., de Bonis, L., Eisenmanns, V., Etienne, E., Geraads, D., Guy, F., Lehmann, T., Lihoreau, F., Lopez-Martinez, N., Mourer-Chauvire, C., Otero, O., Rage, J-C., Schuster, M., Vinot, L., Zazzo, A., & Brunet, M. 2002. Geology and palaeontology of the Upper Miocene Toros-Menalla hominid locality, Chad. *Nature* 418: 12-155

Wendorf, F. and Schild, R. 1980. *Prehistory of the Eastern Sahara*, New York

Wendorf, F. and Schild, R. 1992. The Middle Palaeolithic of North Africa: a status report, in Klees and Kuper 1992: 39-78.

Ziegert, H. 1966. Climatic changes and Palaeolithic industries in eastern Fazzan, Libya, in J.J. Williams (ed.), *South-Central Libya and Northern Chad. A Guidebook to the Geology and Prehistory*, Petroleum Exploration Society of Libya, Tripoli: 65.

7. The Procedures of Archaeological Survey of the Dahan Ubari area

By Ibrahim al-Azzabi[1]

Abstract

This paper provides a succinct summary of recent emergency surveys carried out by the author on behalf of oil companies exploring the desert landscapes of the Ubari Sand Sea, the Wadi Irawen to its south and the escarpment and plateau top of the Massak Sattafat. Some preliminary observations are made about the types of site encountered and the classes of lithic tools collected.

Introduction

This paper is a very brief account of the methodologies that I personally followed in conducting emergency archaeological survey in advance of oil company geo-prospection in the area of the Dahan Ubari (Edeyen Ubari), the plains of Wadi Irawan, the escarpment of Qudam al-Jurf and on a small part of the Massak Sattafat plateau area as well. The detailed study of the data collected and the final results are still to be determined. However, this summary describes some of the material that I found during my survey in the above-mentioned areas as well as the research methodology followed.

The Dahan Ubari (Ubari Sand Sea) was not known in the past for its archaeology (though see Reynolds; White *et al.,* this volume). My exploratory expeditions have resulted in the recording of more than 200 archaeological sites proving that there were human settlements and activity throughout the Pleistocene epoch, starting with the lithic traditions of the Acheulean and the Mousterian, and finishing with the Aterian, in addition to the separate traditions of the Holocene age (from the Mesolithic, to Neolithic Pastoral and Garamantian remains). The exploration was carried out on foot in about 70 percent of all cases because of the difficulties in using cars in an area made up of chains of sand dunes and rocky escarpments and plateau land. Some of the dunes reach a height of over 100 m and their width can be as great as 0.5 km. The interdune corridors consist mostly of old dry valleys and lakes represented by lacustrine sediments and old fluvial deposits (see Drake *et al.*; McLaren *et al.*; White *et al.*, this volume).

Site Classification

The sites have been registered as follows:

1. Name: the name of the site.

Because the area is open, and most sites are similar in their form and hydrographic locations, a number was given to each site corresponding to its name.

[1]Dept of Antiquities, Tripoli

2. The coordinates

Coordinates were determined by GPS (Global Positioning System) instrument.

3. The site structure

This combined a note of the topographic location in relation to dunes, salt flats, duricrusts, organic sediments, rocky escarpments, etc. and brief comment on the physical character of the archaeological evidence on the surface of the site (fireplaces, stone settings, artifact scatters and hollows, etc.).

4. The site classification

Settlement site: this interpretation is highlighted by the density of the archaeological discard (abandonment), and the presence of heavy archaeological artefacts such as grinding stones, large assemblages of stone tools and/or pottery.

Site of stone tool manufacturing: the best proof of this is a high density of flaking debris and unfinished tools.

Transit or temporary site: indicated by discrete concentrations of small numbers of tools.

Rock art site: can be either paintings or engravings.

Site of raw material extraction: this category primarily relates to the extraction of lithic tools, especially well represented on the plateau of the Massak Sattafat and its northern rocky escarpment (Qudam al-Jurf).

5. Site chronology

Since no scientific dating has been carried out, I have no absolute results. However, the typology of stone tools allows tentative dates to be given in accordance with established chronologies for the region (see below).

6. Site drawing and mapping

Sketch plans were made for some sites, and all sites were included on a general map of the area, encompassing all the newly discovered archaeological sites.

Typology of Lithics Collected

(On this see further Reynolds, this volume)

The Pleistocene era

This is represented by the stone tools that relate to the Lower and Middle Palaeolithic:

1. Primitive choppers: Some primitive choppers were found and their use goes back to the Lower Palaeolithic. Very often these choppers are found on a terrace of river pebbles or on plain pebbly land, and in my opinion they resemble the Oldowan style.

2. Advanced choppers: More advanced choppers, in the form of axes, worked both at the front edge and on one of the sides.

3. Primitive axes (bifaces): these are large and crude in manufacture, similar to the Abbevillean style. They have been found by me on the Qudam al-Jurf escarpment of the Massak.

4. Acheulean crude axes: I found examples of these, corresponding with the lower Acheulean, on the Massak plateau.

5. Later Acheulean axes: examples of these, corresponding with the middle Acheulean tradition, have also been found on the Massak plateau.

6. Acheulean scrapers: these have been found on the Qudam al-Jurf escarpment and on the Massak plateau.

7. Denticulates: their sides resemble blades found on the Massak plateau.

8. Acheulean axes: examples corresponding to the late Acheulean tradition have been found in sand sea area around palaeolake sites.

9. Mousterian assemblages: Lithics corresponding to the Mousterian tradition have mainly been found on the Massak plateau.

10. Levallois material: Levallois flakes have been found on the Massak plateau.

11. Bladed tools: blades related to the Aterian tradition have been found in the sand sea area.

12. Scrapers: scrapers are found in many locations.

13. Borers (drills): examples of Epi-Palaeolithic appearance were found in the sand sea area.

The Holocene era

This is represented by lithics of the early Neolithic and Pastoral phases and pottery of the early Neolithic (?), Pastoral and Garamantian phases.

14. Early Neolithic material: flakes and debitage were found on the shores of an old lake.

15. Drills: Some drills (toothed-points) can be dated to the Pastoral era. They were found at a palaeolake settlement site.

16. Pottery: broken pottery fragments that may be Mesolithic (or perhaps more likely Pastoral) were found in the sand sea area.

17. Scrapers: scrapers of Pastoral date were found in the sand sea area.

18. Arrowheads and other points: most examples recovered are from the sand sea area.

19. Pottery: pottery fragments of probable Garamantian date have been found in the sand sea area.

General Observations

As far as concerns the Palaeolithic tools, the primitive choppers have been found in the Sand Sea area, and are rare on the Qadam al-Jurf escarpment as well as on the sandstone massif of the Massak, at least in the area that was subjected to surveying. Early Acheulean material, primarily axes (bifaces), crudely fashioned, large in size and similar to the Abbevillean style, are found on the Massak and the Qadam al-Jurf escarpment, but are rare in the sand sea around the dry lakes in the interdune corridors. Better-made axes, characterised by a long handgrip, date to the upper Acheulean age and are mainly found in the sand sea dunes area, whereas they are rare in the Massak area that was subjected to surveying.

The tools of Mousterian tradition were poorly represented in the Sand Sea area, except for some Levallois flakes, whereas lots of them were found on the Qudam al-Jurf escarpment and the Massak. On the other hand, Aterian tools were found in large numbers in the sand dunes area, especially bladed tools which were well made and date to later times in this cultural period.

The Epi-Palaeolithic tools are found in large numbers on the fringes of the dry lakes, and all are of the form of backed blades and crescent-shapes. Few examples have been noted from the escarpment and Massak plateau.

Microlithic tools and debitage in the Sand Sea area came primarily from the ancient lake shores sites and were rare Qudam al-Jurf escarpment and Massak plateau.

The Pastoral age lithic tools, such as scrapers and drills, stone crushing and grinding apparatus, etc., are largely found by palaeolake shores in the sand sea, indicative of long-lived camps and settlements. Once again, they are rare in the rocky hill areas.

However, Garamantian remains, mostly in the form of tombs, have been identified on the lower slopes of the Qudam al-Jurf escarpment along the south side of Wadi Irawen. A few examples of cairns on the Massak may also date to this phase. Garamantian activity appears to have been of minor impact in the Sand Sea area.

8. Libyan Rock Art as a Cultural Heritage Resource

By Tertia Barnett[1]

Abstract

Numerous rock art sites are known in Libya, including some of the finest paintings and engravings yet recorded. Together these represent one of Libya's most valuable heritage assets, and they form a crucial part of the wider cultural heritage of North Africa. However, the rock art is extremely vulnerable to degradation and destruction by a range of environmental and human agents. With the rapid growth of industry and tourism in Libya, human interference is becoming an increasing threat every year. Rock art is a finite and restricted resource that should be preserved before it is lost forever. In order to ensure its preservation, rock art sites need to be fully documented, and must also be appropriately managed and protected.

This paper presents both a celebration of Libyan rock art and a caution about its vulnerability. Some of the better known areas of Libyan rock art are considered within the broader context of Saharan rock art and prehistory, before recent work in the Wadi al-Ajal, Fezzan is discussed. The results of this work illustrate the potential for identifying new sites and demonstrate that a significant quantity of rock art may still remain undocumented. Rock art is exposed to a range of different threats, and these are identified with particular reference to the engravings in the Wadi al-Ajal. Building on these points, the paper discusses the importance of informed management and conservation of this resource, and stresses the need for urgent action to avoid further destruction of this valuable part of Libya's cultural heritage.

Introduction

Rock art is an extremely precious cultural heritage resource. It has different levels of attraction, including its potential for research and education, its contribution to cultural identity and its aesthetic value, and it has different significance for different groups of people. Rock art is a magnet not only for archaeologists and historians, but its antiquity and visual appeal make it especially attractive to tourists and visitors of all nationalities. However, because the rock art resource is valued by a wide range of people, it is used in different ways and is exposed to a number of different potential threats.

In common with all archaeological features, rock art is a finite and fragile resource. It can easily be interfered with, both intentionally and unintentionally but once damaged or destroyed it has gone forever. Rock art images and their associated landscapes in Libya and in the Sahara are currently exposed to growing threats from a number of different sources, especially oil extraction industries and tourism. The impact of oil exploration is a critical issue for Libyan rock art and has been discussed elsewhere (for example, Anag *et al.* 2002; Liverani this volume). This paper will focus particularly on the implications of tourism and small-scale human intervention, the effects of which can be equally as devastating.

This paper draws attention to the value of Libyan rock art and its landscape context as an integral part of the cultural heritage of both Libya and the Sahara, and it addresses the issue

[1]Rock Art Project Officer, English Heritage Pilot Rock Art Project

of rock art vulnerability. Recent survey work in the Wadi al-Ajal is discussed to illustrate these points and to identify specific and potential threats to the continued survival of rock art in this area. The need for an immediate conservation and management strategy aimed at protecting the rock art resource and encouraging sustainable access to it is highlighted.

The Rock art of Libya and the Saharan Context

Prehistoric rock art of the Sahara
The present day Sahara region boasts an outstanding assemblage of rock art. The exceptional proliferation, quality and preservation of the images have led experts to describe the Sahara as the greatest gallery of prehistoric art in the world (Castiglioni *et al.* 1986; Le Quellec 1993; Mori 1998; Muzzolini 1997). Localised concentrations of rock art are found in rock shelters and on exposed boulders and rocky outcrops across the entire Sahara region, from Western Sahara and the western Maghreb to the Nile Valley and Red Sea Hills (Fig. 8.1). Arid conditions

Figure 8.1. The approximate distribution of known rock art sites in North Africa. Dark areas indicate areas with significant concentrations of rock paintings and engravings.

have ensured excellent preservation of paintings and engravings alike, with the colours of the pigments often glowing as vividly as they did several thousand years ago, and the incised lines of the engravings as sharp and clear as they were originally.

The rock art is believed to span at least the last 7,000 years of human occupation in the Sahara, continuing up until the recent past in certain areas. However, dating is notoriously problematic, particularly for engravings (for example, Watchman 2000; Whitley and Simon 2002), and some specialists have argued for a higher chronology in which the oldest images date to around 10,000 BP, or even pre-date the start of the Holocene (Lutz and Lutz 1995; Mori 1968; 1998). The great antiquity of the images makes their quality of preservation all the more valuable.

In general terms, common themes persist in the rock art across the whole Sahara, although there are distinct regional variations. The images capture an altered Sahara; a landscape teeming

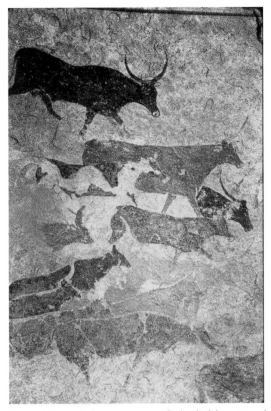

Figure 8.2. A polychrome painting of a herd of domesticated cattle from Jabbaren rock shelter in the Tassili indicates a pastoralist culture once thrived in the central Sahara desert.

with large wild animals and birds, with immense herds of domesticated animals, and with a richness and proliferation of human culture that is incongruous – and untenable – in the arid desert of today (Fig. 8.2). This contradiction of complex and 'accomplished' art in a landscape that now supports negligible human occupation in part explains our fascination with the images today. A significant proportion of the rock art is representative. Large savannah animals such as elephant, giraffe, ostrich and rhinoceros, and domesticated animals, particularly cattle, sheep and goats, camels and horses are widely depicted. Anthropomorphic figures are also frequently shown (Fig. 8.3), and many later images portray manufactured items including metal weapons and the famous 'flying gallop' chariots traditionally attributed to the Garamantians (Camps 1987; Camps and Gast 1982). Abstract signs are also an important feature of the later rock art, and prolific inscriptions in *tifinagh* and Libyco-Berber scripts may be at least 2000 years old.

Considerable alterations in style and content of the rock art through time correlate both with fluctuating climatic and environmental conditions, and with changes in the social structure, economy and ideology of the groups that occupied the Sahara. For example, domesticated camels are thought to have been introduced to North Africa during the third millennium BP (Clutton-Brock 1993; Rowley-Conwy 1988), and their depiction in rock art from this time reflects a widespread adaptation to more arid conditions, with concomitant changes to the structure of trade and communication networks and to the social and ideological framework of the groups occupying the Sahara.

The rock art tradition has persisted through a spectrum of profound cultural transitions, from hunting and gathering to pastoralism, to settled agriculture, proto-urbanism and, finally, to industrialisation. It therefore represents both a critical document of cultural change and continuity, and a valuable resource through which these aspects of the past may be explored. Rock art records intangible aspects of human behaviour and interaction that rarely leave material remains, and are often archaeologically invisible. It has unparalleled potential for providing an insight into ways of life, cultural values and systems of belief that have long since disappeared, and for enhancing our understanding of the cultural heritage of the Sahara.

However, the images are far more than a tool with which to study the past. While the

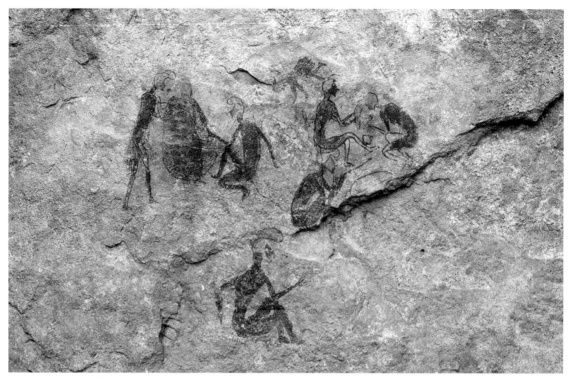

Figure 8 3. Human figures are frequently represented in paintings and engravings across the Sahara, as in the Wadi Teshuinat in the Akakus. (Photo: Toby Savage).

importance of the rock art as a research resource is immeasurable, it has a far broader cultural heritage value, both in contributing to the time-depth and cultural identity of the North African people and as a key tourism resource, where its highly visual appeal enhances its attraction for visitors.

The rock art of Libya

Some of the finest concentrations of Saharan rock art are found in Libya. Fazzan contains two outstandingly rich areas of rock art: the Tadrart Akakus on the Algeria border in south Fazzan (Mori 1998) and the Messak Sattafet/Messak Mellet in the south-west of the region (Lutz and Lutz 1995; Van Albada and van Albada 2000). The Messak Sattafet alone contains hundreds of major rock art complexes, encompassing tens of thousands of engravings, while the paintings from the Tadrart Akakus have few parallels elsewhere in the world. Important collections of rock art have also been recorded further to the north in the Wadi al-Ajal (Barnett 2001; 2002), the Wadi ash-Shati (Muzzolini *et al.* 2002), and the southern fringes of the Hamada al-Hamra (Le Quellec 1985; 1993), while further sites have been recorded at Jabal Uweinat on Libya's eastern border (Zobray 2002). This outstanding collection of rock art not only represents one of Libya's most valuable archaeological resources, it is also a crucial part of the cultural heritage of the Sahara and of the world.

Rock Art, Landscape and Tourism

While studies of rock art traditionally focus principally on the images, contemporary research argues that rock art is an integral part of its surrounding landscape and it should never be viewed in isolation from its physical context (e.g. Bradley 1997; 2000; 2002; Chippendale and Tacon 1998; Nash and Chippendale 2002). Rock art was deliberately created at specific locations in the landscape, which were chosen at that time because of their cultural importance and meaning. In such locations, rock art would have provided a permanent expression of cultural identity, territoriality and beliefs. It would have constantly reiterated the relationship between the people and the landscape, and it may have been a significant component of cultural continuity and stability.

If the significance of the rock art derives from its association with the landscape, then removing it from its physical environment or altering its surroundings devalues its meaning and destroys its impact. This detracts from the archaeological potential of rock art, and also diminishes its tourism value. Rock art is often found in remote regions of the world and is generally associated with wild, empty landscapes that offer tourists a range of possible experiences. The Saharan landscape, for example, caters for several different types of tourist drawn by the sense of discovery, adventure or peace that the desert can offer. It is in combination with these qualities that the rock art is marketed to tourists as part of the desert landscape experience. Consequently, the unadulterated desert setting is what tourists associate with Saharan rock art and what they expect from it.

The Impact of Tourism on Rock Art

While natural processes of erosion, thermal shock (shattering and flaking of rocks as a result of large temperature differences) and lightning cause a continual low level of damage to rock art, human impact has the potential for massive, short-term devastation. A major contributor to rock art destruction is tourism, and two universal types of tourist-related impact can be identified. These are *deliberate damage*, comprising graffiti, vandalism and theft, and *unintentional damage*, including the effects of pollution or misjudged interference (Bahn 1998).

Rock art is particularly vulnerable to the threat that tourism represents because it is relatively freely accessible in the landscape. It can therefore be touched, traced, vandalised and removed, even when it is part of a large rock face or outcrop. Although tourism can bring many economic and cultural benefits, its effects can also be highly destructive if inappropriately managed, and in these situations there is a directly proportional relationship between the extent of tourism and the extent of damage to rock art sites, even when tourists may not be directly responsible. For example, in certain areas of Morocco around forty percent of engravings and ten percent of paintings have been stolen or ruined in attempts to remove them for foreign markets (Bahn 1998). Without a foreign market, these images would still be intact, but now half of the total rock art resource of those areas has been irrevocably destroyed, and the rock art that is removed undamaged is rendered meaningless once extracted from its landscape context. Rock-saws and chain-saws are used in many parts of the world to cut chunks of paintings and engravings from the rock – a practice that was only prevented in the Tassili-n-Ajjer when it became protected as a National Park.

Unintentional damage can, in the longer-term, be equally as devastating as deliberate interference. Studies in South Africa, for example, have show that over the past ten years, human intervention at painted rock art sites has grossly accelerated natural processes, such as flaking and fading, due to large numbers of people camping in the rock shelters. Estimates suggest that within 100 years, there will be no paintings left at these sites (Pager 1989). Ironically, these people are attracted by the very qualities that they are destroying – the peace and isolation of the setting and the aesthetic value of the paintings. Even when the intentions are good, human intervention can be disastrous. In the Sahara and Arizona deserts, for example, attempts in the past few decades to protect rock art from human and natural agents by painting them with varnish-like chemical sealants resulted in a drastic darkening of the rock surface along with the painted and engraved images. There was also possible accelerated destruction of the treated images due to moisture being trapped below the artificial chemical layer (Bock and Bock 1990).

Rock art and tourism in Libya

With global tourism on the increase and growing interest in desert and adventure tourism, Libya is rapidly becoming a much sought-after destination (see Keenan this volume). Rock art, particularly in the Messak, forms part of the main axis of visitor attractions, along with the desert landscape, the culture and the archaeology. Although the emptiness and serenity of the desert are rapidly becoming eroded by expanding volumes of visitors in 4WDs, this impact is ultimately reversible. However, the effects of a burgeoning tourist industry on the rock art and archaeological landscapes can be devastating and permanent.

To illustrate the potential impact on Libyan rock art imposed by tourism and human interference, this paper will focus briefly on a recently identified concentration of rock art located in the Wadi al-Ajal in the Fezzan, and the importance of the relationship between the rock art and its physical surroundings, which gives the rock art value and meaning. Despite being relatively unknown, the rock art of the Wadi al-Ajal is exposed to similar threats as those that menace the well-documented engravings and paintings of the Messak and the Akakus. The main reasons for drawing attention to this little-known collection are to demonstrate that the potential for new discoveries of rock art in Libya must not be underestimated, and that all areas of rock art and their associated landscapes are a crucial part of the cultural heritage resource. This case study stresses that all rock art in Libya is vulnerable and under threat, and that it all demands a comparable level of management and protection.

The Rock Art of the Wadi al-Ajal

Survey of rock art sites in the Wadi al-Ajal was initiated in 2000 under the aegis of the Fazzan Archaeological Project, with further field seasons in 2002, 2004/5 and 2006 (Mattingly *et al.* 2000; 2003). Preliminary reconnaissance has identified the presence of a rich body of rock engravings in the Wadi comprising several hundred images, only a small proportion of which had been documented previously (Barnett 2001; 2002; Barnett and Roberts 2003; Le Quellec 1985; Pauphillet 1953; Pesce 1968; Sattin 1965; Ziegert 1969; Zoli 1926). Provisional research indicates that although the engravings of the Wadi al-Ajal show many similarities to the rock art

from the Messak and Akakus, and correlate with a broader Saharan context and chronological framework, they demonstrate distinct characteristics of style and preferred location. This suggests that we are dealing with a relatively independent and autonomous phenomenon, and one that has the potential for providing critical information about the human groups that occupied or exploited the Wadi over the past several millennia and about their relationships with their environment.

The fieldwork thus far has only surveyed a small proportion of the Wadi, and it is highly probable that there are still extensive unrecorded rock art sites in this region. Equally likely is the possibility that further rock art concentrations exist in other regions of Libya that have not yet benefited from detailed investigation. Sample surveys further to the north (Le Quellec 1985; 1993; Muzzolini et al. 2002) indicate the presence of more sites. Unrecorded rock art or rock art that does not currently assume recognised national or international status is an important part of the cultural heritage and warrants a similar level of protection to areas that are more widely renowned.

Rock art and landscape in the Wadi al-Ajal
Preliminary studies have identified a clear relationship between local landscape features and the distribution of rock art sites that has implications for enhancing our understanding of the role of the rock art. The contemporary landscape of the Wadi al-Ajal is polarised between the vegetated and irrigated wadi, running east to west, and the arid, barren landscapes of the Ubari Sand Sea to the north and the Murzuq Hamada to the south. The stony plateau of the Murzuq Hamada terminates abruptly in a steep, rocky escarpment dropping 80-200 m to the floor of the Wadi. Along much of the escarpment, sheer sandstone cliffs make the upper limits impassable. These are punctuated by ancient palaeochannels cutting down from the Hamada to the Wadi, many of which now allow somewhat difficult access. There is only one natural pass, the Bab el Maknusa, allowing easy access between the Murzuq Hamada and the Wadi al-Ajal.

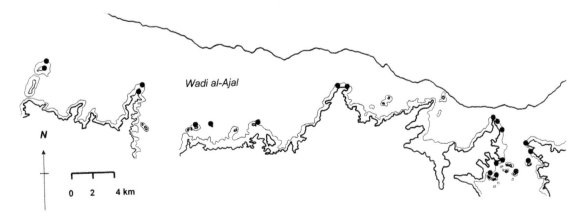

Figure 8.4. Distribution of recorded rock art sites along the hamada escarpment which defines the southern edge of the Wadi al-Ajal. The northern edge of the Wadi is defined by the Ubari Sand Sea. Closed circles indicate concentrations of rock art recorded in 2000 and 2002 surveys.

Figure 8.5. A rock art site located on the upper tip of an escarpment promontory. This dramatic location affords a spectacular view northwards over the Wadi al-Ajal and the Ubari Sand Sea.

Such routes are likely to have been important channels of movement and communication in prehistory, as they are today.

Recording the relationship between the rock art and the landscape revealed a patterned distribution of rock art sites relative to local topographical features. Two main types of patterning could be recognised: first, engravings are associated with major routes of access and communication into and out of the Wadi and, second, engravings form discrete clusters around the ends of promontories of the escarpment, where these project into the Wadi. This distribution pattern is illustrated in Figure 8.4. In addition, a series of more subtle patterns are emerging from the ongoing fieldwork. Detailed study of these patterns will allow us to explore aspects of cultural adaptation and behaviour over time. Without a full record of the engravings our data will be misleading and our interpretation is likely to be erroneous.

Current theoretical approaches stress the importance of evaluating and understanding rock art in relation to its physical setting in the landscape (Chippendale and Nash 2002). As Bradley (2000) observes, rock art is deliberately placed in the landscape and can be a powerful feature of it. A definite relationship exists in the Wadi al-Ajal between rock images and the places in the landscape in which they were created. The recurrent choice of dominant landscape features, such as escarpment promontories, suggests that these locations were perceived as meaningful by the cultures that used or inhabited the Wadi during the middle and later part of the Holocene

(Fig. 8.5). By creating permanent visual images at these places, the importance of the locations was enhanced and their significance was perpetuated through time. The images are drawn from a range of different phases, suggesting that these landscape foci continued to be perceived as important for several thousand years, although their meaning may have altered during this time.

Problems and threats

In contrast to the Messak and the Akakus, the Wadi al-Ajal is relatively densely populated, with many of its inhabitants involved in small-scale agricultural production. A metalled road runs east to west along the length of the Wadi from Sabha, making movement around the Wadi straightforward with a 2-wheel drive vehicle. The presence of the ancient Garamantian capital at Jarma (Mattingly, this volume), the extensive prehistoric landscape, and the proximity of the Ubari Sand Sea combine to make the Wadi one of Libya's most important centres for desert tourism. While many of the visitors to the Wadi pass through quickly on their way to the rock art of the Messak or the Akakus, a significant number will visit rock art sites in the Wadi. These will generally be the larger, more impressive sites, those that are most accessible from the road, or those that are mentioned in the literature or known by local guides. The sites are also visited by local inhabitants, and many have well-worn paths running to them.

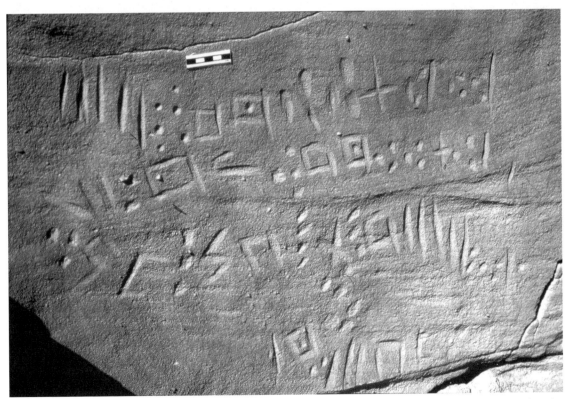

Figure 8.6. Tifinagh inscriptions are common in the Wadi al-Ajal and across the Sahara. They often occur at sites with earlier rock art, but they invariably respect the space of the older images.

At least 10 percent of the images identified during the field survey had been destroyed or interfered with in some way, principally by humans. The impact results from both deliberate and unintentional damage, and can be outlined as follows:

Graffiti

This includes defacing engravings with contemporary inscriptions of names, dates, comments and even pictures of the owner's vehicle. While this may arguably represent a certain continuity in the relationship with the environment and the rock art, much of this graffiti is created by visitors who have no historical understanding of the landscape and have no claim to its heritage.

Previous inscriptions, including much of the tifinagh text (Fig. 8.6), may be construed as an earlier form of graffiti. However, not only was this created by people who depended on the landscape for their survival and therefore had a very different relationship with it than modern-day visitors, these inscriptions respected the space of original engravings and, even when they occupy the same panel, the tifinagh is very rarely superimposed over earlier images. In contrast, modern graffiti is commonly scrawled right over prehistoric images. Figure 8.7

shows an engraving of an archer shooting at an elephant which stands about 2 m tall and forms part of a larger panel dominated by three massive elephants. The site is of considerable interest and importance, and it is situated at one of the more dramatic locations in the Wadi al-Ajal. It has immense potential both for research and for tourism. However, a large Arabic inscription has recently been scrawled right across the surface of this panel, defacing the images and devaluing the site.

While this graffiti is written in chalk and can be removed, albeit with difficulty, many other inscriptions are incised with sharp implements that cause permanent damage. Figure 8.8 shows an engraving of a giant wild African buffalo, or *Bubalus antiquus*, which used to inhabit parts of the Sahara, but which has now been extinct for at least 5,000 years (Mori 1998). This is possibly the oldest engraving so far recorded in the Wadi, and is possibly more than 7,000 years old. It is a key part of the cultural heritage of this area and it is crucial to our understanding of hunter-gatherer occupation here, and of the relationship between hunter-gatherers and early pastoral groups. As Figure 8.8 shows, this engraving has been badly and irreversibly damaged by graffiti incised into the rock surface over the top of the prehistoric image.

Proximity to the road is a significant factor, with

Figure 8.7. A rare engraving of an archer several thousand years old. The figure is approximately 30 cm high and is shooting at an elephant of about 2 m high, of which part of the trunk is visible. These figures form part of a larger composition which includes three large and one small elephant. A large Arabic inscription, part of which can be seen here, has been scrawled in chalk, defacing the entire panel.

the majority of graffiti found at the most obvious and easily accessible sites. Studies in North America have shown that sites close to roads are at least three times more likely to be damaged than those that are harder to reach (Bednarik 1990). Proximity to the road also has other implications, as many of the sites on boulders close to the road appear to be used regularly as toilets. Thankfully this impact *is* reversible. However, this is obviously a factor that must be targeted in a conservation and management plan.

Figure 8.8. This engraving of the extinct giant buffalo, Bubalus antiquus, *is possibly the oldest image so far recorded in the Wadi al-Ajal and is one of the most important pieces of rock art so far identified in this area. It has been permanently damaged by graffiti incised over the image.*

Theft

Removal of chunks of art from a rock panel was noticed at several sites in the Wadi al-Ajal. For example, Figure 8.9 shows a fine engraving that originally comprised at least two giraffe. The image or images on the right side of the panel have been removed completely, and a small remaining fragment of a second giraffe is the only indication that the left-hand engraving was part of a larger composition. This theft has irrevocably damaged the site, which has also been vandalised by graffiti in recent years.

Theft of entire rock art pieces is more difficult to quantify, particularly in areas where there has been no previous documentation work. The extent of this type of theft can only be established through a programme of systematic site recording and monitoring. However, even minimal recording can provide an indication of the possible scale of this activity. For example, during the second phase of survey in the Wadi al-Ajal, repeat visits were made to two of the sites recorded in 2000. At one of these, a small panel engraved with a rare image (Fig. 8.10) was no longer present and is believed to have been removed from the site in the two years since it was first observed.

Figure 8.9. This engraving of a giraffe originally formed part of a larger composition, as indicated by the remaining fragment of a second giraffe. The removal of the right side of the panel has destroyed the visual integrity of this site and diminished its cultural heritage value.

Enhancing

At a number of sites, the original incisions of engravings had been in-filled with chalk or paint. In a few instances, the patina (the natural chemical layer that has built up over the millennia to make the engravings the same colour as the external rock surface) has been removed to expose the underlying rock colour and make the engraving more visible. These actions, which are often done to make the images more distinct for photographs, interfere with the patina covering the engravings and destroy vital chemical evidence that could be used for scientific analyses, such as dating the rock art.

This practice also destroys the visual and historical integrity of the rock art and can easily lead to misrepresentation of the original image, particularly where the lines are faint or ambiguous. Making the images more visible can also attract attention, and possible further damage, to images and sites that might otherwise be ignored and be preserved by their obscurity. Painting and chalking of engravings was commonly used by researchers and conservationists in the 1960s and 1970s in an attempt to prevent unintentional damage to sites that might otherwise go unnoticed and be destroyed by drawing attention to them. However, this has had the adverse effect of attracting deliberate vandalism. At one important site in the Wadi al-Ajal, for example, a number of engravings were painted by the academic researching the site in the 1960s (Zeigert 1969). The site is frequently visited by tourists and local inhabitants, and in recent years further images have been chalked in and covered in chalked inscriptions. There has been a considerable increase in deliberate interference with the site in the two years between the surveys, suggesting a worrying upwards trend in this form of vandalism in the Wadi.

Not only does chalking, painting and reincising engravings have adverse effects on the integrity of the rock art and attract undesirable attention, the effects are virtually impossible to reverse without damaging the engravings further. Rock art doctored in this way can be unsightly and becomes a permanent fixture in the landscape.

This level of impact on engravings can be compared to the inappropriate practice of wetting paintings by throwing water or other liquids on them to make them temporarily

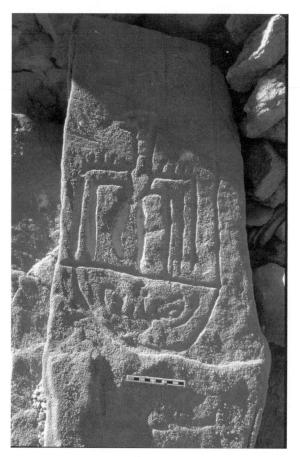

Figure 8.10. An unusual engraving that was recorded in 2000 and found to be absent when the site was revisited in 2002.

more visible for tourists. Used by guides and tourists alike, this practice is extremely widespread, but is an extremely short-term solution. As cases from around the world demonstrate, paintings rapidly fade and become obscured when exposed to liquids. As the paintings fade, the more it becomes necessary to wet them to make them visible. By wetting paintings, soluble salts in the rock are activated and react with chemicals in the pigment which form a white, opaque layer over the paintings (Bahn 1998). Moisture can also cause certain pigments to swell and dislodge from the rock surface, so the paintings flake away. These effects are devastating and permanent. They are particularly pronounced in arid regions such as the Sahara where the effects of moisture are amplified. For example, some rock shelters in the Western Sahara had until recently been covered with vivid paintings similar to those found in the Akakus. After a few years of frequent wetting, these have now completely faded (Savage, pers. comm.).

Significant damage can also be caused in the longer-term by repetitive touching of rock art. This may be simply running a finger along the groove of an engraving, or breathing on a painting. The impact of a few individuals will be minimal, but the accumulated effect of large numbers of visitors will insidiously erode and damage the images.

Figure 8.11. A fine engraving of an ostrich from the Wadi al-Ajal. The accessibility of the Wadi makes it an ideal focus for tourists and visitors wishing to experience Libyan rock art but not wanting to travel further afield. Sites such as these could form part of a rock art tour that would channel visitors to specific, managed areas. However, these sites are under threat from many directions, of which increased tourism is only one, and they need to be rigorously protected to minimise future impact.

The Future of Rock Art in the Wadi al-Ajal

For a country that is beginning to embrace the concept of tourism, a coherent strategy for managing critical cultural heritage resources such as rock art is now imperative. The damage inflicted on the engravings in the Wadi al-Ajal is principally the consequence of human interference, much of which could be avoided or mitigated through educating, training and informing all those likely to come into contact with the rock art. At present, only 10 percent of the engravings are estimated to have been affected but, unless appropriate action is taken soon, this figure is likely to rise significantly as the engravings become more well known.

The location and accessibility of the Wadi al-Ajal exposes it to a proportionately greater threat from general road users, as well as from tourists. However, this accessibility could also be beneficial as it provides considerably more potential for the development of sustainable tourism in the Wadi than in more remote areas such as the Messak. Attracting more visitors to the rock art sites in the Wadi, such as shown in Figure 8.11, could divert a proportion of the tourists away from the Messak and other areas where management strategies would be more difficult to implement, thereby reducing the impact of human interference on these sites.

Discussion and Recommendations

This paper has discussed the rock art of Libya as a vital heritage resource, in addition to being an important part of the cultural heritage of North African. It has suggested that the rock art represents a key tourist attraction, which, in the context of a rapidly expanding tourist industry, has immense economic potential and implications for influencing international perceptions of Libya. However, developing tourism also represents a big threat to Libya's rock art. The rock art is a finite, non-renewable resource and it will be damaged and eventually destroyed as a consequence of tourism if not properly managed.

Recent survey work in the Wadi al-Ajal has demonstrated the existence of a significant, previously unrecorded concentration of rock art, and has raised the question of whether further such concentrations may exist elsewhere in Libya. This research has also shown that the importance of the rock art stems principally from its inclusion in an archaeological and topographic landscape, and it is devalued if removed from this context. Despite being relatively unknown at present, the engravings of the Wadi al-Ajal and their landscape constitute a crucial part of Libya's cultural heritage. Rock art in the Wadi al-Ajal, as in other poorly documented regions of Libya, is exposed to similar threats as the well recorded paintings and engravings of the Messak and Akakus, and it is equally in need of protection.

Within this climate of developing tourism, there is now a pressing need for a flexible, informed approach to ensure long-term protection and sustainability of all rock art sites in Libya. This paper calls on the Libyan authorities to build on what has been learnt from other regions of the world and introduce a conservation and management strategy at the earliest possible opportunity. Early investment in the protection of rock art will anticipate potential problems, thereby minimising the impact on the rock art and reducing future costs.

This paper recommends that the following four key elements should underpin all future strategies concerning rock art:

Understanding and informing

Ongoing archaeological and tourist research is critical to ensure that there is proper understanding of the rock art and its relationship to the landscape, and of how these are used by tourists. This understanding will inform future conservation and management programmes, and any necessary mitigation strategies. Understanding is also crucial in educating, training and informing all those who will have access to the rock art, whether academics, children, tourists, guides or local inhabitants.

Protecting

Stringent legislation is needed to protect all known and unrecorded rock art sites and their landscape contexts by aiming at evaluating and mitigating the impact of current and future development programmes.

Managing

Long-term and short-term management plans are essential for sustainability of the rock art resource. These management plans need to be informed by research and they should be flexible and site-specific in order to anticipate and respond to the different threats to which the rock art and its landscape are likely to be exposed.

Conserving

A conservation strategy aimed at restoring and consolidating damaged sites and mitigating the impact of future interference is an important part of a coherent preservation strategy. It is crucial that any conservation methods are informed, reversible and are monitored long after completion.

References

Anag, G., Cremaschi, M., di Lernia, S. and Liverani, M. 2002. Environment, archaeology, and oil: the Messak Settafet rescue operation (Libyan Sahara). *African Archaeological Review* 19(2): 67-73.

Bahn, P. 1998. *Cambridge Illustrated History of Prehistoric Art*, Cambridge.

Barnett, T.F. 2001. Recent discoveries of rock art in Libya. *International Newsletter on Rock art* 30: 9-14.

Barnett, T.F. 2002. Rock art, landscape and cultural transition in the Wadi al-Ajal, Libyan Fezzan. *Libyan Studies* 33: 71-83.

Barnett, T.F. and Roberts, M.S. 2003. Rock engravings and context in the Wadi el-Ajal, Libyan Fezzan. *International Newsletter on Rock Art* 35: 1-7.

Bednarik, R.G. 1990. About professional rock art vandals. *Survey* 4(6): 8-12

Bock, F. and Bock, A.J. 1990. A review of an attempt to restore petroglyphs using artificial desert varnish at Petrified Forest, Arizona. *American Indian Rock Art* 16: 9-18.

Bradley, R. 1997. *Rock Art and the Prehistory of Atlantic Europe,* London.

Bradley, R. 2000. *An Archaeology of Natural Places,* London.

Bradley, R. 2002. Access, style and imagery: the audience for prehistoric rock art in Atlantic Spain and Portugal 4000-2000 BC. *Oxford Journal of Archaeology* 21(3): 231-47.

Camps, G. 1987. Les chars sahariens. *Travaux du LAMPO*: 107-24.

Camps, G. and Gast, M. (eds). 1982. *Les chars préhistoriques. Archéologie et techniques d'attelage.* Aix en Provence.

Castiglioni, A. and A., Negro, G. 1986. *Fiumi di Pietra. Archivo della preistoria sahariana,* Varese.

Chippendale, C. and Tacon, P.S. (eds.). 1998. *The Archaeology of Rock art*, Cambridge.

Clutton-Brock, J. 1993. The spread of domestic animals in Africa, in T. Shaw, P. Sinclair, B. Andah and A. Okpoko (eds.), *The Archaeologyy of Africa: Food, Metal and Towns*, London: 61-70.

Le Quellec, J.-L. 1985. New rock engravings at Wadi-Buzna (Wadi-L-Ajal), Libya. *Bulletin of the French Prehistoric Society* 82(4): 120-8.

Le Quellec, J.-L. 1993. *Symbolisme et art rupestre au Sahara,* Paris.

Lutz, R. and Lutz, G. 1995. *The Secrets of the Desert: the Rock art of Messak Sattafet and Messak Mellet, Libya,* Innsbruck.

Mattingly, D.J., al-Mashai, M., Balcombe, P., Barnett, T., Brooks, N., Cole, F., Dore, J., Drake, N., Edwards, D., Hawthorn, J., Helm, R., Leone, A., McLaren, S., Pelling, R., Preston, J., Reynolds, T., Townsend, A., Wilson, A. and White, K. 2000. The Fezzan Project 2000: Preliminary report on the fourth season of work. *Libyan Studies* 31: 103-20.

Mattingly, D.J., Daniels, C.M. Dore, J.N., Edwards, D. and Hawthorne, J. (eds). 2003. *The Archaeology of Fazzan*. Volume 1, *Synthesis*, London.

Mori, F. 1968. The absolute chronology of Saharan prehistoric art, in E. Ripoll Perelló (ed.), *Simposio Internacional del Arte Rupestre, Barcelona 1966,* Barcelona: 291-4.

Mori, F. 1998. *The Great Civilization of the Ancient Sahara. Neolithisation and the Earliest Evidence of Anthropomorphic Religion,* Rome.

Muzzolini, A., Pottier, F. and F. 2002. El-Moor (Libye): la limite nord-est de l'école de Tazina, in Pr. A. Jardin (ed.) *Ithyphalliques, tradition orales, monuments lithiques et art rupestre au Sahara,* Saint-Lizier: 163-71.

Muzzolini, A. 1997. Saharan rock art, in J.O. Vogel (ed.), *Encyclopedia of Precolonial Africa,* Walnut Creek: 347-53.

Nash, G. and Chippendale, C. (eds). 2002. *European Landscapes of Rock art,* London.

Pager, S.-A. 1989. The deterioration of the rock paintings in the Ndedema Gorge, Natal Drakensberg, Republic of South Africa. *Pictogram* 2(1): 27-43.

Pauphillet, D. 1953. Les gravures rupestres de Maknusa, Fezzan. *Travaux de l'Institut de Recherches Sahariennes* 10: 107-20.

Pesce, A. 1968. Rock carvings in Wadi Bouzna, Wadi el-Ajal valley, Fezzan. *Libya Antiqua* 5: 109-12.

Rowley-Conwy, P. 1988. The camel in the Nile Valley. New radiocarbon accelerator (AMS) dates from Qasr Ibrim. *Journal of Egyptian Archaeology* 74: 245-8.

Sattin, F. 1965. Le incisioni rupestre di Kuleba e dello Zinkekra. *Libya Antiqua* 2: 73-81.

Van Albada, A. and Van Albada, A.-M. 2000. *La montagne des hommes-chiens. Art rupestre du Messak Libyen,* Paris.

Watchman, A. 2000. A review of the history of dating rock varnishes. *Earth-Science Reviews* 49: 261-77.

Whitley, D.S. and Simon, J.M. 2002. Reply to Huyge and Watchman. *International Newsletter on Rock Art* 34: 12-21.

Zboray, A. 2002. New rock art sites in the Jebel Uweinat/Gilf Kebir region. *Lettre de l'association des amis de l'art rupestre saharien* 22(2): 10.

Zeigert, H. 1969. Überblick zur jüngeren Besiedlungsgeschichte des Fezzan. *Berliner Geographischen Abhandlungen* 8: 49-58.

Zoli, C. 1926. *Nel Fezzan. Note e impressioni di viaggio,* Milano.

9. Transitions in the Later Prehistory of the Libyan Sahara as seen from the Acacus Mountains

By Savino di Lernia[1] and Francesca Merighi[2]

Abstract

During the Holocene, water and food resources dramatically varied. Unpredictable and abrupt climatic fluctuations forced human groups to rely for their food security on livestock and wild plants. The Wadi Tanezzuft, located in south-western Fezzan, between the Acacus and the Tassili mountains, was still active hydrologically after the decisive aridification of the Sahara, some 5000 years BP, creating a large oasis, *c.*80 km long, which attracted peoples from surrounding areas. Here, overexploitation of the environment, depletion of resources, and increasing competition led to deep social and cultural transformations. Settlement systems, rock art, and especially funerary 'megalithic' architecture indicate an increasing sedentism and social hierarchy, with the emergence of complex societies, which led, some centuries later to the onset of an early state.

Introduction

The aim of the present paper is to investigate the major social and economic transformations during later prehistory in south-western Fezzan, with a main emphasis on the Wadi Tanezzuft, the imposing fluvial valley on the western side of the Acacus escarpment.

The region under examination is the westernmost portion of the area licensed to The Italo-Libyan Archaeological Mission of the University of Rome 'La Sapienza' (Fig. 9.1). The research presented here, under the overall direction from 1997-2001 of Prof Mario Liverani, is part of a larger project on climatic and environmental variations in the Holocene, and analysis of cultural trajectories, from the *Early Acacus* hunter-gatherers up to the rise of the *Garamantian* civilisation (e.g. Cremaschi and di Lernia 2001; di Lernia 1999; di Lernia and Manzi 2002; Liverani 2000a/b/c).

The choice of Wadi Tanezzuft as specific test area to analyse this historical process has not been accidental. This fluvial valley, west of the Acacus scarp, escaped aridification for millennia, when compared to the neighbouring regions (Cremaschi 2001). As a matter of fact, the birth of a large oasis after the onset of desertification at 5000 BP attracted pastoral communities escaping the incoming aridity (throughout the paper, the notation 'BP' always refers to uncalibrated years before present (AD 1950). We should look at this valley as a melting pot that played a special role in the relationships between valleys and mountains, sub-Saharan and northernmost regions.

One of the aims of this research was an attempt to evaluate in detail the chronological setting of the *Late Pastoral*, previously generically dated to some 5000-3500 BP (Cremaschi and di Lernia 1998). New data now available from burial contexts in the area highlighted the longer duration of the Pastoral Neolithic, characterised by incipient social ranking and increasing sedentism,

[1] Dipartimento di Scienze Storiche, Archeologiche ed Antropologiche dell'Antichità, University of Rome 'La Sapienza'.
[2] Dottorato di Ricerca in Archeologia (Preistoria), University of Rome 'La Sapienza'.

important pre-conditions of the later socio-economic developments. They also confirmed the high degree of ethnic fragmentation already envisaged in the settlement record.

In this general context, we have combined environmental and settlement data, funerary organisation, and skeletal biology, to understand the nature of these cultural transitions. Possible evidence of population continuity and/or discontinuity, the recognition of increasing social complexity in the region, as well as the emergence of ranked classes are important paths of this research. To do this, it is crucial first to assess the palaeoenvironmental context of this historical process.

Climatic Change and Cultural Trajectories in the Wadi Tanezzuft

At the beginning of the *Late Pastoral* period, some 5000 BP, in a general context of desertification,

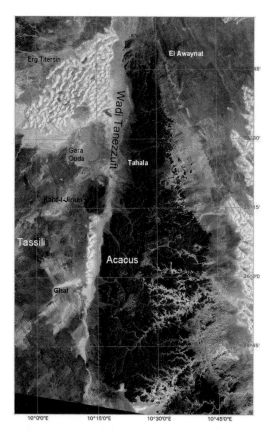

Figure 9.1. Landsat image of the Wadi Tanezzuft area with indication of main localities.

Figure 9.2. (right) Hypothesis of oasis contraction in the Wadi Tanezzuft, from around 5000 to 2000 years BP, on the basis of distribution of funerary sites.

Wadi Tanezzuft became a large (but probably fragmented) oasis, some 80 km long by 15 km wide from Ghat to Tahala. In the following centuries the river underwent a progressive desiccation, and the connected oasis broke up, with the exception of restricted areas, the same ones that are today occupied by modern oases: Tahala, Ghat and Barkat (Cremaschi and di Lernia 2001). Changes in settlement distribution seem to follow this pattern, with ancient west to east movements from the Gara Ouda playa to the northern Tanezzuft, and later north/south shifts along the alluvial plain (Fig. 9.2). After the date of 2755 BP palaeoenvironmental information in the area become quite scarce (Cremaschi 2001). In any event, this model took on definitive form during the *Garamantian* period, when citadels, villages and associated cemetaries are exclusively attested in the immediate vicinity of modern oases.

Impacts and effects of the definitive climatic deterioration were obviously different according to specific areas, and cultural adaptations to these phenomena were consequently variable. Changes in mobility and replacement of animal stock, as well as possible movements of populations, may have been effective strategies to face up to shortage and famine caused by increasing aridity. As Fekri Hassan recently suggested (2000), innovation and contacts among different human groups can be the result of 'leap-frog' shifts operated by small entities, rather than of unilinear trajectories by entire communities. In fact, the latest research in the Wadi Tanezzuft stressed the absence of wholesale population replacement during the *Late Pastoral*. Morphological (Bruner *et al.* 2002) and mt DNA (Babalini *et al.* 2002) analysis of several *Late Pastoral* and *Garamantian* skeletal remains highlighted strong elements of biological continuity. Of particular interest, however, is the marked heterogeneity in the genetic composition of the later Pastoral groups, possibly related to increasing exogamy through time (di Lernia and Rickards 2005). Stable isotopes study ($^{87}Sr/^{86}Sr$) of bone and dental enamel from a number of burial sites in the Acacus and surroundings also confirms an increasing mobility during the *Late* and *Final Pastoral* (Tafuri et al. 2006). Exogamy is also ascribed to *Garamantes* by historians, and was attested among Tuareg and Tebu populations until the last centuries (e.g. Fantoli 1933).

Anyway, a high degree of ethnic fragmentation in the Tanezzuft Valley and surroundings seems to be attested for the beginning of the *Late Pastoral* period, and it surprisingly recalls the scenario known on the basis of ethnohistorical sources at the beginning of the twentieth century.

Hundreds of large settlements were found in the Wadi Tanezzuft Valley. Economic emphasis was on ovicaprine herding, and wild plant exploitation, with intensive approaches to the environment (di Lernia 2002). During the same period, megalithic structures with a funerary function make their first appearance in the area (di Lernia *et al.* 2002). They consisted of large, isolated tumuli, highly scattered north of Khaf-l-Jinun (Fig. 9.3). These early burial structures are first dated by radiocarbon determinations to some 4500 BP and are mainly located in crucial areas for control of resources. Their use was apparently restricted to dominant individuals – generally adult males – probably holding a special 'social' position within the group. The social differentiation of these burials is mainly expressed through age and gender; anyway, the low quantity of such tombs, compared to the population of the area, reveals above all a vertical

Figure 9.3. In Aghelachem, view of Tumulus 1 from north-west, before the excavations. The tumulus is radiocarbon dated to c.4300 years BP.

division, associated with the existence of specific clan members, probably ruling by virtue of individual qualities.

Palaeodemography (Hassan 1981) interpolated with ethnohistory (Fantoli 1933), ethnoarchaeology (Holl 1990, A. Smith 1992; S. Smith 1980) and archaeology (di Lernia *et al.* 2002), suggest that the extant stone monuments of the Tanezzuft are insufficient for the burial of all the people who died in the valley during the *Late Pastoral*, supporting the hypothesis of socially selected access to these burials. Considering an approximation of 500-1000 people living in the Tanezzuft area (but see also Daniels 1989 for similar figures), and multiplying such numbers for the time span covering the diffusion of *Late Pastoral* megalithic structures (i.e., 1600 years: from 4300 to 2700 BP, which can be reduced to 1100 years removing the only date older than 3800 BP) we have a minimum estimate of 6800 deceased during the time period considered in this study. Such an impressive number of people is badly represented in the Tanezzuft archaeological record, where a figure of 500 tombs is attested, with an average of 1-4 people per tomb (giving a potentially maximum number of individuals equal to 2000 buried people).

In some ways, these megalithic tombs seem to be expression of highly dispersed (tribal?) groups. Following this approach, these first stone structures may have been used as territorial markers when competition for food resources started to arise (see also the first attestations of 'fighting' in the rock art of the Tadrart Acacus, dated after 4500 years BP by Mori 1965). Following Augustin Holl, their diffusion "can be linked to the dynamics of social systems and conceptualised as social strategies geared to the long-term buildup of a social landscape" (Holl 1998, 161).

The *Late Pastoral* Development: The Emergence of Social Stratification

During the fourth millennium BP, the contraction of the oasis, associated with the systematic depletion of resources, intensified by over-exploitation of soils and pastures, strongly affected the socio-economic pattern of these pastoral tribes. While the groups settled around the eastern fringe of the Acacus mountain and in the Erg Uan Kasa still persisted in their highly nomadic and specialised pastoralism, the *Late Pastoral* populations in the Wadi Tanezzuft underwent a deep reorganisation of their settlement system (di Lernia 2002). Increasing sedentism is now more evident, with the complete exploitation of water reserves in proximity of the palaeo-oases, such as the Ghat-Tahala-Al Awaynat system. A similar 'adaptation' appears to occur also in the other great fluvial systems of the region (Wadi al-Ajal).

Settlement patterns show a highly diversified land organisation, the possible assertion of an incipient socio-political establishment. As a matter of fact, burial structures appear to be no more dispersed, but clustered in peculiar areas with a specific funerary function. They herald the establishment of the first 'formal burial areas' for the disposal of the dead. At the same time, we can identify the origins of the first long-used ceremonial centres, characterised by articulated stone monuments and densely exploited until the *Garamantian* age and even later, into Islamic times (di Lernia *et al.* 2002).

The rearrangement of the economic pattern in the Wadi Tanezzuft corresponds well with a deep adjustment of the social system, as attested by mortuary record and funerary practices. They suggest a higher value attributed to lineage rather than to single individuals: all the horizontal segments of the society – males, females, and children – are now represented and buried in megalithic tombs. Nonetheless, the use of megalithic funerary structures, even if now more extensive than in previous centuries, was still vertically restricted to a small part of the population.

As already discussed, demographic analyses, supported also by ethnographic, ethnohistorical and archaeological data, demonstrate that only a portion of the society had access to this particular class of tombs. Conversely, the majority of the deceased was disposed of in other – yet to be found – places.

During the late fourth millennium BP we note further progressive changes in the funerary practices, with a shift from multiple to single burials. The main change concerns the treatment of children (Fig. 9.4): initially we found infant burials (including a foetus) generally interred together with their mother, and with both spatially separated from those of adult males. A few centuries later children were buried alone, in purpose-built structures. Grave goods became richer and more articulated, with many 'personal' and 'ritual' objects. Of clear importance is the presence in the tombs of carnelian and faience beads, which testify to the existence of long-range contacts with the eastern regions, as well as the first (indirect?) assertion of metal working (Cristiani and Lemorini 2002), and the first evidence of cultivation of palm dates, dating back to some 3500-3300 BP (Cottini and Rottoli 2002).

This leads us to hypothesise the existence already in the mid-fourth millennium BP of families able to control social and economic contacts, managing the access to specific prestige objects, even over very large distances (see McDonald 1998). At the end of the fourth millennium all

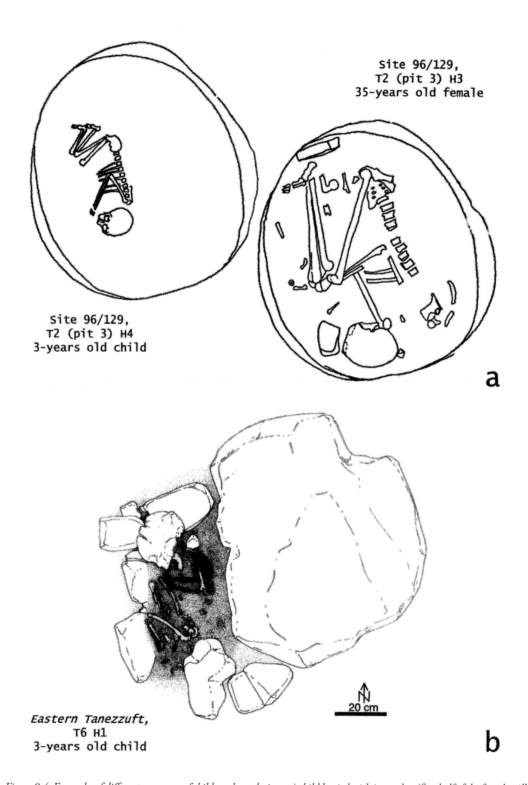

Figure 9.4. Examples of different treatment of children through time: a) child buried with its mother (first half of the fourth millennium BP); b) built stone structure with single burial of a child (3300 ± 40 years BP).

Figure 9.5. Hypothesis of main cultural transitions in the later prehistory of south-western Fezzan, seen from the Acacus.

these trends seem to have been fully accomplished: on the whole, these burials appear to be the expression of a segmental, semi-sedentary society, where smaller groupings of structures inside a single cluster may be related to social units, such as clans or extended families. The same coexistence of different prestige objects among the grave goods suggests the emergence of an incipient process of 'treasuring', which erupted a few centuries later with the advent of the *Garamantian* civilisation.

The late fourth – early third millennium BP was previously poorly known on the basis of the settlement record, and the *Late Pastoral* development was only generically reconstructed up to some 3500 BP (Cremaschi and di Lernia 1998). New radiocarbon dating from *Pastoral* burials (the latest set at 2720 ± 40 BP) as well as the funerary practices, cast new light upon the social life of this period. The archaeological record of the Tanezzuft Valley highlights the persistence of many *Late Pastoral* features (e.g. the diffuse settlement pattern along the fluvial valley; architecture of the tombs; economic emphasis on ovicaprine herding), together with new socio-economic traits already foreshadowing the later developments (presence of élites; treasuring; trade/exchange over large distances).

We propose the term '*Final Pastoral*' to identify this *transitional* period (3500 to 2700 BP) up to the spread of the *Garamantian* civilisation in our study area , partially covering the long archaeological gap previously attested between the two phases (Fig. 9.5). Future researches may help in refining the archaeological reconstruction of this rather obscure historical phase.

From *Final Pastoral* to *Garamantes*: the Emergence of an Early State

As already discussed, the third millennium BP, at the very end of the *Pastoral* phase, is scarcely attested in the archaeological record of the study area, probably due to the poor preservation of archaeological contexts. Possible oasis settlements might be buried under the modern villages (as in the case of the *Garamantian* site of Fehwet, south of Ghat), with obvious problems of archaeological visibility (Castelli *et al.* 2005).

Only scarce palaeoenvironmental information is available for these later phases of Saharan prehistory. However, recent information provided by dendrochronological analysis of *Cupressus dupreziana* tree rings, offer a higher scale of resolution (Cremaschi 2001; this volume; Cremaschi *et al.* 2002): a phase of intensified rainfall is attested between the fourth and the second century BC, apparently corresponding with the formation of the *Garamantian* polity. It is followed by a decrease in precipitation up to 1600 BP. Afterwards, hyperarid conditions are attested in coincidence with the latest radiocarbon dates for the *Garamantian* occupation. It is thus attractive to hypothesise a causal relation between marked climatic changes and the collapse of *Garamantian* civilisation, as discussed at the London conference on "Catastrophes in the Ancient World" (Cremaschi *et al.* 2002).

On archaeological bases, an important chronological gap seem to be attested between the Wadi al-Ajal and the Wadi Tanezzuft, whose roots must probably be sought in the different environmental and socio-economic conditions of the two areas (Fig. 9.5). In northern Fezzan, the earliest phase of the *Garamantian* civilisation is attested at Zinchecra, on the northern edge of the Messak plateau, dated to more than 2600 BP (e.g. Daniels 1989; Mattingly this volume; Mattingly *et al.* 2002; 2003). This site still shows important elements of *Late Pastoral* tradition (pottery, dung accumulation, ovicaprine herding, etc.), with a true *Garamantian* organisation (site complexity; trade; emphasis on cereal exploitation). A new set of radiocarbon dates for this initial *Garamantian* phase in the area has been recently provided by the British Mission: it appears that the oldest determinations concentrated on the interval between 2600-2400 BP (Mattingly *et al.* 2002). The definitive establishment of the *Garamantian* polity in the valley of Wadi al-Ajal is clearly accomplished in the area with the foundation of Garama some 2250 BP and the setting up of irrigation systems (foggaras: Mattingly *et al.* 2000, 2002). In the Wadi Tanezzuft, preliminary data on the *Garamantian* sites of Aghram Nadharif and Fehwet, indicate a slightly later take off of this civilisation, radiocarbon dated to some 2100 uncalibrated years BP (Liverani 2000a/b).

It is worth noting that such a chronological diversity appears to reflect some important socio-economic differences. The onset of *Garamantian* civilisation in the Tanezzuft area may represent a local trajectory of development of the pastoral tradition. As an example, extensive agriculture is almost unknown in the Tanezzuft, except for the oasis exploitation evident at the village of Fehwet, mainly based on date palm cultivation (Castelli *et al.* 2005). Furthermore, no traces of foggaras have been found in the area, given its peculiar geomorphological features (Cremaschi and di Lernia 2002). This points to a local, much more pastoral-oriented, economical tradition of the Wadi Tanezzuft region.

The same concentration of sites in the oases follows a settlement pattern already set some two millennia earlier. The ethnic fragmentation attested at the end of the *Late Pastoral*, with

different tribes exploiting specific micro-environments and articulated in different segments, recalls the ethnic fragmentation described by Herodotus and other historians. It is not by chance, therefore, that according to historical sources, the *Garamantes*, inhabiting the 'Greater Phazania' are distinguished from the *Atarantes*, settled in the area of Ghat (Liverani 2000c).

It must be stressed that the caravan routes exploited by the *Garamantes* seem to utilise the same paths used for centuries by prehistoric shepherds during their seasonal movements. The impressive 'Royal Tumulus' at In Aghelachem, the only site resembling some of the monuments present in the Germa region, is located far from any village, along a corridor (or *akba*) connecting the Tanezzuft with the Auis and Wadi al-Ajal (di Lernia *et al.* 2002). This specific location clearly represents a cultural way to exercise political and ideological rights over a crucial resource – trade. The same function may be asserted for Tumulus 1, a huge conical tumulus dated to more then 4200 BP, located in the same area on top of a flatiron, some 20 m above the *Garamantian* 'Royal Tumulus'.

In a certain sense, *Late* and *Final Pastoral* people became *Garamantes*, as settlement system, funerary evidence, and palaeoanthropological data seem to suggest. The differences are noticeable, but the elements of continuity seem to prevail over the indications of a cultural break, or even of a population replacement. Morphological analysis – as with the facial geometry of *Late-Final Pastoral* and *Garamantian* samples – and genetic studies done on skeletal remains have highlighted elements of biological continuity.

All these considerations reinforce the idea that pastoral tribes of the Tanezzuft may have been *incorporated* into the larger economic and political system of the Garamantes, whose political and cultural core was hundreds of kilometres north-eastwards (see also Mattingly, this volume; Liverani 2006). The Tanezzuft Valley should hence be considered as a 'periphery' of this system. This is also indicated by the historical accounts, which concentrated their attention to the Wadi al-Ajal, the 'nuclear' area of the *Garamantian* polity, and gave a different name to the people living in the two regions.

Some Remarks

On the whole, the transition to the *Garamantian* polity should be considered as a phenomenon of local evolutionary trajectory, whose roots may be seen in the emergence of sedentism and increasing social ranking, already traceable in the final *Late Pastoral* (Table 9.1).

In short, the onset at some 5000 BP of arid conditions led different groups to concentrate in areas still rich in water resources, such as the Tanezzuft Valley. Here, the settlement systems underline the existence of social units (tribes?) featuring a diffuse pattern of occupation, and a food security system based on small livestock. The social structure appears to have been characterised by the presence of dominant individuals, in a context of possible increasing competition for crucial resources. These trends developed in the fourth millennium BP, with new forms of social management of the landscape, as shown by the first true necropoles and ceremonial centres.

During the *Final Pastoral*, settlements appear to have become highly concentrated in the oases, and an incipient sedentism, relying at least partially on plant exploitation, is attested. Funerary practices highlighted the emergence of important families, controlling long-range routes and

economic contacts, and managing the access to specific prestige objects (McDonald 1998). It is likely that these élites became part of the larger, *Garamantian* political system, fully attested in the south-western Fezzan in the second half of the first millennium BC, but they still also reflected specific local traditions.

Culture (years bp)	Settlement Pattern	Funerary Pattern	Economy	Social System
Late Pastoral (5000-3500)	diffuse, nomadic, erg/fluvial valley	diffuse, large isolated conical tombs (rare grave goods)	cattle/small livestock, plant exploitation	dispersed tribes, egalitarian, (big men?)
Final Pastoral (3500-3000/2700)	diffuse, semi-sedentary, fluvial valley	clustered (burial grounds), conical shaped + v-types, prestige objects	small livestock, intensive plant exploitation	segmentary, élites controlling exchange
Early Garamantian (3000/2700-2200)	social territory, sedentary? restricted oases	large necropoles, conical shaped + bazinas, prestige objects	cultivation, livestock (ass? dromedary?)	chiefdom
Classical Garamantian (2200-1800)	political territory, sedentary, site hierarchy, present oases	monumental cemetery, bazinas, prestige objects	trade, cultivation, irrigation, caravan road	(chiefdom) Early State

Table 9.1. Schematic view of the main cultural features of late prehistoric-early historical times in the Acacus mountains.

References

Castelli, R., Gatto, M.C., Liverani, M. and Mori, L., 2005. A preliminary report of excavations in Fewet, Libyan Sahara. *Journal of African Archaeology* 3 (1): 69-102.

Cottini, M. and Rottoli, M. 2002. Some information on archaeobotanical remains, in di Lernia and Manzi 2002: 169-180.

Cremaschi, M. 2001. Holocene climatic changes in an archaeological landscape: the case study of Wadi Tanezzuft and its drainage basin (SW Fezzan, Libyan Sahara). *Libyan Studies* 32: 5-28.

Cremaschi, M. and di Lernia, S. 1998. The geoarchaeological survey in central Tadrart Acacus and surroundings (Libyan Sahara). Environment and cultures, in M. Cremaschi and S. di Lernia (eds.), *Wadi Teshuinat. Palaeoenvironment and Prehistory in south-western Fezzan (Libyan Sahara)*. Milano: 245-298.

Cremaschi, M. and di Lernia, S. 2001. Environment and settlements in the mid-Holocene palaeo-oasis of Wadi Tanezzuft (Libyan Sahara). *Antiquity* 75: 815-825.

Cremaschi, M. and di Lernia, S. 2002. A territorial approach to the study area: landscape, geomorphology, and problems, in di Lernia and Manzi 2002: 7-16.

Cremaschi, M., Liverani, M., di Lernia, S., Pelfini, M. and Santilli, M. 2002. The late desertification in the central Sahara: rise and decline of the kingdom of Garamantes, in S. Leroy and I. S. Stewart (eds.), *Abstracts of the International Conference 'Environmental Catastrophes and Recovery in the Holocene'* (Brunel University, London, 28th August-2nd September 2002). London.

Cristiani, E. and Lemorini, C. 2002. Stones, bones and other grave goods in a techno-functional perspective, in di Lernia and Manzi 2002: 197-216.

Daniels, C. 1989 Excavation and fieldwork among the Garamantes. *Libyan Studies* 20: 45-61.

di Lernia, S. 2002. Dry climatic events and cultural trajectories: adjusting Middle Holocene pastoral economy of the Libyan Sahara, in F. Hassan (ed.) *Droughts, food and culture*, New York: 225-250.

di Lernia, S. (ed.) 1999. *The Uan Afuda Cave (Tadrart Acacus, Libyan Sahara). Hunter-gatherer societies of Central Sahara*, (Arid Zone Archaeology, Monographs 1), Firenze.

di Lernia, S. and Manzi, G. (eds.) 2002. *Sand, Stones, and Bones. The Archaeology of Death in the Wadi Tanezzuft Valley*, (Arid Zone Archaeology, Monographs 3), Firenze.

di Lernia, S. and Rickards, O. 2005. Genetics in African Archaeology. First insights from the Acacus Mts. (Libyan Sahara). submitted.

di Lernia, S., Bertolani, G. B., Castelli, R., Merighi, F. and Palombini, A. 2002. A regional perspective: the survey, in di Lernia and Manzi 2002: 25-68.

Fantoli, A. 1933. *La Libia negli scritti degli antichi (brani geografici e naturalistici)* (Collezione di opere e di monografie a cura del Ministero delle Colonie 15), Roma.

Hassan, F. 1981. *Demographic Archaeology*, New York.

Hassan, F. 2000. Climate and cattle in north Africa: a first approximation, in R. Blench and K. MacDonald (eds.), *The Origins of African Livestock*, London: 61-86.

Holl, A. 1990. Les formes du pastoralisme au Sahara néolithique (9000-3000 B.P.), in H.-P. Francfort (ed.), *Nomades et sédentaires en Asia centrale*, Paris: 141-155.

Holl, A. 1998. Livestock husbandry, pastoralism, and territoriality. *Journal of Anthropological Archaeology* 17.2: 143-165.

Liverani, M. 2000a. The Garamantes: a fresh approach. *Libyan Studies* 31: 17-28.

Liverani, M. 2000b. Looking for the southern frontier of Garamantes. *Sahara* 12: 31-33.

Liverani, M. 2000c. The Libyan caravan road in Herodotus IV, 181-185. *Journal of the Economic and Social History of the Orient* 43.4: 496-520.

Liverani, M. (ed) 2006. *Aghram Nadharif*. Arid Zone Archaeology, Monographs 5. Firenze: All'Insegna del Giglio.

MacDonald, K.C. 1998. Before the Empire of Ghana: Pastoralism and the origins of cultural complexity in the Sahel, in G. Gonnah (ed.), *Transformations in Africa: Essays on Africa's later past*. Leicester: Leicester University Press: 71-103.

Mattingly, D.J., al-Mashai, M., Balcombe, P., Barnett, T., Brooks, N., Cole, F., Dore, J., Drake, N., Edwards, D., Hawthorne, J., Helm, R., Leone, A., McLaren, S., Pelling, R., Preston, J., Reynolds, T., Townsend, A., Wilson, A. and White, K. 2000. The Fezzan Project 2000: preliminary report on the fourth season of work. *Libyan Studies* 31: 103-120.

Mattingly, D.J., Edwards, D. and Dore, J. 2002. Radiocarbon dates from Fazzan, Southern Libya. *Libyan Studies* 33: 9-19.

Mori, F. 1965. *Tadrart Acacus. Arte Rupestre e Culture del Sahara Preistorico*, Torino.

Smith, A. 1992. *Pastoralism in Africa. Origins and development ecology*, London.

Smith, S. 1980. The environmental adaptation of nomads in the West African Sahel: a key to understanding prehistoric pastoralists, in M.A.J. Williams and H. Faure (eds.), *The Sahara and the Nile*, Rotterdam: 451-487.

Tafuri M., Bentley A.B., Manzi G. and di Lernia, S. in press. Mobility and kinship in the prehistoric Sahara: strontium isotope analysis of Holocene human skeletons from the Acacus Mts. (southwestern Libya). *Journal of Anthropological Archaeology*.

10. Lakes of the Edeyen Ubari and the Wadi al-Hayat

By Kevin White[1], Matt Charlton[1], Nick Drake[2], Sue McLaren[3], David Mattingly[4], Nick Brooks[5]

Abstract
The Fazzan has evidence for the previous existence of numerous lakes at various times during the Quaternary period; attesting to periods of decreased aridity. These palaeolakes are of importance for two reasons: firstly they provide a focus for prehistoric human activity and possess a rich archaeological record; and secondly, they provide dateable evidence of previous climatic conditions, which can be correlated with similar evidence from other parts of the Sahara to reconstruct the palaeoenvironmental history of the region. The main problem limiting adequate survey of these palaeolakes is the difficulty of access to the Sand Sea of the Edeyen Ubari, coupled with the very large areas involved. Optical remote sensing provides a useful tool for discriminating and locating palaeolakes on the basis of the mineral signature (mostly calcium carbonate and gypsum) they left behind when the water evaporated. However, some important palaeolakes do not possess such a clear mineral signature, and attempts to map the palaeohydrology using only optical remote sensing systems would result in significant undersampling. It is necessary, therefore, to also utilise Synthetic Aperture Radar (SAR) remote sensing systems as well. These active systems detect palaeolakes on the basis of surface characteristics, such as roughness. Remote sensing images also provide a means of plotting navigable routes to the palaeolake sites, enabling efficient field survey. These surveys have added to our understanding of the archaeological record of the Edeyen Ubari and surrounding areas, indicating periodic activity at these sites during Achuelean, Mousterian, Aterian, early- and mid-Holocene times. Dating of palaeolake sediments supports the archaeological chronology and confirms a growing body of evidence suggesting wetter climates associated with peaks in solar insolation in this part of the Sahara.

Introduction

The climate history and geoarchaeology of the Sahara are attracting increasing amounts of attention, as they complement the much more complete data from more temperate climatic zones. However, the Sahara presents numerous difficulties for conventional fieldwork, due to the aridity of the climate and the difficult terrain presented by features such as Sand Seas (Edeyen). These problems are particularly evident in Fazzan, southern Libya, where recent research has identified significant records of archaeological and palaeoenvironmental information.

Present day rainfall in Fazzan is less than 20 mm per year on average, and exhibits high interannual variability (Pallas 1978). However, both archaeological remains and geomorphological evidence in Fazzan indicate that this currently hyper-arid region experienced wetter phases in the past (Drake *et al*. this volume). Rock carvings and other archaeological remains attest to the existence of a more benign environment during the early to mid-Holocene, when humans and large humid-climate fauna existed in currently inhospitable areas (Cremaschi and di Lernia 1998). Lake sediments and various geochemical crusts demonstrate the existence of open

[1]Department of Geography, University of Reading
[2]Department of Geography, King's College London
[3]Department of Geography, University of Leicester
[4]School of Archaeology and Ancient History, University of Leicester
[5]Tyndall Centre for Climate Change Research, University of East Anglia

Figure 10.1. Landsat Thematic Mapper image of the study area, showing the dark outcrop of the Messak Sattafet outcropping between the Edeyen Murzuq to the south and the Edeyen Ubari to the north.

water bodies and a higher groundwater table during several phases of the Late Quaternary (Cremaschi 1998; this volume; White *et al.* 2000). Successive arid and humid phases in the Sahara over this period are well documented (Fontes and Gasse 1991; Gasse *et al.* 1990; Szabo *et al.* 1995), but were not necessarily synchronous throughout the region (Gasse *et al.* 1990). New information from data-sparse areas such as Fazzan is, therefore, particularly welcome.

In common with many other dryland regions, the landforms of Fazzan preserve a record, albeit much erased and modified, of past environments. These landforms can be clearly seen in remotely sensed imagery from the Landsat Thematic Mapper (Fig. 10.1). To the south lies the Murzuq Hamada (Messak Sattafet), a plateau of Nubian Sandstone (the Murzuq Formation) dipping gently to the south. The northern edge of the Messak Sattafet terminates in a steep escarpment, exceeding 100 m in height in places, overlooking the Wadi al-Hayat and deeply incised by scarp slope drainage. The base of the Wadi consists of a linear groundwater-fed oasis zone, with a chain of ephemeral lakes, or playas, of varying salinity. The Wadi al-Hayat is bounded to the north by the Edeyen Ubari.

Dune forms in the Edeyen Ubari Sand Sea are dominated by linear dune ridges oriented east-north-east to west-south-west. A few seasonal and perennial lakes occupy some interdune corridors, attesting to a high water table in places, but the most significant geomorphological features in the Edeyen Ubari are duricrust deposits, indurated surface crusts composed of varying amounts of calcium carbonate, gypsum and silica, with abundant root casts attesting to the intimate association with vegetation. Outcrops of duricrust are often also the loci of abundant lithic artefacts, suggesting that these areas have been important for humans at some stage in their development.

Remote Sensing the Lakes of Edeyen Ubari and Wadi al-Hayat

Satellite imagery provides the potential to survey large, inaccessible areas and is therefore ideally suited to help overcome the problems with conventional fieldwork outlined above. Both optical and radar images were used in this survey of palaeolakes in the Edeyen Ubari and Wadi al-Hayat. The optical and radar data are described separately below, after which the results of the remote sensing studies are summarised.

Optical imagery
Optical imagery consisted of Landsat Thematic Mapper (TM) images from 1987, and Enhanced

Figure 10.2. RADARSAT image showing the oasis agriculture of Ubari in the south-east and numerous interdune duricrusts capping palaeolake deposits showing as brighter areas along the top half of the image.

Figure 10.3. JERS radar image of the same area as Figure 10.2. Note that the duricrust areas are not detected by the longer wavelength and different incidence angle of the JERS radar system.

Thematic Mapper images from 1999 and 2000. The term TM will be used to denote both types of Landsat imagery hereafter. Images from each of these years was obtained (Fig. 10.1) covering the Wadi al-Hayat, the Messak Sattafet, the north-west part of the Edeyen Murzuq and the south-central part of the Edeyen Ubari. These images are multispectral, consisting of 6 bands representing visible to short wavelength infrared radiation (Bands 1-5 and 7) at 30 m nominal resolution (pixel size), one low-resolution thermal infra-red band, and one 15 m band comprising a broad range of visible and near infra-red wavelengths. The thermal infra-red bands were not used in this study, while the 15 m band was used chiefly to plot routes through the Edeyen Ubari along interdune corridors. Figure 10.1 shows the northernmost areas covered by the 2000 images, containing the study area. The bands used to create the images are Bands 7, 4 and 1.

The intensity of a pixel in a single-band image is determined by how strongly the ground surface in the area covered by that pixel reflects the wavelength of light represented by that particular band. Three bands are combined to form a false colour composite image, and different combinations are used to detect different features and different types of mineralogy. For example, gypsum and calcrete crusts are relatively reflective towards the blue end of the visible part of the electromagnetic spectrum; they are therefore prominent in Band 1 (0.45 - 0.53 microns wavelength), which represents visible blue light. The distribution of palaeolakes, which are typically associated with these surface crusts, is therefore assessed using images representing either Band 1 only, or a combination of Bands 7, 4 and 1. Mineralogical analyses may also be carried out using mixture modelling, a procedure in which the 'purest' pixels, that is those representing the highest proportions of a given type of surface, are identified via statistical methods. A fixed number of surface types is set; each pixel in an image may then be described in terms of the proportion of each surface type occurring within it, based on the values representing these

surfaces corresponding to the purest pixels. In this way, satellite images may be converted to proportional surface cover maps; such a procedure was employed to map proportions of gypsum in the study area, which is indicative of wetter conditions in the past.

Radar imagery

Synthetic aperture radar imagery acquired by two different satellites was employed in the geographical study. Data from the Canadian RADARSAT mission, acquired at a wavelength of 5.6 cm (Fig. 10.2), were obtained for the region extending north and east of Jarma, including much of the Wadi al-Hayat and parts of the Edeyen Ubari (Fig. 10.2). An image the Japanese Earth Resources Satellite (JERS-1) acquired at a wavelength of 23 cm, was also obtained (Fig. 10.3). Both of the images provide coverage of the Edeyen Ubari and the Wadi al-Hayat.

Optical satellite imagery essentially measures the colour, and by extension the mineralogical composition, of a surface. Radar, due to its much longer wavelengths, measures the roughness, or textural variation, of a surface. The strongest reflections of a radar pulse will occur at surfaces whose topography varies on scales similar to the radar wavelength; shorter radar wavelengths are therefore capable of discerning features on a smaller scale than longer wavelengths. ERS imagery reveals structure within the Edeyen Ubari due to the interaction of the radar with the micro-topography of the dunes. In contrast, JERS imagery only reveals the dune structure in certain locations, while most of the sand sea appears as a largely featureless region. However, both types of imagery proved useful in detecting areas of enhanced roughness corresponding to certain types of duricrust which are not visible in the optical imagery.

The duricrust deposits are typically fairly linear, oriented along the interdune corridors, several hundred metres to several kilometres long, and several hundred metres wide. Where their mineralogy is dominated by calcrete they have a very light colour and consequent prominence in Band 1 of the TM data. The palaeolake deposits are concentrated in the southern regions of the Ubari Sand Sea, and are most common west of the town of Ubari. The distribution of palaeolakes is related to surface elevation, with most deposits occurring below 530 m above mean sea level (amsl). A string of palaeolake deposits is also visible immediately to the south of, and abutting the edge of, the sand sea in the TM imagery. These included the highest elevation palaeolake sediments in the Wadi al-Hayat, at around 560 m amsl at 26.03745 N, 13.30949 E, which probably represent a localised level controlled by the surrounding sand dunes rather than a situation typical of the Wadi.

While calcrete-rich duricrusts are apparent in the radar imagery, optical imagery proved much more appropriate for their identification. However, duricrusts with low carbonate content are only evident in the radar imagery. A large area, located some 10 km northeast of Ubari town, consists of a complex of bright reflectors extending for several kilometres. Field surveys revealed this set of features to be associated with extensive duricrust deposits consisting of aeolianite and numerous root casts, many of which extend vertically upwards. A few patches of calcrete were observed, but these are too limited in extent to be apparent in the optical data. The features detected in the radar imagery therefore correspond to surfaces that are much rougher than, but similar in composition to, the surrounding sand dunes. These surfaces interact strongly

Figure 10.4. Landsat Thematic Mapper imagery showing gypcrete duricrust (white areas) adjacent to escarpment of the Messak Sattafet. Note that the duricrusts appear to pick out shoreline features along the base of the escarpment.

with the radar beam, resulting in high backscatter and a bright signal in the final image. The presence of aeolianite and root casts without lake sediments indicates a water table near or at (but not significantly above) the surface at some time in the past, associated with abundant vegetation. This region may therefore be characterised as a swamp, indicating that the combined use of optical and radar data provides a means of identifying different types of palaeoenvironment.

Between the Edeyen Ubari and the Messak Sattafet, remote sensing reveals large areas characterised by a gypsum surface crust. These are readily identified in Band 1 of the TM data; the most prominent of these extends either side of the Ubari-Ghat road for some 20 km between 26.497 N; 12.468 E and 26.469 N; 12.388 E (Fig. 10.4). In this area, a sharp boundary between the light areas associated with gypsum and darker regions corresponding to the piedmont sandstone extends along the base of the escarpment some 5 km from the road. This boundary is likely to be associated with the shoreline of a large palaeolake; although the boundary proved difficult to discern on the ground, it appears that it occurs around 530 m amsl. Below this shoreline, a full sequence of palaeolake sediments is evident in section, with a basal mottled yellow layer overlain by red silts with root casts, interpreted as lacustrine sediments. This, in turn, is overlain by grey organic lacustrine silts with numerous mollusc shells. These deposits are usually capped by duricrusts, predominantly calcretes and cal-silcretes overlain by a thin capping of gypsum crust in places. This juxtaposition of sediments and duricrusts could be explained by the gradual desiccation of a large lake, which culminated in gypsum precipitation and was followed by weathering, duricrust formation and extensive deflation so that now only remnants of the lake shorelines are left in favourable positions protected from erosion.

The sediments and duricrusts at the base of the escarpment define the southern limit of a postulated mega-palaeolake. In a few locations they terminate just below deposits containing numerous rounded pebbles, interpreted as beach deposits. These pebbles are most evident at a site south of Jarma, where they are associated with what appears to be a wave-cut platform etched into a promontory of the escarpment (26.510267N; 13.08636E). It would take a lake a considerable amount of time to form a topographic feature like this in solid bedrock, suggesting that the lake level was at this height for a considerable amount of time. The height of this lake shoreline feature was measured using Differential GPS (Table 10.1) in order to estimate the height of the palaeolake surface. On the opposite side of the Wadi al-Hayat depression, location of the north shoreline was more difficult; the fringing dunes of the Edeyen Ubari will not retain

Figure 10.5. Extent of the Fazzan megalake superimposed onto a map of the Fazzan.

topographic evidence of a shoreline in the same way as the bedrock escarpment to the south. The height of the highest outcrops of organic rich lake sediments containing mollusc remains were measured instead (sites 5 and 6).

These results indicate a lake surface approximately 500 m above mean sea level. Variability around this height may be caused by errors in our location of beaches, or by slight tectonic

Point	Latitude	Longitude	Elevation (metres above mean sea level)
1. S shoreline, Jarma	26.510267	13.08636	497.34
2. S shoreline, Jarma	26.508577	13.08532	497.89
3. S shoreline Jarma	26.507161	13.08136	498.78
4. S shoreline al-Ghrayfah	26.507161	13.08136	509.58
5. N shoreline, duricrust deposit	26.599113	13.08031	464.41
6. N shoreline duricrust deposit	26.560403	13.07078	458.02

Table 10.1. Locations and heights of probable palaeolake shorelines (DGPS coordinates in decimal degrees).

movement that may have occurred since the desiccation of the lake, and ground settlement due to abstraction of groundwater. Sites 5 and 6 are potentially more error prone as they are characterised by a deflation surface and are therefore probably somewhat lower than the original shoreline position. Alternatively the different beach heights could represent separate high stands of the lake, the lower levels being slightly later.

The Differential GPS results enable us to determine the area of the palaeolake. The GTOPO30 digital elevation model (DEM) produced by U.S. Geological Survey, provides elevation estimates at 30-arc seconds intervals (approximately 830 m by 830 m at these latitudes), but large strips of this DEM are grossly in error, with the escarpment and Edeyen Ubari being smoothed out in the area east of Jarma. Nevertheless, these results do enable a first attempt at estimating the size (76,250 km²) and perimeter (2,500 km) of the palaeolake. Because of the serious errors in the DEM, this should be regarded as a preliminary estimate. However, though not as big as Lake Megachad (3 million km²), Lake Megafazzan is the second largest Pleistocene lake in the Sahara so far reported. In general terms it appears that the lake had one arm in the Wadi al-Ajal that went from Sabha, terminating to the west of Ubari. Other arms of this lake would have stretched from Sabha along Wadi ash-Shati and Wadi Barjuj (Fig. 10.5).

Conclusions

Remote sensing has proved invaluable for surveying the palaeolakes of the Edyen Ubari and the Wadi al-Hayat. Optical data from the Landsat Thematic Mapper, is very useful for mapping calcrete-capped palaeolake sediments, on the basis of the mineralogical signature, which contrasts strongly with the surrounding quartz sands. Radar imagery from JERS and RADARSAT missions have enabled us to include duricrusts which are less carbonate-rich and therefore do not have a strong mineralogical signature. Radar is able to detect these on the basis of the harder, rougher indurated surface.

References

Cremaschi, M. 1998. Late Quaternary geological evidence for environmental changes in south-western Fezzan (Libyan Sahara), in M. Cremaschi. and S. di Lernia (eds), *Wadi Teshuinat: Palaeoenvironment and prehistory in south-western Fezzan,* Centro Interuniversitario di Ricerca per le Civiltà e l'Ambiente del Sahara Antico: 13-47.

Cremaschi, M. and di Lernia, S. 1998. The geoarchaeological survey in central Tadrart Acacus and surroundings (Libyan Sahara): Environment & culture, in M. Cremaschi. and S. di Lernia (eds), *Wadi Teshuinat: Palaeoenvironment and prehistory in south-western Fezzan,* Centro Interuniversitario di Ricerca per le Civiltà e l'Ambiente del Sahara Antico: 243-296.

Fontes, J.C. and Gasse, F. 1991. PALHYDAF (Palaeohydrology in Africa) program: objectives, methods, major results. *Palaeogeography, Palaeoclimatology, Palaeoecology,* 84: 191-215.

Gasse, F., Tehet, R., Durand, A., Gibert, E. and Fontes, J.C. 1990. The arid-humid transition in the Sahara and the Sahel during the last deglaciation. *Nature,* 346: 141-146.

Pallas, P. 1978. Water resources in the Socialist People's Libyan Arab Jamahiriya. *Proceedings of the 2nd Symposium on the Geology of Libya*: 539-591.

Szabo, B.J., Haynes, C.V. and Maxwell, T.A. 1995. Ages of Quaternary pluvial episodes determined by uranium-series and radiocarbon dating of lacustrine deposits of Eastern Sahara. *Palaeogeography, Palaeoclimatology, Palaeoecology,* 113: 227-242.

White, K., McLaren, S., Black, S. and Parker, A. 2000. Evaporite minerals and organic horizons in sedimentary sequences in the Libyan Fezzan: implications for palaeoenvironmental reconstruction, in S.J. McLaren and D.R. Kniveton (eds), *Linking Climate Change to Land Surface Change:* 193-208.

Theme 3

Ecology and Environment

11. Quaternary Climate Change in the Jarma Region of Fazzan, Libya.

By Nick Drake[1], Kevin White[2] and Sue McLaren[3]

Abstract

This paper aims to further our understanding of climate change and human occupation in the now hyper-arid region of Fazzan, Libya. Uranium/Thorium (U/Th), [238]Ra and optically stimulated luminescence (OSL) dating of lake and spring deposits in the Wadi al-Ajal and the Ubari Sand Sea suggest that the environment of the area was moist soon after 245,000 BP, 226,000 BP and sometime between 84,500 and 58,000 BP At these times the region was occupied by an extremely large lake that we call lake 'Megafazzan'. Lake Megafazzan attained an area of about 70,000 km² during the last of these lake phases (84,500 and 58,000 BP).

The region attained a positive hydrological balance at times during the Holocene as evidenced by the spring and lake deposits at the base of Wadi al-Ajal (Wadi al-Hayat) dating to the middle Holocene. Archaeological evidence supports these findings. Rock art depicts animals that are now found in a more humid environment while evidence of human settlement is found in the region throughout much of the Holocene. A comparison of our dating results with those from lake deposits in the Murzuq Sand Sea and the Akakus region suggests a more moist environment between 14,000 and 3000 BP punctuated by abrupt periods of drought. The similarity in timing between these drought events, increased cold water upwelling by the Canary Current and ice rafting events in the north Atlantic suggest that change in Atlantic circulation may be the cause of this abrupt climate change. The implications of these findings for the archaeology of the region are briefly discussed.

Introduction

The aim of this paper is to evaluate the results of dating the lake, duricrust and spring deposits in the vicinity of Jarma located in a hyper-arid zone of the Fazzan region of Libya (Fig. 11.1) We put these results into a regional context by comparing them to other palaeoenvironmental studies that have been conducted in the Fazzan and the Sahara as a whole. This compilation of dates is then compared to palaeoenvironmental records from the Atlantic Ocean in order to try and elucidate the causes of climate change that has occurred in the region during the Holocene. Furthermore, wherever possible we relate the results to the archaeology of the region in order to further our understanding of the human response to these changes.

We have developed an effective methodology for locating, mapping and investigating sites of geomorphological and archaeological interest over large areas of previously poorly mapped terrain (White *et al.*, this volume). Satellite image processing and Digital Elevation Model (DEM) analysis was used in conjunction with field studies and GPS surveying to identify and map geomorphological features that formed during previous wet phases. Regional scale DEMs were processed in order to identify promising candidate regions for the location of palaeochannels and lakes, relative to the regional water table. Radar (ERS-2, JERS-1 and Radarsat) and Enhanced Landsat Thematic Mapper (ETM) images of these candidate regions were analysed for evidence

[1]Department of Geography, Kings College London
[2]Department of Geography, University of Reading
[3]Department of Geography, University of Leicester

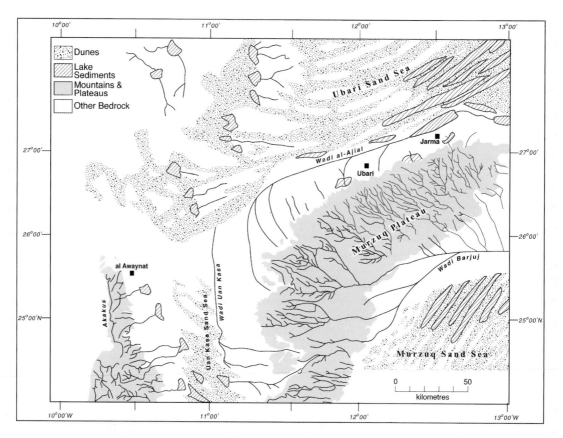

Figure 11.1. Location of the study area and a simplified representation of its geomorphology.

of palaeochannels and palaeolakes. Analysis of ETM data has identified numerous duricrusts that are found overlying palaeolake beds. Analysis of radar imagery has been particularly useful for mapping palaeochannels buried beneath shallow sheets of sand. The combination of remote sensing and GPS technology has also provided an effective tool for planning and navigating routes into remote areas of difficult terrain where these palaeoenvironmental indicators have been located (Brooks *et al.* 2003).

The geomorphology, sedimentology and archaeology of these regions have been investigated in the field and samples collected for subsequent analysis (McLaren *et al.,* this volume) and dating. This methodology has revealed an extensive palaeochannel and lake network throughout the Fazzan (see Fig. 10.5 in White *et al.*, this volume) but to date only the river and lake network at the base of the Wadi al-Ajal and the lakes on the margins of the Ubari Sand Sea have been investigated in any detail. All sites investigated have provided invaluable palaeoenvironmental information (see McLaren *et al.,* this volume) for details of these sites and descriptions of the deposits).

Many of these sites were found to be associated with prehistoric artefacts and provide useful information of the past occupation of the region (Reynolds, this volume). However, there are

many gaps in our understanding of this record that spans the past several hundred thousand years with lithic remains representing the Acheulean to the Late Pastoral Neolithic periods (Mattingly *et al.* 2000; 2003). An improved understanding of the timing of the desiccation of the lakes rivers and springs located in the region will not only further our understanding of climate change but may also further our understanding of the archaeology. For example, the preliminary results of the project suggest that the Garamantes emerged *c.*3000 BP at the end of the final phase of Holocene desiccation (Mattingly *et al.* 2000; 2003; Mattingly this volume). However, we need a better understanding of the details of the critical transition from Neolithic herders to irrigated agriculture that appears to have given rise to the Garamantian culture. An improved knowledge of the stages by which the climate changed and the surface water features dried up will thus further our understanding of the process by which the later irrigation systems tapping deeper groundwater reserves were developed.

Methods

To determine the age of the lake and spring deposits we have employed Uranium/Thorium (U/Th), ^{238}Ra and optically stimulated luminescence (OSL) dating. U/Th and ^{238}Ra methods were applied to shells and calcium carbonate samples from the lake deposits as well as to gypsum from spring line deposits (McLaren *et al.* this volume). OSL techniques were applied to sands directly underlying the lake sediments, thus providing dates that represent a time just before the onset of a lacustrine period.

Differential GPS was used to measure the height of wave cut platforms and shoreline deposits. This information was combined with a digital elevation model (DEM) of the region to in a geographical information system (GIS) in order to reconstruct the area of the lake.

Background

No previous palaeoenvironmental work had been carried out in the study area. However, research in other parts of the Fazzan indicate that this currently hyper-arid region experienced wetter phases in the past (Petit-Maire *et al.* 1980; Cremaschi, 1998; Cremaschi and di Lernia 1998). Palaeolake deposits indicate the presence of extensive water bodies while rock art attests to the existence of a more benign environment when large humid-climate fauna existed in currently inhospitable areas (Cremaschi and di Lernia 1998). Petit-Maire *et al.* (1980) have applied Uranium/Thorium (U/Th) dating techniques to fossil molluscs from the palaeolake deposits of Wadi ash-Shati, 150 km north of the study area, and suggest that there were lakes present at 90,000, 60,000 and 40,000 BP. To the south there appears to have been an extensive set of lakes on the margins of the Murzuq Sand Sea that formed during two sedimentary cycles, one starting around 9500 BP and terminating around 8350 BP, and the other at 8100 BP and terminating around 6000 BP (Cremaschi, 1998). In the Akakus Massif 300 km to the southwest of the study area pollen extracted from dung associated with Pastoral sites indicates a final desiccation from around 5000 leasing to abandonment at 3900 BP (Grandi *et al.* 1998).

Results

Escarpment Lake Deposits

Remote sensing has revealed an extensive deposit of palaeolake sediments at the base of the escarpment that divides the Murzuq plateau from the Wadi al-Ajal (Fig. 11.1). Molluscs found within these sediments have been dated to the Pleistocene using U/Th methods (Table 11.1) and dates are broadly consistent with those from Wadi ash-Shati (Petit-Maire *et al.* 1980) and the previously understood Saharan palaeohydrology (Szabo *et al.* 1995; Causse *et al.* 1989; Fontes and Gasse 1991). We have reconstructed this lake by using differential GPS to measure the height of wave-cut platforms and shoreline deposits and then analysing a digital elevation model of the region using GIS techniques to map the extent of the lake and the likely location of the river channels (see Fig. 10.5 in White *et al.*, this volume). The results suggest an extremely large lake with a perimeter of 2,500 km and an area of 76,250 sq km.

No archaeological sites are found associated with this shoreline though we have found scattered lithics dominated by Acheulean material. Much of the human activity during this period appears to have been restricted to the Murzuq Plateau where we have found many Acheulean and Mousterian sites and have identified a new blade industry of unknown age (Reynolds this volume).

Wadi al-Ajal Palaeochannels, Playas and Springs

A chain of playas linked by a palaeochannel occupies the base of the Wadi al-Ajal. The Garamantian capital of Jarma is located on the margins of one such playa. Scatters of Palaeolithic stone tools and late Neolithic sites found on the playa margin suggest a long period of human occupation in the basin (Reynolds this volume). Trenching of the sediments revealed a gypsum

Location	Mollusc Species	Date
Graifa, South Shore of Wadi al-Ajal	*Melanoides tuberculata*	61200 ± 1230 BP
Graifa, South Shore of Wadi al-Ajal	*Afroplanorbis sp.*	69200 ± 3800 BP
Graifa, South Shore of Wadi al-Ajal	*Melanoides tuberculata*	71300 ± 6200 BP
Graifa South Shore of Wadi al-Ajal	*Melanoides tuberculata*	84500 ± 4600 BP
Graifa, South Shore of Wadi al-Ajal	bulk *Melanoides* sample	82400 ± 3300 BP
North Shore of Wadi al-Ajal	*Corbicula africana*	56600 ± 3800 BP
North Shore of Wadi al-Ajal	*Corbicula Africana*	58200 ± 4700 BP
North Shore of Wadi al-Ajal	*Corbicula Africana*	61300 ± 7900 BP

Table 11.1. U/Th dates of mollusc shells

Location	U/Th Date BP	[226]Ra Date BP
Graifa springline crystals deposit 1	4100 ± 700	None
Graifa springline crystals deposit 2	3000 ± 2000	3100 ± 295
Graifa springline crystals deposit 3	3500 ± 1200	5500 ± 850
Tindal springline crystals	4000 ± 2100	3950 ± 350

Table 11.2. U/Th and [226]Ra dating of gypsum springline deposits.

crust underlain by 2 m of silts and clays with displacive gypsum crystals that become increasingly common towards the surface. Aeolian sands unconformably underlie this deposit. These features are indicative of a lacustrine deposit overlying aeolian sands, and suggest that after a period of aridity a lake became established and then gradually dried up. A sample at the base of the lacustrine clay layer was dated using OSL, yielding an age for the appearance of the lake of 5900 ± 1000 BP The onset of dry conditions was determined by dating displacive gypsum crystals using U/Th and [238]Ra methods, yielding ages of 4000 ±2000 BP and 3650±210 BP respectively.

Though we need to be cautious when interpreting a limited number of dates it appears that this lacustrine period in the Wadi al-Ajal is later than any other so far identified in the Fazzan. A period of aridity at 6000 BP followed by a return to more humid conditions is consistent with evidence of the cessation of activity at settlement sites in the Akakus at this time, their reestablishment soon after and their final abandonment at about 3900 BP (Grandi *et al.* 1998). These results have further archaeological significance because they indicate that Jarma playa had dried up before the town of Jarma became established on its margins. This suggests that the location of Jarma was not controlled by water availability from the lake, but was more likely to be due to the presence of salt, an important commodity in the trans-Sahara trade routes that the Garamantes developed.

We have found further evidence for the intensification of aridity and consequent lowering of the groundwater table in the Wadi al-Ajal from about 5000 BP onwards. At the base of the Murzuq Plateau, at the contact between the Nubian Sandstone and underlying impervious marls, gypsum has been precipitated by evaporating groundwater, thus providing evidence of a previously active springline. We have U/Th and [238]Ra dated a number of these gypsum deposits (Table 11.2). The gradual desiccation of springs between 5000 and 3000 BP is consistent with the dessication of Jarma Playa during this time and the diverse array of evidence for the final dessication of the Akakus and Wadi Tanezzuft (Cremaschi and di Lernia 1998). These dates are of considerable significance as they provide the only age control on the lowering of the aquifer and presumably on the need of the inhabitants to start large-scale construction of irrigation systems such as foggara that are abundant in this region.

Figure 11.2. Landsat Thematic Mapper (TM) Band 1 sub-image of part of the Wadi al-Ajal and the Ubari Sand Sea Palaeolake deposits highlighted in white. There appear to be 30 lake deposits in a region of 15x7 km. More palaeolakes are found in other areas of the sand sea. Numbers indicate latitude and longitude.

The Ubari Sand Sea Interdune Lacustrine Deposits

Remote sensing has identified a group of about 50 palaeolakes within the southern edge of the Ubari Sand Sea (Fig. 11.2). In most basins three terraced lacustrine surfaces were identified, suggesting three separate lake phases. The two higher level terraces consist of calcrete duricrusts overlying laminated carbonates while sediments near the base of the depressions generally consist of calcretes overlying organic palaeolake sediments sometimes containing *Melanoides tuberculata* and less commonly *Bulinus truncatus*. *Melanoides tuberculata* can exist at a range of salinities in diverse environments, but is absent from locations subject to periodic aridity, indicating that the lacustrine environment was characterised by perennial water bodies (see McLaren *et al.* this volume). The inter-dune basin floor organic lake sediments are currently being radiocarbon dated. No organic matter was found in the lake sediments that form higher elevation lake terraces and thus samples were collected for optically stimulated luminescence (OSL) dating. These have yielded ages of 255,000±76,000 BP and 245,000±88,000 BP for two samples from the upper terrace in two separate inter-dune basins and a date of 226,000±61,000 BP for the intermediate terrace from a single basin. The OSL signal for these samples is close to saturation and thus they could be broadly correct, or they could be older. Nonetheless these results indicate the existence of two lake phases in the Ubari Sand Sea that are considerably older than those found in the Wadi al-Ajal.

Archaeological surveys suggest a long period of human occupation with abundant lithic remains ranging from Acheulean to the late Pastoral phase at these palaeolake sites. The most notable finds include a scatter of 30 hand axes at EDU 5, and a fragment of what appears to be a predynastic knife that suggests links with Egypt in the late Neolithic. Sites also contained grinding stones, ostrich eggshell and bone fragments, a late Pastoral antenna-type tomb, a cemetery of Garamantian style tombs and much middle to late pastoral pottery. The pottery appears to be similar to that found at Zinkekra, thus providing evidence of a link between late

Pastoral activity at Zinkekra and in the Ubari Sand Sea. However, similar pottery has been found in the Akakus region and the Murzuq Sand Sea, and has been excavated from tombs as old as 5000 BP (Cremaschi and di Lernia 1999) indicating a wide spatial distribution over a long time frame. Notwithstanding this, the pottery lends support to the hypothesis that Zinkekra provided a regional centre for the surrounding pastoral activity.

These preliminary studies have shown that the Ubari Sand Sea is extremely rich in lake deposits and associated archaeology and provide hints that the region was occupied by a people with similar material remains to those found in the Wadi al-Ajal. The organic lake sediments appear to be associated with the late Pastoral archaeology. This suggests that numerous perennial lakes were present in the region during the last 6000 years and thus radiocarbon dating of palaeolake sediments holds great promise in determining the timing of climate change during the late Holocene that is critical in the understanding of the transition to irrigated agriculture. The view that these lakes persisted later than those in the other parts of the Fazzan is supported by the fact that the Ubari Sand Sea is the only place in the region where a small number of perennial lakes still persist, such as Lake Mandara and Lake Gabr Oun.

Discussion

There is a need for caution when interpreting our dating results as we have used different techniques each with different limitations. U/Th dating of molluscs is problematic as the aragonite in all the shells that we have investigated has been replaced by calcite. Thus contamination during replacement is a possibility and could explain the large range of dates provided by different shells from the same deposits. The U/Th dating of gypsum crystals is a technique that has been pioneered by us due to the scarcity of other datable material. Though the method appears to provide results that are consistent with the geomorphological evidence, it is experimental, and needs to be directly compared to other methods if a suitable gypsiferous deposit can be found. OSL dating is increasingly thought to be a reliable technique. However, dating of the Pleistocene lake deposits in the Ubari Sands Sea is problematic because we need to make assumptions about the depth of burial and the moisture content, both of which could have varied substantially over time. Notwithstanding these problems our palaeoenvironmental results show that the study area contains both Pleistocene and Holocene lacustrine deposits. Thus the region provides a link between the Pleistocene deposits of the Wadi ash-Shati and the Holocene deposits of the Akakus where there have been previous palaeoenvironmental studies (e.g. Petit-Maire *et al.* 1980; Cremaschi, 1998; Cremaschi and di Lernia 1998). Consequently research in the region provides a key to understanding the palaeoenvironments of the Fazzan as a whole. By linking this information to the archaeology we are starting to gain an insight into the human adaptation to these changes. If we combine recent climate change research with our results, and those of the other palaeoenvironmental studies that have been carried out in the region, we can improve understanding of the causes and regional extent of these changes.

A comparison of our Holocene results with those of Cremaschi (1998) provides a picture of considerable climate change during the Holocene (Fig. 11.3A). There appears to be abrupt climate change in the form of drought at about 10,000, 8600, 7000 and 6000 BP and a final

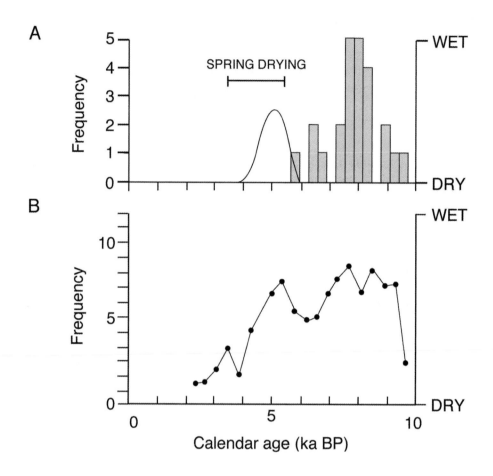

Figure 11.3. Histograms of radiometric dates from Holocene fresh water environments in the Fazzan compared to those from the entire Sahara: A) Radiometric dates for the Fazzan. The gray histogram represents the radiocarbon dates acquired by Cremaschi (1998) from lacustrine environments in the Murzuq Sand Sea and the Wadi Tanezzuft that we have since calibrated. The black lines represent a schematic interpretation of the water level in Jarma Playa and the activity of springs in Wadi al-Ajal, B) Histogram of dates for the Sahara collated by Guo et al. (2000).

desiccation at around 3000 BP. These results suggest that the Fazzan is one of a few regions in the Sahara where the evidence for many periods of abrupt climate change have been preserved in the landscape, albeit with different types of evidence recordable in different parts of the region. This fact, coupled with the abundance of archaeological remains, means that the Fazzan provides a very promising area for the study of climate change and the human response to it.

When we compare the dates of lacustrine episodes in the Fazzan with a recent collation of all radiocarbon dates from freshwater environments in the Sahara over the last 10,000 years (Guo *et al.* 2000; Fig. 11.3B)) we also see evidence of abrupt climate change at similar times, though the period of drought between 7000 and 6000 BP in the Sahara data appears to be represented by two distinct episodes at 7000 and 6000 BP in the Fazzan data. In Figure 11.3B the abrupt

change appears to be superimposed on a gradual drying trend that starts at about 8000 BP and results in the final desiccation of the Sahara at about 3000 BP. Palaeoclimate modelling studies of the Sahara can not simulate these abrupt changes, however, they suggest that the gradual drying trend is the product of a weakening of the African monsoon caused by a gradual reduction in insolation due to Milankovich cycles (Claussen *et al.* 1999), as is evidenced by the reduction of summer insolation in the Sahara during the latter part of the Holocene from a peak at about 10,000 BP (Fig. 11.4A). Modelling suggests that feedbacks in the climate system mean that gradual Milankovich climate forcing results in an abrupt reduction in vegetation cover

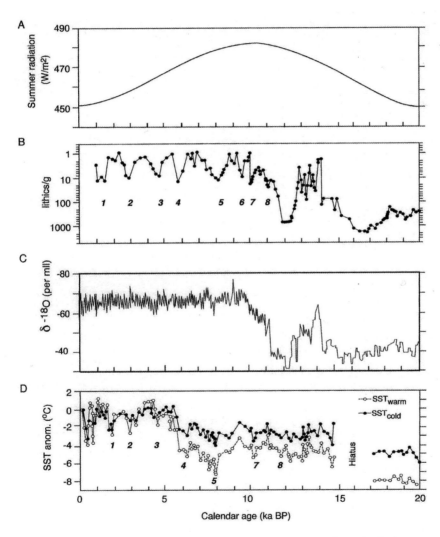

Figure 11.4. Comparison of selected palaeoclimate records from the Atlantic, Sahara and Greenland: A) Summer insolation at 20°N (Source: deMenocal et al. 2000). B) Ice rafted lithics concentration from a deep-sea sediment core off the cost of Iceland (Source: Bond et al. 1997). C) Oxygen isotope concentration of the Greenland GISP-2 ice core (Source: deMenocal et al. 2000). D) Maximum (SSTwarm) and minimum (SSTcold) sea surface temperature changes from the Atlantic Ocean just off the coast of Mauritania (Source: deMenocal et al. 2000).

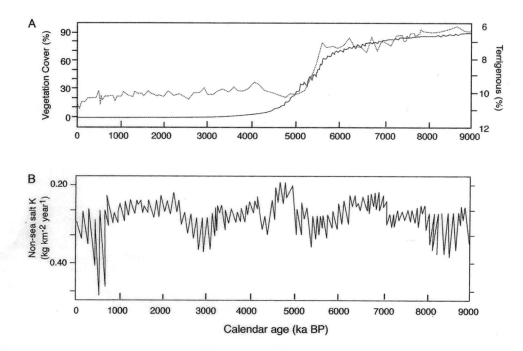

Figure 11.5. Selected palaeoclimate information for the last 10,000 years: A) Modelled fractional vegetation cover (grey line) (Source: Claussen et al. *1999) and West African Aeolian dust supply variations (black line) (Source: deMenocal* et al. *2000). B) Non sea salt potassium from the GISP2 ice core (Source: Bond* et al. *1997).*

around 5000 BP (Fig. 11.5A). This appears to be supported by data from deep sea cores that show a significant increase in aeolian dust transport from the Sahara into the Atlantic Ocean from 5000 BP onwards (Fig. 11.5A).

The Atlantic aeolian dust record indicates a gradual dessication of the Sahara, it does not appear to record the evidence of abrupt climate change evident in the continental lake record, nevertheless there are other ocean climate proxies from the Atlantic that record events at similar times. For example, abrupt droughts in the Fazzan and the Sahara as a whole occur at similar times to peaks in ice rafted lithic concentrations from deep sea sediment cores off the coast of Iceland (Bond *et al.* 1997, Fig. 11.4B) These periods of ice rafting do not seem to be related to changes in the temperature of the Greenland ice cap which was quite stable in the Holocene (Fig. 11.4C). Thus this ice rafting may be due to localised surface water cooling caused by a change in Atlantic currents producing a southward movement of cold sub-polar waters at 1500, 3000, 4200, 6000, 8500 BP etc. deMenocal *et al.* (2000) showed that these cooling events are coherent with cooling of the Atlantic Ocean off the West African coast (Fig. 11.4D) that appear to be associated with a strengthening of the cold Canary Current. Our results suggest that these events coincide with the drought periods in Fazzan and the Sahara. Thus it appears that changes in the circulation of the Atlantic can cause climate change in the Sahara. This conclusion accords with the findings of the controls on the current rainfall in the Sahel whereby sea surface temperature changes in the Atlantic appear to explain the persistent drought in the region (Zeng *et al.* 1999).

Evidence of abrupt climate change and widespread drought is also found further afield at similar times. Studies of lake sediments in regions adjacent to the Sahara suggest widespread drought in more humid areas around 8500, 6000 and 4200 BP at a number of widely separated locations (Gasse 2000). Furthermore, abrupt climate change and drought seem to be synchronous between the Sahara and Northern China deserts (Guo *et al.* 2000), the two largest source areas of dust on Earth. Perhaps it is because of this that these periods appear to be related to increases in the amount of non-sea salt potassium in the Greenland ice core GISP2 (Fig. 11.5B). This potassium comes from continental dust, is thought to be a good indicator of dust activity, and seems to imply periods of widespread wind erosion and extensive Northern Hemisphere aridity at these times.

Conclusion

The study area contains a remarkably long and rich record of climate change, largely due to the fact that during some humid periods the Fazzan basin has filled with water to form a very large lake. Upon the onset of more arid conditions the lake recedes and fragments into numerous small lakes sometimes interconnected by river systems. U/Th and OSL dating of lake and spring deposits suggest that there were numerous humid episodes during the Quaternary. The Holocene results have been combined with lacustrine dates from other parts of Fazzan. The results suggest substantial climate variability with a gradual drying trend commencing during the early Holocene being punctuated by short episodes of aridity that appear to correlate with changes in the circulation of the Atlantic Ocean. The final desiccation of the springs and lakes in the Wadi al-Ajal appears to have occurred between 4000 and 3000 BP.

These abrupt arid periods could be expected to have profound effects on human occupation in the region and some at least appear to correspond to gaps in the archaeological record of Fazzan (e.g. at 6000 BP). Furthermore, the timing of the loss of surface water in the Wadi al-Ajal roughly corresponds to the development of the Garamantes and thus supports the idea that exploitation of groundwater resources played a role in this process.

References

Bond, G., Showers, W., Cheseby, M., Lotti, R., Almasi, P., deMenocal, P., Priore, P., Cullen, H., Hajdas, I., and Bonani, G., A 1997. Pervasive millennial-scale cycle in North Atlantic Holocene and glacial climates. *Science* 278: 1257-1266.

Brooks, N., Drake, N., McLaren, S. and White, K., 2003. Studies in geography, geomorphology, environment and climate, in Mattingly, *et al.* 2003: 37-74.

Causse, C., Coque, C., Fontes, J.Ch., Gasse, F., Gibert, E., Ben Ouezdou, H., and Zouari, K. 1989. Two high levels of continental waters in the southern Tunisian chotts at about 90 and 150 ka. *Geology* 17: 922-925.

Claussen, M., Kubatzki, C., Brovkin, V., Ganopolski, A., Hoelzmann, P. and Pachur, H.J. 1999. Simulation of an abrupt change in Saharan vegetation in the mid-Holocene. *Geophysical Research Letters* 26: 2037-2040.

Cremaschi, M. 1998. Late Quaternary geological evidence for environmental changes in south-western Fazzan (Libyan Sahara), in Cremaschi and di Lernia 1998a: 13-47.

Cremaschi, M. and di Lernia, S. 1998a. (eds.) *Wadi Teshuinat: Palaeoenvironment and prehistory in south-western Fazzan (Libyan Sahara)*, Centro Interuniversitario di Ricerca per le Civiltà e l'Ambiente del Sahara Antico.

Cremaschi, M. and di Lernia, S. 1998b. The geoarchaeological survey in central Tadrart Akacus and surroundings (Libyan Sahara): Environment and culture, in Cremaschi and di Lernia 1998a: 243-296.

Cremaschi, M. and di Lernia, S. 1999. Holocene climate changes and cultural dynamics in the Libyan Sahara. *African Archaeological Review* 16: 211-238.

deMenocal, P., Ortiz, J., Guilderson, T. and Sarnthein, M. 2000. Coherent high and low Latitude climate variability during the Holocene warm period. *Science* 288: 2198-2202.

Fontes, J.C. and Gasse, F. 1991. PALHYDAF (Palaeohydrology in Africa) program: objectives, methods, major results. *Palaeogeography Palaeoclimatology Palaeoecology* 84: 191-215.

Gasse, F. 2000. Hydrological changes in the African tropics since the last glacial maximum. *Quaternary Science Reviews* 19: 189-211.

Grandi, G.T., Lippi, M.M. and Mercuri, A.M. 1998. Pollen in dung layers from rockshelters and caves of Wadi Teshuinat (Libyan Sahara), in Cremaschi and di Lernia 1998a: 95-106.

Guo, Z., Petit-Maire, N., Kropelin, S. 2000. Holocene non-orbital climatic events in present-day arid areas of northern Africa and China, *Global and Planetary Change* 26: 97–103.

Mattingly, D.J. 2000. Twelve thousand years of human adaptation in Fazzan (Libyan Sahara), in G. Barker, and D. Gilbertson, (eds), *The Archaeology of Drylands. Living at the margins.* One World Archaeology 39, London:160-79.

Mattingly, D.J., al-Mashai, M., Balcombe, P., Drake, N.A., Knight, S., McLaren, S., Pelling, R., Reynolds, T., Thomas, D., Wilson A.I., and White K. 1999. The Fazzan Project 1999: preliminary report on the third season of work, *Libyan Studies* 30: 129-145.

Mattingly, D.J., al-Mashai, M., Balcombe, P., Barnett, T., Brooks, N., Cole, F., Dore, J., Drake, N.A., Edwards, D., Hawthorne, J., Helm, R., Leone, A., McLaren, S., Pelling, R., Preston, J., Reynolds, T., Townsend, A., Wilson A.I., and White, K.H. 2000. The Fazzan Project 2000: preliminary report on the fourth season of work. *Libyan Studies* 31: 103-120.

Mattingly, D.J., Brooks, N., Cole, F., Dore, J., Drake, N.A., Leone, A., Hay, S., McLaren, S., Newson, P., Parton, H., Pelling, R., Preston, J., Reynolds, T., Schrufer-Kolb, S., Thomas, D., Tindall, A., and White, K.H. 2001. The Fazzan Project 2001: preliminary report on the fifth season of work. *Libyan Studies* 31: 103-120.

Mattingly, D.J.M., Daniels, C.M. Dore, J. Edwards, D. and Hawthorne, J. 2003. *The Archaeology of Fazzan Volume I: Synthesis*, Society for Libyan Studies, London.

Petit-Maire, N., Delibrias, G. and Gaven, C. 1980. Pleistocene lakes in the Shati area, Fazzan. *Palaeoecology of Africa* 12: 289-295.

Szabo, B.J., Haynes, C.V. and Maxwell, T.A. 1995. Ages of Quaternary pluvial episodes determined by uranium-series and radiocarbon dating of lacustrine deposits of Eastern Sahara. *Palaeogeography Palaeoclimatology Palaeoecology* 113: 227-242.

White, K., McLaren, S., Black, S. and Parker, A. 2000. Evaporite minerals and organic horizons in sedimentary sequences in the Libyan Fazzan: implications for palaeoenvironmental reconstruction, in S.J. McLaren and D.R. Kniveton (eds*.), Linking Climate Change to Land Surface Change*: 193-208.

Zeng, N., Neelin, D.J., Lau, K.M., Tucker, C.J. 1999. Enhancement of interdacadal climate variability in the Sahel by vegetation interaction. *Science* 286:1537-1540.

12. Dendroclimatology of *Cupressus dupreziana*: Late Holocene Climatic Changes in the Central Sahara

By Mauro Cremaschi[1], Manuela Pelfini[1] and Maurizio Santilli[1]

Abstract

The *Cupressus dupreziana*, the Tassili cypress, still lives in a small number of specimens at Tamrit, on the Algerian Tassili. Living trees are surrounded by a number of dead trunks, which were traditionally exploited, due both to the strength of the wood and to its resinous scent, to make the main doors of houses. Doors made of cypress wood from the old cities of Ghat and Barkat have been used by us for dendroclimatic research.

The tree rings of 11 samples were measured and dated with a consistent number of AMS [14]C datings. A dendroclimatic curve has thus been obtained, spanning from 5200 to 500 yr BP (5900-520 cal yr BP). As the width of the growth rings depends on water availability, the curve represents a detailed record of changes in rainfall on a decade scale. It indicates several drought spells, intercalated by phases of enhanced precipitation (at 3000, 2000 yr BP = 3200, 2400 cal yr BP) and the onset of extreme arid conditions at 1500 yr BP (1370 cal yr BP). These data are in good agreement with the local geological record and consistent with palaeoclimatic proxies from Equatorial Africa and Middle East, therefore they may be regarded as of general relevance.

The doors of old Ghat and of other desert towns made from the *Cupressus dupreziana* are valuable archives for palaeoenvironmental reconstruction: as an important part of the cultural heritage, they must be protected and preserved for future research.

Introduction

Tree ring study for palaeoclimatic reconstruction (dendroclimatology) can be successfully applied at the middle latitudes up to the Mediterranean region, where forests are the main climax vegetation and, while subjected to deforestation since the Neolithic, they are still extant over wide areas in any natural or man-dominated ecosystem (Kuniholm 1994, 1996).

Dendroclimatology has given important results also in semi-arid areas (Zahner 1968, Glerum 1970, Fritts 1976). In these regions tree growth is limited by the availability of water, and the ring-width variations primarily reflect this variable. However, unfavorable climatic conditions may induce modifications in the growth rate of the wood and produce multiple or false rings very often undistinguishable from annual rings, making the reading of the actual growth increment difficult and sometimes leading to errors in dating. In the deserts, the extreme arid conditions and the scarcity of trees may render dendroclimatology unworkable. However, a notable exception to this statement is represented by the *Cupressus dupreziana*: the results presented in this paper demonstrate its valuable significance for palaeoclimatic reconstruction.

Cupressus dupreziana still survives in the catchment basin of Wadi Tanezzuft, but already existed at least 2000 years ago, as demonstrated by a radiocarbon dating age which gave 1640 ± 80 yr BP published by Hachid (2000). We may thus take this tree to have recorded changes in precipitation in the area over a long period.

1 CIRSA CNR, IDPA, Dipartimento di Scienze della Terra, Università di Milano,

In the frame of the geo-archaeological researches promoted by the Italo-Libyan Joint Mission in south-west Fazzan and aimed at reconstructing the late Holocene climatic changes in the Wadi Tanezzuft valley (Cremaschi 2001), the potential of the cypress as a palaeoclimatic source of data appeared so crucial as to call for dendroclimatic analyses, although the reliability of *Cupressus dupreziana* wood for tree-ring study had previously been reputed to be low (Liphschitz 1986; Grissino-Mayer 1993).

Wood and Samples

Cupressus dupreziana, the Tassili cypress (*tarout* in the Targhi language) was first described by the French captain A. Duprez (Maire 1933; Dubief 1999) and classified by Camus, in 1926 (*Cupressus dupreziana* Camus 1926; synonymous: *C. lereddii* Gaussen 1961). It lives in an area of some 200 km² on the Tamrit plateau of the Tassili N'Ajjer, at 1000-1800 m in elevation, some 150 km south-east

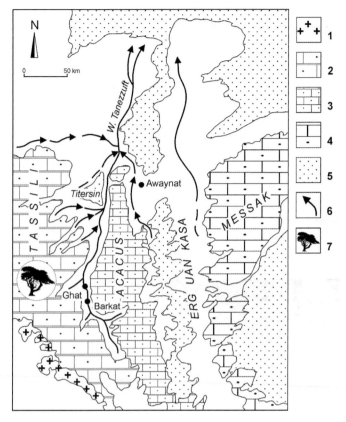

Figure 12.1. Location of the Cupressus dupreziana *area and of the desert town in which the doors samples have been collected. 1) Pre-Ordovician granite; 2) Tassili sandstone(Silurian); 3) Acacus sandstone (Upper Silurian-lower Devonian); 4) Nubian sandstone (Cretaceous); 5) dune fields (Pleistocene-Holocene); 6) main drainage directions; 7) location of the* Cupressus dupreziana *area.*

of Janet and some 60 km west of Ghat (Fig. 12.1). Today, less than two hundred trees are still living, surrounded by various dead trunks (Simoneau and Debazac 1961; Dobr 1988).

But well before the Duprez studies, the cypress was well known to local people and, due to the large size of mature specimens and thanks to the strength of the wood and its resinous scent, it was systematically exploited and was used, up to one hundred years ago, to make the main doors of the traditional houses of the desert villages.

The doors are composed of several beams (from two to five) (Fig. 12.2), ranging in size from 120 to 150 cm in length, from 25 to 10 cm in width, and from 4 to 2 cm in thickness, obtained by cutting the trunk longitudinally through superposed tangential sections (Fig. 12.3). They were probably obtained from dead trunks, easier to process, than the large living trees solidly anchored to the ground by deep ramified roots. The exploitation may have been selectively concentrated on old dead trunks, which at present are scarcely found at the location. The doors dispersed throughout the villages surrounding the Tassili: Ghat, Barkat, Janet and Gadames, represent a

Figure 12.2. The door Gh5 from Ghat. Notice the growth rings still visible at macroscale.

Figure 12.4. A Cypress door at Barkat.

Figure 12.3. Location of the beam section inside the cypress trunk according to the ring direction. 1) samples GhE1, Gh6B; 2) samples GhG4, Gh5A, GhD; 3) samples Gh10a, Gh5E1, 4) sample GhA2S; 5) not included in this study; 6) samples Bk1a, Gh701.

non-renewable archive for the history of the Cypress in the area (Fig. 12.4).

Some wood doors are still in use in Ghat and in Barkat, but many, after breakage of pivots, have been recently replaced with iron doors and thereafter discarded, bound sooner or later to be used as fuel. As a non-destructive technique could not be used up until now on still functional doors, only discarded wood was used for sampling. Samples for tree-ring counting were obtained by cutting perpendicular sections from individual beams, their surface polished with abrasive papers and prepared according to standard procedure (Schweingruber 1988).

Tree-ring widths were measured with a precision of 0.01 mm, through LINTAB equipment and by the computer program TSAP (Rinn 1996).

Results

When polished sections of the cypress beams are observed under the microscope, the seasonal components (early and late wood) can be clearly distinguished and the individual rings can be measured with great accuracy. However, while sets of clear-cut annual rings are dominant, some groups of discontinuous and indistinct tree rings have been

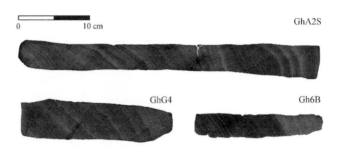

Figure 12.5. Polished sections of three samples (GhA2, Ghg4, Gh6B) from Ghat. Notice the rings with spring sharply separated from late wood.

observed (Fig. 12.5). Occurrence of sets of incomplete and discontinuous rings makes the standard cross-dating procedure rather difficult and the synchronization of single curves on an annual basis impossible (Schweingruber *et al.* 1990). However, by basing the synchronization of the curves on a decade-scale trend derived from a 21-year running mean, a good superposition was obtained from samples of different beams, which on the basis of a similar structure of the curves, appears to have been extracted from the same tree.

The time scale of the ring growth has been checked trough AMS radiocarbon dating. For this purpose the overlapping curves obtained for the samples GhA2S and GhG4 (Fig. 12.6) coming

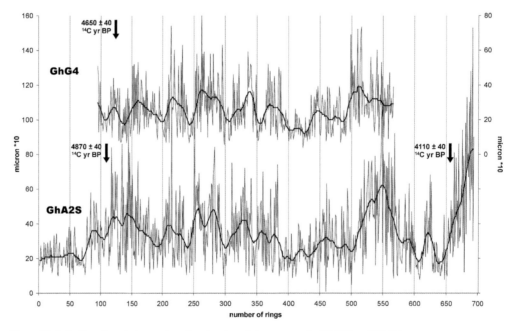

Figure 12.6. Radiocarbon dating and synchronization of the two samples GhA2S and GhG4.

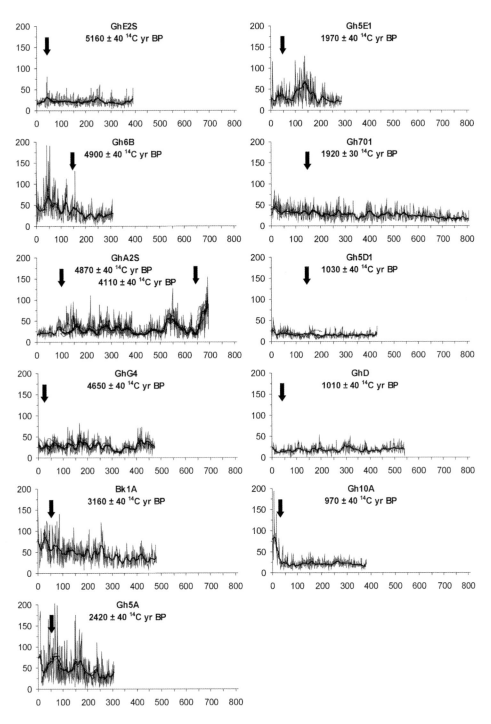

Figure 12.7. Individual dendroclimatic curves of the studied samples. Radiocarbon datings and their locations are indicated; abscissa: number of rings, ordinate: ring width (micron °10).

from the same tree, were dated. In the curve GhA2S, composed of 580 rings, the 570th ring (average of 5 rings) was dated at 4110 ± 40 yr BP, and the 30th ring (average of 5 rings) was dated to 4870 ± 40 yr BP, with a difference of 760 radiocarbon age for 540 rings. One more radiocarbon dating was performed on the sample GhG4 centered on the 28th ring, having the same position of the 30th ring in the sample GhA2, and the result was 4650 ± 40 yr BP. If we compare the curves on the basis of the radiocarbon dating, their superposition appears impossible. Yet on the contrary, the two curves are well synchronized on the basis of the ring sequence. In this case, if the date of 4870 ± 40 is reputed unsatisfactory and the date 4650 ± 40 is preferred: there is a good coincidence between the radiocarbon age of the wood and the number of the rings (a difference in 540 radiocarbon years with a sigma ± 40 corresponds to 520 rings approximately).

While many problems on the dating of the sequence are to be solved and several additional radiocarbon dates are still in progress, we can assume that at least a part of ring sequence of *Cupressus dupreziana* may be regarded as of annual growth rate, and while disturbances such as false or partially absent rings may affect some specific periods, they do not hinder the general dendroclimatic trend. Furthermore, the correlation of the single curves, at the present state of our knowledge, is not possible on an annual basis, but it is compatible with a decade-scale basis.

Some samples display a characteristic growth trend due to the physiological age of the trees: the curves have a negative exponential shape, implying a progressive reduction of the ring width (Schweingruber 1988). The physiological trend is particularly evident in the samples with bowed rings, samples that are cut from the central part of the tree (Fig. 12.7).

However, the climatic signal may be recovered inside the growth trend as in the sample Gh6B, where a phase of low growth rate interrupts the physiological trend indicating a crisis event, or in the case of the sample Gh10a, where after a 30-year-long positive oscillation corresponding to the juvenile phase, the curve becomes permanently flat, with a low mean-ring width, indicating a long unfavorable period.

Many other curves (GhES2, GhA2S, GhG4, Gh5D1, GhD), from samples with flat rings, located far from the pith of the tree, are not influenced by the physiological growth trend. As effects of intraspecific competitions (*Cupressus dupreziana* never formed dense forests) and of interspecific competitions (parasite attacks do not influence decade-based sequences), the fluctuation of the mean-ring width may be linked mainly to a climatic factor. Furthermore, all the curves display low values of the first order of autocorrelation (0.09-0.63; average 0.30) and high values of mean sensivity (0.32-0.77, average 0.50), indicating that the influence of the growing trend may be considered low (Schweingruber et al. 1990).

The Dendroclimatic Curve

Solid correlation of the individual curves is based upon 11 AMS radiocarbon dates (Table 12.1). Each wood section was dated at least by one sample. Wood for dating was physically separated by a chisel, carefully cleaned and thinned so that the final sample to submit to dating consisted of 3-5 individual rings. Conventional ages were calibrated at 65 percent average by the OXCAL version program employing the intcal98 calibration curve (Stuiver *et al.* 1998).

Sample	Lab. Number	Age C^{14} Y. BP
GHE2S	GX 27377 AMS	5160 ± 40
GHA2S	GX 27032 AMS	4870 ± 40
GHG4	GX 27376 AMS	4650 ± 40
GH6B	GX 27932 AMS	4900 ± 40
GHA2S	GX 27033 AMS	4110 ± 40
BK1A	GX 27935 AMS	3160 ± 40
GH5A	GX 27933 AMS	2420 ± 30
GH5E1	GX 27979 AMS	1970 ± 40
GH701	GX 27934 AMS	1920 ± 30
GH5D1	GX 27980 AMS	1030 ± 40
GHD	GX 27034 AMS	1010 ± 40
GH10A	GX 27936 AMS	970 ± 40

Table 12.1. Radiocarbon dates from the cypress samples

Though discontinuous, the curve obtained in this way covers a time interval spanning from 5140 yr BP (5900 cal yr BP) up to 500 yr BP (cal 520 yr BP) (Fig. 12.8). It shows ample fluctuations in tree-ring width which are to be interpreted in terms of alternating wet and dry periods, as the main limiting factor of *Cupressus dupreziana* growth is the availability of water (Barry 1970). Furthermore, the cypress trees are located on a plateau where permanent water tables do not exist at shallow depth and cannot contribute to the tree life. Thus, the changes in water availability can be directly linked to rain supply.

The curve records three wet periods of high precipitation (wide rings) peaking at 5000 yr BP (5700 cal yr BP), 3200 yr BP (3400 cal yr BP) and 2300 yr BP (2500 cal yr BP). In this time interval there are three short but severe dry phases (thin rings) at 4700 yr BP, 4350 yr BP and 4150 yr BP (5370 cal yr BP, 4960 cal yr BP and 4670 cal yr BP). The period from 2000 yr BP (1940 cal yr BP) up to 1500 yr BP (1370 cal yr BP), is a stable period of moderate, narrow rings, suggesting moderately dry conditions; but from 1500 yr BP (1370 cal yr BP) to 500 yr BP (520 cal yr BP), the curve is composed of very narrow rings, indicating very dry conditions. Unfortunately, an important gap, about one thousand years long, breaks the continuity of the curve from 4000 yr BP and 3200 yr BP (4500 and 3420 cal yr BP). Some minor breaks also exist later, but they do not interrupt the general trend the curve.

Regional and Remote Comparisons

There is a general congruence between the dendrochronological curve and the local geological proxies. During the late sixth millennium BP several lakes existed in the ergs Uan Kasa and

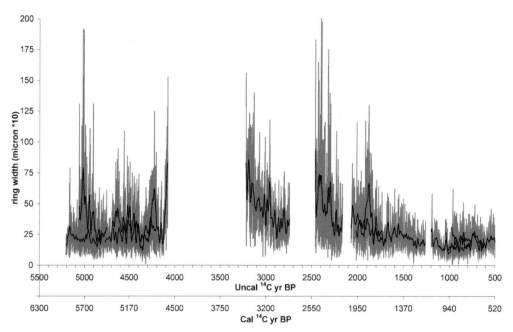

Figure 12.8. The dendroclimatic curve of Cupressus dupreziana.

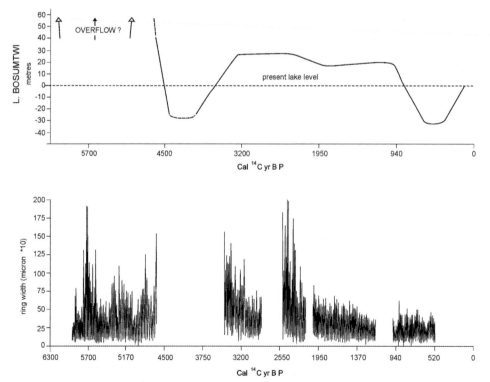

Figure 12.9. The dendroclimatic curve of Cupressus dupreziana *compared with the late fluctuation of the late Bosumtwi (Ghana).*

152

Titersin, surrounding the Wadi Tanezzuft valley (Cremaschi 1998; 2001; 2002) which dried out before 4500 uncalibrated yr BP, in agreement with the dry periods at 5370-4670 cal yr BP, as indicated in the dendroclimatic curve. The wet periods at 3400 and 2500 cal yr BP are contemporary to fluvial activity in wadi Tanezzuft and to the ephemeral water table rise in erg Uan Kasa at 2410 cal yr BP (Cremaschi 2003).

A broad coincidence also exists with the records from lake fluctuations in eastern Africa (Lakes Langeno, Abhé, Harel, Ziway-Sahale, and Hanlé-Dobi) (Gasse and Street 1978; Gasse et al. 1980; Gasse and Fontes 1989) and of lake Bosumtwi (Maley 1994), in central Africa (Ghana) (Fig. 12.9).

Comparison with the high resolution palaeoclimatic records recently obtained from the ice cores of Mt. Kilimanjaro (Gasse 2002; Thompson et al. 2002) and from the speleothems of the Soreq cave (Bar-Matthews et al. 1998) (Fig. 12.10) is problematic as regards detail because the dendroclimatic curve is still fluctuating. However, some meaningful coincidences may be observed: all the records show a cluster of a dry phases at about 5000 yr cal BP and the two later phases of enhanced precipitation at 3200 and 2500 cal yr BP can be clearly seen both in the record Kilimanjaro and Soreq records. Depletion in precipitation after 1370 cal yr BP appears more severe and stable in the *Cupressus dupreziana* record.

From these circumstances, it appears that most of the climate changes recorded by the cypress were not local, but may be extended to all the monsoon dominated areas of tropical Africa, up to the southern fringe of the dry lands of the middle east.

Conclusion

The period covered by the dendrochronological curve of the *Cupressus dupreziana* is of crucial importance for the history of the recent climatic change in the central Sahara, spanning in time from the end of the wet Holocene up to the present desertification.

A further point of interest is that the curve gives more information about the genesis and the decline of the oasis, which is the main physiographic and geomorphologic phenomenon in arid land of the late Holocene, implying important consequences for the cultural dynamics. The dry events at 5370-4670 cal yr BP may be associated to the withdrawal of the monsoon rain to the south.

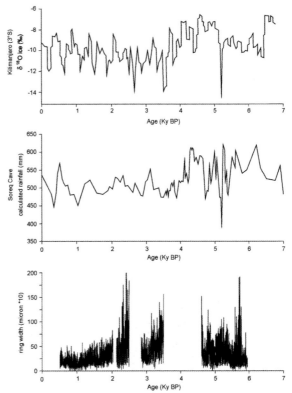

Figure 12.10. The dendroclimatic curve of Cupressus dupreziana *compared with the δ¹⁸O fluctuations in Kilimanjaro ice cores and calculated rainfall from speleothems in the Soreq cave.*

Figure 12.11. A cypress door still in use in a private traditional art museum in Ghat (1999).

As a consequence, the whole Saharan area suffered a contraction of water availability. Previously widespread over the territory, water resources became limited to specific confined areas where, due to favorable geological conditions, the hydrological reservoirs were not exhausted by the incoming drought (Gasse 2000). This phenomenon has been recently studied in the Wadi Tanezzuft, which at about 5000 yr BP, when the surrounding ergs and mountains were desertified, fed a large oasis about 80 km long (Cremaschi and di Lernia 1999; 2001; Cremaschi 2001). The two periods of enhanced precipitation at 3400 and 2500 cal yr BP, short but apparently intense, were responsible for the partial recharge of the acquifers, and can be seen as the climatic causes of the persistence of the oasis from the IV to the II millennium BP. The existence of large areas still suitable for life inside a drying territory had important cultural implications, as during these millennia, the pastoral communities concentrated in the oases, becoming sedentary, operating domestication of the date palm, introducing agriculture, and giving rise to complex societies. As these wet periods are recorded all over tropical Africa, the case of the palaeo-oasis of Wadi Tanezzuft may probably be extrapolated to the whole Saharan region.

The *Cupressus dupreziana* record also demonstrates that desertification is a very recent event. Moderately wet conditions persisted up to 1940 cal yr BP, and present hyperarid conditions began only at 1370 cal yr BP, when they caused a dramatic contraction of the oasis, which in the case of the wadi Tanezzuft coincided with the collapse of the Garamantic kingdom (Cremaschi 2003; Cremaschi et al. 2002).

Further research is needed to fill the gaps still existent in the dendroclimatic curve. It would be important to understand whether the large interval deprived of samples from 4500 to 3420 cal yr BP, is just a chance occurrence, or whether it indicates a phase of poor development of the cypress trees, as in part it corresponds to a dry period in most African records. Further samples are needed to improve the resolution of the diagram from a decennial to an annual scale of events.

To solve these problems, more research is needed and more samples have to be studied. This statement necessarily implies particular ethics and strategies on the parts of both scientists and officers. The doors made from *Cupressus dupreziana* are a part of the desert cultural heritage and relevant archive of information for palaeoclimatic reconstruction and they are threatened with destruction. Scientists must develop non-destructive techniques for their study, government officials must promote policies aimed at protecting the doors from destruction and preserving them in the context of archaeological parks and local museums (Fig. 12.11).

Acknowledgements

This research has been promoted and directed by M.C., who is responsible for the field work and palaeoclimatic interpretation. Dendroclimatic analysis is by M.P. and M.S.. The authors' email addresses are: mauro.cremaschi@unimi.it.; manuela.pelfini@unimi.it; maurizio.santilli@unimi.it. The authors are deeply indebted to Mohammed Denda representative in Ghat of the Department of Antiquities and Umar Airalla, who helped in many ways the research of samples of Tarut doors. The radiocarbon dates were performed at the Geochron Lab. The authors are grateful to A. Cherkinski, for cooperation and suggestions.

References

Bar-Matthews, M., Avner, A. and Kaufman, A. 1998. Middle to Late Holocene (6500 Yr. Period) paleoclimate eastern Mediterranean region from stable isotopic composition of Speleothems from Sireq Cave, in A.S. Issar and N. Brown (eds), *Water, Environment and Society in Times of Climatic Change*, The Hague: 203-214.

Barry, J.P. 1970. Essai de monographie du *Cupressus dupreziana* A. Camus, cyprès endémique du Tassili des Ajjer (Sahara Central). *Bulletin de la Société d' Histoire Naturelle de l'Afrique du Nord* 61: 95-178.

Camus, A. 1926. Le *Cupressus dupreziana* A. Camus, Cyprès Nouveau du Tassili. *Bulletin de la Societé Dendrologique Française* 58: 39-44.

Cremaschi, M. 1998. Late Quaternary geological evidence for environmental changes in south-western Fezzan (Libyan Sahara), in M. Cremaschi and S. di Lernia, (eds.), *Wadi Teshuinat. Palaeoenvironment and Prehistory in south-western Fezzan (Libyan Sahara)*, Quaderni di Geodinamica Alpina e Quaternaria, 7, Milan: 13-48.

Cremaschi, M. 2001. Holocene climatic changes in an archaeological landscape: the case study of wadi Tanezzuft and its drainage basin (SW Fezzan, Libyan Sahara). *Libyan Studies* 32: 3-27.

Cremaschi, M. 2002. Late Pleistocene and Holocene climatic changes in the central Sahara: the case study of the Southwestern Fezzan Libya, in F.A. Hassan (ed.), *Droughts, Food and Culture*, New York: 65-82.

Cremaschi, M. 2003. Steps and timing of the desertification in the late antiquity. The case study of the Tanezzuft oasis (Libyan Sahara), in M. Liverani (ed.), *Arid Lands at the Time of the Roman Empire*, AZA Monographs, Roma: 1-14.

Cremaschi, M. and di Lernia, S. 1999. Holocene climatic changes and cultural dynamics in the Libyan Sahara. *African Archaeological Review* 16, 4: 211-238.

Cremaschi, M. and di Lernia, S. 2001. Environment and settlement in the mid-Holocene palaeo-oasis of the wadi Tanezzuft (Libyan Sahara). *Antiquity* 37: 453-457.

Cremaschi, M., di Lernia, S., Liverani, M., Pelfini, M. and Santilli, M. 2002. The late desertification in the central Sahara: rise and decline of the kingdom of Garamantes, in S. Leroy and I.S. Stewart (eds.), *Environmental Catastrophes and Recovery in the Holocene*, (Abstracts volume, Brunel West London): 23-24.

Dobr, J. 1988. *Cupressus dupreziana. Threatened Plants Newsletter* 20: 8.

Dubief, J. 1999. *L'Ajjer Sahara Central*, Paris

Fritts, H.C. 1976. *Tree Rings and Climate*, New York.

Gasse, F. 2000. Hydrological changes in the African tropics since the Last Glacial Maximum. *Quaternary Science Reviews* 19: 189-211.

Gasse, F. 2002. Kilimanjaro's secrets revealed. *Science* 298: 548-549

Gasse, F. and Fontes, J.C. 1989. Palaeoenvironment and Palaeohydrology of a tropical closed lake (Lake Asal, Djibouti) since 10,000 yr BP. *Palaeogeography, Palaeoclimatology, Palaeoecology* 69: 67-102.

Gasse, F., and Street, F.A. 1978. Late Quaternary lake level fluctuations and environments of the Northern Rift valley and Afar Region (Ethiopia and Djibouti). *Palaeogeography, Palaeoclimatology, Palaeoecology* 24: 279-325.

Gasse, F., Rognon, P., and Street, F.A. 1980. Quaternary history of the Afar and Ethiopian Rift Lakes. In M.A.J. Williams and H. Faure (eds.), *The Sahara and The Nile*, Balkema, Rotterdam: 361-400.

Gaussen, H. 1961. A propos du Cypres des Ajjers. Son intere forestier. *Revue forestière française*, 2: 98-102.

Glerum, C. 1970. Drought ring formation in conifers. *Forestal Sciences* 16, 2: 246-248.

Grissino-Mayer, H.D. 1993. An updated list of species used in tree-ring research. *Tree-Ring Bulletin* 53: 17-43.

Hachid, M. 2000. *The Tassili des Ajjer*, Paris.

Kuniholm, P. 1994. Long tree-ring chronologies for the Eastern Mediterranean, in *Archaeometry '94: Proceedings of the 29th International Symposium on Archaeometry*, Ankara: 401-409.

Kuniholm, P. 1996. The prehistoric Aegean: dendrochronological progress as of 1995. *Acta Archaeologica* 67: 327-335.

Liphschitz, N. 1986. Overview of the dendrochronological and dendroarchaeological research in Israel. *Dendrochronologia* 4: 37-58.

Liverani, M. 2000. The Garamantes a fresh approach. *Libyan Studies* 31: 17-28.

Maire, R. 1933. Etudes sur la flore et la vegetation du Sahara central. *Mémoires de la société d'histoire naturelle de l'Afrique du nord* 3: 49-50.

Maley, J. 1994. Middle and late Holocene changes in tropical Africa and other continents: paleomonsoon and sea surface temperature variations, in H.N. Dalfes, G. Kukla and H. Weiss (eds.), *Third Millennium BC Climate Change and Old World Collapse* (NATO ASI Series I. Global Environmental Change 49): 611-640.

Rinn, F. 1996. *TSAP Time Series Analysis and Presentation*. Version 3.0 Reference manual, New York.

Schweingruber, F.H. 1988. *Tree Rings. Basics and applications of dendrocronology*, New York.

Schweingruber, F.H., Eckstein, D., Serre-Bachet, F. and Bräkerm, O. 1990. Identification, presentation and interpretation of event years and pointer years in dendrochronology. *Dendrochronologia* 8: 9-38.

Simoneau, P. and Debazac, E.F. 1961. Le Cyprès des Ajjer. *Revue Forestiale Française* 2: 90-97.

Stuiver, M., Reimer, P.J., Bard, E., Beck, J.W., Burr, G.S., Hughen, K.A., Kromer, B., McCormac, F.G., Plicht, J. and Spurk, M. 1998. INTCAL98 Radiocarbon age calibration 24,000-0 cal BP. *Radiocarbon* 40: 1041-1083.

Thompson, L.G., Mosley-Tompson, E., Davis, M.E., Henderson, K.A., Brecher, H.H., Zagorodnov, V.S., Mashiotta, T.A., Lin P., Mihhalenko, V.N., Hardy, D.R. and Beer, J. 2002. Kilimanjaro ice core records: evidence of Holocene climate change in Tropical Africa. *Science* 298: 589-593.

Zahner, R. 1968. Water deficits and growth of trees, in R. Zahner (ed.), *Water deficit and Plant Growth II*, Academic Press, New York: 191-254.

13. Late Quaternary Environmental Changes in the Fazzan, Southern Libya: Evidence from Sediments and Duricrusts.

By Sue McLaren[1], Nick Drake[2], Kevin White[3]

Abstract

The palaeogeomorphological and sedimentological research that has been conducted as part of the geoarchaeological Fazzan Project has provided information about past environments and environmental change in the Wadi al-Ajal area and parts of the Ubari and Murzuq Sand Seas in southern Libya. As a result of the palaeogeomorphological investigations carried out so far, a range of duricrusts and sediments from various palaeoenvironments has been identified, sampled and analysed. These duricrusts included: calcretes, cal-silcretes and silcretes as well as dark organic palaeolake sediments with abundant fresh water gastropods including *Melanoides tuberculata, Corbicula africana, Bulinus truncates* and *Afroplanorbis sp.*; small lake/pond sediments; and palaeospringline deposits containing fibrous gypsum and anhydrite minerals.

Studies of the sedimentology along with geomorphological evidence and archaeological remains in the Fazzan indicate that this currently hyper-arid region experienced wetter phases in the past. Lake sediments and various geochemical crusts demonstrate the existence of ponds and lakes and a higher groundwater table during several phases of the Late Quaternary (Cremaschi 1998; White *et al.* 2000). This paper concentrates on the range of different deposits present within the study area and discusses what they can tell us about past environmental conditions.

Introduction

Palaeoenvironmental reconstructions for the Late Quaternary (that is the last 250,000 to 300,000 years) have been made in the Fazzan area. Over the Quaternary Period the Earth has experienced major climate changes, between colder glacial phases and relatively warmer interglacials. Such changes in climate resulted in several advances and retreats of ice cover at higher latitudes whilst nearer the equator there were changes in temperature, evaporation and rainfall. The landscape and deposits preserved in the Fazzan reflect these varying environmental changes. Key geomorphological features are frequently associated with archaeological artefacts and other materials suitable for dating. The preserved late Quaternary deposits in the study area are generally associated with the presence in the past of surface water or near-surface groundwater, and include a variety of geochemical crusts and palaeolake sediments, as well as the remains of various species of mollusc. This paper is linked with White *et al.* (this volume) who discuss the usefulness of remote sensing in identifying palaeolakes in the Fazzan and Drake *et al.* (this volume) who describe the timing of the wetter phases in this part of the Sahara and links our evidence with that of other workers who have studied late Quaternary palaeoenvironmental change in other parts of the Sahara.

[1]Department of Geography, University of Leicester
[2]Department of Geography, King's College London
[3]Department of Geography, University of Reading

Modern-day Geomorphology

The study area focuses on the southern part of the Ubari Sand Sea, along the Wadi al-Ajal and Wadi Irawan, the Messak Settafet and the northern part of the Murzuq Sand Sea (Fig. 13.1). The Ubari Sand Sea is a large, predominantly linear dune field. The main trend of the dunes is in an east-north-east to west-south-west direction (Brooks *et al.* 2003). The interdune areas often contain evidence of past higher water tables in the form of duricrusts and black organic palaeolake sediments, often with significant scatterings of lithics, ostrich shell and bones. Presently, in some places there are higher water tables that result in perennial and seasonal lakes with surrounding palm trees. The palaeolake deposits are concentrated in the southern regions of the Ubari Sand Sea, and are most common west of the town of Ubari. The distribution of palaeolakes is related to surface elevation, with most deposits occurring below 530 m (Brooks *et al.* 2003).

South of the Ubari Sand Sea is the flat playa surface of the Wadi al-Ajal (Fig. 13.2). After rainfall a number of short-term lakes often form which, on drying out, results in the precipitation of soluble salts such as gypsum and halite that were dissolved by the water from the previous rainfall event. In some places the salts precipitate out as small crystals on the playa surface.

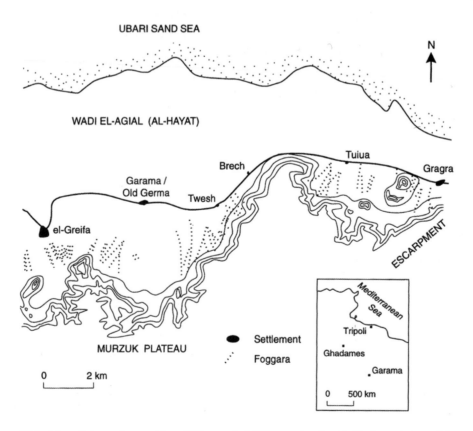

Figure 13.1. Map of the study area (from White et al. *2000 reproduced with kind permission of Springer Science and Business Media).*

Figure 13.2. Salt encrusted surface in the Wadi al-Ajal.

These salts are prone to erosion and are often entrained by the wind and transported down wind. Elsewhere the salts form a more indurated crust. There are also a number of phreatophyte or spring mounds that have formed as a result of sand being trapped by vegetation over time allowing mounds to gradually build up, some of which are up to ten metres high.

Moving towards the escarpment of the Messak Settafet beyond the playas and the oases around the Wadi al-Ajal is a gently rising pediment surface, which has a thin covering of angular alluvium and colluvium. The slopes of the escarpment are generally steep (except towards the base) and are dominated by gravity-driven processes. Small low angled alluvial fans and relict hillslopes known as flatirons (Dorn 1994) are also present.

The Messak consists of the Jarma (or Germa) marl Beds, which are overlain by the Murzuq Formation (Nubian sandstone). At the top of the escarpment is the flat hamada surface that is largely covered in a lag of angular varnished pebbles through to boulders that lie on top of a skeletal entisol soil. In some areas there are depressions that are lacking in any coarse debris. These features are often circular with no clear evidence of flow either into or out of them and are thought to be areas of sediment accumulation as a result of slope wash from the surrounding area. Abundant Pleistocene and Holocene lithics are found scattered on the hamada surface. There are distinctive southward dip-slope drainage systems that feed from the Messak down towards the Wadi Barjuj. Beyond this fluvial system is the large expanse of the Murzuq Sand Sea, which also contains abundant remnant deposits of ancient palaeolakes.

Geochemical Sediments

Duricrusts are extremely useful in providing evidence of past environmental changes in arid regions such as the Fazzan, as they yield information concerning the availability and composition of groundwater, as well as being associated with palaeolake deposits yielding organic material for radiocarbon dating. There are a wide variety of duricrusts in the Fazzan: calcretes and gypcretes are the most common; cal-silcretes and silcretes are present but are relatively rare. Calcrete, gypcrete and cal-silcrete occur both in isolation but in some places they are found together. Some of these duricrusts appear to cap organic-rich lake sediments.

Duricrusts are commonly found in low-latitude regions in arid and semi-arid environments, although they have also been found in more temperate locations such as the U.K. (Strong *et al.* 1992). They form in a wide range of geomorphological settings as a result of a number of different controlling processes. For example, indurated crusts can form in lake or pan settings (e.g. Thomas *et al.* 2003), in valleys (e.g. Nash and McLaren 2003), in river channels (McLaren 2004), or on weathering surfaces. Waters, containing minerals in solution, move vertically and laterally through deposits by processes of drainage and evapotranspiration as a result of capillary rise. Over time the concentration of waters with respect to elements such as calcium and silica leads to supersaturation and eventually to precipitation of crystals. Different geochemical processes occur in different locations in the landscape and at varying rates, and this will affect their preservation potential.

Calcretes

Calcium carbonate ($CaCO_3$) cemented crusts are known as calcretes, and tend to form where moisture is deficient (Goudie 1983). They range in form from massive indurated through to powdery types (Goudie 1973). Most calcretes form where rainfall is between 400 and 600 mm p.a. but in some areas it may be higher (although evapotranspiration rates are high in such environments). Phreatic calcretes i.e. those associated with the groundwater table, tend to form in more arid conditions and pedogenic or soil-related forms in slightly wetter environments.

Calcretes form as a result of carbonate solutions moving through sediment profiles. These solutions gradually become more and more concentrated until precipitation of calcium carbonate minerals starts to occur (Nash and McLaren 2003). Mechanisms involved in inducing precipitation include decreasing the

Figure 13.3. Rubbly Calcrete in the Ubari Sand Sea.

partial pressure of carbon dioxide; increasing the pH to above pH 9.0; evaporation; biological activity including evapotranspiration; and the common ion effect (Wright and Tucker 1991). The sources of carbonates for the cement can be quite variable. Dissolution of bedrock or sediment, aerosols, rainfall, groundwater, river or lake water, shells, plants and sea spray (in coastal locations) are some of the more common sources (McLaren 1993; Gardner and McLaren 1994).

Calcretes are abundant in the Wadi al-Ajal and in both the southern part of the Ubari Sand Sea and the northern part of the Murzuq Sand Sea. These sand sea calcretes are predominantly found in the interdune areas (see Fig. 13.3), which are likely to have been wetter than dune crests as they are closer to the groundwater table. West of Jarma, and particularly west of Ubari, calcrete surfaces are easily identified due to the lack of disturbance of the surface by human

Figure 13.4. SEM micrograph showing quartz clasts floating in a micritic calcrete matrix (scale bar is 150 microns).

activity, and are often partly hidden by wind-blown sands. Extensive zones of highly indurated calcrete fragments, ranging from pebble to boulder size, are common to the south of the Ubari-Ghat road west of Ubari, close to the escarpment edge.

Around the Wadi al-Ajal, calcretes are found in sections in some of the wells such as at 26.57517 N, 12.94617 E). The duricrusts in the wells are highly indurated with displaced floating clasts, minimal porosity and replacement of grains (Fig. 13.4). There are no laminations in the well calcretes and a lack of evidence of biological features such as rhizoliths and calcified micro-biota. This suggests a groundwater origin – in the zone of intense evaporation and capillary rise directly above the water table.

Silcretes and cal-silcretes

Siliceous crusts may develop in highly alkaline evaporitic basins and in association with micro-organisms. Silcretes are found in a variety of geomorphological settings, of which the most common are in association with remnants of palaeosurfaces, pan margins and in palaeodrainage systems (Nash *et al*. 2004). There is a great deal of debate as to whether silcretes are a result of weathering, hydrological processes or pedogenesis (Watson and Nash 1998).

The most commonly cited source of silica is as a result of chemical weathering of silicate minerals. Apart from the quartz sands of the Ubari and Murzuq Sand Seas, the Murzuq Sandstone Formation is also rich in quartz, so there is no shortage of surficial quartz from which the silica cement could have been derived. Other sources are from aerosols, silica-rich plants and

micro-organisms such as diatoms. Transportation of silica-rich solutions is mainly in the form of movements of groundwater, pore water and surface water.

Analysis of the micromorphology of the cal-silcretes and silcretes in the Murzuq Sand Sea reveals evidence of cement replacement, suggesting that they were originally calcretes that have had the carbonate cement replaced or partially replaced by silica. This may be as a result of changes in the pH of the pore waters.

Gypsum crusts

Gypsum crusts, or gypcretes, are only preserved in very arid areas, as their calcium sulphate cement ($CaSO_4.2H_2O$) is relatively soluble, more so than calcium carbonate or silica. In Fazzan they are present as surface crusts above calcretes, generally as a massive or powdery deposit that often forms an erosion-resistant horizon at the land surface. Water pumped from wells in Fazzan is rich in both calcium and sulphate, suggesting that groundwater may be the source of the gypsiferous cement. For example at Tuwash sampled groundwater contained 94 ppm Ca and 220 ppm S, whilst at Al Grayfah well waters contained 296 ppm Ca (the water chemistry data was determined by ICP-MS).

Apart from the cement in gypcretes, gypsum is found in a variety of crystal forms throughout Fazzan. Desert roses are large intergrowths of lenticular gypsum crystals and are found within the sandy and silty sediments of the Wadi al-Ajal. Desert roses form by displacive crystallisation in the host sediment under arid conditions, and are indicative of a fluctuating groundwater table. Large amounts of gypsum and anhydrite (gypsum with the water of crystallisation driven off) are found in the form of old springlines along the base of the escarpment. At the contact between the Jarma Beds (shales, siltstones and thin interbedded sandstones) and the overlying Murzuq Formation, discontinuous tufas (calcareous deposits) have been deposited by evaporating groundwater. In places, large crystals of gypsum ($CaSO_4.2H_2O$) are found between brecciated blocks of sandstone and marl. Good examples can be seen adjacent to the village of Tuwash (26.534 N, 13.10817 E). This is indicative of post-depositional emplacement by mineral-rich groundwater. In places high surface temperatures have driven off the water of crystallisation, turning the gypsum to anhydrite. These tufas provide evidence of a previously active springline, with groundwater moving along the junction between the impervious Jarma Beds and the porous overlying Murzuq Formation. The tufa deposits are mostly covered by recent colluvium, and are only exposed in shallow wadi sections.

Palaeolake Sediments of the Wadi al-Ajal

Palaeolake sediments are found along the mountain front at the base of the escarpment around and to the west of Jarma. In places a full sequence of palaeolake sediments is evident in section, with a basal mottled yellow layer overlain by red silts with root casts, interpreted as lacustrine sediments.

Figure 13.5. Melanoides tuberculata *shells from palaeolake sediments in the Wadi al-Ajal (from White* et al. *2000 reproduced with kind permission of Springer Science and Business Media).*

This, in turn, is overlain by grey organic lacustrine silts with numerous mollusc shells (Fig. 13.5). These deposits are usually capped by duricrusts, predominantly calcretes overlain by a thin capping of gypsum crust in places. This sedimentary sequence may be the result of the gradual desiccation of a large lake, which culminated in gypsum precipitation and was followed by weathering, duricrust formation and extensive deflation so that now only remnants of the lake shorelines are left in favourable positions protected from erosion.

Under the scanning electron microscope (SEM) there is evidence of an organic control on the formation of these calcrete duricrusts, with abundant calcified tubules and filaments of soil micro-organisms present (Fig. 13.6). It is clear that these crusts are derived from lake sediments, as in thin section a number of small shell fragments are present within the calcrete. Shells within the duricrust are too poorly preserved for dating; however, mollusc

Figure 13.6. SEM micrograph showing calcified tubules (scale bar is 30 microns).

shells found in the grey organic silts beneath them are well preserved. At all sites where shells have been found, *Melanoides tubercolata* has been the dominant species, but *Bulinus truncatus* is also common at some locations. Both *Melanoides tubercolata and Bulinus truncatus* have been found in Holocene lacustrine deposits in the Erg Uan Kasa and the Murzuq Sand Sea by Girod (1998) and in Wadi ash-Shati by Petit-Maire *et al.* (1980). Girod (1998) describes these species as being widespread throughout the Mediterranean, Middle East and Africa. *Melanoides tubercolata* survives in a range of salinities and environments, but is absent from locations subject to periodic aridity, indicating that Fazzan environments in question must have been characterised by perennial water bodies that varied in salinity over time.

Palaeolakes of the Ubari and Murzuq Sand Seas

Palaeolakes in the southern Ubari and the northern Murzuq Sand Seas are characterised by scattered patches of calcrete, cal-silcrete and silcrete now forming inverted relief. These grey duricrusts are generally highly indurated and have a rubble-like texture (Figs 13.3 and 13.7). The cements are predominantly made up of finely crystalline micrite with small amounts of later-stage coarser sparry crystals that have displaced the largely quartz matrix. The fine size of the crystals may be a result of rapid precipitation under conditions of high evaporation. In places cemented root casts (rhizoliths) are abundant and are a result of calcium carbonate precipitation around plant roots. In some places the primary phase of calcrete development has been followed by a later-stage partial replacement by silica.

Figure 13.7. Calcrete capping palaeolake sediments that now displays inverted relief, Ubari Sand Sea.

Summary

The sedimentological and palaeogeomorphological indicators of past environments should be interpreted within the context of global climatic change and its impact on the Sahara in general and the Fazzan in particular (see Cremaschi this volume; Drake *et al.* this volume). The range of sediments and fossils present indicate conditions in the past that were, at times, significantly wetter than they are today with standing perennial water bodies present. It is currently thought that arid phases in the Sahara have generally coincided with glacial conditions in the northern hemisphere. Glacial conditions resulted in lower sea surface temperatures, reduced evaporation, lower atmospheric moisture availability and decreased atmospheric instability. Humid episodes are thought to be associated with interglacial stages. The average rainfall today is less than 20mm p.a. yet in the early Holocene archaeological remains including rock carvings provide supporting evidence for conditions significantly wetter than they are today, that were able to support humans and large mammals such as hippopotamus, giraffe and elephants (see Alley *et al.* 1997; Barber *et al.* 1999; Beck 1998; Gasse and van Campo 1994 and Maley 1977 for further details).

References

Alley, R.B., Mayewski, P.A., Sowers, T., Stuiver, M., Taylor, K.C. and Clark, P.U. 1997. Holocene climatic instability: A prominent, widespread event 8200 years ago. *Geology* 25: 483-486

Barber, D.C., Dyke, A., Hillaire-Marcel, C., Jennings, A.E., Andrews, J.T., Kerwin, M.W. and Bilodeau, G., McNeely, R., Southon, J., Morehead, M.D. and Gagnon, J.M. 1999. Forcing of the cold event of 8,200 years ago by catastrophic drainage of Laurentide lakes. *Nature* 400: 344-348.

Beck, W. 1998. Warmer and wetter 6000 years ago? *Science* 279: 1003-1004.

Brooks, N., Drake, N., McLaren, S. and White, K. 2003. Studies in Geography, Geomorphology, Environment and Climate. In D. Mattingly (ed.), *The Archaeology of Fazzan Volume I: Synthesis*, Society for Libyan Studies, London: 37-74.

Cremaschi, M. 1998. Late Quaternary geological evidence for environmental changes in south-western Fazzan (Libyan Sahara), in M. Cremaschi and S. di Lernia (eds), *Wadi Teshuinat: Palaeoenvironment and prehistory in south-western Fezzan (Libyan Sahara)*, Centro Interuniversitario di Ricerca per le Civiltà e l'Ambiente del Sahara Antico, Milan: 13-47.

Dorn, R.I. 1994. The role of climate change in alluvial fan development, in A. D. Abrahams and A.J. Parsons (eds), *Geomorphology of Desert Environments*, London: 593-615.

Gardner, R. and McLaren, S. 1994. Variability in early vadose carbonate diagenesis in sandstones. *Earth Science Reviews* 36: 27-45.

Gasse, F. and van Campo, E. 1994. Abrupt postglacial climate events in West Asia and North Africa monsoon dynamics. *Earth and Planetary Science Letters* 126: 435-456.

Girod, A. 1998. Molluscs and palaeoenvironment of Holocene lacustrine deposits in the Erg Uan Kasa and in the Edeyen of Murzuq (Libyan Sahara), in M. Cremaschi and S. di Lernia (eds), *Wadi Teshuinat: Palaeoenvironment and prehistory in south-western Fezzan (Libyan Sahara)*, Centro Interuniversitario di Ricerca per le Civiltà e l'Ambiente del Sahara Antico, Milan: 73-88.

Goudie, A.S. 1973. *Duricrusts in Tropical and Subtropical Landscapes*, Oxford.

Goudie, A.S. 1983. Calcretes, in A.S. Goudie and K. Pye (eds), *Chemical Sediments and Geomorphology*, London: 93-131.

Maley, J. 1977. Palaeoclimates of the Central Sahara during the early Holocene, *Nature* 269: 573-577.

McLaren, S.J. 1993. Use of cement types in the palaeoenvironmental interpretation of coastal aeolian sedimentary sequences, in K. Pye (ed), *The Dynamics and Environmental Context of Aeolian Sedimentary Systems*. Geological Society Special Publication 72: 235-244.

McLaren 2004. Characteristics, evolution and distribution of Quaternary channel calcretes, southern Jordan. *Earth Surface Processes and Landforms* 29: 1487-1508.

Nash, D.J. and McLaren, S.J. 2003. Kalahari valley calcretes: their nature, origins and environmental significance. *Quaternary International* 111: 3-22.

Nash, D.J., McLaren, S.J and Webb, J.A. 2004. Petrology, geochemistry and environmental significance of silcrete-calcrete intergrade duricrusts at Kang Pan and Tswaane, central Kalahari, Botswana. *Earth Surface Processes and Landforms* 29: 1559-1586.

Petit-Maire, N., Delibrias, G. and Gaven, C. 1980. Pleistocene lakes in the Shati area, Fazzan. *Palaeoecology of Africa* 12: 289-295.

Strong, G.E. Giles, J.R.A. and Wright, V.P. 1992. A Holocene calcrete from North Yorkshire, England: implications for interpreting palaeoclimates using calcretes. *Sedimentology* 39: 333-347.

Thomas, D.S.G., Brook, G., Shaw, P.A. Bateman, M. Haberyan, K., Appleton, C. Nash, D. J., McLaren, S. J., and Davies, F. 2003. Late Pleistocene wetting, drying in the NW Kalahari: an integrated study from Tsodilo Hills, Botswana. *Quaternary International* 104: 53-67.

Watson, A. and Nash, D.J, 1998. Desert crusts and varnishes, in D.S.G. Thomas (ed), *Arid zone Geomorphology: processes, form and change in drylands*, Wiley, London: 69-109.

White, K., McLaren, S., Black, S. and Parker, A. 2000. Evaporite minerals and organic horizons in sedimentary sequences in the Libyan Fazzan: implications for palaeoenvironmental reconstruction, in S.J. McLaren and D.R. Kniveton (eds), *Linking Climate Change to Land Surface Change:* 193-208.

Wright, V.P. and Tucker, M.E. (eds). 1991. *Calcretes*. Reprint series Volume 2 of the International Association of Sedimentologists, Oxford.

14. Biogeographical Studies in the Regions of Hamada al-Hamara, Wa'sa and the Hamada al-Gharbiya (the Hamada of Ghadamis) and Evidence for Environmental Degradation.

By Sulayman al-Mahdi Bilkhayer[1]

Abstract

The paper reviews recent surveys of vegetation in the Hamada al-Hamara, Wa'sa and the Hamada al-Gharbiya (the Hamada of Ghadamis). Evidence is presented of environmental degradation, marked by the disappearance of established flora from these zones.

Introduction

Hamada al-Hamara, Wa'sa and the Hamada al-Gharbiya (the Hamada of Ghadamis) are all areas that are subject to severe ecological pressures because of their location within desert environments. However, in addition to natural factors affecting the tolerance levels of plants these areas are also affected by the pressures of pastoral farming. As a consequence, over time, the vegetation in the study areas has developed a level of resistance and can cope with small-scale changes in the already harsh environment.

Evidence for Environmental Degradation

The field sites have been studied for a number of years by researchers at the Centre of Agricultural Research in Libya and in recent years they have been alarmed by the escalation in the level of environmental degradation that has occurred. Many plant species including *Artemisia herba-alba, Pituranthos rohlfsianus, Astragalus* spp. and *Zilla spinosa* have entirely disappeared in some locations. These plants have been replaced by plants characterised by being toxic or having spikes or dangerous thorns. This change and degradation of the vegetation is thought largely to be a result of increased and uncontrolled pastoral farming, potentially beyond sustainable levels. Paving of the roads in and around the area has occurred at the same time. The improved transport networks have made it easier to bring in water from outside the study areas, further increasing the susceptibility of this area to environmental degradation in the future.

Plants that are still present in the three study areas are shown in Table 14.1. More than 50 plant types have been identified. Numbers (1), (2) and (3) in the table relate to the locations that the plants have been found in. (1) indicates the plants found in Hamada al-Hamara, (2) identifies the plants from Hamada al-Gharbiya (the Hamada of Ghadamis) and (3) those from Wa'sa.

In addition to the loss of vegetation, including specific plant species over recent years, the three study areas have also suffered the loss of many animals such as the famous Libyan Gazelle

[1] The Centre of Agricultural Research, Tripoli

(antelope), other antelopes, and ostriches. These animals have all now disappeared as a result of unregulated hunting (of which the Libyan Gazelle was the last to vanish).

Plant Family/ Genus/Species	Areas where found	Plant Family/ Genus/Species	Areas where found
FUNGI			
PEZIZALES			
Terfezia spp.	1		
LICHENS			
LECANORACEAE			
Lecanora esculenta	1		
GYMNOSPERMS			
EPHEDRACEAE			
Ephedra spp.	2-3		
ANGIOSPERMS			
APIACEAE		CHENOPODIACEAE continued	
Pituranthos rohlfsianus	1-2	Salsola baryosma	2-3
		Salsola longifolia	1
ASCLEPIADACEAE		Traganum nudatum	1-2
Pergularia tomentosa	2		
		CISTACEAE	
ASTERACEAE		Helianthemum lippii	1-2-3
Anvillea garcinii	1-2		
Artemisia herba-alba	1-2	CONVOLVULACEAE	
Artemisia judaica	2	Convolvulus supinus	1-3
Atractylis serratuloides	1-2		
Pulicaria spp.	1-2	CUCURBITACEAE	
		Citrullus colocynthis	2-3
BORAGINACEAE			
Heliotropium bacciferum	2	EUPHORBIACEAE	
		Euphorbia retusa	1-2-3
BRASSICACEAE			
Anastatica hierochuntica	2	FABACEAE	
Diplotaxis harra	1-3	Acacia tortilis	2
Oudneya africana	1-2-3	Anthyllis henoniana	3
Zilla spinosa spp. spinosa	1-2-3	Astragalus spp.	1-3
		Retama raetam	1-2-3
CAPPARACEAE			
Capparis cartilaginea	2	GERANIACEAE	
		Monsonia nivea	1
CHENOPODIACEAE			
Anabasis articulata	1-2-3	ILLECEBRACEAE	
Atriplex halimus	2-3	Gymnocarpos decandrus	1
Bassia muricata	1	Paronychia arabica	1
Cornulaca monacantha	2		
Hammada schmittiana	1-2-3	LAMIACEAE	
Kochia indica	1-2	Marrubium deserti	1-2

POACEAE		RUTACEAE	
Cymbopogon schoenanthus	2	Haplophyllum tuberculatum	1-2-3
Panicum turgidum	2		
Stipagrostis ciliata	1-2-3	SCROPHULARIACEAE	
Stipagrostis pungens	3	Anarrhinum fruticosum	1-3
		Kickxia aegyptiaca	1
POLYGONACEAE			
Calligonum spp.	1-2-3	SOLANACEAE	
		Hyoscyamus muticus	2
RESEDACEAE			
Reseda villosa	2	TAMARICACEAE	
		Tamarix passerinoides var. macrocarpa	1-2-3
RHAMNACEAE			
Ziziphus lotus	1-2-3	ZYGOPHYLLACEAE	
		Fagonia bruguieri	1-2
		Nitraria retusa	2

Table 14.1. Vegetation found in the three study areas during the last visit in January 2001. (1) Hamada al-Hamara area; (2) Hamada al-Gharbiya (the Hamada of Ghadamis) area; (3) Wa'sa area.

Coping Strategies

Over recent years there have been attempts to collect the seeds of plants from the study areas for storage in order to safeguard species that might otherwise be lost due to their becoming extinct or through mutation of genetic material in the plants as a consequence of the environmental changes.

The Libyan Centre of Agricultural Research has made use of two ways to preserve seeds from loss. The first method is to try and reproduce and grow the plants in protected fields. This process provides further seeds as well as plants for replanting. The second way is to store the seeds in a refrigerator which can be done for varying time periods. If the purpose of storage is for the medium term, they can be kept at temperatures of about 0°C and with relative humidity at between 15 to 20 percent. Under such conditions the storage duration would be in the order of 20 to 30 years. If long-term storage is required then the seeds need to be stored at -22°C with a relative humidity of about 5 to 6 percent. The seeds can then be stored for between 50 to 100 years.

By using such methods of preservation of seeds and the genetic material that they contain, the Centre of Agricultural Research in Libya has available samples that could be used to try and re-establish the plants if they become extinct from the Hamada al-Hamara, Wa'sa and the Hamada al-Gharbiya (the Hamada of Ghadamis). This process is therefore endeavouring to save current species from potential extinction from the study areas.

Acknowledgements
Thanks are due to Professor Marijke van der Veen and Tony Gouldwell of the School of Archaeology and Ancient History, University of Leicester, for help with the translation and transcription of the species names.

15. Food and Farming in the Libyan Sahara

By Marijke van der Veen[1]

Abstract
Botanical and faunal remains recovered by British, Italian and Libyan archaeologists from excavations of rock shelters in the Acacus mountains and settlement sites in the Wadi al-Ajal are providing a wealth of information regarding past diet and subsistence strategies. These data, covering occupation of the Libyan Sahara spanning the last 10,000 years, are reviewed here. Three separate subsistence strategies are identified: hunter-gatherers, pastoralists and farmers. Complex interrelations between nature and culture, and close contacts between the region and the wider world are identified.

Introduction

How did people in the past acquire their food? Did they go out to hunt animals and collect plant foods in the wild, or did they practice animal husbandry and crop cultivation? Did all their food come from the immediate environment in which they lived or did they acquire additional foodstuffs through long-distance trade and exchange? These types of questions are the concern of 'environmental archaeology', that area of archaeology that studies the relationship between people and their natural environment. This volume is concerned with the interactions between the natural resources of the Sahara and its cultural heritage, and what is more likely to draw these two aspects together than a study of food? Food procurement and production is influenced by the available natural resources of vegetation, soil nutrients, water, and temperature, as well as by the social structure of a society. Food consumption is closely linked to cultural concepts of what is nice to eat, what is prohibited, and what foods reflect one's cultural identity. By studying the history of food and farming in the Libyan Sahara we draw on both biological and cultural evidence and can identify the unique way in which past and present human societies in this region have shaped their lives.

The most direct evidence for food comes in the form of food remains (such as leftovers of meals, kitchen waste, agricultural by-products used as fodder or fuel). Recovered from archaeological excavations, these remains typically consist of fragments of bones from hunted or domesticated animals (often showing evidence of butchery), fruit stones, nutshells, the chaff and grains of cereals and the seeds of pulses, berries and herbs. In many environments these biological materials decay within a matter of years, but the arid conditions in the Libyan Sahara, while putting limitations on the extent of human settlement and agricultural production, have preserved these materials. The exceptionally dry conditions and consequent absence of bacterial decay leave such food remains remarkably well preserved, looking as if they were only discarded yesterday. Consequently, the region is very rich in such archaeological remains, offering a veritable feast for environmental archaeologists.

[1]School of Archaeology and Ancient History, University of Leicester

Over the past 50 years the fieldwork and research carried out by teams of British, Italian and Libyan archaeologists has produced an abundance of information about the cultural and environmental record of the region. In this paper I offer a brief synthesis of their work. At present, most of the evidence comes from a limited number of archaeological sites in just two parts of the region: from the prehistoric rock shelters in the Acacus mountains (especially from Uan Afuda, Ti-n-Torha and Uan Muhuggiag), and from two settlement sites in the Wadi al-Ajal: Zinkekra and Jarma. The paper identifies recent achievements, periods of change, areas of debate, as well as the urgent need for work in a wider part of the region than is currently the case.

Types of Subsistence

If we plot the principal sources of food for the last 10,000 years, we can identify three broad phases, each with a different type of subsistence strategy:

Hunter-Gatherers: c. 10,000-7000 BP

During this early phase people acquired their food by hunting wild animals and collecting wild plant foods. Most of the information comes from excavations at rock shelter and cave sites in the Acacus mountains: Uan Afuda in Wadi Kessan (Corridi 1998; di Lernia 1999), Uan Tabu in Wadi Teshuinat (Corridi 1998; Garcea 1998), Uan Muhuggiag in Wadi Teshuinat (Corridi 1998; di Lernia and Manzi 1998), and Ti-n-Torha in Wadi Ti-n-Torha (Barich 1987; Gautier 1987; Wasylikowa 1992a; 1992b; 1993).

Initially wild Barbary sheep provided the majority component of the diet, but over time we see both an increase in the range of wild animals hunted and a growing importance of wild plants. Gazelle, hare, rock hyrax, porcupine, jackal and wild birds are added to the diet and there is evidence for fishing: the bones of fish as well as actual fishhooks are clear pointers to the much wetter conditions at this time compared to the present day. Environmental evidence has revealed the existence of quite substantial lakes, and the wetter conditions also facilitated the growth of more abundant vegetation than we see today (Schulz 1987; Thinon et al. 1996). Botanical remains found during excavations of rock shelters such as Ti-n-Torha include a wide range of seeds and fruits, especially seeds of wild grasses, suggesting that these seeds were deliberately collected for food, and formed an important component in the diet. We see a similar pattern in other parts of the Sahara, such as in south-west Egypt (Barakat and Fahmy 1999; Wasylikowa and Dahlberg 1999). In fact, wild grasses remain an important source of food today, as witnessed by ethnographic research throughout the Sahara and Sub-Sahara (Harlan 1989a and 1989b).

Pastoralists: c. 7000-3500 BP

By about 7000 years ago we see a dramatic change: while wild animals were still being hunted, the majority of the meat intake now came from domestic animals. The evidence comes from just two sites, both rock shelters: Uan Muhuggiag, Wadi Teshuinat (Barich 1987; Gautier 1987; Wasylikowa 1992a; 1992b; 1993), and Uan Telocat, Wadi Imha (Corridi 1998; Garcea and Sebastiani 1998).

Domestic cattle bones were found at both these rock shelters, dating to the sixth to fourth millennia BP. During the early part of this phase, cattle bones dominate the faunal assemblages, though bones of domestic sheep and goat also occur. Notably, however, people continued to collect wild plant foods, such as grasses and fruits. There is no evidence for the domestication of any plants at this stage. Towards the end of this phase we see a gradual shift away from cattle to more sheep and goat and finally more goat than sheep, pointing to a gradual increase in aridity, also known from other evidence (Gautier 1987; cf. Cremaschi *et al.,* this volume; Drake *et al.,* this volume). This pattern is particularly clear at Uan Muhuggiag. Thus, during this period people were leading a pastoral lifestyle, moving with their animals in search of grazing. The use of ceramics at this time and the repeated return to the same rock shelter suggests a high degree of territoriality and a structured use of the landscape. By the end of this phase the climate in the region was as arid as it is today and settlement density decreased rapidly – the aridity making previous population levels impossible. It would appear that many people moved southwards with their herds as early as 5000 years ago (Holl 1998), others moved north towards the coast and east towards the Nile valley. From this time onwards occupation diverges: we see sparse nomadic occupation, based on camels rather than cattle, and settled occupation in the oases, based on crop cultivation. Mutual cooperation and reliance between these nomads and farmers made this a winning strategy in the arid conditions that have prevailed since.

Agriculturalists: c. 2700 BP - present
There is a gap in our evidence of almost 1000 years, but by just after 3000 years ago we find the first evidence for agriculture. The earliest evidence comes from Zinkekra in the Wadi al-Ajal (Daniels 1968; 1989; Van der Veen 1992), with the evidence from Jarma (Mattingly 2003; Mattingly, this volume; Pelling 2000; 2003; 2005) starting approximately when that at Zinkekra finishes. Moreover, isolated finds come from funerary contexts in the Wadi Tanezzuft (Cottini and Rottoli 2002), and from Uan Muhuggiag, Wadi Teshuinat (Van der Veen 1995; Wasylikowa and Van der Veen 2002; 2004).

A full range of domesticated crops and animals was found at Zinkekra, a hilltop village located on the escarpment along the Wadi al-Ajal, where occupation dates to between 2700 and 2400 BP. The site represents the earliest excavated evidence for permanent settlement and farming in the Libyan Sahara. Here a large assemblage of desiccated and charred plants was recovered, mostly of domesticated cereals and fruit crops such as emmer wheat, bread wheat, barley, dates, grapes and figs. These are not plants in the early stages of being domesticated, but fully-fledged cultivars, pointing to a developed system of agriculture, similar to present-day oasis cultivation. The bones of cattle, sheep, goat and pig point to the continued reliance on domestic animals, though crop plants now represent the main component of the subsistence strategy.

Jarma represents a long-lived settlement located in the Wadi al-Ajal itself. Here a long occupational sequence has been established, lasting almost 2000 years, starting during the Garamantian proto-urban period and running to the nineteenth century (Mattingly, this volume). Wheat and barley continue to be the most important cereal crops, but we see a reversal in terms of the type of wheat crop: in the early Garamantian period emmer wheat was the

principal wheat crop, in the later period it was bread wheat. This is a phenomenon we find right across the Mediterranean and Europe around this time, representing an expansion of agriculture (Van der Veen 1995). Cultivated fruits occur too: mostly dates, grapes and figs, as at Zinkekra. We see new introductions too in this period, notably the camel, pearl millet and sorghum, though the exact dates of their arrival in the region are still to be established. Towards the very end of the sequence, sometime during the seventeenth to nineteenth centuries AD we see the appearance of maize and chilli or sweet pepper, both of American origin (Pelling 2000).

Isolated finds are known from two sites in the Acacus mountains. Date stones, presumed to represent the domesticated date palm, *Phoenix dactylifera*, have been found in tombs in the Wadi Tanezzuft, dated to *c.*3000 BP and in the 'Royal Tumulus' at In Aghelachem dated to *c.*1800 BP (Cottini and Rottoli 2002). Similarly, such dates stones have been found at Uan Muhuggiag; one of which has been directly dated to 2130 ± 70 BP (OxA-4389; Wasylikowa and Van der Veen 2002).

Comparisons with Other Regions

Even though our database is still small, the pattern that has emerged is clearly different from that of other areas, such as the Near East, Egypt or the south-western Sahara. In the central Sahara wild plants play a prominent role in the subsistence strategy for some 7000 years, and in parts of the Sahara they continue to be important today (Harlan 1989a; 1989b). A similar pattern has been observed in the south-western Sahara (Amblard 1996; Amblard and Pernès 1989) and the West Africa Savanna region (Neumann 1999). In contrast, in the Near East plants are domesticated as early as 10,000 years ago (Miller 1991), while in the Nile valley crop cultivation starts *c.*7000 years ago (Wetterstrom 1993). This does not mean that the

		Plant Foods	Meat
Hunter-gatherers c. 10,000 - 7000 BP			
	early	Wild plants	Wild Barbary sheep
	late	Wild grasses, wild fruits and other wild seeds	Wild Barbary sheep, gazelle, hare, birds, fish
Pastoralists c. 7000 - 3500 BP			
	early	Wild grasses, wild fruits and other wild seeds	Domestic cattle, as well as sheep and goat
	late	Wild grasses, wild fruits and other wild seeds	Goat and sheep, cattle disappears
Agriculturalists c. 2700 BP - present			
	early Garamantian	Emmer wheat, barley, bread wheat, dates, fig, grapes	Cattle, sheep, goat, pig
	late Garamantian	Bread wheat, barley, emmer wheat, dates, fig, grapes, pearl millet	Cattle, sheep, goat, pig, and camel

Table 15.1. Simplified overview of subsistence strategies in the Libyan Sahara.

central Sahara is less advanced in its development. After all, the region sees the introduction of domestic cattle as early as in the Near East, and the same is true for ceramics, used for storing and cooking foods. Instead, what we see is the adaptation to a specific set of circumstances, combining aspects of different subsistence strategies in a way that best suits the local conditions (Tables 15.1-15.2).

	Libyan Sahara	Near East	Egypt	Western Sahara
Ceramics (food containers)	8000 BP	8000 BP	7000 BP	4000 BP
Domestic animals (meat)	7000 BP	8000 BP	7000 BP	5000 BP
Domestic plants (plant foods)	2700 BP	10,000 BP	7000 BP	3500 BP

Table 15.2. Approximate earliest records of food producing strategies in Libya and related regions.

Explanations and Questions

The shifts that have been observed, moving from hunting and gathering to herding cattle and later sheep and goat while continuing to collect wild grasses, and finally the switch to arable farming, can be tied in quite closely with known fluctuations in climate and in particular with known fluctuations in rainfall. The start of the hunter-gatherer phase has be explained by the onset of the wetter climatic conditions at that time, with animals, plants and people able to move back into the Sahara (Muzzolini 1989; 1993; Roberts 1989; Schulz 1987; Thinon et al. 1996). The start of the pastoralist phase is usually explained with reference to a short mid-Holocene dry phase (Barker, this volume). The increase in sheep and later goat, at the cost of cattle, during the later part of the pastoralist phase is again explained by linking it to the growing aridity of the region and the disappearance of sufficient water and grazing for cattle which need more water than sheep or goats (Gautier 1987). The prominent role of wild grasses is thought to be due to their local abundance (Harlan 1989a), and the absence of agriculture to the lack of sufficient rainfall to grow crops, and the lack of sufficient grazing for cattle to permit permanent settlement (Van der Veen 1995).

All of this is very plausible, but is such an approach not too deterministic? Does such an approach not see people simply responding to events outside their control? The environmental conditions in this region undoubtedly restrict what is possible, but they do not determine what foods are exploited. The latter is determined by cultural factors such as the social structure of a society, the role of food sharing versus food ownership, and cultural affinities. There is no time here to go into a detailed debate of these issues, but I would like to highlight two examples.

Firstly, the results from the recent excavations at Uan Afuda suggest that during the late hunter-gatherer period wild Barbary sheep may have been forcefully kept within this rock shelter, a cultural control of a food resource unique to the region (di Lernia 2001). This unusual form of management did not develop into the local domestication of Barbary sheep. Instead, when domesticated animals arrived, they were introduced from elsewhere and animal husbandry started off with a heavy emphasis on cattle, not sheep. Should we postulate a discontinuity of populations at this point, or a change from social ownership of animals to one based on private capital?

The accompanying rock art of this period confirms the crucial ideological role of Barbary sheep, just as the rock art of the following period highlights the ideological importance of cattle.

Secondly, why does agriculture start so late in the region? If the conditions in the Wadi al-Ajal were suited to agriculture 3000 years ago, they might have been suitable 5000 or even 6000 years ago. So why did agriculture not happen earlier? It appears to represent a conscious choice; after all, there were contacts with populations further east, who did practice agriculture. The current evidence suggests that people preferred their semi-nomadic lifestyle to a settled life in the Wadi. Unless, of course, we have been looking in the wrong places. Could agriculture have started in areas of the region not touched by archaeological research? The occurrence of date stones at Wadi Tanezzuft and Uan Muhuggiag in the Acacus mountains may point in that direction. Only time and further research will tell.

Cultural Affinities

Right throughout the last ten thousand years we see changes in the sources of food and in farming, pointing to cultural contacts and interactions with the surrounding regions. During the early period we see that the region looked east. The domestic cattle, sheep and goat that were introduced into the region during the seventh millennium BP almost certainly came from the east, from Egypt, and the Levant beyond. Wheat and barley also came from the same region, as did dates, grapes and figs. Towards the second half of the first millennium BC and the first half of the first millennium AD there is a northern focus; at this time we see connections with the Phoenician, Greek and especially with the Roman worlds.

African crops, such as pearl millet and sorghum, were late introductions into the region: both arriving during the late Garamantian period (Pelling pers. comm.), though wheat and barley remained the principal cereal crops. Sorghum and pearl millet are summer crops – in contrast to wheat and barley, which are autumn-sown crops – and their introduction is usually associated with double cropping (Watson 1983). Both pearl millet and sorghum can tolerate drier conditions than wheat or barley and the physiology of both allows cultivation during the heat of the summer. This means that two crops can be harvested from the same plot of land, thus representing an expansion of production. Both are often used as animal fodder in this region and their cultivation suggests the need for fodder crops in the absence of natural grazing.

At the same time as the introduction of these African crops we see the arrival of the camel, and together they highlight contacts with the south and southeast: the incorporation of the region into the Arabic and Islamic world. Later still, we see the introduction of maize and either chilli or sweet pepper, both crops that originated in the Americas. By now the region was participating in the near-global trade networks so typical of the early modern period. Thus, the foodstuffs eaten and the evidence for increasing dietary breadth highlight the growing contacts of the Libyan Sahara with the wider world, though at the same identifying that its cultural affinity lay mostly with North Africa.

The Future

As I have indicated, many questions remain. To answer these we need more fieldwork, and we need to widen our research scope to incorporate parts of the region hitherto unexplored. We need

to do this soon, before the rich cultural and natural heritage of the region disappears under new development. Our evidence reveals that the people of the Libyan Sahara have developed their own unique way of life, shaped not just by the local environment, but by the choices they made over the last ten thousand years. Throughout the last 10,000 years they maintained contacts with the surrounding areas. We need to explore these contacts in more detail, to try and understand the role of wider cultural and political developments in influencing what choices people made. The remarkable preservation of plant and animal foods at archaeological sites in this region has been a tremendous asset in reconstructing food and farming in the Libyan Sahara. Let us hope that the next 50 years will be as profitable as the last 50 years have been.

References

Amblard, S. 1996. Agricultural evidence and the interpretation of the Dhars Tichitt and Oualata, southeastern Mauritania, in G. Pwiti and R. Soper (eds.), *Aspects of African Archaeology. Papers from the 10th Congress of the Pan-African Association for Prehistory and Related Studies*. Harare: 421-427.

Amblard, S. and Pernès, J. 1989. The identification of cultivated pearl millet (*Pennisetum*) amongst plant impressions on pottery from Oued Chebbi (Dhar Oualata, Mauritania). *African Archaeological Review* 7: 117-126.

Barakat, H. and Fahmi, A. 1999. Wild grasses as 'Neolithic' food resources in the Eastern Sahara: a review of the evidence from Egypt, in van der Veen 1999: 33-46.

Barich, B.E. (ed.) 1987. *Archaeology and Environment in the Libyan Sahara. The excavations in the Tadrart Acacus, 1978-1983*, Oxford, British Archaeological Reports, International Series 368, (Cambridge Monographs in African Archaeology 23).

Corridi, C. 1998. Faunal remains from Holocene archaeological sites of the Tadrart Acacus and surroundings (Libyan Sahara), in Cremaschi and di Lernia 1998: 89-94.

Cottoli, M. and Rottoli, M. 2002. Some information on archaebotanical remains, in S. di Lernia and G. Manzi (eds) *Sand, Stones and Bones. The archaeology of death in the Wadi Tanezzuft Valley (5000-2000 BP)*. Florence (Arid Zone Monographs 3): 169-178.

Cremaschi, M. and di Lernia, S. (eds) 1998. *Wadi Teshuinat Palaeoenvironment and Prehistory in South-Western Fezzan (Libyan Sahara)*, Milan (CNR Quaderni di Geodinamica Alpina e Quaternaria n. 7).

Daniels, C.M. 1968. Garamantian excavations: Zinchecra 1965-67. *Libya Antiqua* 5: 113-194.

Daniels, C.M. 1989. Excavation and fieldwork amongst the Garamantes. *Libyan Studies* 20: 45-61.

di Lernia, S. 1999. *The Uan Afuda Cave. Hunter-Gatherer Societies of Central Sahara*, Florence (Arid Zone Monographs 1).

di Lernia, S. 2001. Dismantling dung: delayed use of food resources among early Holocene foragers in the Libyan Sahara. *Journal of Anthropological Archaeology* 20: 408-441.

Garcea, E.A.A. 1998. Arterian and 'early' and 'late Acacus' from the Uan Tabu rockshelter, Tadrart Acacus (Libyan Sahara), in Cremaschi and di Lernia 1998: 155-183.

Garcea, E.A.A. and Sebastini, R. 1998. Middle and late pastoral neolithic from the Uan Lelocat rockshelter, Tadrart Acacus (Libyan Sahara), in Cremaschi and di Lernia 1998: 201-216.

Gautier, A. 1987. The archaeozoological sequence in the Acacus, in Barich 1987: 283-308.

Harlan, J.R. 1989a. Wild-grass seed harvesting in the Sahara and Sub-Sahara of Africa, in D.R. Harris and G. C. Hillman (eds), *Foraging and Farming*. London: 79-98.

Harlan, J.R. 1989b. Wild grass seeds as food resources in the Sahara and Sub-Sahara. *Sahara* 2: 69-74.

Holl, A.F.C. 1998. Livestock husbandry, pastoralism and territoriality: the West African record. *Journal of Anthropological Archaeology* 17(2): 143-165.

Mattingly, D.J., al-Mashai, M., Aburgheba, H., Balcombe, P., Eastaugh, E., Gillings, M., Leone, A., McLaren, S., Owen, P., Pelling, R., Reynolds, T., Stirling, L., Thomas, D., Watson, D., Wilson, A.I. and White, K. 2000. The Fezzan Project II: preliminary report on the 1998 season. *Libya Antiqua n.s.* 4 (1998) [2000]: 219-49.

Mattingly, D.J., Daniels, C.M. Dore, J.N., Edwards, D. and Hawthorne, J. 2003. *The Archaeology of Fazzan. Volume 2, Synthesis.* London.

Miller, N.F. 1991. The Near East, in W. van Zeist, K. Wasylikowa and K.-E. Behre (eds), *Progress in Old World Palaeoethnobotany.* Rotterdam, Balkema: 133-160.

Muzzolini, A. 1989. La "néolithisation" du nord de l'Afrique et ses causes, in O. Aurenche and J. Cauvin (eds), *Néolithisations,* Oxford, British Archaeological Reports, International Series 516: 145-186.

Muzzolini, A. 1993. The emergence of a food-producing economy in the Sahara, in Shaw *et al.* 1993: 227-239.

Neumann, K. 1999. Early plant food production in the West African Sahel: new evidence, in van der Veen 1999: 73-80.

Pelling, R. 2000. Faunal and botanical sampling, in Mattingly *et al.* 2000: 230-36.

Pelling, R. 2003. Medieval and early modern agriculture and crop dispersal in the Wadi el-Agial, Fezzan, Libya, in K. Neumann, A. Butler and S. Kahlheber (eds), *Food, Fuel and Fields. Progress in African Archaeobotany.* Cologne, Heinrich-Barth Institut: 129-138.

Pelling, R. 2005. Garamantian agriculture and its significance in a wider North African context: the evidence of the plant remains from the Fazzan project. *Journal of North African Studies* 10.3-4: 397-411.

Roberts, N. 1989. *The Holocene. An Environmental History,* Oxford, Blackwell.

Schulz, E. 1987. Holocene vegetation in the Tadrart Acacus: the pollen record of two early ceramic sites, in Barich 1987: 313-326.

Shaw, T., Sinclair, P., Andah, B. and Okpoho, A. (eds.). 1993. *The Archaeology of Africa. Food, Metals and Towns,* London, Routledge.

Thinon, M., Ballouche, A. and Reille, M. 1996. Holocene vegetation of the Central Saharan mountains: the end of a myth. *The Holocene* 6(4): 475-462.

Veen, M. van der 1992. Garamantian agriculture: the plant remains from Zinchecra, Fezzan. *Libyan Studies* 23: 7-39.

Veen, M. van der 1995. Ancient agriculture in Libya: a review of the evidence. *Acta Palaeobotanica* 35(1): 85-98.

Veen, M. van der (ed.) 1999. *The Exploitation of Plant Resources in Ancient Africa,* New York, Kluwer Academic/Plenum Publishers.

Wasylikowa, K. 1992a. Holocene flora of the Tadrart Acacus area, SW Libya, based on plant macrofossils from Uan Muhuggiag and Ti-n-Torha/Two Caves archaeological sites. *Origini* 16: 125-159.

Wasylikowa, K. 1992b. Exploitation of wild plants by prehistoric peoples in the Sahara. *Würzburger Geographische Arbeiten* 83: 1-13.

Wasylikowa, K. 1993. Plant macrofossils from the archaeological sites of Uan Muhuggiag and Ti-n-Torha, Southwestern Libya, in L. Krzyzaniak, M. Kobusiewicz and J. Alexander (eds), *Environmental Change and Human Culture in the Nile Basin and Northern Africa until the Second Millennium BC.* Poznan, Poznan Archaeological Museum (*Studies in African Archaeology,* Vol. 4): 25-41.

Wasylikowa, K. and Dahlberg, J. 1999. Sorghum in the economy of the early Neolithic tribes at Nabta Playa, Egypt, in van der Veen 1999: 11-31.

Wasylikowa, K and Veen, M. van der 2002. Radiocarbon dates from Uan Muhuggiag, Libya, in C. Bronk Ramsey, T.F.G. Higham, D.C. Owen, A. W. G. Pike and R.E.M. Hedges (eds), Radiocarbon dates from the Oxford AMS system: *Archaeometry* Datelist 31, *Archaeometry* 44, 3, Supplement 1: 132-133.

Wasylikowa, K. and Veen, M. van der 2004. An archaeobotanical contribution to the history of watermelon, *Citrullus lanatus* (Thunb.) Mats. & Nakai (syn. *C. vulgaris* Schrad.). *Vegetation History and Archaeobotany* 13(4): 213-217.

Watson, A.M. 1983. *Agricultural Innovation in the Early Islamic World,* Cambridge, Cambridge University Press.

Wetterstrom, W. 1993. Foraging and farming in Egypt: the transition from hunting and gathering to horticulture in the Nile valley, in Shaw *et al.* 1993: 165-226.

16. Animal Bones from the Sahara: Diet, Economy and Social Practices

By Annie Grant[1]

Abstract

Animal bones are often amongst the most common of archaeological finds, but in tracing the history of the development of archaeology at both global and regional levels, it is clear that their potential to further our understanding of the development of human societies has frequently been ignored, or at best been given a back seat in relation to the study of structures and artefacts. This is perhaps partly because animal remains can seem so mundane: bone finds usually consist of fragments discarded in settlement deposits, the refuse from the processing of animal carcasses primarily for food, although also for leather, skin and other products. However, as their study has advanced and more and more excavators and researchers have paid attention to bone finds, their potential to help archaeologists not only to reconstruct key aspects of the subsistence and economy of past societies but also to inform our understanding of social structures and ritual or religious behaviour has been clearly demonstrated. This paper reviews the current and potential contribution of faunal studies to the archaeology of Saharan societies.

Introduction

Bone preservation varies considerably in different contexts: in alkaline soils in temperate climates bones and teeth many thousands of years old are recovered in very good condition; in acid soils and less temperate environments, bones are often recovered in very poor condition, or, worse, will not have survived at all. The study of animal bone remains from Saharan and other very arid places has inevitably been inhibited by the relatively poor preservation that is common. Typically, Saharan bone assemblages are small, amounting to no more than a few thousand specimens at most, and also very fragmented, making species identification and further detailed analysis difficult and sometimes impossible. There are however some striking exceptions, one of which is discussed below.

Despite these difficulties, the potential is still there, and this paper aims to take a brief and preliminary look at some of the ways that the study of animal bone remains is enriching, and can further enrich, our understanding of the development of human societies in the Sahara region. It is not in any way a comprehensive review of currently available evidence, but has made a selection from some published and unpublished material for illustrative purposes.

Faunal Analysis from Saharan Sites

Analysis of species frequencies, although perhaps the most basic of the archaeozoologist's tasks, shows the relative importance of the different animals exploited by human populations, and how this varies spatially and chronologically. The animal bones recovered during David Mattingly's excavations at Jarma in the oasis area of Fazzan in southern Libya provide an opportunity to look at changing patterns of animal husbandry and food procurement strategies over a long period

[1]Dean of Students, University of East Anglia

Approximate date in centuries	Sheep/ goat %	Cattle %	Pig %	Camel %	Horse %	Dog %	Wild mammal %	Bird %	Fish %	Other %	Total N
16th - 18th CE	65	1	1	12	0.3	9	1	8	0	2	372
11th - 15th CE	65	5	3	4	0	0	5	16	0	3	80
7th - 10th CE	74	16	2	4	0	0	0.4	3	0	1	236
6th CE	79	15	2	1	1	0	1	1	0	1	702
3rd - 5th CE	78	17	2	1	0.4	0	1	1	0.1	1	1965
2nd - 3rd CE	83	14	1	0.4	0.3	0.1	1	1	0	0.3	2537
1st - 2nd CE	67	31	1	0	0	0	1	1	0	1	187
1st BCE / 1st CE	75	23	0	0	0	1	1	0	0	1	139
Total N	4893	924	76	85	22	39	48	94	1	36	6218

Table 16.1. Jarma, Fazzan: species proportions (percentages are rounded to the nearest whole number except when less than 0.5%). The dates in column one are approximate and based on a preliminary analysis of ceramic, stratigraphic and radiocarbon data (Mattingly et al. 2002)

of time. His excavations have uncovered evidence for a more or less continuous occupation of the town from its foundation in the fourth century BCE until it was abandoned in the early twentieth century CE (Mattingly *et al.* 2003 and Mattingly, this volume). The bone remains analysed for this paper were identified by Mattie Holmes, and although their full study has not yet been completed, even preliminary analysis has provided some important insights into the development of this settlement.

Throughout the period from the first century BCE until the latest period of occupation, the faunal assemblage is dominated by the remains of domestic species, primarily sheep and/or goats; the numbers of cattle bones indicate that these animals also played a significant, but much smaller role in the local economy. Other domestic species represented include camel, pig, horse, dog and birds. While the relative proportions of caprovines (sheep and goats) have fluctuated a little, although given the relatively small sample size, not very significantly, their remains make up at least two thirds of all the assemblages from the first century BCE to the twentieth century CE (Table 16.1).

In contrast, there is clear evidence of a gradual decline in the role of cattle. These animals are most important in the early centuries of the first millennium through the Classic and late Garamantian phases (second to fifth centuries CE), but decline significantly in importance after the tenth century CE (Table 16.1). Cattle are far more sensitive indicators of the availability of water than sheep or goats as their water and food requirements are considerably greater. This reduction in their occurrence follows a general trend that began much earlier in the Sahara region and Nile basin reflecting the gradual overall desertification of the region throughout the Holocene (see, for example, various papers in Krzyzaniak *et al.* 1993). However, the marked decline in the second millennium CE at Jarma may be indicative of more local fluctuations, or changes in the overall subsistence strategy that may also be indicative of population or cultural change.

Small numbers of pig remains were found in all first and second millennium phases of occupation at Jarma, including those dated to the Islamic period. Although finds of pig bones are not unknown in Saharan contexts, they are much more common at sites in the Mediterranean zone, particularly during the Roman period. At Jarma, there is a very slight, although not necessarily significant, increase over time (Table 16.1), but at the Mahgrebian sites of Cherchel (Clark 1995) and Setif (King 1991), pig bone proportions drop significantly from Roman to Islamic periods. The continued presence of pig remains into the second millennium in Northern Africa may indicate a gradual adoption of Islam in some parts of the Sahara and the Mahgreb and of a continuation of local traditions, or perhaps of the presence of a mixed population including some that maintained sub-Saharan or European dietary traditions. Pork consumption may also be evidence of individual or even community compromises in the strictness of their adherence to Islamic dietary laws in the face of shortages of other meat sources. A study of the incidence of pig remains and of the role of this animal in North African history would be worthy of further research.

The location of the Jarma bone finds within occupation levels or rubbish pits suggests that the majority of bone remains examined so far derive from food refuse. However, even the cattle, sheep and goats that were the primary food species no doubt supplied a range of other valuable products, not least of which may have been manure to fertilise the cultivated areas of the oasis. While animals of a wide range of species may also be consumed at the end of their lives, the primary purpose of the husbandry of some may not have been food production. Horse and camel bones are found in deposits dating from the second/third centuries CE and during the Classic and late Garamantian period both species may have been used for transport, essential for both economic contact and for maintaining or creating relationships with other social groups as well as ultimately for food (Table 16.1). Horse bones are absent from the seventh century CE onwards (with the exception of a single bone from a recent context) and at the same time, camel remains increase in frequency. Camels are of course the desert animal *par excellence* for both riding and transport and their increasing role in the later periods is thus not surprising. However, whether the use of horses ceased for climatic or economic reasons, or because of changing networks of contact involving travel over different types of terrain or the movement of more, or different types of, goods will perhaps only become clear with further excavation and analysis of finds from contemporary settlements in the region.

There are other significant changes in animal exploitation, including a steady increase in the proportion of bird bones found in the refuse deposits (Table 16.1). Most of the remains are those of chickens or other galliforms, although a wider range of species was exploited in the Garamantian period. The increase in chicken keeping, which was most apparent in eleventh to fifteenth century deposits, may reflect changing cultural preferences, or a desire for a meat component in the diet that could no longer be met by domestic mammals. It may not be coincidental that it is in this period that there is the most pronounced drop in the proportion of cattle bones and the highest proportion of wild animal remains. Further research will be required to see if this apparent diversification of resources in the Islamic period is matched at other settlements in the region. At all other periods wild mammals seem to have played no

more than a very small role in the diet: their remains account for no more than one percent of the total number of bones recovered.

The Romano-Libyan settlements in the Tripolitanian pre-desert further north, although also focussing on sheep and goat husbandry, were much more reliant on wild animals, particularly gazelles, than their contemporaries in the Fazzan. The Tripolitanian farmers, relying as they did on floodwater irrigation methods, may have only had the capacity to manage relatively small herds of domestic animals in order to prevent both environmental damage and competition for food (van der Veen *et al.* 1996). The greater availability of water in the oasis zone of Fazzan seems to have provided the potential to grow sufficient crops to feed both a human and animal population.

Species proportions provide a broad indication of animal exploitation, but mortality profiles offer much more detailed understanding of animal husbandry practices, and of the particular animal products that were of most importance. For some phases in the occupation of old Jarma, there were insufficient numbers of bones recovered to allow detailed analysis, but it was possible to investigate sheep husbandry in four phases of occupation spanning the second to tenth centuries; Figure 16.1 shows kill off rates for sheep during this period. The most striking result is the similarity in the profiles throughout these centuries; apparent differences are as likely to be the result of sample bias as of any changes in animal management. There seems to have been a gradual culling of young, juvenile and young adult sheep, with only around 40 percent of animals retained to adulthood. This is consistent with a management strategy focussed mainly on meat production, although those animals kept into adulthood, and likely

Figure 16.1. Jarma, Fezzan: kill-off pattern for sheep based on bone fusion data. Ages are approximate ages at fusion of principle long bones based on Silver (1969).

to have been largely females used for breeding, may also have supplied milk and hair or wool. In economies where milk, breeding and/or wool or hair production play a more important role, a much higher proportion of the animals are maintained into adulthood, with relatively few animals culled as juveniles.

Cattle make far more significant demands on agricultural resources, particularly in area without extensive grassland vegetation. At Jarma this is reflected in the relatively small role that they play in overall species proportions, and also in the cattle management strategies employed. During the second and third centuries CE, the only periods for which sufficient cattle bones were recovered for detailed analysis of mortality profiles, most of the cattle were maintained into their second year. However, around 40 percent had been killed before they were approximately two and a half years old, and only 20 percent had been kept beyond four years. Again, this suggests a focus on meat production, with perhaps only those essential for herd maintenance retained beyond maturity. This age profile suggests that it is unlikely that milk was significantly exploited, but some of the older cattle may have been needed for traction, particularly that associated with cultivation.

It is all too easy to offer environmental explanations for patterns of species exploitation or husbandry strategies particularly when attempting to interpret faunal assemblages from extreme environments where resource availability is highly constrained. In the earlier Holocene, when the Saharan climate is known to be significantly more humid, cattle remains tend to be very much more common, but they start to decline by the later Neolithic as conditions become increasingly arid (Churcher 1999; Kröpelin 1993). That this trend seems to be continued at Jarma tempts us to see environment as a key factor, but it is also crucial that we do not ignore many of the other social and cultural factors that influence human choice and behaviour.

Social and Ritual Aspects

Assessing the relative importance of animal and plant foodstuffs in the human diet in the past is extremely difficult, but our assumption, based on the likely carrying capacity of the Saharan environment, and using ethnographic analogy, is that meat played a relatively small role in terms of quantity (see further, van der Veen, this volume). However, despite, or even because of this, meat and other animal food products may have played a very important role in terms of its social and ritual significance. Choices made by human societies even in relation to food consumption and animal husbandry can frequently run counter to the apparent logic of contemporary perspectives.

To illustrate this point, I shall turn to one of Libya's neighbours to the east, Sudan, and move back in time. The northern part of Sudan is rich in archaeological remains and one of the best known sites is the town of Kerma, located on the right bank of the Nile. Kerma, a complex, defended town is the type-site of a civilization that survived for a thousand years, from 2500 to 1500 BCE (Bonnet 1990; Bonnet 2000). To the northeast of the town is a very large necropolis containing at least 20,000 tombs. In these tombs, natural mummification has sometimes preserved not only bone but also skin, feathers, hair, horn and other organic materials, providing insights that are denied to us at sites where preservation is poor. Although the size,

wealth and preservation of the necropolis at Kerma is exceptional, many other cemeteries of the Kerma culture have been found at other locations in northern Sudan including Säi to the north (Jourdan 1981) and site P37 in the north Dongola Reach to the south (Welsby 2001).

The burial tradition in these cemeteries is inhumation in a circular grave covered by a low tumulus. In some of the best preserved tombs at Kerma the corpse was laid on a wooden bed and/or a cattle hide, accompanied by a number of grave goods, including pots containing cereal grains, complete animals and cuts of meat (see, for example, Bonnet 1990, Fig. 66; Bonnet 2000, Fig. 19). The number of animals and other grave goods seems to be related to the importance of the individual. Although preservational conditions are rarely matched at other locations, it is clear from the surviving bone remains and other non-organic finds that this burial tradition was widespread throughout the Kerma territory.

The cemetery evidence from Kerma and other sites offers insights into the nature of a highly distinctive and well-developed set of rituals and religious beliefs in which animals played a crucial role. Characteristically, graves contain the bones of sheep and/or goats and/or dogs. Cattle bones are not found inside tombs of the Classic Kerma period but some of the largest tumuli are partly surrounded by a crescent of cattle bucrania, the horn cores and part of the frontal bone, sometimes in very large numbers (Bonnet 2000 Figs 39, 40; Chaix and Grant 1992; Grant 2001).

Each of the four species represented in cemetery deposits made important contributions to the economy of the region, providing essential food and other resources as is evidenced by bones found in food refuse in deposits within the town at Kerma (Chaix and Grant 1992). However, they also played roles in the ritual activities associated with death, and these roles were important enough for them to be sacrificed at the time of the death of powerful members of society. Sheep, and, to a lesser extent, goats had a dual role: they were interred with the corpse as companions and butchered into joints for food, apparently for the afterlife. Cattle play a very different role in the funerary rituals. The bone evidence for this species is limited to bucrania and, unlike the sheep, goats and dogs that were buried in the cemeteries, the cattle seem likely to have been eaten, although not within the cemetery zones (Chaix and Grant 1992). The bucrania around the tombs may have been a visible and impressive sight for a considerable period after the other animals were covered over by the burial tumuli, a long-lasting reminder of the individual buried below. It is possible, if not likely, that cattle had an important role in symbolising wealth or status within the society in life as well as at the time of death. These burials suggest a hierarchical society, with status symbolised at least in part by the lavishness of animal sacrifices made at the time of death.

Animal remains from prehistoric Sudan are providing evidence of a complex relationship between ritual and economic, embodied in sacrifice and conspicuous display. The Kerma finds are exceptional but evidence for the symbolic role of animals and food in human societies is not (for example, Grant 2002). It is therefore important to remember that the study of animal bones has the potential to enhance our understanding of the ways in which human exploitation of animals has adapted to the desert environment of the Sahara in different climatic, economic and political circumstances, inform us about subsistence behaviour, economy and trade, and

also enhance our understanding of ritual, religion and social and ethnic differentiation and the way that this was expressed materially.

In a recent review article Marshall and Mutunda (1999) comment on the very small number of archaeozoologists currently working in Africa. They also note that many of these are Europeans and Americans; this highlights a need for both further research and for training of African nationals in this important area of archaeological research.

References

Bonnet, C. (ed.) 1990. *Kerma, Royaume de Nubie*, Geneva: Musée d'Art et d'Histoire.

Bonnet, C. 2000. *Edifices et rites funéraires à Kerma*, Paris.

Chaix, L. and Grant, A. 1992. Cattle in ancient Nubia, in A. Grant (ed.), *Animals and their Products in Trade and Exchange*. Paris: Anthropozoologica 16: 61-66.

Churcher, C.S. 1999. The Neolithic fauna from archaeological contexts in Dakhleh Oasis, Egypt. *Archaeozoologia* 10: 47-54.

Clark, G. 1995. The Faunal Remains, in N. Benseddik and T. Potter (eds), *Fouilles du Forum de Cherchel 1977-1981*. 6ᵉ supplément au Bulletin d'Archaeologie Algerienne: 159-196.

Grant, A. 2001. The animal remains, in D. Welsby (ed.), *Life on the Desert Edge. Seven Thousand Years of Settlement in the Northern Dongola Reach, Sudan, Volume 2*. London: Sudan Archaeological Research Society: 544-555.

Grant, A. 2002. Food, status and social hierarchy, in P. Miracle and J. Milner (eds), *Consuming Passions*. Cambridge: MacDonald Institute Research Papers: 17-23.

Jourdan, L. 1981. Campagne 1976-1977 a l'île de Säi. Offrandes animals dans des tombes de la nécropole Kerma. *Cahiers de Récherches de l'Institut de Papyrologie et d'Egyptologie de Lille* 6: 96-109.

King, A. 1991. Animal bones, in A. Mohamedi, A. Banmansour, A. Amarmra and E. Fentress (eds), *Fouilles de Sétif (1977-1984)* 5ème Supplement au Bulletin d'Archéologie Algeriènne: 248-259.

Kröpelin, S. 1993. The Gilf Kebir and lower Wadi Howar: contrasting early and mid-Holocene environments in the Eastern Sahara, in L. Krzyzaniak, M. Kobusiewicz and J. Alexander (eds), *Environmental Change and Human Culture in the Nile Basin & Northern Africa until the second Millennium BC*. Poznan: Poznan Archaeological Museum: 249-258.

Krzyzaniak, L., Kobusiewicz, M. *et al.* (eds). 1993. *Environmental Change and Human Culture in the Nile Basin and Northern Africa until the Second Millennium BC*, Poznan: Poznan Archaeological Museum.

Marshall, F. and K. Mutunda 1999. The role of zooarchaeology in archaeological interpretation: a survey of the African literature from later archaeological periods, c. 20,000 BP - present. *Archaeozoologia* 10: 83-106.

Mattingly, D., Edwards, D. and Dore, J. 2002 Radiocarbon dates from Fazzan, southern Libya. *Libyan Studies* 33: 9-19.

Mattingly, D.J., Daniels, C., Dore, J.N., Edwards, D. and Hawthorne, J. 2003. *The Archaeology of Fazzan. Volume 1, Synthesis.*

Silver, I. 1969. The ageing of domestic animals, in D. Brothwell and E. Higgs (eds), *Science and Archaeology*, London: 283-302.

van der Veen, M., Grant, A. and Barker, G. 1996. Romano-Libyan agriculture: crops and animals, in G. Barker, D. Gilbertson, B. Jones and D. Mattingly (eds), *Farming the Desert: the UNESCO Libyan Valleys Archaeological Survey*. Paris/London: UNESCO/ Society for Libyan Studies: 227-263.

Welsby, D. 2001. *Life on the Desert Edge. Seven Thousand Years of Settlement in the Northern Dongola Reach, Sudan, Volume 2*. London: Sudan Archaeological Research Society.

Theme 4

Historical Archaeology

17. The Garamantes: the First Libyan State

By David Mattingly[1]

Abstract

The ancient people known as the Garamantes are of great significance in Libya's history and the period when their kingdom dominated the central Sahara (between 900 BC and AD 500) represents a key phase in the socio-economic development of Fazzan. They brought in or consolidated a series of dramatic changes. They were the first Libyan State (a recognised kingdom, covering a vast territory). They were sedentary farmers, practising advanced irrigated agriculture and living in towns and villages. New crops and new technology were adopted at this time, along with improved draught animals (horses and camels) and even wheeled transport. The Libyan language appeared in written form for the first time and metallurgy was developed (involving iron and copper working, and probably gold and silver also). Trans-Saharan trade networks were created that have had continued importance down to the recent past.

Recent survey and excavation based around the Garamantian capital at Jarma in the Wadi al-Ajal have produced dramatic evidence in support of these claims and have shed new light on the structure, scale and complexity of Garamantian society and its economic activity. They may properly be described as the first true civilisation of the Central Sahara. Yet they continue to be overlooked and underestimated in literature on the Sahara and on African civilisations. The reasons behind this state of affairs are complex, but no longer justifiable, with the weight of evidence now stacking up.

Despite their demonstrable importance to Libyan cultural history, there are still many questions unanswered about this remarkable people. Further efforts are required to record and preserve this heritage and to shed more light on their desert lifestyle. Some comments will be made about future research directions and desiderata for conservation and presentation.

Introduction

When we look out from the Roman empire towards its more remote neighbours, the most common basis for our perspective is the testimony of the ancient sources, though they are widely acknowledged to be problematic in their treatment of non-Mediterranean peoples, often characterising them as the 'Barbarian Other'. A particular issue is the extent to which such stereotypical views were anachronistically maintained in currency long after the information to discredit them was available to the Romans (on the peoples of ancient Libya, Desanges 1962; Mattingly 1995, 17-49). This paper will consider the case of the Garamantes of the Libyan Sahara, combining the evidence from literary sources and archaeological investigation (for past work on the Garamantes, see *inter alia*, Daniels 1970; 1989; Pace *et al.* 1951; Ruprechtsberger 1997). The Garamantes have special importance in Libyan history and in the story of the Libyan desert as a whole in that they represent the first instance of an urban agricultural state, dominating the Central Sahara for a millennium – from *c.*2500 to 1500 years ago.

The ancient sources generally characterised the Garamantes as a populous, but wayward desert people, with a propensity for lawlessness and raiding (Mattingly *et al.* 2003, 76-79). Above all,

[1]School of Archaeology and Ancient History, University of Leicester

such people were deliberately presented as unknown (or unknowable) and mysterious long after the time at which more regular and sustained contact between their homelands and the Roman world had developed (Desanges 1962, 93-96). The Garamantes were thus synonymous with all that the Mediterranean world found strange and threatening about the great desert, though the frequent appearance of the name in Latin poetry may also have something to do with the fact that it worked so well in Latin scansion. The cumulative picture that can be built from literary references alone is thus complex, partly self-contradictory and, ultimately, mysterious. Herodotus (4.174) was the first to mention them – occupying the desert region around one of a series of spring mounds and raising fabulous cattle, whose horns were so long that, allegedly, they had to graze backwards (Liverani 2000c). The details of the Herodotean account were regularly replayed in sources down to the end of antiquity, by which point the information was hundreds of years old and no doubt very out of date (see for example, Solinus 30)

As a populous neighbouring people, it is no surprise that the Garamantes had military clashes with the Romans. The Garamantes were the main target of the Saharan raid of L. Cornelius Balbus in 20 BC, for which feat he was the last person outside the Imperial family to receive a full triumph (Pliny *NH* 5.35-38). They were bit players in the revolt of Tacfarinas in the reign of Tiberius and provided Vespasian with an excuse for a further desert campaign in AD 70 (Mattingly *et al.* 2003, 83). The Roman references to military campaigns against the Garamantes suggest that the desert was considered as much of a challenge as the Libyan fighters, but there is no evidence that the oases of the Garamantes were ever occupied more than fleetingly by Rome. Other references stress their barbarity, their lack of order, their polygamy, their warlike character. Consider the epithets used to characterise them: numerous, savage, fierce, indomitable, outermost (or evil), panting, naked, miserable, tent- or hut-dwelling, scattered, promiscuous, lawless, receivers of booty, light armed, given to brigandage, black. Perhaps it is not surprising that the only proposed identifications of Garamantes in Roman art show them meeting a fate appropriate to criminals and barbarians, thrown to wild beasts in the Roman arena (Pace *et al.* 1951, 489-92). Some scholars have seen support for the Roman view in Saharan rock art. The similarity between Libyan desert tribesmen depicted both in Egyptian reliefs of the late second millennium BC and contemporary rock art from southern Algeria and Fazzan appears to reinforce the view of wild men of the desert, with ostrich feather plumes topping off flamboyant hairstyles, their semi naked bodies heavily tattooed and draped in animal skins, though few have paused to consider whether the image was still apposite for the Garamantes a thousand years later (Ruprechtsberger 1997, 66-68).

The almost universally negative tone of the literary sources arouses suspicion that they may not have done full justice to the Garamantes, relying instead on a mixture of preconception and prejudice. The Garamantes, as depicted in our sources, eked out a miserable existence in a mythical world, in which fact and fiction are intertwined. As a result, nothing prepares us for the possibility that the Garamantes were primarily made up of advanced agriculturalists, were a civilisation in its own right or an advanced Saharan state – yet I hope to demonstrate that these claims are not unrealistic ones of the historical Garamantes.

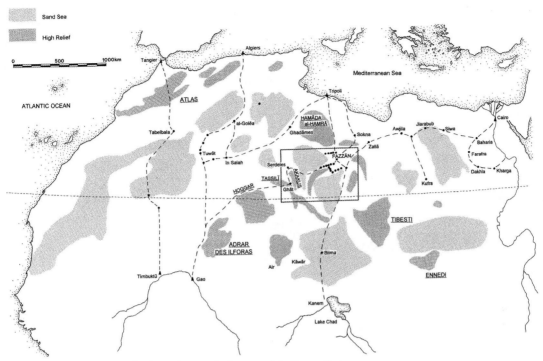

Figure 17.1. Map of the central Sahara, showing the location of the Fazzan Project.

The negative attitudes of our ancient sources have fed through to influence much modern scholarship on the Garamantes. In his seminal book, *Rome beyond the Imperial Frontiers*, Mortimer Wheeler characterised the relationship between Rome and her troublesome southern neighbours as "the age-old struggle between the settled civilisation of the Mediterranean littoral and the nomads or semi-nomads of the mountain and desert" (1954, 129). He went on to outline how the wily Romans dealt with the "Fezzani nomads" by "turning them into food-producers, by teaching them to till their own deserts" (1954, 131). Desert irrigation systems that had been recorded by Italian archaeologists in the 1930s were thus interpreted by Wheeler as the result of Roman technical instruction and 'Romanised' monuments as structures built by or for the use of Roman technical advisers and merchants present in Fezzan. Wheeler's account goes a good deal beyond the ancient sources in identifying an active role for Romans in the economic transformation of her desert neighbours – in his view, farming depended on Roman know-how, there were technical advisers and foreign residents to help bring about this great triumph of paternalistic humanity.

A programme of work on the Garamantes by the late Charles Daniels in the 1960s and 1970s produced significant results to advance our knowledge of this enigmatic people, but had been only partially published at the time of his death in 1996 (Daniels 1989, for his last summary; cf. Mattingly *et al.* 2003, 22-36 for a review of his work). I directed the multidisciplinary and multi-period Fazzan project across six seasons from 1997-2002, involving both survey work

and detailed excavation in the Libyan Sahara. At the same time, I was also able to raise a grant to bring to press the results of Daniels' work. The results of the combined programme will be published as a series of monographs over the next few years (Mattingly *et al.* 2003; forthcoming). In parallel, important new research has also been undertaken in recent years by the Italian team led by Mario Liverani in the Akakus and Tanezzuft area some 500 km south-west of Jarma (Liverani 2000a; 2000b). We are now in a much better position than ever before to re-evaluate the Garamantes and their place in the history of Fazzan (Fig. 17.1).

There are many components of the Fazzan project and I shall focus here only on those elements relevant to the story of the Garamantes. The key site of our work is Jarma (1000 km south of Tripoli in a linear depression known as the Wadi al-Ajal or Wadi al-Hayat). Jarma was known in antiquity as Garama and was the capital of the Garamantes, though the site was overlain by a sequence of post-Garamantian and Islamic oasis towns. However, the most visible elements of the Garamantian heritage of Fazzan are the tens of thousands of tombs strung out along the southern flank of the elongated oasis of the Wadi al-Ajal. Rather in the manner of the Etruscans in Tyrrhenian Italy, as a consequence the Garamantes were initially studied primarily with respect to their many cemeteries, with little attention paid to their settlements or their farming systems and economy. A society based on tens of thousands of burials, but seeming to lack permanent settlements, fitted into the preconceived view drawn up from the ancient sources of the Garamantes comprising a semi-nomadic tribe. This the Fazzan Project has attempted to redress.

Climate Change and the Rise of the Garamantes

As other papers in this volume show, the rise of the Garamantes coincides with the aftermath of the catastrophic incident of climate change about 5000 years ago, which brought about the transformation of the Pastoral hunting communities of the late Neolithic into agriculturalists (Cremaschi and di Lernia 1998; Mori 1998). This process perhaps also involved the advent of some new people and innovations coming into the central Sahara from the east (Mattingly *et al.* 2003, 232-46). The history of Fazzan is fundamentally one of dramatic changes in environment, climate and human activity over time. A clear trend running through, though, is one of overall decreased water availability over time (Mattingly 2000). To a large extent, this interrelationship of people, climate and hydrology is characteristic of long-term Saharan societies.

After the onset of full desert conditions about 5000 years ago, it is clear that human activity became more focussed in parts of the landscape where surface water was still available in the form of shallow lakes, springs or lay at a shallow depth below ground. Many of the lakes known to exist before this date in the sand sea dried up and the best evidence for continuing surface water sources, lakes and springs, appear to have lain in the valley-like depressions, such as the Wadi al-Ajal. It is not clear when the transition to agriculture occurred – by the early first millennium BC it was already well developed in Garamantian lands. Our survey work has located many Pastoral phase sites in the depression of the al-Ajal, where a number of springs, lakes or playas may have served to provide an increasingly important focus for population. Some of the latest Pastoral lithics, and pottery related in style to the Pastoral forms, come from the series of early

Garamantian hillforts along the southern edge of the al-Ajal valley (Mattingly *et al.* 2003, 136-42). There thus appears to be some element of continuity between the late Pastoral population of the region and the Garamantes.

A complication in the process of the transition from the late Pastoral herding communities to the agricultural Garamantes is the possible role played by palaeo-berbers, postulated migrations of Mediterranean (non-negroid) peoples into the Sahara during the last two millennia BC (Mattingly *et al.* 2003, 342-46). Such a movement appears to be clear in the rock art, where Berber types are certainly attested alongside the earlier dominant negro physiognomy, and there is some support in the skeletal evidence. In addition, the evidence for the diffusion of the horse, the camel and the chariot, along with a technological package linked to oasis agriculture, also fits with such movements of people westwards from the oases in the vicinity of the Nile. But it seems unnecessary to postulate large-scale migrations. The tale of a group of five young men from the Nasamones people, based on the oasis of Awjila, who journeyed south-west across the Sahara to the Niger (Herodotus 2.32-2.33), may provide an echo of the impact of small bands of travellers, utilising horses (and later camels) to penetrate deep across the Sahara.

Burial monuments became increasingly more elaborate in the last millennia BC, with greater social differentiation apparent. The east-facing antenna tombs appear to belong to the period 5000-3000 BP, reflecting the emergence of elites within the desert societies (Mattingly *et al.* 2003, 201-02). The very Late Pastoral Phase was thus a period of accelerated social change due to climatic and environmental downturn and marked by the arrival of new people and new technology in the depressions. The Garamantian civilisation arose out of this new situation, marking a distinctive and significant phase in the cultural evolution of the Saharan region.

The Garamantes

The period of the Garamantes (broadly between 1000 BC and AD 500) brought in or consolidated a series of dramatic changes (Mattingly *et al.* 2003, 346-362). These included the rise of a major polity and an urban civilisation in the Sahara. This society was hierarchical and probably slave-using; the adoption of a written script for the Libyan language is another important marker of social complexity. Garamantian agriculture developed to encompass a range of Mediterranean and desert crops that require intensive irrigation (cereals, grapes, olives, dates), whilst also coinciding with the introduction of horses, camels and wheeled transport to the Sahara. The employment of these draught animals also facilitated the creation of trade and political relations that extended north to the Mediterranean, east to Egypt and south to sub-Saharan Africa. The Garamantian period witnessed a massive demographic expansion to a level that was probably not equalled again until the last 40 years (Daniels 1989, 49, estimated that there were at least 120,000 Garamantian burials in the al-Ajal alone).

Garamantian settlement

The Garamantian period can for convenience be divided into four broad phases. The period from *c.*1000-500 BC is the *Early Garamantian phase*, with its cultural roots in part in the Late Pastoral traditions of the third-second millennia BC. Most of the early Garamantian settlements currently

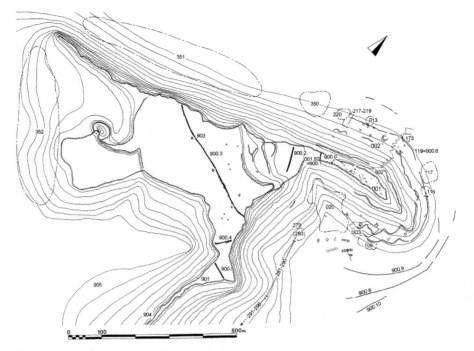

Figure 17.2. Plan of the early Garamantian settlement at Zinkekra.

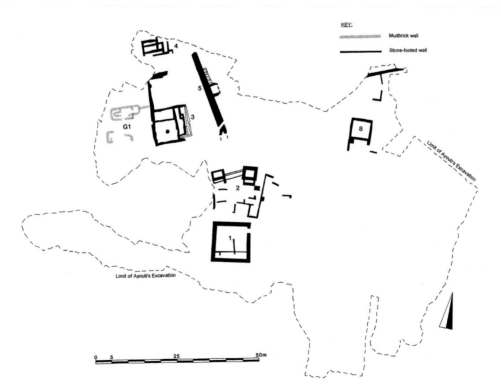

Figure 17.3. Plan of buildings excavated at the centre of Old Jarma, the Garamantian capital Garama.

194

known are situated along the edge of the escarpment, many in defensible positions, such as the classic hillfort site of Zinkekra (Fig. 17.2; Daniels 1968). Botanical remains from the first half of the first millennium BC demonstrate the existence by then of irrigated cultivation. At least 13 examples of hillforts or escarpment edge sites are now known in the Wadi al-Ajal area. It is likely that targeted research throughout Fazzan would yield many further examples of such early Garamantian sites, though it seems clear that overall site numbers are lower than in the Classic Garamantian phase. The first phase of occupation at Zinkekra ended around 500-400 BC, at which point it appears that an urban site originated in the valley centre at Jarma (ancient Garama), though occupation probably continued at Zinkekra on a reduced scale until at least the first century BC. This period 500-1 BC may be characterised at both sites as the *Garamantian proto-urban phase*.

Over time, Garama emerged as the Garamantian capital and in the Roman period, what we refer to as the *Classic Garamantian phase* (AD 1-300), it was adorned with substantial public buildings and temples utilising stone on a scale and quality of dressing not previously witnessed (Figs 17.3-17.4). Since there is no evidence to suggest a Roman occupation of Fazzan, these must be the result of contact, diplomacy and trade between the Roman empire and the Garamantian kingdom. Garamantian culture was extremely eclectic and somewhat heterogeneous – the variety of tomb types in contemporary use may reflect maintenance of discrete tribal identities within the structure of the polity (Mattingly *et al.* 2003, 187-234). The *Late Garamantian Phase* (AD 300-700) is broadly speaking a continuation

Figure 17.4. Detail of masonry of one of the central buildings at Old Jarma (GER 1.1).

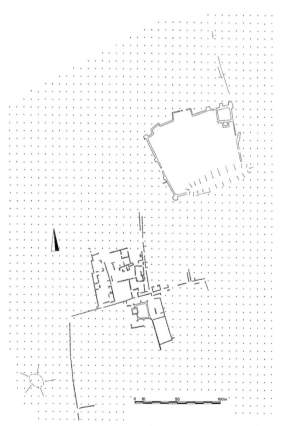

Figure 17.5. Plan of central area of the Garamantian town of Qasr ash-Sharaba, showing the existence of a fort, two smaller fortified structures (qsur) and elements of a 'gridded' road layout.

of the Classic Phase, but with an increasing emphasis on defensive structures - walls, *qsur* and enclosed settlements.

The evolved settlement pattern reflects the increasing localisation of farming activity in the oases along the base of the depression. In addition to the large urban centre at Garama, there were clearly a number of major settlements whose size and internal organisation suggest an interpretation as towns. Qasr Bin Dughba in the eastern Wadi al-Ajal is one clear example, as is Qasr ash-Sharaba in the Wadi Barjuj/'Utba area (Fig. 17.5-17.6). It is now clear that the

Figure 17.6. General view of Qasr Bin Dughba, a Garamantian urban site in the eastern Wadi al-Ajal.

characteristic Garamantian settlement was a nucleated community located in the centre of the depressions where agriculture was practised. In addition to urban settlements, there were densely packed villages and hamlets all along the valley of the al-Ajal, to match the extensive evidence of cemeteries along the foot of the escarpment. The immediate hinterland of Jarma alone contains over 20 such sites and the total for the al-Ajal in Garamantian times will almost certainly have exceeded 50 (Fig. 17.7). This was a densely occupied landscape – indicating intensive exploitation through sophisticated irrigation systems.

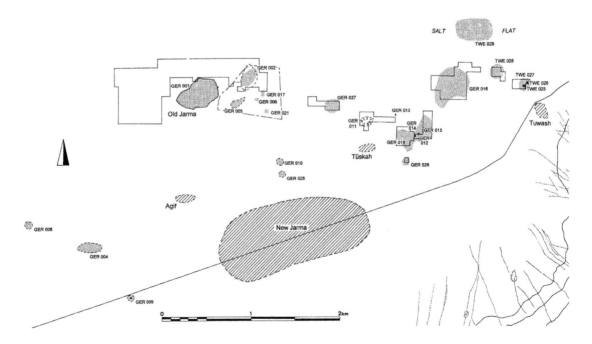

Figure 17.7. Map of settlement and other sites located in the vicinity of Jarma. Most of the settlements appear to have been small villages and hamlets.

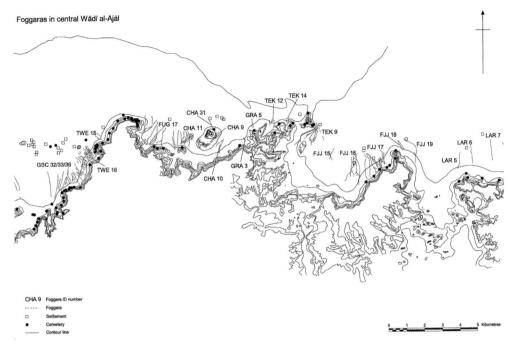

Figure 17.8. Map showing the distribution of key Garamantian sites, cemeteries and foggaras between Larcu and Jarma in the western Wadi al-Ajal.

Garamantian farming

The system of desert farming is strikingly different from the floodwater farming systems of the pre-desert zone to north of Fazzan (Barker *et al.* 1996a/b), involving irrigation from subterranean aquifers. The irrigation systems, called foggaras, were designed to provide free-flowing water to a large part of the depression floor and constituted a major landscape feature (Mattingly *et al.* 2003, 235-65). These features are dealt with in Andrew Wilson's paper elsewhere in this volume – I only wish to emphasise here the numbers and scale of construction involved (Fig. 17.8). We now know that more than 600 of these water channels were constructed (involving the digging of more than 100,000 shafts up to 40 m deep and with the total combined length of the underground channels extending to several 1000 km length). Although such features are notoriously difficult to date, we are certain that they relate primarily to the Garamantian and early post-Garamantian periods (as some examples occur in areas with no permanent Islamic settlement). They clearly facilitated large-scale and extensive cultivation of the valley floor oasis area.

As noted already in connection with Zinkekra, Garamantian agriculture was well developed at an early date, to judge from a series of botanical samples dated to the first half of the first millennium BC from Zinkekra (van der Veen 1992). This important work is now supplemented by a sequence of stratified samples from the excavations at Jarma. A small amount of faunal evidence from Daniels' excavations at Zinkekra, Saniat Jibril and Jarma, is complemented by a far larger sample from the Fazzan Project excavations (see further, the papers by Grant and van

197

der Veen, this volume). Some preliminary conclusions are possible. The date palm was central to Garamantian farming, as it has been for all subsequent phases of life in Fazzan. However, the early appearance of well-developed cereal cultivars (notably bread wheat) at Zinkekra is significant, as is the presence of other cultivated plants that were not previously native to the region. The weed species for the most part indicate harsh arid background conditions, though a few species might suggest some marshy pools or irrigated fields. Additions to the 'early' list from Zinkekra are relatively few at Garamantian Jarma, though there is some preliminary evidence that millet and sorghum may have become progressively more important in late Garamantian and early Islamic times, perhaps indicating the first stages of a more intensive system of double cropping linked to a change in the irrigation regime (with these new crops providing the second harvest in high summer).

The faunal record also shows a substantially complete range of livestock at Zinkekra, though it is potentially interesting that the camel is not attested in those early contexts. It is certainly present at the oasis centre sites of Classic Garamantian date. The pig and horse appear to be other introductions of the Garamantian period, though these appear also at the earlier Garamantian sites.

The Garamantian kingdom

The Garamantes constituted a Saharan kingdom of large size, though our ancient sources are a bit vague on geographical limits (Fig. 17.9). It is already clear that a similar pattern of settlements of Garamantian date existed in some of the other major oasis depressions of Fazzan (as demonstrated for the Wadi 'Utba, Murzuq and Hofra districts). However, it is apparent that Garamantian culture in these outer regions was not a straightforward replica of that encountered in the al-Ajal. In particular, funerary monuments appear to have been more restricted in evolution and elaboration outside the heartlands of the Wadi al-Ajal. Nonetheless, aspects of burial orientation and ritual, the use of red ochre, the presence of headrests and the range of imports from the Roman world suggest close cultural affinities with the Garamantes. Similarly, the indications of irrigated agriculture in these areas provide another link with the Garamantes. Despite the minor differences in material culture, then, there seems to be good reason to associate the other main groups of oases in Fazzan with the Garamantian kingdom. What we can recognise in these data, however, is the hegemonical nature of the Garamantian power, encompassing a range of desert oases, each with appreciably different traditions. The name of the Garamantian capital, Garama, indicates that the kingdom was built up initially from a base in the western Wadi al-Ajal. It is no surprise to see the greatest levels of wealth being deployed in this area during the Classic Garamantian phase. The unification of the whole of Fazzan in this phase will have depended to some extent on military power and when that power appears to have waned in late antiquity, the kingdom fragmented – at any rate that seems the logical conclusion to be drawn from the fact that our medieval sources mostly talk of the populations of individual oases.

Although much of Garamantian territory was waterless desert wastelands, the maximum geographical reach of the kingdom extended along chains of oases across an area of *c.*250,000

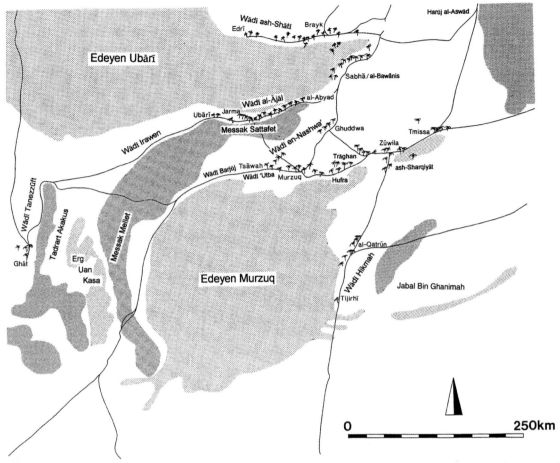

Figure 17.9. Map of Fazzan. The likely extent of the Garamantian kingdom at its height ran from Ghat in the south-west, Tijirhi in the south-east, Zuwila and Tmissa in the east, Edri, Brayk and Sabha in the north.

km². No reliable figures can be suggested for the total number of villages and towns, though this seems certain to have by far exceeded the *c*.100 villages and hamlets of early modern times. Similarly, it is not unreasonable to suggest that at its peak the population of Garamantian Fazzan greatly exceeded the 33,500 recorded in the Italian 1936 census. A maximum population figure in the range 50,000-100,000 is not implausible.

The Garamantian economy and trade

The economy of ancient Fazzan was undoubtedly founded above all on agriculture and the foggaras indicate that this was a period of peak regional production (*cf.* Fig. 2.7 above). However, there is also ample evidence to show that the Garamantes were engaged in much more wide-ranging economic activity (Mattingly *et al.* 2003, 355-62). Several of the surveyed settlement sites, as well as the excavations at Jarma and Saniat Jibril, have yielded evidence of metallurgy, both ferrous and copper alloy, indicating that Fazzan was an important early centre of African metallurgy. As yet there is no evidence of where the Garamantes carried out their primary

Figure 17.10. A Garamantian figurine head of human form from the area of the temple at Jarma.

smelting of iron, though that is likely to have been close to the major regional ore source in the Wadi ash-Shati, an area as yet very poorly explored for its Garamantian remains. The copper source may well have been sub-Saharan, though there is some evidence of casting of small copper ingots at Jarma itself. Saniat Jibril has been identified as a major centre of manufacturing activity, though similar processes were evidently carried out at many other sites. A large number of hearths have been identified from surface traces, along with a crucible fragment and numerous off-cuts of copper alloy. Preliminary analysis of material from Saniat Jibril and Jarma shows that both iron smithing and copper alloy working were being carried out in the same hearths.

There is a mass of evidence for the working of semi-precious stones at Garamantian sites. The principal stone involved is the translucent red carnelian (known in the Roman sources as Garamantian carbuncles or Carthaginian stones – the latter reference simply suggests the trade route by which they first reached a Roman market). There is also an opaque turquoise material commonly known as Amazonite. The most likely source of the carnelian is the volcanic area of the Jabal Hasawnah in northern Fazzan (perhaps the *Mons Gyri* mentioned in Roman literature as the source of gems), while the amazonite (or zuma stone as it is sometimes known) originates in northern Tibesti some hundreds of kilometres south-east of Jarma. The most common local use of both stones appears to have been for bead production. Flawed and broken half-finished beads in these stones attest to local production, as do the grooved stones, which were used to shape and polish both the semi-precious stone and ostrich eggshell beads. These 'bead polishers' have been recorded in very large numbers at Saniat Jibril and at a number of other Garamantian sites. Garamantian beads may well have been traded south to sub-Saharan areas as well as north.

Glass beads are also frequent finds on Garamantian sites and there are hints at Saniat Jibril that glass working, at least for bead production, also took place there. There are major local sources of key materials used in glass production, such as the natron deposits of the lakes of the Edeyen Ubari, just to the north-east of Jarma.

There is also abundant evidence for the local production of pottery and this combination of metallurgy, glass-making and pottery production demonstrates the relative sophistication of Garamantian control of pyrotechnical processes. Local ceramic production in Garamantian Fazzan included a range of distinctive forms with painted geometric decoration of probable late antique date. Terracotta figurines of human and animal form, discovered at Jarma in the 2001

excavations of Garamantian levels also appear to be local works (Fig. 17.10).

Salt was another key commodity of the Sahara. Several parts of Fazzan have notable areas of salt flats (*sabkha*) and there is a particularly large one to the north and north-east of Jarma itself. This area has produced vestigial traces of large embankments on the *sabkha*, perhaps created to enhance salt formation. Non-metallic industrial residues, believed to relate to salt production are common finds on Garamantian settlements near to areas of salt flat and are suggestive of large-scale and well-organised salt production.

Rotary quern stones make their first appearance in Fazzan around the second century AD. The changeover from simple rubbers to querns is most noticeable at Saniat bin Huwaydi, where some early burials of the first century AD have flat leaf-shaped rubbers, whilst the later phases of burial, when they include grinding equipment, incorporate rotary querns. Some of the earliest examples, in basaltic lava, were imported from the Roman province to the north, but a distinctive set of models in local stone was soon developed and remained the standard grinding equipment down to the early twentieth century.

The existence of Garamantian trans-Saharan trade has long been discussed (Bovill 1968). The large volume of imported Roman material also indicates that something of value must have been passing the other way. Despite the doubts expressed by Brett (this volume; *cf.* also Insoll this volume), it now seems that the Garamantes did control a trading system that operated both north and south of the Sahara. There are hints in the ancient sources of the Garamantes trading in wild beasts (for the arenas of the Roman world), in semi-precious stones and in ivory. Ivory items have been found at Jarma, notably bracelet fragments, confirming the local availability of the material and (probably) Garamantian working of it into artefacts. Similarly, several notable finds of gold artefacts in earlier excavations at Jarma would seem to confirm the long-held suspicion that the Garamantes were also involved in trading gold across the Sahara. The Classical sources speak of the Garamantes hunting the *troglodytae* and 'Ethiopians', a strong hint of slave raiding against neighbouring peoples (Herodotus 4.183; Ptolemy 1.10). The selling-on of such captives northwards across the Sahara may not have been all that large-scale, the intensive nature of irrigated cultivation (and the dangerous task of foggara construction) could have absorbed an almost unlimited numbers of slaves within Fazzan itself.

In terms of its territorial extent, its settlement and population density and its socio-political organisation, the Garamantian kingdom was quite obviously a major force to be reckoned with in the Central Sahara. The settlement density, the number and scale of the cemeteries and the foggara systems all combine to highlight the Garamantian period as one of peak population and oasis cultivation. But decline appears to have set in during late antiquity. There are important hints in the archaeological record that Garamantian settlements became more overtly defensive in character from the second or third centuries AD. The presence of fort-like structures (*qsur*) at the heart of many village sites is one indication of this trend, and at least one 'urban' site was provided with a substantial enceinte wall. This may suggest a decline in the military position of the kingdom *vis à vis* its neighbours or, alternatively, a progressive fragmentation of political power leading to the rise of numerous local power blocs.

The Post-Garamantian Age

The name of the Garamantes disappeared from history after the sixth century AD, largely a result of the relative isolation of western Fazzan in the early Islamic period (Mattingly *et al.* 2003, 90-98, 362-65). During this time some Garamantian villages appear to have continued and additional sites amongst these may have been embellished with mud-brick castle-like structures. Both Jarma and the urban site of Qasr ash-Sharaba have yielded radiocarbon dates of the tenth-eleventh century AD, demonstrating the continuation of two of the main Garamantian urban centres. Over time, however, the number of villages seems to have declined markedly, and some parts of the landscape were abandoned by sedentary cultivators, perhaps linked to an indisputable shift from foggara to well irrigation. When the region became fully assimilated into the Islamic world – perhaps only by the eleventh century AD – there was still a people of the Wadi al-Ajal known as the '*Khorman*', surely a dim echo of the one-time Saharan kingdom of the Garamantes.

A New Agenda for Libya's Saharan Heritage

The work discussed here has produced a solid foundation on which to build for the future of interdisciplinary geographical, archaeological and historical studies of Fazzan. Yet many questions remain unanswered. I am acutely conscious that much remains to be done, at a time when modern development and increased access to the desert by 4WD vehicles is starting to have a profound impact on the state of preservation of Libya's Saharan heritage (see papers in this volume by Barnett, Keenan and Liverani). It is striking how much has been lost or changed in the generation that separates my work from that of Daniels. What is needed above all is increased investigation of the region by the relevant Libyan agencies and foreign research teams, backed up by better conservation and protection of the sites so far discovered. The Department of Antiquities has undertaken important measures at Jarma and al-Hatiya, but much more could be done if enhanced funds were made available.

Further excavation work at the main Garamantian centres will surely continue to enrich our knowledge of this Saharan kingdom. We also need to extend survey work into other parts of Fazzan that have been hitherto neglected by archaeologists – most notably the Wadi ash-Shati. As the area of Fazzan with the largest number of springs and the most abundant iron deposits, I predict we shall find considerable traces of Garamantian period activity here.

Another key question for further research is the demographic make-up of the people and regional variation across Fazzan. Were the Garamantes a mixed population from the outset and can we detect any social differentiation in ethnic terms over time? One of the ways this could be explored would be through renewed excavation of burials, including graves of differing social rank and date, coupled with human anthropological examination and where possible DNA analysis. It may also be possible to trace the prevalence over time of particular diseases such as malaria through DNA analysis. As the Fazzan was one of the most likely corridors through which malaria reached the Mediterranean, this could shed light on the timing of the spread of malaria from sub-Saharan Africa. Excavation of burials would also advance our understanding of Garamantian burial rites and morphology and how these related to pre-Garamantian practices.

Other issues that require further work include the excavation of secondary Garamantian centres away from Jarma itself, more work on the date and character of early metallurgy and salt-refining at Garamantian sites and further attempts to date the phase of abandonment of the foggaras. The foggaras as a class of monument merit further examination and some effort should be made to preserve them from further degradation in at least one area of Fazzan where they are still visible in the landscape. The Libyan inscriptions of Garamantian and later date need more study to document them in detail, to differentiate between them and, hopefully, to advance understanding of their content.

There is a very large assemblage of finds of Garamantian date, many of which have been the subject of recording by CMD or the FP (a start has been made on compiling a computerised museum catalogue). This includes a large number of imports into the Sahara from the Mediterranean world, including at least 100 intact amphoras now in the Jarma museum. This latter group of material in particular would repay further detailed identification and study.

Finally, and most importantly, the achievements of the archaeological work reported on here should not distract attention from the fact that there are serious threats to the archaeology of the Garamantian kingdom and action must be taken urgently to prevent irreversible losses to the cultural heritage of the first Libyan State.

Acknowledgements

This paper presents a concise summary of some of the main conclusions on the Garamantes resulting from the Fazzan Project (the text is partly based on the monograph-length treatment of Mattingly *et al.* 2003. The reader is referred to that volume for expansion of the ideas expressed here and for fuller accompanying references and illustrations). For interim reports on the work, see successive editions of the journal *Libyan Studies* from 28 (1997) to 33 (2002). The work of the Fazzan Project (and the publication of the Daniels work) has been made possible by the support of the Society for Libyan Studies, the Leverhulme Trust, the British Academy, the NERC, the AHRB, the University of Leicester. The project has involved the input of a large team, too many to name individually here – for full acknowledgements see Mattingly *et al.* 2003, xxv-xxvi).

References

Barker, G. and Gilbertson, D. (eds). 2000a. *The Archaeology of Drylands. Living at the margin,* One World Archaeology 39, London.

Barker, G., Gilbertson, D., Jones, B. and Mattingly, D. 1996a/b. *Farming the Desert. The UNESCO Libyan Valleys Archaeological Survey, vol. 1 Synthesis,* (editor G. Barker), *vol. 2 Gazetteer and Pottery* (editor D.Mattingly), UNESCO, Paris.

Bovill. E.W. 1968. *The Golden Trade of the Moors* (2nd ed.), Oxford.

Cremaschi, M. and di Lernia, S. (eds). 1998a. *Wadi Teshuinat. Palaeoenvironment and Prehistory in south-western Fezzan (Libyan Sahara). Survey and Excavations in the Tadrart Acacus, Erg Uan Kasa, Messak Sattafet and Edeyen of Murzuq, 1990–1995,* Milan.

Daniels, C.M. 1968. Garamantian excavations: Zinchecra 1965-1967. *Libya Antiqua* 5: 113-94.

Daniels, C.M. 1970. *The Garamantes of Southern Libya*. London.

Daniels, C.M. 1989. Excavation and fieldwork amongst the Garamantes. *Libyan Studies*: 20: 45-61.

Liverani, M. 2000a. The Garamantes: a fresh approach. *Libyan Studies* 31: 17-28.

Liverani, M. 2000b. Looking for the southern frontier of the Garamantes. *Sahara* 12: 31-44.

Liverani, M. 2000c. The Libyan caravan road in Herodotus IV.181-184. *Journal of the Economic and Social History of the Orient* 43.4: 496-520.

Mattingly, D.J. 1995. *Tripolitania,* London.

Mattingly, D.J. 2000. Twelve thousand years of human adaptation in Fezzan (Libyan Sahara), in Barker and Gilbertson 2000: 160-79.

Mattingly, D.J., Daniels, C.M., Dore, J.N., Edwards, D. and Hawthorne, J. 2003. *The Archaeology of Fazzan. Volume 1, Synthesis,* London.

Mattingly, D.J., Daniels, C.M., Dore, J.N., Edwards, D. and Hawthorne, J. Forthcoming. *The Archaeology of Fazzan. Volume 2, Gazetteer, Pottery and other finds,* London.

Mori, F. 1998. *The Great Civilization of the Ancient Sahara. Neolithisation and the earliest evidence of anthropomorphic religion,* Trs. B.D. Philips, Rome.

Pace, B., Sergi, S. and Caputo, G. 1951. Scavi Sahariani. *Monumenti Antichi* 41: 150-549.

Ruprechtsberger, E.M. 1997. *Die Garamanten, Geschichte und kultur eines Libyschen Volkes in der Sahara,* Mainz.

Veen, M. van der. 1992. Garamantian agriculture: the plant remains from Zinchecra, Fezzan. *Libyan Studies* 23: 7-39.

Wheeler, M. 1954. *Beyond the Imperial Frontiers,* London.

18. The Spread of Foggara-based Irrigation in the Ancient Sahara

By Andrew Wilson[1]

Abstract

This paper proposes a new model for the diffusion of foggara-based irrigation across the Sahara in ancient and medieval times. Recent fieldwork by the Fazzan Project has established that the foggaras of the Wadi al-Ajal are of Garamantian origin (last centuries BC / early centuries AD), and appear to have been used perhaps until the early middle ages (ninth to eleventh centuries), but probably not beyond this. Abandonment of some of the foggaras may even have begun as early as the fourth century AD. It is argued that foggara irrigation technology was introduced from Egypt in the second half of the first millennium BC, and enabled the development of a Garamantian agricultural society in Fazzan, which controlled trans-Saharan trade. From Fazzan, foggaras spread north to the fringes of the Garamantian world, to southern Tunisia and the southern Aurès in the Roman period.

An apparent collapse in north to south trans-Saharan trade in the late Roman period (fourth/fifth centuries AD), linked to the decline of the Tripolitanian coastal cities, weakened the Garamantian state, not least by affecting supplies of slaves used in foggara construction and maintenance. Coupled with a declining water table, problems of labour and maintenance gradually led to the abandonment of most foggaras, and a shift to smaller-scale agriculture supported by wells. Meanwhile, however, development of oasis zones in the west central Sahara (especially the Touat and Gourara) facilitated the subsequent development of new north to south trade routes through what is now the Algerian Sahara. These oases are today the zones of most highly developed foggara use anywhere outside Iran; local tradition puts foggara use here as early as the eleventh century AD, and there are grounds for thinking it may go back to the seventh century if not earlier. There are strong similarities, in construction and nomenclature, between the foggaras of Fazzan and those of the west central Sahara, and it is most likely that the foggaras of the Touat and Gourara were introduced from Fazzan. From these oases the foggara subsequently spread to the Tidikelt, Tafilelt and Figuig. Fazzan played a pivotal role in the spread of foggara irrigation across the Sahara; not only did the technology spread along trans-Saharan trade routes, but it enabled the development of oases as trading centres. As such, the history of the foggara in the Sahara is inseparable from the history of trans-Saharan trade.

Introduction

The Garamantes of Fazzan were the most powerful of the Libyan tribes of the Sahara mentioned in surviving Greek and Latin literature, and recent archaeological work has revealed something of the extraordinary achievements of their culture (see Mattingly this volume). In particular, survey and excavation in the Wadi al-Ajal by Charles Daniels in the 1960s and 1970s (Daniels 1968; 1970a/b; 1971; 1972; 1989), and the Fazzan Project in the last few years (Mattingly *et al.* 1997; 1998a/b; 1999; 2000a/b; 2001; 2002; 2003), has established that in the last few centuries BC and the early centuries AD the Wadi al-Ajal supported a population that was not equalled again until the later twentieth century. This population lived in towns, some of them fortified, and villages scattered throughout the oasis floor of the wadi, for some 160 km from al-Abiod in the east to Tin Abunda in the west (Fig. 18.1). The Garamantes appear to have played a vital role in trans-Saharan trade from at least the fifth century BC (on the evidence of

[1]Institute of Archaeology, University of Oxford

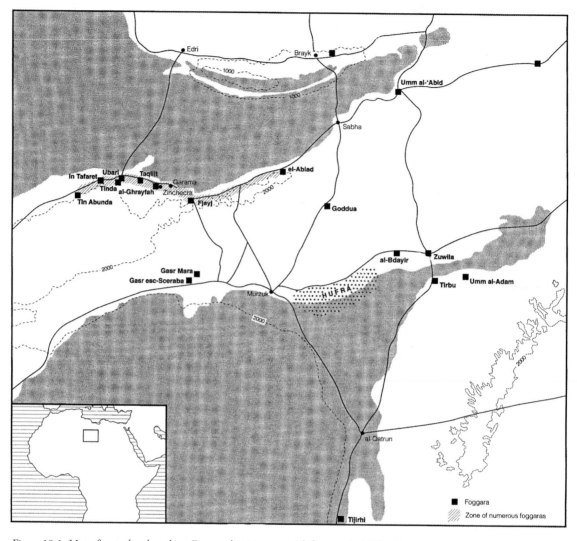

Figure 18.1. Map of central and southern Fezzan, showing areas with foggaras (A. Wilkins).

Herodotus) to the fourth century AD; the trade routes initially ran south-west to north-east from the Niger kingdoms through Fazzan to Egypt, with the later development of more direct northerly routes to the Punic emporia and then the Roman cities of Tripolitania – Lepcis Magna, Oea and Sabratha (Liverani 2000a/b). During the first three centuries AD Roman amphorae, ceramics and glassware were carried south to Fazzan, in return for goods from sub-Saharan Africa – perhaps animal skins, ivory, gold, and, most importantly slaves acquired either by raiding or in exchange for salt produced in Fazzan by evaporation. From the third century AD onwards, there are signs of increasing stress or even disintegration of the Garamantian kingdom; Roman imports seem to be in increasingly short supply, and mud-brick and stone forts, or *qsur*, were constructed at intervals along the wadi. Several of these have now been dated by [14]C dating of organic inclusions in the mud bricks (Mattingly *et al.* 2002), and by associated pottery, to the

later Garamantian period. The *qsur* seem to indicate less peaceful conditions; either a fear of external attack, or internal stresses within Garamantian society.

During its heyday, the Garamantian kingdom achieved a level of population and incipient urbanism unrivalled by any other ancient Saharan culture (Mattingly, this volume). Large quantities of water must have been required for the irrigation of agricultural lands on which local settlement depended, and also for the production of salt by evaporation, which was critical to the Garamantes' trade with sub-Saharan Africa. Although the transition to fully hyper-arid conditions seems to have occurred around the fifth century AD (see Cremaschi, this volume), the climate of Fazzan in the Garamantian period had already taken on many of the characteristics of today's arid climate – low rainfall, and very high temperatures and evaporation rates. The springs at the foot of the hamada escarpment had ceased to flow at the end of the second millennium BC, leaving subterranean aquifers as the only source of water. How were the Garamantes able to access the water necessary for irrigated agriculture, stock-rearing and salt production?

The Foggaras of Fazzan
The fieldwork undertaken by the Fazzan Project shows that the answer is to be found in a vast network of subterranean irrigation systems known as *qanats*, or 'foggaras'. A foggara is an

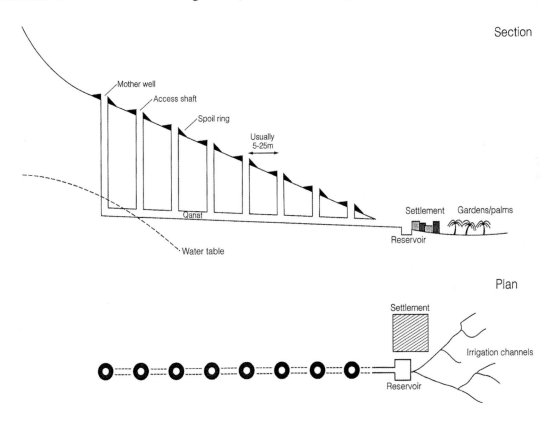

Figure 18.2. Diagram showing a foggara or qanat. The vertical scale in the section is greatly exaggerated for clarity (A. Wilkins).

Figure 18.3. Foggara spoil rings between In Tafaret and Ed Disa. (Photo: A. Wilson).

underground tunnel which drains water out of a water-bearing rock stratum or aquifer; the tunnel slopes gently but the ground surface above it drops away more steeply so that eventually the tunnel emerges at the surface, and the water can be distributed to fields for irrigation, or used for drinking (Fig. 18.2). A characteristic of foggaras is that the tunnel is not dug sideways into the hillside; instead, a mother well is sunk to establish the depth to water in the area where the aquifer is found, and an area that can be irrigated is selected downhill from this. The course between the mother well and the land to be irrigated is surveyed on the surface, and the tunnel is then dug in short stretches between pairs of access shafts. The excavated earth is piled up in rings around the shafts, to protect them from erosion and clogging by surface run-off water; lines of these spoil rings are the tell-tale surface traces of the underground channels (on *qanats*/foggaras generally, see Goblot 1979) (Fig. 18.3).

Figure 18.4. Foggara running through aceramic cemetery at In Tafaret (Photo: A. Wilson).

The remains of hundreds of foggaras are still visible along the south side of the Wadi al-Ajal for some 160 km between al-Abiod and Tin Abunda, running from the foot of the hamada escarpment towards the centre of the wadi. Modern agriculture, urban development and bulldozing for aggregates is rapidly destroying these ancient monuments, devastating a landscape that represents one of the most intensive zones of foggara usage in the world outside Iran. Aerial photographs from the 1960s show at least 550 foggaras, plus tributaries and branches, revealed by their lines of spoil rings, and each running for between a few hundred metres and 4.5 km. While these occur along the length of the Wadi al-Ajal, in some areas they are closely associated with settlements of the Garamantian period, and this is especially clear to the west of Ubari (for a fuller treatment of the evidence for foggaras in the Wadi al-Ajal, see Wilson and Mattingly 2003). At In Tafaret and Tin Abunda, some 30 km west of Ubari, there are groups of foggaras in a zone where there seems to have been no habitation of medieval or later date, but several Garamantian settlements and a number of cemeteries are to be found close to the foggaras at the escarpment foot. This strongly suggests that the foggaras here must be of Garamantian date, as there is no other period of settlement with which they could be associated.

The Garamantian date of the foggaras is confirmed by an example near Fjayj, where a Garamantian settlement overlies the spoil mounds of one foggara. Hut scoops cut into the foggara spoil heaps show that the settlement is later than the foggara, and as the settlement is dated by pottery of between the first and fourth centuries AD, the foggara should date to before

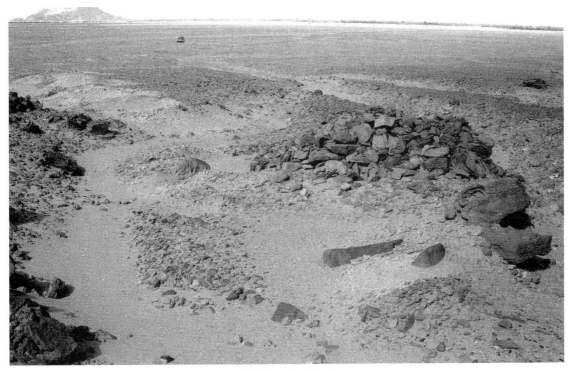

Figure 18.5. Tomb overlying foggara spoil heap at Taglilt (Photo: A. Wilson).

the fourth century at the very latest; possibly much earlier. Indeed, it may already have been abandoned by the time the settlement encroached on the spoil mounds.

Evidence to suggest an earlier date, perhaps in the late centuries BC, for some of the foggaras comes from the areas of In Tafaret, west of Ubari, and Taglilt, between al-Qrayfah and Tinda. At In Tafaret two foggaras run though different cemeteries of drum cairns (Fig. 18.4), and an early date (first millennium BC) for these cemeteries is suggested by the fact that there is no pottery associated with the tombs. The manner in which the foggaras cut through the cemeteries indicates that the foggaras are later than the cemeteries, which were no longer in use. But nearby there are cemeteries of a different type, with more nucleated tombs, each with an altar to the east of it, and pottery (Punic and Roman amphorae) of the second century BC to second century AD. One of the foggaras starts near this cemetery, but does not cut into it, perhaps because the cemetery was in use when the foggara was constructed.

At Taglilt, foggaras also cut through the dispersed aceramic cemeteries of the early Garamantian period at the foot of the escarpment, but seem to avoid the nucleated cemeteries, with tombs with offering tables and stelae, and Roman-date pottery. In the cairn cemeteries, several tombs seem to overlie foggara spoil mounds (Fig. 18.5), suggesting that some of the foggaras here date to the later phases of the cairn cemeteries, a little before the transition to the nucleated cemeteries.

Altogether, the evidence demonstrates that foggaras were known in Fazzan certainly before the fourth century AD, and probably by the later centuries BC or the early centuries AD. They were undoubtedly introduced to the Libyan Sahara during the Garamantian period, and they must have been the means by which the Garamantes were able to practise irrigated agriculture on a scale to support unprecedented population levels in the Wadi al-Ajal. Elsewhere in Fazzan, foggaras are known at Tawila, the Hufra, ash-Sharqiyat, at al-Bdayir, Zuwila, Tirbu, Zuwaya, Qasr Mara, and Umm al-'Abid; although none of these has yet been dated, many are broadly associated with Garamantian settlements.

It was the foggara irrigation technology, then, which enabled the rise of Garamantian culture, and the population growth made possible by irrigated agriculture was probably a major factor in the development of a Garamantian state, under central control. We know nothing for certain of the organisation of labour for constructing the foggaras, but while specialist surveyors would have been required for setting out and levelling the course of a foggara, the hard and dangerous labour of digging tunnels in the unstable gravels and marls may well have been the job of slaves. After all, what would be more natural for a society that derived some of its wealth from trading slaves across the Sahara than to use them to perform the hardest and most dangerous tasks?

But if we can now explain the roots of Garamantian success in the arid climate of the Sahara, we still need to ask: where did this technology come from, and how did it reach Fazzan? Foggaras, also known as *qanats*, *kariz* and *aflaj*, are found from Morocco to China, and even in South America; the technique is one of the most widely diffused irrigation technologies in the northern hemisphere (Goblot 1979). The subject is debated, but the majority view is still that foggaras were probably invented in Persia, perhaps in the late Assyrian period or under the Achaemenids (see now Dalley 2001/2002). Most studies of the spread of foggara technology,

and especially those which have considered North Africa, have assumed that the technique was spread by migrating or invading peoples, coming through or from the Mediterranean region. Thus, for instance, it had been suggested that the foggaras of Fazzan must have been introduced either by the Romans (Caputo 1937, 309-10), or by Arabs in the early Islamic period (Klitzsch and Baird 1969); and the foggaras of the Algerian Sahara were thought to have been introduced in the early Islamic period either by Jewish refugees or by exiled Persians (Goblot 1979, 167-9). But now that the Fazzan Project has shown that the foggaras of the Wadi al-Ajal pre-date Roman or Islamic contact, these theories need to be discarded.

Foggaras in Achaemenid Egypt

Instead, it seems more likely that foggaras got to Fazzan from Egypt, as recent excavations at 'Ayn-Manawir in the Kharga oasis in the Western Desert have established that a series of foggaras there date from the period of the Achaemenid Persian domination of Egypt (Wuttmann 2001). Twenty-two foggaras have been discovered, and one was shown by excavation to date from the Achaemenid period. A house which yielded a cache of tablets dated from 436 to 388 BC was built over spoil from the foggara's construction, and further spoil from channel maintenance operations was piled against the wall of the house, showing that the foggara was in service during the life of the house, in the fifth and fourth centuries BC. Elsewhere at the site, a temple produced a series of tablets including contracts relating to the sale of water rights, in 'days of water', which can hardly refer to anything other than the distribution of water from foggaras. These contracts are dated from between 443 BC onwards, and refer to 20 different foggaras.

The evidence from 'Ayn-Manawir, then, shows that foggaras were known and used in the Egyptian Western Desert by the mid fifth century BC at the latest; and they may have arrived there as an introduction from Achaemenid Persia. At this period, trade routes from the Niger bend ran up through Fazzan to Egypt via the oases of the Western Desert, and it seems most likely that foggara technology was introduced to Fazzan along these trans-Saharan trade routes during the second half of the first millennium BC (on early trans-Saharan routes, see Liverani 2000a/b). Once established in Fazzan, foggaras enabled the rise of the Garamantian state and further development of Saharan trade routes.

Figure 18.6. Aerial photograph of a foggara near Badès (ancient Badias) on the southern side of the Aurès mountains (Baradez 1949, 169, Photo C).

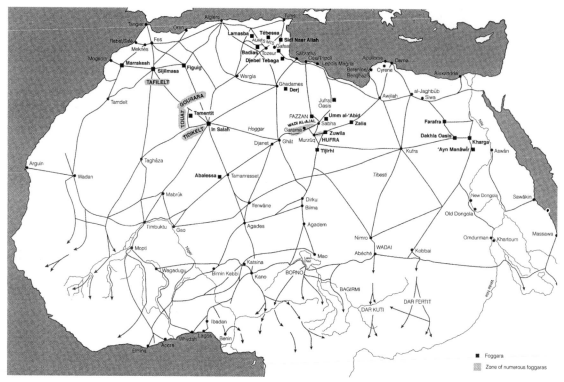

Figure 18.7. Map of the Sahara, showing trade routes (AD 200-1900) and foggara oases (A. Wilkins; after Ade Ajayi and Crowder 1985, 32).

Once it is realised that the history of the foggara is intimately connected with the development of Saharan trade, and that the technology spread along trade routes rather than being carried by waves of invaders or refugees, the foggaras of Tunisia and Algeria appear in a new light.

Diffusion Northwards to the Maghreb

Foggaras of Roman date are known from the Aurès mountains in Algeria, from near Tebessa, and from Sidi Nasr Allah to the north of Gafsa (Fentress 1979, 170; Durand 1894; Gresse 1901). The foggaras near Tebessa appear to have been abandoned in the late Roman period, to judge by Roman material found in the fill of their shafts. The foggaras of the Aurès are shown on Jean Baradez's air photographs (1949, 169 photos A, B and C) of the *limes* region near Badès (ancient Badias) (Fig. 18.6).

To the north of the Aurès mountains, several Roman settlements, including Lambaesis and Aïn Chador, were supplied by foggara-type aqueducts (Fentress 1979, 168-71 and n.23 p. 174, citing Birebent 1964). These systems tap aquifers; they run underground, tunnelled between pairs of access shafts, but they differ from the traditional foggara in that their tunnels are revetted in stone and their access shafts regularly steined and capped with stone slabs and covered with a mound of stones to prevent unauthorised abstraction. Sometimes the canalisation was laid on the floor of the galley, covered with stone slabs, and the tunnel then packed with stones and

rubble to prevent collapse of the roof, and eliminate the need for maintenance. These would appear to be Romanised, improved foggaras.

To date, research on the foggaras of Algeria and Tunisia has considered them a Roman introduction to the region, brought perhaps by Syrian auxiliaries, as foggaras were used in Roman Syria (Fentress 1979, 170; Goblot 1979, 119-21). But this theory failed to explain why they are confined to the frontier zone, or why the spread of foggaras to Morocco did not happen in the Roman period. Now that the foggaras of Fazzan are known to be of Garamantian date, it appears more likely that the Algerian and Tunisian foggaras were a technological introduction from Fazzan, along the trade routes up through Ghadames to southern Tunisia and the Aurès range. This supposition finds some support in a series of Berber legends from the Aurès, which imply that they were considered a Berber rather than a Roman technology.

The legends vary in detail, but all have a similar form. A queen ruled over the castle of Roumi and the town of Mertoum (both in the Guert Gassès plain in the Aures, just north of the foggara in Fig. 18.6), and her land suffered a terrible drought. The queen had a beautiful daughter, and promised her in marriage to whomsoever could bring water to her land. Two suitors came forward: one made a spring flow at the foot of the cliff by Roumi, and the other dug a tunnel bringing water from the foothills of the Nementcha mountains not only to supply Roumi and Mertoum, but also to irrigate the surrounding land as well. The second suitor won the princess (Masqueray 1878, 461).

The successful suitor's aqueduct is clearly a foggara – a tunnel, bringing water from the piedmont zone, and irrigating fields as well as supplying habitations. In some versions of the legend, the tunnel-builder is explicitly said to be a Berber: the Roman wins because the Berber's tunnel takes too long to build, and the princess kills herself rather than marry a Roman; or one suitor is Roman and the other black; the black suitor wins and the princess' father kills her rather than marry her to him. The emphasis may differ; in the first version quoted, it is on the technology used, and in the other two, on the ethnic origin of the suitors. But several structural elements of the legend remain constant: the princess, the two suitors, and the water supply schemes, of which one is always a tunnel. And all versions come from the Aurès region, from the frontier between Roman and Berber culture. Viewed in the light of the foggara distribution pattern just outlined, it is clear that they reflect a distant memory of the competing merits of Roman and Berber water technologies in the contact zone between the two cultures.

Apart from Fazzan, the densest concentrations of foggaras outside Iran are to be found in the Algerian Sahara, in the oases of Touat, Gourara and Tidikelt (Goblot 1979, with bibliography; Bisson 1989; Kobori 1989) (Fig. 18.7). Their origins are unknown; they are often assumed to have been introduced by Jewish refugees, or Zenata Berbers, or Barmacid Persians (Goblot 1979, 167-9); none of these theories has any firm evidence to support it. In the light of the evidence for early foggaras in Fazzan and in the Aurès region and southern Tunisia, we might rather suspect that the Algerian oases got their foggaras either directly from Fazzan, via east to west trade routes, or indirectly via the intermediary of the Aurès region. The Tidikelt was settled much later than the other two oases, and we would expect the Touat and Gourara to be the zones where foggaras were used first. Indeed, tradition associates the introduction of foggaras

to the Algerian Sahara with the Touat oasis, and there were certainly foggaras at Tamentit in the Touat by the fourteenth century. Ibn Khaldoun says of Tamentit that "water flows to the surface from the ground in a strange manner not found in the Tell of the Maghreb" (Lô 1953, 143). Jewish communities had settled in the Touat by the sixth century AD (Oliel 1994), and there may already have been foggaras to support a community then.

At Tamentit water from most of the foggaras is distributed on a volume basis, through a divider grille (*kesria*), but there are four foggaras whose water is distributed on a time-share basis. These four foggaras have Berber names, while the others have Arabic names, and they run on a different alignment. Three of these four run under the village (*qasr*) of Tamentit, and should therefore pre-date it. These may be some of the earliest foggaras at Tamentit, although others on the same alignment as the time-share foggaras have now fallen into disuse, and may also be very old (Capot-Rey and Damade 1962).

The Algerian foggaras are called by the same name – *feggaguir* – as the Libyan foggaras, and they were built and maintained by *haratin* slave labour, rather as I have hypothesised for the Garamantian foggaras of Fazzan. If I am right in believing that they were introduced from Fazzan, this should have happened well before the eleventh century, by which time the foggaras of Fazzan had largely gone out of use – or even long before. The process by which the Garamantian foggaras of Fazzan fell into decay may have commenced as early as the fourth century AD, at which date the foggara at Fjayj may already have been abandoned. At this time an apparent collapse in north-south trans-Saharan trade, linked to the decline of the Tripolitanian coastal cities, weakened the Garamantian state, and affected supplies of slaves used in foggara construction and maintenance. Coupled with a declining water table, problems of labour and maintenance gradually led to the abandonment of most foggaras in the early middle ages, and a shift to smaller-scale agriculture supported by wells (for further discussion of this issue, see Wilson and Mattingly 2003). The development of oasis zones in the west central Sahara (especially the Touat and Gourara) appears to have commenced around this period, and the settlement of these oases enabled the subsequent development of new north-south trade routes in the early Islamic period.

Conclusion

From the Touat and Gourara oases the foggara spread to the Tidikelt, Tafilelt and Figuig; the introduction of *khettaras* to Marrakech in the twelfth century may have come not from Spain, as Goblot suggested (Goblot 1979, 152-5), but from the Tafilelt. Fazzan therefore played a pivotal role in the spread of foggara irrigation across the Sahara from Egypt to Algeria and perhaps Morocco (Fig. 18.7). Not only did the technology spread along trans-Saharan trade routes, but it enabled the development of oases as trading centres. As such, the history of the foggara in the Sahara is inseparable from the history of trans-Saharan trade. Other oases in the Libyan Sahara have foggaras whose date and origin has not been investigated – for example, the Jofra oasis and Derj near Ghadames.

References

Ade Ajayi, J.F. and Crowder, M. 1985. *Historical Atlas of Africa*, Cambridge.

Baradez, J. 1949. *Fossatum Africae. Recherches aériennes de l'organisation romaine dans le Sud-Algérien*, Paris.

Birebent, J. 1964. *Aquae Romanae: recherches d'hydraulique romaine dans l'est algérien*, Alger.

Bisson, J. 1989. The origin and evolution of foggara oases in the Algerian Sahara, in P. Beaumont, M. Bonine and K. McLachlan (eds), *Qanat, kariz and khattara: traditional water systems in the Middle East and North Africa*, London and Wisbech:178-209.

Capot-Rey, R. and Damade, W. 1962. Irrigation et structure agraire à Tamentit (Touat). *Travaux de l'Institut de Recherches Sahariennes* 21: 99-119.

Caputo, G. 1937. Archeologia, in G. Caputo (ed.), *Il Sahara Italiano. Parte prima: Fezzán e Oasi di Gat*, Roma: 301-30.

Dalley, S. 2001/2002. Water management in Assyria from the ninth to the seventh centuries BC. *Aram* 13-14: 443-60.

Daniels, C.M. 1968. Garamantian Excavations. Zinchecra 1965-67. *Libya Antiqua* 5: 113-94.

Daniels, C. 1970a. The Garamantes of Fezzan. Excavations on Zinchecra, 1965-1967. *The Antiquaries Journal* 50.1: 37-66.

Daniels, C.M. 1970b. *The Garamantes of Southern Libya*, Wisconsin and North Harrow.

Daniels, C.M. 1971. The Garamantes of Fezzan, in F.F. Gadallah (ed.), *Libya in History. Historical conference, 16-23 March 1968*, Tripoli: 261-87.

Daniels, C.M. 1972-1973. The Garamantes of Fezzan - an interim report of research, 1965-1973. *Libyan Studies* 4: 35-40.

Daniels, C.M. 1989. Excavation and fieldwork amongst the Garamantes. *Libyan Studies* 20: 45-61.

Durand, S.A. 1894. Rapport sur les travaux de recherches d'eau exécutées à Aïn-Djedied en août-octobre 1894. *Recueil des notices et mémoires de la Société archéologique de Constantine* 29: 582-90.

Fentress, E.W.B. 1979. *Numidia and the Roman Army; social, military and economic aspects of the frontier zone*, BAR International Series 53, Oxford.

Goblot, H. 1979. *Les qanats: une technique d'acquisition de l'eau*, (Industrie et artisanat 9), Paris and New York.

Gresse, A. 1901. Restauration des travaux hydrauliques anciens de Sidi-Nasseur-Allah, in P. Gauckler (ed.), *Enquête administrative sur les installations hydrauliques romaines en Tunisie* vol. 1.5, Tunis: 311-7.

Klitzsch, E. and Baird, D.W. 1969. Stratigraphy and palaeohydrology of the Germa (Jarma) area, Southwest Libya, in W.H. Kanes (ed.), *Geology, archaeology and prehistory of the southwestern Fezzan, Libya. Petroleum Exploration Society of Libya, Eleventh Annual Field Conference 1969*, Tripoli: 67-80.

Kobori, I. 1989. Comparative studies on the formation of qanat water system - Pt. I. *The Bulletin of the Institute of Social Sciences, Meiji University* 12.1: 1-40.

Liverani, M. 2000a. The Garamantes: a fresh approach. *Libyan Studies* 31: 17-28.

Liverani, M. 2000b. The Libyan caravan road in Herodotus IV.181-185. *Journal of the Economic and Social History of the Orient* 43: 496-520.

Lô (Capt.) 1953. Les foggaras du Tidikelt. *Travaux de l'Institut de Recherches Sahariennes* 10: 139-79.

Masqueray, E.M. 1878. Ruines anciennes de Khenchela (*Mascula*) à Besseriani (*Ad Maiores*). *Revue africaine* 22: 444-72.

Mattingly, D.J., al-Mashai, M., Balcombe, P., Chapman, S., Coddington, H., Davison, J., Kenyon, D., Wilson, A. I. and Witcher, R. 1997. The Fezzan Project 1997: methodologies and results of the first season. *Libyan Studies* 28: 11-25.

Mattingly, D.J., al-Mashai, M., Aburgheba, H., Balcombe, P., Eastaugh, E., Gillings, M., Leone, A., McLaren, S., Owen, P., Pelling, R., Reynolds, T., Stirling, L., Thomas, D., Watson, D., Wilson, A. I. and White, K. 1998a. The Fezzan Project 1998: preliminary report on the second season of work. *Libyan Studies* 29: 115-44.

Mattingly, D.J., al-Mashai, M., Balcombe, P., Chapman, S., Coddington, H., Davison, J., Kenyon, D., Wilson, A.I. and Witcher, R. 1998b. The Fezzan Project I: research goals, methodologies and results of the 1997 season. *Libya antiqua* n.s. 3: 175-99.

Mattingly, D. J., al-Mashai, M., Balcombe, P., Drake, N., Knight, S., McLaren, S., Pelling, R., Reynolds, T., Thomas, D., Wilson, A.I. and White, K. 1999. The Fezzan Project 1999: preliminary report on the third season of work. *Libyan Studies* 30: 129-45.

Mattingly, D.J., al-Mashai, M., Balcombe, P., Barnett, T., Brooks, N., Cole, F., Dore, J., Drake, N., Edwards, D., Hawthorne, J., Helm, R., Leone, A., McLaren, S., Pelling, R., Preston, J., Reynolds, T., Townsend, A., Wilson, A.I. and White, K. 2000a. The Fezzan Project 2000: preliminary report on the fourth season of work. *Libyan Studies* 31: 103-20.

Mattingly, D.J., al-Mashai, M., Aburgheba, H., Balcombe, P., Eastaugh, E., Gillings, M., Leone, A., McLaren, S., Owen, P., Pelling, R., Reynolds, T., Stirling, L., Thomas, D., Watson, D., Wilson, A.I. and White, K. 2000b. The Fezzan Project II: preliminary report on the 1998 season. *Libya antiqua* n.s. 4 [2000]: 219-49.

Mattingly, D.J., Brooks, N., Cole, F., Dore, J., Drake, N., Leone, A., Hay, S., McLaren, S., Newson, P., Parton, H., Pelling, R., Preston, J., Reynolds, T., Schrüfer-Kolb, I., Thomas, D., Tindall, A., Townsend, A. and White, K. 2001. The Fezzan Project 2001: Preliminary report on the fifth season of work. *Libyan Studies* 32: 133-53.

Mattingly, D.J., Dore, J.N. and Edwards, D.N. 2002. Radiocarbon dates from Fazzan, southern Libya. *Libyan Studies* 33 (2002): 9-19

Mattingly, D.J., Daniels, C.M., Dore, J.N., Edwards, D.N., Hawthorne, J.W.J. (with contributions by others). 2003. *The Archaeology of Fazzan*, vol. 1, *Synthesis*, London.

Oliel, J. 1994. *Les juifs au Sahara: Le Touat au Moyen Age*, CNRS histoire, Paris.

Wilson, A.I. and Mattingly, D.J. 2003. Irrigation technologies: foggaras, wells and field systems, in D.J. Mattingly, C.M. Daniels, J.N. Dore, D. Edwards and J. Hawthorne (eds), *The Archaeology of Fazzan* vol. 1 *Synthesis*, London: 235-78.

Wuttmann, M. 2001. Les qanats de 'Ayn-Manâwîr, in P. Briant (ed.), *Irrigation et drainage dans l'antiquité. Qanâts et canalisations souterraines en Iran, en Egypte et en Grèce*, Collection "Persika"; Séminaire du Collège de France, mars 2000, 2, Paris: 109-35.

19. Libyans Here and There: A Comparison between Ancient Libyan and Greek Cultures.

By Daoud Hallag[1]

Abstract

This paper challenges the conventional picture of Greeks from Thera colonising ancient Libya and instead asserts that it is possible that Thera itself had been colonised by Libyans at an earlier date. It is also suggested that it was the descendants of these Hellenised Libyans who returned home with Battus to found the 'Greek' colonies in Libya. Various similarities between the culture of the Minoan period and ancient Libyan culture are highlighted, as well as some possible Libyan ethnic characteristics in figures depicted in the famous Minoan frescoes from Thera.

Introduction

To be Libyan is wonderful. Libya in the past lent its name to a continent: Herodotus wrote of three continents of the ancient world – Asia, Europe and Libya. It is clear and self-evident that Libya's importance and its history were regarded in antiquity as a huge depository of human culture. Since the emergence of Greek mythology we find Libyans occupying a prominent place in Mediterranean society.

At the zenith of Greek gods sitting on the top of the Mount Olympus was Zeus, the father of all gods in Libya. When Zeus was challenged by Poseidon, sitting on his throne of water, he made him the husband of the goddess Libya who bore him children. This union and its issue formed a link between the gods of the Greeks and those of the Egyptians and Phoenicians. As such Libya was established as an idol worthy of worship in the pantheon of the Olympic deities and was well integrated in Greek religion and cult. One source even refers to Libya as the mother of Athens (Bazama 1975).

My title, "Libyans Here and There", represents an attempt to reclaim something as part of Libya's fragmented recollection of history. This paper will make a comparison between the culture of ancient Libyans and the cultures of the late Greek bronze age, whether in Crete, in some part of the Aegean archipelago or in Mycenae on the Greek mainland. In so doing I am not giving in to flights of fancy, but I am trying to reverse a tendency on the part of some historians to belittle or unjustly treat the history of others.

Some of the historical writings about Libya have been wrongly classified and were written from unreasonable points of view that were in themselves unjust to the body of knowledge. Such established views continue to be a deep-seated and largely unquestioned models to our day. To demonstrate the problems I shall use the example of the five cities (Pentapolis): Euesperides or Berenice (Benghazi), Tavchira (Tokrah), Ptolemais (Tolmetha), and Apollonia (Susah) and Cyrene (Shahat) as the capital.

[1]Archaeological Researcher, Department of Antiquities, Shahat

Battus and the Colonisation of Cyrene

According to the traditional view, Cyrene was first colonised by Greeks from Thera (modern Santorini, 100 km north of Crete) led by Battus in 630 BC. On this point Chamoux (1953) ventured to say:

> "Finally, we must confess that this Greek Battus travelled abroad and built Greek cities in Libya emphasising Greek culture, language and affiliation. For the two centuries that the Battiad throne remained standing the Greeks held themselves at a distance from the Libyans, the native owner of the country".

However, we know from Herodotus that the men who came with Battus to Cyrene were not accompanied by women. Therefore, Libyans gave them their daughters in marriage and from the outset Cyrene must have witnessed a great big wedding party. In addition, it was actually the native Libyans who directed the newcomers to the best spot in the Green Mountain. Thus, what Chamoux has said remains unscientific.

We need to question how come two hundred young men, disembarking from just two boats, managed to occupy the most beautiful parts of the Green Mountain at the time when Libyans were capable of fighting off the much-feared armies of the pharaohs? Also, what were the real causes that made the Delphic oracle order Battus to leave for Libya in particular, rather than another country overseas? Could the expulsion of two hundred young men in two boats have solved the problem of famine in Thera? And if the matter was related to famine, as reported in some sources, why then did the two hundred men not go to another of the many Aegean islands, or to the Greek mainland? One possibility is that the colonists sent to Cyrenaica were the remnants of a Libyan group who had early exerted their own influence in the area of Akrotiri in the south-western part of the island of Thera.

Figure 19.1. Possible representations of Libyans from Thera (after Marinatos 1974).

Libyans on Thera?

My suggestion is that Battus was a Libyan, descendant of Libyan refugees, and his forefathers, the masters of the seas, were present on Thera for more than a thousand years before his return. Professor Marinatos, a modern Greek archaeologist, stated (1974):

> "One is surprised in the Minoan village to find significant Libyan influence, and one may naturally ask if there were colonies in the form of Libyan castles on our shores. The anthropological models depicted on the Theran frescoes – the wall paintings – provide food for thought for those who intend to research more, and the majority of such signs on those models were gathered on Plate 106".

The upper part of the scene (Fig. 19.1) shows a number of Brachycephalic skulls, always with short hair, in the middle part we have put together all the belongings of the professional sailors including the shipmasters whom we suppose were Aegean peoples. As for the lower part, it shows men with pronounced Libyan ethnic characteristics, and one of them is represented more than once. One of those warriors, in the tents' shadow, wears a helmet, on his chest there is a visible thick knot and he has frizzled hair. But the most obvious sign is his small and turned-up nose, and probably negroid characteristics, depicting someone of Libyan ancestry. Sir Arthur Evans acquired (1894) a small head in the south of Libya that he thought belonged to the Hellenic epoch and that he described as Minoan in date but representing an Egyptian, with the same turned-up nose.

Figure 19.2. *Theran painting of a boy with possible Libyan hairstyle.*

The wall painting has led the way for us to express freely our opinion for the first time and gives us the opportunity to finally say what we think of the deep and old relation between Libyans and Aegean peoples. I think what I must say in this instance that this relationship was deepened in the middle of the sixteenth century BC, and relations seem to be intimate and constructed on mutual cooperation and that opened a new page in the history of the Aegeans and particularly in the Libyan history, and it is useful to state that what we have learnt about Libya from frescos on Thera differs from what we know about Libya from Egyptian sources. The Egyptians knew Libyans as official guests to their country, or as soldiers, prisoners or enemies, whereas here in Thera, we find Libyans in the daily lives and routine in their settlements, jobs, families and in their clothes. In 1968 a colourful head was found in Thera, and I do not hesitate to relate it back to its African roots (cf. Marinatos 1974, 53-57).

Further evidence of Libyan immigrants on Thera comes from another fresco from Akrotiri, depicting a young man catching fish. His hair is shaved in a style known until today in Libya under the name 'fringe and pony tail', where the head is shaved except for a fringe of curls on the forehead (called 'forelocks') and bigger curls left on the back of the head and dubbed the 'pony tail' (Fig. 19.2). Marinatos compared this craze with the haircut of students in the al-Atar oasis school in Mauritania, and we know that Libya in those times stretched from the Nile Delta in the

Figure 19.3. Theran painting of man with possible Libyan hairstyle.

east to Tangier on the Atlantic Ocean in the west. Also from Thera is another fresco painting of a man with Libyan facets (sixteenth century BC), and his hair was styled like the hair of his ancestors, whose chiefs of ancient Libyans in Egypt used their beards to express their authority even before the Pharoahs did (Figs 19.3, 19.4).

Battus the Libyan returned with two hundred experts in irrigation (water engineering) especially in land reclamation and construction, and the landscapes of the Cyrenaican Pentapolis are proof of their effectiveness in water management. Libyans who lived in Cyrene told them "there was a hole in the skies", and this great quotation is a shorthand to define the weather of the Green Mountain that still enjoys a great seasonal rainfall.

The name Battus derieves from the Libyan word B.T.Y., which means a Ruler/leader and was used as the Delta kings' title (Khushaym 2002). It is also common knowledge that the people of the Delta were mostly Libyans. So the name and the epithet that Battus was known by was actually Abti, which is still used in the Cyrenaican dialect, and pronounced Batti. Battus in the Arabic language also denotes the language of people on earth as well as the language of the gods.

Support for my theory of Libyan influence in Crete comes from the British scholar and famous archaeologist, Sir Arthur Evans, who spent almost 40 years of his life investigating in Knossos in Crete. What he said on the subject was:

"The immigrants from North Africa were the ones who woke Crete up and transformed it from its Neolithic state, to a better phase wither higher urban living. Those immigrants were from the Tehenu who were living on the borders of the western Delta, and who were terrified by the regrouping of Egyptians in one kingdom encompassing all parts of the Delta and the Nile basin around 3400 BC." (Peake and Fleure 1927).

Figure 19.4. Detail of a rock painting from the Algerian Tassili showing the same forelock and pony-tail as illustrated in Figs 19.2-19.3.

Therefore, I believe that the Tehenu sought refuge overseas and established the basis for Minoan civilisation in Crete approximately 5,000 years ago. Since Mycenaean civilisation on the Greek mainland was in turn influenced by Minoan civilisation on Crete, and both had some influence on later Greek civilisation, this suggests a profound Libyan influence on the emergence of Greek culture. One reason that it took place was because of the sudden drought that ancient Libyans experienced in the era of great droughts and the disappearance of greenery from the face of what became a barren desert about 5,000 years ago. Some Libyans sought sanctuary alongside the Nile waters, some of them even went overseas to help establish a great civilisation in the Aegean and Cretan archipelago. Ancient Libyans did not all immigrate, of course; as a matter of fact the majority preferred to stay on and live in the desert. Libyans have achieved the conquest of the Great Sahara, and they did not just pass across it but settled in it on permanent basis.

They did not live above the desert but rather made the desert live under their genius, and history never witnessed anything like this in the past. From Lepcis Magna to Timbuktu, Siwa to Carthage there were many routes for caravans penetrating the desert in all directions, bringing goods of the Sudan and central Africa to the northern coast, at the same time forwarding the produce of the coast and the Greek islands to West Africa. In the last millennium BC waves of early Libyans came forth to colonise the desert, equipped with caravans and knowledge (al-Nayhum 1991, 251).

The desert was always a home for heavenly visions (al-Kuni 1428). Despite its harshness, the desert environment promotes visions and sharpens the mind to craft a culture. Henri Lhote said about the prehistoric paintings in southern Algeria:

> *"What we have seen in the rock mazes in Tassili is beyond any stretch of imagination, and we have copied hundreds of wall paintings that depict thousands of animals and humans. And some of those figures stand on their own, other are clustered in complex groups and in some cases the scenes are clearly related to the normal daily life or relate to religious and spiritual passion ... We are surprised by the multitude of methods, subjects, and the large number of drawings in addition to older drawings ... The oldest Tassili rock art belongs to unknown school, and it has been suggested it might be of an indigenous source. The documents we have allow us to understand what took place over eight thousand years of the history of the biggest desert in the world and in the history of man."* (Lhote 1991).

Modern archaeological investigation of the rock engravings and paintings in Algeria and in the south of Libya (Acacus, Massak) has increased greatly in recent decades. We now know of about 60,000 rock art images, and this is only an estimation and it could be more. The earliest works could be 9000 years old (Guide 1981). With the passage of time we find that some of the ancient Libyan traditions depicted in the rock art managed to get to the area of ancient of Greece, further evidence that Libyan traditions contributed to the evolution of the civilisation of the ancient Mediterranean. For instance, evidence of the worship of snakes and bulls in Crete parallels long-established Libyan customs.

I have touched very little in this paper on Libya itself, which Aristotle described as sweet-scented (al-Badawi 1969). My point is that Libya will remain a huge and mysterious cultural storehouse unless we examine the impact of Libyan peoples on Crete and the islands in the Aegean archipelago.

Note

This is a somewhat abbreviated version of the Arabic version of this paper. Thanks are due to Faraj Najem for the translation.

References

al-Badawi, Abdel Rahaman. 1969. Libya in Aristotle's Books, [in Arabic], *The Faculty of Arts Journal* 3 (1969).

al-Kuni, Ibrahim. 1428. *The Home of Heavenly Visions*, [in Arabic], al-Jamahiriya Centre for Books, Tripoli.

al-Nayhum, Sadeq. 1991. *Our History,* Vol. 2, [in Arabic], London.

Bazama, Muhammad Mustafa. 1975. *Libya Hadha al-Ism fi Judhurih al-Tarikhiyya,*[in Arabic] Benghazi.

Chamoux, F. 1953. *Cyrène sous la monarchie des Battiades*, Paris.

Guide 1981 = Guide to the Exhibition of Prehistoric Rock Drawings in Tadrart Acacus, Libya, organised by the Libyan department of antiquity in cooperation with the University of Roma, Tripoli.

Khushaym, Ali Fahmi, 2002. *The Arabic Latin: comparative study*, [in Arabic], The Centre of Arab Culture, Cairo.

Lhote, H. 1991. *The Tassili Paintings*, [in Arabic] Beirut.

Marinatos, S. 1974. *Excavations at Thera vi (1972, season)*, Athens.

Peake, H. and Fleure, H.J. 1927. *The Corridors of Time*, Oxford.

20. Islamic Archaeology and the Sahara

By Timothy Insoll[1]

Abstract

Large parts of the Sahara have been home to Muslim populations, both immigrants and indigenous converts, almost from the beginnings of the Arab conquests of North Africa in the early eighth century AD. An extensive Islamic archaeological record has thus been generated within the Sahara, but this, surprisingly, has been little investigated. This paper will assess aspects of the Islamic archaeology of the Sahara by focussing upon the central Saharan slave and salt trade route running through Fazzan to the Lake Chad region, and, further to the west, the trade route linking parts of North Africa with Gao on the River Niger in Mali. Through concentrating upon these long-distance trade routes it will prove possible to reflect upon various facets of the Islamic archaeological record in the Sahara; mosques, burials, the urban environment, and the residue of the trade routes and the trade processes themselves. These routes will be set within their historical and regional contexts, and their role as trans-Saharan conduits for Islamisation elsewhere in Africa will be emphasised.

Some of the difficulties inherent in undertaking archaeological research in the Saharan environment will also be considered, drawing briefly upon the author's recent research in Timbuktu where, for example, wind- and water-lain sand deposits precluded effective archaeological excavation without sizeable technical support. Finally, possible future directions for research will be considered, and it will be suggested that Islamic archaeology within the Sahara has functioned as a poor cousin in comparison to other areas of archaeological research within the region in terms of research design and resources invested – a situation which needs to be changed.

Introduction

This paper could have followed a variety of approaches in attempting to examine Islamic archaeology within the Sahara. An overview of research completed, site by site, could be provided following the format of, for example, Geoffrey King (1989) in his review of Islamic Archaeology in Libya. This route, however, will not in the main be undertaken, as the broader remit allowed by the organisers of the conference permits a different approach to be followed in considering the archaeology of Islam within the vast area which is the Sahara, being some 5,400 km at its widest point east to west (Wright 1989,1). Instead this paper will focus on the central Saharan slave and salt trade route running through Fazzan to the Lake Chad region, and, further to the west, the trade route linking parts of North Africa with Gao on the River Niger in Mali. This approach is being adopted as it allows an evaluation of various facets of the Islamic archaeological record within the Sahara, but also through the adoption of a north – south perspective it allows the Sahara to be seen in context, as rooted firmly within the socio-political contexts at its northern and southern extremes.

Such an approach allows this author to declare his own southern specialisation (Insoll 1996; 2000a; 2003), with a corresponding weakness with regard to North African material. This said, it is hoped that the remainder of the papers will compensate for the omission here of some North Saharan data, and for the fact that the material is very much viewed through southern,

[1]School of Art History and Archaeology, University of Manchester.

223

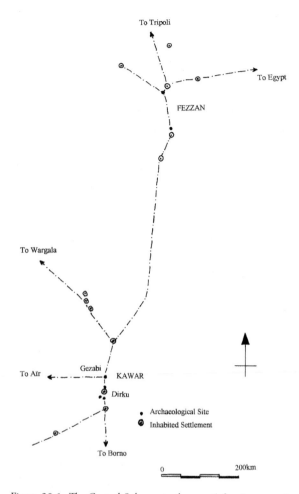

To Tripoli

To Egypt

FEZZAN

To Wargala

To Aïr

Gezabi

KAWAR

Dirku

• Archaeological Site
⊙ Inhabited Settlement

To Borno

0 200km

Figure 20.1. The Central Saharan trade route (after Lange and Berthoud 1977: 20).

sub-Saharan spectacles. Yet such an emphasis might also allow the evaluation of material less frequently considered within North African frameworks where the view to the south sometimes ends in the Sahara, without a consideration of the worlds beyond. Thus the adoption of a cross-Sahara, south – north perspective both allows a consideration of a range of material as well as rooting parts of the Sahara within its surrounding context.

This notion of context is an important one, for as well as the Sahara sitting geographically, obviously, within its surrounding area; the archaeology of Islam within this region does not stand alone in terms of cultural 'fit' either. In other words, the archaeology of the Islamic period, in itself a variable temporal concept, is tied to events and material which precede it. Islam within the Sahara did not suddenly appear and wipe clean everything that went before; continuity and/or syncretism are frequently major factors which have to be considered as well. This is well attested in North Africa, as Hrbek and El-Fasi (1992, 34) note, "in many regions, Romanized and Christian Africans continued to represent the majority of the population during the first two centuries after the conquest. King, in the review just mentioned, also makes the same important point with regard to settlement in North Africa after the advent of Islam, namely, that "the Islamic conquest led to the overlay of Islam onto already existing cultures" (1989, 194). He supports this statement with evidence from, for instance, Tocra, with archaeology indicating Byzantine to Early Islamic continuity, and similarly, at Ptolemais, modern Tulmaytha, where continuity into the Islamic period, rather than the previously described 'squatter occupation' is seen as of importance (King 1989, 195).

Yet the picture in North Africa, the Sahara, or south of the Sahara is obviously not only one of continuity following the advent of the Islamic era, by conquest or conversion. Pentz (2002, 67) has recently discussed such issues with regard to parts of Tunisia, where he sees 'relocation' of settlement as a factor of some importance. Whilst in the Sahara itself a variety of processes are evident. Nonetheless, the notion of continuity is an important one in considering Islamic archaeology, in the Sahara, and indeed in many other parts of the Islamic world (Geertz 1968; Insoll 1999).

The Central Saharan Trade Route

The Pre-Islamic Context

Bearing in mind the points just made, the archaeology of the Central Sahara in the Islamic period needs to be set within the context of that which preceded it. Yet this statement in itself suggests continuity when in reality the details of trans-Saharan trade and contacts which might have predated the arrival of Muslim traders from perhaps as early as the late ninth century, is unclear. In part this was probably due to the existence of the Garamantes. Slaves and ivory could have been obtained in the central Sahara and Sudan, and the so-called Ethiopian slaves pursued by the Garamantes might have been ancestors of peoples such as the Teda-Tebu or other groups further south (see Cline 1950). However, archaeological evidence indicating the existence of such trade and other possible contacts is elusive, and items of North African origin before the Arab trade have yet to be conclusively proven south of Fazzan.

Survey of the Oases of Kawar in northern Chad (Fig. 20.1), for example, a strategic location on any such trade route, failed to find any evidence for this pre-Islamic trade even though similarities have been suggested between the name 'Agisymba', placed south of the Garamantes country by Ptolemy, and 'al-Qasaba' (the citadel), one of the principal Kawar settlements (Lange and Berthoud 1977, 33; and see below). Lewicki's (1971, 114) statement regarding the Mediterranean coast that it was an area, "where since times immemorial there had been numerous Phoenician and Grecian trading-posts and emporia; their presence and affluence were largely a result of trans-Saharan trade" is not, at present at least, supported by the archaeological evidence.

It is also probable that North African requirements which did exist for sub-Saharan African products during the Carthaginian and Roman periods were met by the Garamantes. However, as Daniels notes (1970, 43), "no ancient authority actually states that caravan trade either from or via the Garamantes existed". Furthermore, until recently, little archaeological research had been undertaken in Fazzan, the Garamantian heartlands (for exceptions see Daniels 1970; 1989; El-Rashedy 1986). The Garamantes appear to have been secretive in their trade and sources of materials, and the only known commodity obtained from them are carbuncles, possibly aggrey beads, though this too, is far from sure. Imported Roman 'South Gaulish' wares dating from the first and second centuries AD have been found in the Garama region, along with "fine red wares and glass" of the fourth century (Daniels 1989). More recent excavations at the site of Aghram Nadharif at the southern end of the Wadi Tanezzuft have provided further evidence for northern imports in the Garamantian heartlands. These included two types of Roman amphorae, Tripolitania 1 of the first century AD and Tripolitania 3 of the third to early fourth centuries (Liverani 2000, 36).

This is a picture reinforced by other excavations in the Wadi el-Agial, a *c.*180 km linear depression running east-west across Fazzan, and in which the former Garamantian capital, Garama (Germa), was sited (Edwards *et al.* 1999; Mattingly *et al.* 1997; 1998; Mattingly, this volume). Some sherds of imported pottery are described which were found during the recent excavations and surveys in the Wadi el-Agial. These include, for example, African Red Slip Ware and Tripolitanian Red Slip Ware of the first to fourth centuries AD along with amphora sherds

of Tripolitanian type and similarly dated (Mattingly *et al* 1998, 136), but this appears to be as far south that such types of ceramics are found. The imported pottery testifies to Garamantian contacts with the Mediterranean, but the Garamantes, it can tentatively be suggested, acted as a form of buffer perhaps, or filter, to direct contacts between the Mediterranean and the regions south of the central Sahara during the Carthaginian and Roman periods. That this might be a feasible interpretation would appear to be further supported by the fact that the Garamantes contacts were apparently protective of both their trade and their independence. This in turn galled the Roman authorities and led to various skirmishes, as well as punitive expeditions heading south into Garamantian territory, including one led by Balbus, and described in some detail by Lhote (1960).

The Islamic Period

Having briefly presented the evidence which seemingly indicates little connection across the Central Sahara in the pre-Islamic era, one of the primary results of the Islamisation of this region is the fact that it was subsequently interconnected north-south. Unfortunately, little relevant archaeological research has been completed, which hampers an investigation of anything meaningful seemingly above and beyond providing a gazetteer of sites and monuments. This pessimistic position stated with regard to archaeology; it is however possible to begin to consider something of the processes which generated the Islamic archaeological record of the region, based upon the historical sources.

The Muslim conquest of North Africa began, according to Lapidus (1988, 368), "with scattered raids from Egypt". By *c.*679 Qayrawan ('caravan' – "a halt at the head of the desert road from Egypt" [Brett and Fentress 1996, 84]) was founded as a centre for further Arab operations and headquarters for the conqueror of the region, 'Uqba ibn Naf'i, and Tunisia was occupied. This was followed by the Arabs reaching both Morocco and Spain by 711, though their overall numbers were still fairly limited. Gradually the indigenous inhabitants of North Africa converted to Islam, with nomadic Berbers tending to convert prior to their sedentary counterparts who initially remained Christian (Hrbek and El-Fasi 1992, 34). Even then, again as Lapidus (1988, 368) notes, "while many Berbers threw in their lot with the Arabs, many others adopted Kharijism, which allowed them to accept the new religion but to oppose Arab domination". In totality, the conversion of the population of North Africa and the Saharan regions to Islam was not really complete until the thirteenth century, but once achieved, a degree of unity was lent to the region which had previously not existed. The key to this unity was Islam, and the existence of a contiguous *Dar al-Islam* stretching far into the Sahara served to facilitate trade and other contacts over long distances.

As noted, little relevant archaeological research has been completed. This is something bemoaned, for instance, by Edwards (2001, 49) with reference to the southern Fazzan in his review of archaeological work of the Islamic period undertaken there. A variety of sites are described, many of great importance, and all meriting further investigation. These include Murzuq, with its walled town dominated by a castle and 'Turkish' barracks and mosque, as well as the various *qsur* which have been identified, some possibly dating back to the Garamantian

period, Qasr Mara for example, and others from what Edwards describes as the 'medieval' period, as in the Wadi al-'Utba (Edwards 2001, 57), and thus more unequivocally Islamic.

Elsewhere in the southern Fazzan, the Islamic city at Jarma has been investigated by Mattingly *et al* (1998), with trial excavations and planning of the standing remains completed. Importantly, this research project has also included a detailed examination of faunal and botanical remains, something frequently ignored within Islamic archaeological research or given only cursory attention (Insoll 1999; MacLean and Insoll 2003). A fairly usual dietary picture has been reconstructed with, besides emmer wheat and barley amongst the crops being cultivated, sheep and goat predominating, with chicken, camel, cattle, and pig remains also found. The latter is described as presenting something of an 'enigma' (Mattingly *et al* 1998, 128), considering the widespread Islamic prohibition on the consumption of pork. Though perhaps human behaviour might also have to be factored in here, being the difference between ideals and reality (Insoll 1999, 95-99), or alternatively an allowance made for the continued existence of another minority community.

Soundings have also been made in Old Ghat, though only 'early modern' levels were found, leading the investigator to suggest that "medieval Ghat was located somewhere else" (Liverani 2000, 39). Whilst the crucial early trade centre of Zawila remains, according to Edwards (2001, 61), "largely unexplored archaeologically". This is a major omission in our archaeological understanding of the Islamic period in the Sahara considering that Al-Ya'qubi writing in the 870s records that it was an Ibadi, thus Kharijite, centre involved in the slave trade (Levtzion and Hopkins 1981, 22). Zawila was also what Wright (1989, 28) describes as "the main market of the central Sahara", and was thus firmly connected to the south, via Kawar to Bilma and ultimately to Kanem in the Lake Chad region of the Central Sudan.

Muslim contacts with the Central Sudan appear to have been initiated by followers of Kharijite Ibadi tenets in the first instance. Historical references to Ibadi contacts exist and have been reviewed by Lewicki (1971). He suggests that the first Ibadi "merchant-missionaries" (Lewicki 1971, 127) probably travelled from the kingdom of Zawila through Kawar to the Central Sudan as early as the mid-eighth century. Lewicki further notes that no clear evidence attesting to local converts to Ibadi Islam in the Central Sudan exists in the Arabic sources. However it is indisputable that it was across the Sahara that the first Muslim missionaries and merchants travelled, and it is possible that a part of the local population might have converted to Ibadi Islam in Kanem.

As Connah (1981, 222) notes, Kanem was ideally situated close to Lake Chad at the southern end of any feasible trade route running via Kawar and Fazzan to North Africa; this location being, "doubtless no accident" (Lange 1984, 247). The Kawar Oasis has already been referred to in the context of pre-Islamic trade, and are in reality a group of oases, running north-south for some 75 km on the main trade route between the Central Sudan and Fazzan (Fig. 20.1). The Kawar Oasis has been surveyed and a series of large archaeological sites recorded (Lange and Berthoud 1977). These are, as yet, unexcavated, but represent the remains of former settlements, which were in turn divided into two main groups with the northern sites catering to travellers and the southern ones to the salt trade. An example of one of the settlement sites which was recorded

is provided by Gezabi, a mound measuring 470 m north-south and 300 m wide, which was covered with sherds of pottery and, "*de bijoux étrangers à la région et des tapis originaires du nord et l'on distingue les traces de nombreuses habitations*" (Lange and Berthoud 1977, 21).

Similarly, extensive remains were found in the salines at the southern end of the Oasis. An example of such a site is provided by Dirku, where to the southwest of the salt workings were discovered the remains of the old town which had been extensively robbed for building materials, but which was still partly walled in the mid 1970s. Lovejoy (1986, 59) mentions that the earliest historical reference to salt production at Kawar is by al-Idrisi in 1154. However, it is quite possible that sites such as Bilma were worked from an earlier period. Al-Ya'qubi refers to the Bilma trail as a slave trading route at the end of the ninth century (Reyna 1990, 28), though no mention is made of salt. From the south, ivory, slaves, and animal products were exported north, whilst above all, horses, along with weapons, books, cloth and beads, and salt from the workings at Bilma, and possibly also from Fazzan would have been exported south (Lange 1984; 1992; Lange and Berthoud 1977).

Further to the east and away from the main central Saharan trade route the Islamic archaeology is even less well investigated. However, reminders of the last gasp of the trans-Saharan slave trade directed from areas such as Dar al-Kuti via Wadai are found in the Saharan regions of northern Chad and southern Libya. Here large numbers of sites have been recorded, some of which appear to have been associated with the slave trade operating in the eighteenth – nineteenth centuries (see Wright 1992 for historical background). At Ouagayi in Chad for example, a complex of fired-brick structures was recorded, of which two groups of buildings and three courtyards were uncovered (Huard and Bacquié 1964). Situated between Tripoli and Ouara, the capital of Wadai, a role in the slave trade is strongly implied. Other comparable sites in the Chadian Sahara include Goz Calmai, Kerenegui, and Callagodei. Though it should also be noted that some of these might be associated with the Senusi movement, a religious brotherhood founded *c.*1843 which established centres in Tibesti, Borku, and Wadai (Cline 1950, 19; Lebeuf 1962; Wright 1989, 81).

The Tibesti massif, at *c.*500 km long on its northern and eastern sides (Cline 1950, 19) provides a further area which merits serious archaeological attention. The focus of trade routes from Fazzan, Aïr, and to the east linked, as mentioned, to Wadai, and the Kufra Oasis, it is the home, predominantly, of the Tebu peoples (Cline 1950; Wright 1989). Cline (1950, 18-21) reviews archaeological work completed, and makes the point, still relevant today, that most attention has been focussed upon rock art. This is indeed a recurring problem throughout the Sahara where research activities are skewed in favour of rock art; both engravings and paintings, to the detriment of other areas of endeavour. This point noted, Cline (1950, 18-21) does mention the existence of Turkish remains in Tibesti including a fortified post at Bardai. However, the association with Islam here is really only through the fact that the Turks are predominantly Muslim, and its ascription to the archaeology of Islam is as valid as describing subsequent French military works in the same region as somehow constituting part of an archaeology of Christianity.

The Gao-centred Saharan Trade Routes

The Pre-Islamic Context

Moving to the west, another case study is provided by considering some of the Islamic archaeology connected with trade routes centred on Gao in Mali, and thus strictly speaking also connected to the central Sahara via the Adrar des Iforas, Aïr, and Hoggar mountains. As before it is initially necessary to consider the pre-Islamic background, and at first glance it would seem that a convincing case for pre-Islamic trans-Saharan contacts can be made, however, when the evidence is examined in detail it can be seen to be flawed.

Contacts with North Africa prior to the arrival of Muslim traders in the late eighth century were limited. However, archaeological evidence appears to contradict this and to indicate that extensive travel took place in the Sahara, and by inference, north-south contacts, in the second half of the first millennium BC. These are supposedly attested by, for example, numerous rock-engravings and paintings, many of which depict chariots, sometimes harnessed to horses, either crudely engraved or painted, so-called, "flying gallop chariots" (Muzzolini 1997, 349). These are grouped in two relatively narrow bands running across the desert. One leads from southern Morocco through the Adrar of Mauritania and along the Tichitt-Walata escarpment to the area west of Timbuktu. Whilst the second runs from the Gulf of Syrtis in Libya to the Niger Bend, near Gao in Mali, with an offshoot to the Aïr mountains (Camps 1974; Lhote 1982, 15-44; Mauny 1978; Muzzolini 1986). Owing to these narrow groupings, they have been interpreted as 'chariot tracks', or even to quote Lhote (1960, 129), "a great highway, cutting through the whole of the Sahara from Phazania, (Fazzan), to the Niger".

Further supporting evidence for trans-Saharan contacts prior to the start of Muslim controlled trade in the ninth century would appear to be lent by various historical documents which also record contacts, albeit limited in number, over time. Perhaps one of the best known being the mention by Pliny the Elder of a punitive expedition led by the Roman Proconsul Cornelius Balbus against the Garamantes in 20 BC. As well as capturing the Garamantian capital Garama, situated in the central Fazzan, Balbus's expedition reached several rivers, one of which was named the Dasibari, which has been interpreted as the River Niger, possibly in the vicinity of Gao. This identification was based upon a connection formed between the name 'Dasibari' with the Songhai word 'Isabari', from 'Isa' (river) and 'Bari' (big), with 'Das' meaning 'masters of the river'. Therefore becoming 'Da Isa Bari', and possibly the river recorded by Pliny and reached by Balbus (Lhote 1960, 131-2).

But this evidence disintegrates under closer scrutiny. The distribution of the chariot rock engravings and paintings for instance, as Connah (1987, 119) points out, need not follow routes but merely distributions of rock outcrops. Equally, the utility of the very means of transport illustrated can also be questioned when the chariots themselves are examined (see for example Lhote 1982, 79-82; Muzzolini 1986; Roset 1986, 136-7). It appears that the chariots shown are predominantly light vehicles not really suitable for commercial transport, such as hauling loads of ivory or gold, but more suited to hunting and warfare (Brett and Fentress 1996, 20-21;

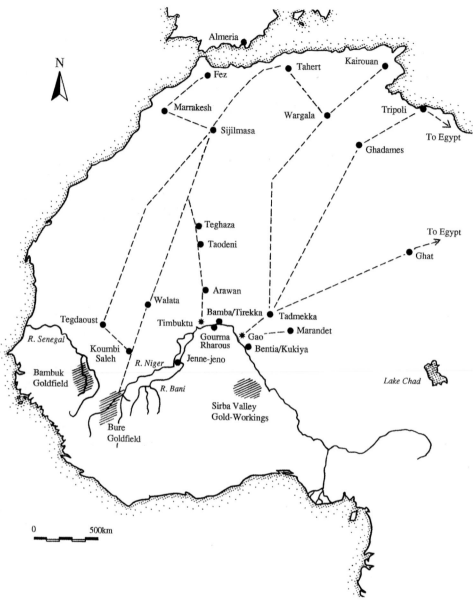

Figure 20.2. The Western Saharan trade routes.

Wright 1989, 6). Secondly, the historical records can also be questioned, the expedition of Cornelius Balbus and the identification of the Dasibari with the Niger for example (Lhote 1960). Although the punitive expedition against the Garamantes no doubt took place, the trip to the banks of the Niger has no evidence to support it. There is at present a total lack of archaeological evidence on the Niger Bend, or elsewhere in the Western Sahel, attesting to a Roman or other pre-Arab Mediterranean presence, albeit fleeting (Dawa 1985; Insoll 1996). Furthermore, the factual basis of the historical data can also be queried as Balbus was only proconsul for a year, severely limiting what he could do (Salama 1990, 288).

The Islamic Period

Once again then, one of the primary contributions of the Islamisation of this part of the Sahara was that it served to unify formerly disparate communities under the banner of Islam, and to open up the Sahara as a conduit for trade and other contacts. This can be seen in the proliferation of trade goods found of northern provenance in southern trade centres such as Gao, or of southern commodities in north Africa, or both within Saharan centres.

Further similarities with the situation described for the central Sahara and Central Sudan also exist. Not least in the initial agents of Islamisation in the Western Sahel region, and by inference in the Saharan trade centres through which they passed, trade centres which in many instances were founded as a result of the opening up of the Sahara after Islamisation (Fig. 20.2). These initial agents of Islamisation appear again to have been Ibadi merchants and missionaries. Ibadi sources, for example, refer to trade between Tahert and Tadmekka (Lewicki 1971, 117), almost certainly to be identified with the site of Essuk in the Adrar des Iforas Mountains in Mali (Farias 1990).

Essuk/Tadmekka was a very important Berber or Tuareg-controlled trade centre, and one that still awaits detailed archaeological investigation. Although archaeological evidence for Islamisation thus far dates only from after the tenth century, it is possible, as Nehemia Levtzion has suggested (1973, 45) that Tadmekka was initially Ibadi in outlook. This would have been due to its aforementioned links with Tahert, an Ibadi Kharijite overlay which was eradicated following a joint campaign launched against its inhabitants by forces from the Kingdom of Ghana, and those of the Southern Almoravids, a reforming Berber movement between 1083-4 (Farias 1990, 93).

Thus far only preliminary observations on this important site have been made. However, the presence of two mosques, including a congregational mosque measuring 23.5 x 15.5 m, and divided into five rows parallel to the mihrab has been reported (Cressier 1992, 71-3). Muslim cemeteries, pre-Islamic tombs, Arabic inscriptions, and the remains of a settlement have also all been variously recorded (Cressier 1992; De Gironcourt 1920; Farias 1990; Mauny 1951). These indicate the considerable antiquity of settlement at Essuk/Tadmekka. The inscriptions recovered are of especial significance and over 188 were transcribed by De Gironcourt (1920) at the start of the twentieth century. Some of these have recently been investigated by Farias (1990; 1999; 2003) including "the oldest dated epigraph so far reported from the Adrar or anywhere else in West Africa" (1990, 95). This is a graffiti on a rock face, dating from the period between the 13th July 1013 and the 2nd July 1014. Furthermore, another inscription from Essuk (meaning the market) conclusively supports the identification of the site with that of Tadmekka or Tadmakkat of the Arabic historical sources. This inscription refers to "a market in conformity to [or a longing for] Bekka [or Mecca]" (Farias 1999, 109).

The position of Essuk/Tadmekka also indicates the primacy of the Sahara, often overlooked, as an agent for Islamisation elsewhere in sub-Saharan Africa. It seems that it functioned until the early eleventh century as the furthest southern frontier of the *Dar al-Islam* (Levtzion 1978, 650), and hence a possible retreat for Muslim merchants from Gao, later to be the capital of the Songhai Empire. This was a status shared by another important Saharan trade centre to the west in Mauritania, Tegdaoust, in all probability the Awdaghost of the Arabic sources, and trading

partner of Koumbi Saleh, the capital of the kingdom of Ghana. Here, the earliest evidence found indicating northern contacts dates from the ninth century and consists of Ifriqiyan glazed pottery and semi-precious stones (Devisse 1992, 197). However, the main period of occupation dates from the late ninth to early fourteenth centuries, when Muslim dominated trade was in full flow (Robert 1970a and 1970b; Robert-Chaleix 1989; Vanacker 1979).

Tegdaoust covers some 12 ha, and is composed of two principal components, a town and a necropolis (Robert 1970a, 64). The necropolis which is aligned north-south over about 700 m is of some interest owing to the differing orientation of the skeletal remains within it, and the distinct types of graves found, some with mihrabs. Corpse orientation varied from being buried north-south with the face to the east in one group of interments (north central) to others facing south with heads to the west (northern group) (Robert 1970b, 65). This variation is something which has been interpreted by the excavators (Robert 1970b, 65) as indicating different phases of Islamisation. Alternatively, it might equally indicate coexisting religious traditions.

A more concrete assertion of Muslim identity at Tegdaoust was provided by a large stone-built mosque which was also uncovered. This was oriented south-south-east, interpreted as possibly indicating Maghrebi or Andalusian (Spanish) influences (Robert 1970b, 66). Al-Bakri (*ca.* 1068) refers to the main mosque at Awdaghust in his description of the town, "in Awdaghust there is one cathedral mosque and many smaller ones, all well attended ... The people of Awdaghust enjoy extensive benefits and huge wealth ... There are handsome buildings and fine houses" (Levtzion and Hopkins 1981, 68). Well-constructed courtyard houses were another feature recorded at Tegdaoust (Polet 1985). These are structures which appear to exhibit an emphasis upon privacy. Items obtained via trade directed to North Africa were also recovered, including ceramics from Ifriqiya, the Maghreb, and al-Andalus (Robert 1970b).

Elsewhere in this region Islamic archaeological remains abound, but few have been systematically, or even cursorily explored. Retreating to the previously condemned position of providing a gazetteer, selected important examples include a group of sites in Northern Niger, significant for the fact that they provide a rare indication of the existence of Sufism, archaeologically, within this part of the Sahara. At In-Teduq for example, a site intimately connected to Gao through the Azawagh Valley, and where clusters of stone-built tombs, places of prayer, and houses or shops were recorded grouped around a mosque (pre-sixteenth century, but otherwise undated) (Paris, Bernus and Cressier 1999). The whole interpreted as indicative of the site being centred around the monumentalisation of the *qibla*. Similar Sufi centres existed elsewhere in the Azawagh and Aïr regions but still await archaeological exploration (Norris 1990, xvii). At Assode in the centre of the Aïr Massif, for instance, a 'great mosque' similar to the extant mosque in Agadez (founded mid fifteenth/early sixteenth century) has been noted (Cressier 1989, 155; Cressier and Bernus 1984, 39).

Also in Northern Niger are two important copper-working centres which seem to have supplied settlements such as Gao (Insoll 2000a). These are Marendet, perhaps to be identified with medieval Maranda, and Azelik, perhaps to be identified with medieval Takedda. At Marendet, over 40,000 crucibles and mould fragments were found dated to between the sixth to eleventh centuries (Bernus and Cressier 1991; Lhote 1972, 450-3). Unfortunately, specific

evidence for early Islam was not found at either of these copper-working sites, the more surprising considering they figure in the relevant Arabic historical sources (Levtzion and Hopkins 1981), and hence must have been exposed to Islamic influences from an early date. This stands in contrast to the In Gall-Tegidda-n-Tesemt area, also in Niger, where over ten sites were test excavated with a variety of evidence recovered indicating contacts with the Muslim world, including numerous coins dating from the ninth to tenth centuries (Bernus and Cressier 1991).

The importance of trans-Saharan trade has frequently been alluded to, but unfortunately staples of this trade such as salt, gold, and slaves are rarely found. Whereas more durable, and dare it be said, less important commodities such as glazed pottery and glass are. Many trade commodities are known only to us from the Arabic sources (Levtzion and Hopkins 1981), paper, cloth and spices, in addition to those already listed, for example. Thus the salt mining site of Teghaza in Northern Mali is doubly significant, being testimony to the extensive salt trade to Gao and Timbuktu, and unusual from an architectural perspective, for survey at this site, the Tatantal of the Arabic sources, found that the houses and even the mosque were built of blocks of rock salt (Monod 1938; 1940; Terrasse 1938).

A spectacular exception to the general invisibility of much of the Saharan trade is provided by a further unique find in Mauritania, where at the 'lost caravan' site in the Ijafen dunes several thousand cowry shells once in sacks, along with 2,085 bars of brass were found (Monod 1969). These items, dating from the twelfth century, had been buried for safe-keeping by a caravan crossing the desert to the Western Sahel and never recovered. This find also provides what appears to be the sole reported instance of the archaeological survival of a camel caravan. This is surprising considering the extent of the trade, which was regularised, leaving nothing to chance, and we are fortunate in that al-Idrisi gives us an insight into how Saharan travel was organised in the autumn caravan season. To quote, "they travel in the following manner: they load their camels at late dawn, and march until the sun has risen, its light has become bright in the air, and the heat on the ground has become severe. Then they put their loads down, hobble their camels, unfasten their baggage and stretch awnings to give some shade from the scorching heat and the hot winds of midday ... When the sun begins to decline and sink in the west, they set off. They march for the rest of the day, and keep going till nightfall when they encamp at whatever place they have reached" (Levtzion and Hopkins 1981, 118).

The Practice of Islamic Archaeology in the Sahara: the Example of Timbuktu

Obviously, much has been omitted in the preceding review on account of space, but the few brief examples chosen give an indication of both the importance of, and the potential offered by, the Islamic archaeology of the Sahara. Much work remains to be done, and from this southern oriented overview it can be stated that the serious investigation of the Islamic archaeology of the Sahara is still very much in its infancy. One of the primary problems for this situation must be the difficulties inherent in working within the Sahara itself. Not least the logistical difficulties posed by one of the world's greatest deserts and least hospitable terrains. Furthermore, besides the logistical difficulties, methodological ones are also posed to archaeologists contemplating working in the region, again dictated by the terrain and climatic conditions which can be encountered.

An example of this is provided by briefly considering the results of recent excavations conducted in Timbuktu, literally on the edge of the Sahara in northern Mali. The aims of this project were twofold; to investigate the origins of the city, and secondly, to begin to sift legend from the relevant historical sources. Notably, a tradition which popularly ascribes the founding of the city to *c.*1100, when a seasonal pastoral camp centred around a well under the charge of an old slave woman, Buktu (hence Tin or Tim Buktu – 'the Place of Buktu') began to grow into a permanent urban centre (Bovill 1968; Dubois 1897).

The degree of success in approaching these aims was varied, and surprisingly all material which was recovered from the excavations post-dated 1590, i.e. after the Moroccan invasion of Songhai, and their subsequent occupation of the capital, Gao, and Timbuktu. Thus nothing relevant to assessing the origins of the city was recovered. This stands in contrast to the results of the survey which seemed to indicate from surface material found, including, for example, a sherd of Chinese Celadon dated to the late eleventh – early twelfth centuries (R. Scott pers. comm.), that earlier occupation areas had been isolated within Timbuktu (Insoll 1998). This impression also appeared to be substantiated by the collections of the Timbuktu Museum which included types of pottery present in the wider surrounding area (S.K. and R.J. McIntosh 1986), as well as found in excavations at Gao (Insoll 1996; 2000a). These pottery types, such as black burnished geometric decorated, or red slipped wares would elsewhere be dated to the twelfth century, but could go back as early as the eighth century (Insoll 1996; 2000a). Thus it seemed that material which might enable an evaluation of the origin myths of Timbuktu was present.

Rather than poor archaeological practice, the lack of material relevant to understanding the origins of Timbuktu, despite apparent surface indications to the contrary, can be attributed to one primary physical reason; being a legacy of the physical proximity of the Sahara (Insoll 2002). This is a result of the climatic factors to which Timbuktu has been exposed, being situated at the interface between the Sahara and the River Niger. Thus sandstorms and sand encroachment have been a recurring problem in the city.

Rene Caillié (1968, 75), for example, the first European to visit and importantly, return from Timbuktu, describes how during his stay in 1828 he saw near the Sankore mosque, one of the prominent monuments in the city next to which the recent excavations were completed, "a small hillock of sand, and some buildings overwhelmed by the sand blown up by the east wind". Similarly, the French archaeologist Raymond Mauny (1952, 907) records that within the Sankore mosque itself, the floor level was raised by a metre of sand during 1952. This is certainly a factor evident in the archaeological sequences and has helped create the great depths of archaeological deposits present in the city, as attested by a verbal report received from a Belgian water engineer that they had found archaeological material at a depth of 16 m. The earlier archaeological material pertinent to the foundations of the city could thus be buried much deeper than the 5 m of deposits excavated so far.

To this primary Saharan-derived factor can be added two of local consequence, which are of little relevance for the purposes of the discussion here. These are, secondly, the related factor of flooding. This might seem strange on the edge of the Sahara, but has been of importance within Timbuktu, and is in part a result of the deliberate situation of the city astride a seasonal

channel, now dry, running from Korioume on the River Niger, to Kabara, the former port of Timbuktu, and onto the pool of Kabara to the west of Timbuktu itself.

A third factor of significance in creating and altering the archaeological record in Timbuktu is the history of the city itself. Both historical sources and explorers accounts (e.g. Barth 1890) contain references to the periodic destruction of parts of the city for various reasons. The net result of these physical processes is that what have been termed "islands of archaeology" (Insoll 2000b, 484) have been created sitting amidst the areas of modern occupation. These being areas of archaeology where the occupation sequences can be considerably deeper than can be safely investigated by conventional test excavation, a process hampered by a further Saharan limiting factor, the absence of timber suitable for shoring purposes. Finally, another factor to add in is the 'mystification' of Timbuktu, a creation of historical imagination, but something truly beyond the scope of this paper (but see Herbert 1980; Insoll 2002). Thus, having asserted, repeatedly, that the Islamic archaeology of the Sahara is neglected, which is correct, it is also fair to add that this might partly be due to the demanding logistical and methodological obstacles which must frequently be surmounted in the practice of archaeology in the Sahara.

Conclusions

This paper has considered something of the material inventory of Islam within the Sahara, and to a lesser extent, the practical problems which can beset the practice of archaeology within this region. The review which has been completed has also been highly selective, deliberately so, but also in part dictated by the many blanks in the relevant archaeological map of the Sahara. Therefore, numerous future directions for research exist. To cite but a couple of examples; the serious investigation of the Ibadi archaeology of the Sahara merits attention, to match the excellent work completed on the relevant historical texts (Lewicki 1960; 1962; 1964; 1971; Thiry 1995). Equally, the complexity of the archaeology of Islam in the Sahara needs recognising, through acknowledging that diverse groups produced the remains grouped under the all-encompassing, but sometimes restrictive label of 'Islamic archaeology', a label which sometimes seemingly promotes visions of a mono-culture. What we are viewing was anything but, and ethnicity and other facets of identity can be explored through archaeology, utilising, for instance, the abundant epigraphic record present in parts of the Sahara (Farias 1990), as an aid in interpreting our archaeological material (Insoll 2003). If the will is there, the archaeological record is certainly rich enough to permit an insight into the immense and diverse material legacy of one of the worlds greatest religions in one of its most fascinating regions

References

Barth, H. 1890. *Travels and Discoveries in Northern and Central Africa*, London.

Bernus, E. and Cressier, P. (eds.). 1991. *Azelik-Takadda et l'implantation médievale*, Paris.

Bovill, E.W. 1968. *The Golden Trade of the Moors*, London.

Brett, M. and Fentress, E. 1996. *The Berbers*, Oxford.

Caillié, R. 1968. *Travels Through Central Africa to Timbuctoo*, London.

Camps, G. 1974. *Les civilisations préhistoriques de l'Afrique du nord et du Sahara*, Paris.

Cline, W. 1950. *The Teda of Tibesti, Borku, and Kawar in the Eastern Sahara*, Menasha (Wisc).

Connah, G. 1981. *Three Thousand Years in Africa. Man and his environment in the Lake Chad region of Nigeria*, Cambridge.

Connah, G. 1987. *African Civilisations*, Cambridge.

Cressier, P. 1989. La grande mosquée d'Assode. *Journal des Africanistes* 59: 133-162.

Cressier, P. 1992. Archéologie de la devotion Soufi. *Journal des Africanistes* 62: 69-90.

Cressier, P. and Bernus, P. 1984. La grande mosquée d'Agadez: architecture et histoire. *Journal des Africanistes* 54: 5-39.

Daniels, C. 1970. *The Garamantes of Southern Libya*, North Harrow.

Daniels, C. 1989. Excavation and fieldwork amongst the Garamantes. *Libyan Studies* 20: 45-61.

Dawa, S. 1985. *Inventaire des sites archéologiques dans le cercle de Gao*. Mémoire de fin d'études. Unpublished Dissertation. Bamako: Ecole Normale Supérieure.

De Gironcourt, G.R. 1920. *Missions De Gironcourt en Afrique occidentale, 1908-1909, 1911-1912*, Paris.

Devisse, J. 1992. Trade & Trade Routes in West Africa, in I. Hrbek (ed.), *Unesco General History of Africa. Vol 3. Africa From the Seventh to the Eleventh Century*. (Abridged Edition), London: 190-215.

Dubois, F. 1897. *Timbuctoo the Mysterious*, London.

Edwards, D.N. 2001. The archaeology of the southern Fazzan and prospects for future research. *Libyan Studies* 32: 49-66.

Edwards, D.N., Hawthorne, J., Dore, J., and Mattingly, D.J. 1999. The Garamantes of Fazzan revisited: publishing the C.M. Daniels archive. *Libyan Studies* 30: 109-27.

El-Rashedy, F. 1986. Garamantian burial customs: their relation to those of other peoples of North Africa. *Libya Antiqua*, Paris: 77-105.

Farias, de Moraes, P.F. 1990. The oldest extant writing in West Africa. *Journal des Africanistes* 60: 65-113.

Farias, de Moraes, P.F. 1999. Tadmakkat and the image of Mecca: epigraphic records of the work of the imagination in 11th-century West Africa, in T. Insoll (ed.), *Case Studies in Archaeology and World Religion. The Proceedings of the Cambridge Conference*. BAR S755, Oxford: 105-15.

Farias, de Moraes, P.F. 2003. *Arabic Medieval Inscriptions from the Republic of Mali: Epigraphy, Chronicles, and Songhay–Tuareg History*, London.

Geertz, C. 1968. *Islam Observed: Religious Development in Morocco and Indonesia*, New Haven.

Herbert, E. 1980. Timbuktu: A Case Study of the Role of Legend in History, in B. Swarz and R. E. Dumett (eds.), *West African Culture Dynamics*, The Hague: 431-54.

Hrbek, I, and El-Fasi, M. 1992. Stages in the development of Islam and its dissemination in Africa, in I. Hrbek (ed.), *Unesco General History of Africa. Vol 3. Africa From the Seventh to the Eleventh Century (Abridged Edition)*, London: 31-49.

Huard, P. and Bacquie, Capt. 1964. Un établissement Islamique dans le désert Tchadien. *Bulletin de la institut français d'Afrique noire (B)* 26: 1-20.

Insoll, T. 1996. *Islam, Archaeology and History. Gao Region (Mali) c.AD 900-1250*. Cambridge Monographs in African Archaeology 39. BAR S647, Oxford.

Insoll, T. 1998. Archaeological research in Timbuktu, Mali. *Antiquity* 72: 413-17.

Insoll, T. 1999. *The Archaeology of Islam*, Oxford.

Insoll, T (with various contributions). 2000a. *Urbanism, Archaeology and Trade. Further Observations on the Gao Region (Mali). The 1996 Fieldseason Results*. BAR S829, Oxford.

Insoll, T. 2000b. The origins of Timbuktu. *Antiquity* 74: 483-4.

Insoll, T. 2002. The archaeology of post-medieval Timbuktu. *Sahara* 13: 7-22.

Insoll, T. 2003. *The Archaeology of Islam in Sub-Saharan Africa*, Cambridge.

King, G.R.D. 1989. Islamic archaeology in Libya, 1969-1989. *Libyan Studies* 20: 193-207.

Lange, D. 1984. The kingdoms and peoples of Chad, in D. T. Niane (ed.). *UNESCO General History of Africa. Volume 4. Africa from the Twelfth to Sixteenth Centuries*, London: 238-65.

Lange, D. 1992. The Chad region as a crossroads, in I. Hrbek (ed.), *General History of Africa, Volume 3: Africa from the Seventh to the Eleventh Century (Abridged Edition)*, London: 216-25.

Lange, D. and Berthoud, S. 1977. Al-Qasaba et d'autres villes de la route centrale du Sahara. *Paideuma* 23: 19-40.

Lapidus, I.M. 1988. *A History of Islamic Societies*, Cambridge.

Lebeuf, A.M.D. 1962. Enceintes de briques de la région Tchadienne, in G. Mortelmans and J. Nenquin (eds.), *Actes du IVe Panafricain Congres de Prehistoire et de l'Etude du Quaternaire*, Tervuren: 437-43.

Levtzion, N. 1973. *Ancient Ghana and Mali*, London.

Levtzion, N. 1978. The Sahara and the Sudan from the Arab conquest of the Maghrib to the rise of the Almoravids, in J.D. Fage (ed.), *The Cambridge History of Africa. Volume 2*, Cambridge: 637-80.

Levtzion, N. and Hopkins, J. F. P. 1981. *Corpus of Early Arabic Sources for West African History*, Cambridge.

Lewicki, T. 1960. Quelques extraits inédits rélatifs aux voyages des commerçants et des missionaires Ibadites nord-africains au pays du Soudan occidental et central au moyen age. *Folia Orientalia* 2: 1-27.

Lewicki, T. 1962. L'état nord-africain de Tahert et ses rélations avec le Soudan occidental à la fin du VIIIe et au IXe siècle. *Cahiers d'études africaines* 8: 513-35.

Lewicki, T. 1964. Traits d'histoire du commerce transsaharien, marchands et missionaires Ibadites en Soudan occidental et central au cours des VIIIe - XIIe siècles. *Etnografia Polska* 8: 291-311.

Lewicki, T. 1971. The Ibadites in Arabia and Africa. *Cahiers d'histoire mondiale* 13: 3-130.

Lhote, H. 1960. *The Search for the Tassili Frescoes*, London.

Lhote, H. 1972. Recherches sur Takedda, ville decrité par le voyageur arabe Ibn Battouta et située en Air. *Bulletin de l'institut fondamental d'Afrique noire (B)* 34: 429-70.

Lhote, H. 1982. *Les chars rupestres sahariens*, Paris.

Liverani, M. 2000. Looking for the southern frontier of the Garamantes. *Sahara* 12: 31-44.

Lovejoy, P.E. 1986. *Salt of the Desert Sun*, Cambridge.

MacLean, R. and Insoll, T. 2003. Archaeology, luxury, and the exotic. The examples of Islamic Bahrain, and Gao, Mali. *World Archaeology* 34.3: 558-70.

Mattingly, D.J., al-Mashai, M., Balcombe, P., Chapman, S., Coddington, H., Davison, J., Kenyon, D., Wilson, A. I. and Witcher, R. 1997. The Fezzan Project 1997: methodologies and results of the first season. *Libyan Studies* 28: 11-25.

Mattingly, D.J., al-Mashai, M., Aburgheba, H., Balcombe, P., Eastaugh, E., Gillings, M., Leone, A., McLaren, S., Owen, P., Pelling, R., Reynolds, T., Stirling, L., Thomas, D., Watson, D., Wilson, A.I. and White, K. 1998. The Fezzan Project 1998: preliminary report on the second season of work. *Libyan Studies* 29: 115-44.

Mauny, R. 1951. Sur l'emplacement de la ville de Tademekka, antique capitale des berbères soudanais. *Notes africaines* 51: 65-69.

Mauny, R. 1952. Notes d'archéologie sur Tombouctou, *Bulletin de l'institut français d'Afrique noire (B)* 14: 899-918.

Mauny, R. 1978. Trans-Saharan contacts and the Iron Age in West Africa, in J.D. Fage (ed.), *The Cambridge History of Africa, Volume 2: From c.500 BC to AD 1050*, Cambridge: 272-341.

McIntosh, S.K. and R.J. 1986. Archaeological reconnaissance in the region of Timbuktu, Mali. *National Geographic Research* 2: 302-19.

Monod, T. 1938. Teghaza, la ville en sel gemme (Sahara occidental). *La Nature* (15 Mai): 289-296.

Monod, T. 1940. Nouvelles remarques sur Teghaza (Sahara Occ.). *Bulletin de l'institut français d'Afrique noire* 2: 248-54.

Monod, T. 1969. Le 'Ma'den Ijafen: une épave caravaniere ancienne dans la Majabat al-Koubra. *Actes du 1er colloque international d'archéologie africaine, 1966. Fort Lamy*, Fort Lamy: 286-320.

Muzzolini, A. 1986. *L'art rupestre préhistorique des massifs centraux Sahariens*. BAR S318, Oxford.

Muzzolini, A. 1997. Saharan rock art, in J. Vogel (ed.), *Encyclopedia of Precolonial Africa*, Walnut Creek: 347-52.

Norris, H.T. 1990. *Sufi Mystics of the Niger Desert*, Oxford.

Paris, F., Bernus, E. and Cressier, P. (eds.). 1999. *Vallée de l'Azawagh (Sahara du Niger)*, Paris.

Pentz, P. 2002. *From Roman Proconsularis to Islamic Ifriqiyah*, Copenhagen.

Polet, J. 1985. *Tegdaoust IV. Fouillé d'un quartier de Tegdaoust*, Paris.

Reyna, S.P. 1990. *Wars Without End*, Hanover.

Robert, D. 1970a. Les fouilles de Tegdaoust. *Journal of African History* 11: 471-493.

Robert, D. 1970b. Report on the excavations at Tegdaoust. *West African Archaeological Newsletter* 12: 64-8.

Robert-Chaleix, D. 1989. *Tegdaoust V*, Paris.

Roset, J.P. 1986. Iwelen - an archaeological site of the chariot period in northern Aïr, Niger. *Libya Antiqua*, Paris: 113-46.

Salama, P. 1990. The Sahara in classical antiquity, in G. Mokhtar (ed.), *General History of Africa (Abridged Edition), Volume 2: Ancient Civilisations of Africa*, London: 286-95.

Terrasse, H. 1938. Sur des tessons de poterie vernisée et peinte trouvés à Teghasa. *Bulletin du comité d'études historiques et scientifiques d'Afrique occidentale français* 21: 520-22.

Thiry, J. 1995. *Le Sahara Libyen dans l'Afrique du Nord médievale*, Leuven.

Vanacker, C. 1979. *Tegdaoust II. Recherches sur Aoudaghost. Fouillé d'un quartier artisinal*, Nouakchott.

Wright, J. 1989. *Libya, Chad and the Central Sahara*, London.

Wright, J. 1992. The Wadai-Benghazi slave route, in E. Savage (ed.), *The Human Commodity. Perspectives on the Trans-Saharan Slave Trade*, London: 174-84.

Theme 5

Tourism, Development and Conservation

21. Tourism, Development and Conservation: a Saharan Perspective

By Jeremy Keenan[1]

Abstract

The paper explores the role played by tourism in both the destruction and the conservation of the Sahara's cultural heritage. In so doing, it takes the opportunity to present some of the results of a four-year research project into "The geopolitics of the destruction and conservation of rock art in the Sahara", which provides an analysis of both the many causes of its destruction and the difficulties being encountered in its conservation. A key factor in both the 'destruction' and 'conservation' of this heritage, as well as the Sahara's 'living' cultures, is tourism. After many years without tourism, the Central Saharan regions of Libya and Algeria, in particular, are showing the potential for becoming major international tourism destinations. However, the resumption of tourism in these regions in the last few years has revealed many of the more negative and detrimental features of 'mass tourism'. After examining the actions and responsibilities of both governments and local communities, the paper concludes that the way in which tourism is managed over the next few years will determine whether the environmental catastrophe predicted and feared by many of the Sahara's local communities will be avoided.

Introduction

This paper is based on a four-year research programme (1999-2002) into the impact of tourism in the Central Sahara and a concurrent research programme entitled "The geopolitics of the destruction and conservation of rock art in the Sahara". As the title of the latter programme might suggest, my concern has not been to draw up a detailed inventory of damage to rock art and associated antiquities across the Sahara, but to focus more on the spatial, political, economic and social factors, as well as the intellectual implications, behind both the destruction and the management of the conservation of such antiquities. I should also make clear that although this paper was presented at a conference in Libya, my remarks are addressed, except where specifically mentioned, to the countries and peoples of the Sahara as a whole. The looting and destruction of the Sahara's antiquities is a pan-Saharan problem. Its solution must also be pan-Saharan. A prominent Tuareg recently claimed that the Sahara is on the brink of an environmental catastrophe. He is quite correct. But if this catastrophe is to be averted, the countries of the Sahara must suppress their nationalisms and override their very different political and administrative systems to collaborate more effectively. In the same way that the creators of the Sahara's pre- and proto-historic antiquities had no concern for national frontiers, these 'lines on the colonial map' are more of a convenience than an inconvenience for present-day professional looters.

The Scale and Significance of the Sahara's Antiquities

A consequence of thinking of the Sahara in terms of its component parts – the Egyptian or eastern desert, the Libyan desert, the Algerian Sahara, the Moroccan Sahara, the Sahel, and so

[1]Visiting Professor and Director of the Saharan Studies Programme at the Institute of Arab and Islamic Studies, University of Exeter.

241

forth – is that it becomes difficult to grasp its enormity. The Sahara is roughly the size of the USA and by far the largest hot desert in the world, with a very fragile ecosystem comparable in its eco-environmental importance to Antarctica and the Amazon Rain Forest – and deserving of the same protection. Within its vastness, the Sahara embodies an immensely rich natural and cultural heritage, both prehistoric and living, much of which has been recognised as warranting UNESCO World Heritage status. Recognition of this status has and is being extended to many other parts of the Sahara, other than the Tassili-n-Ajjer, in the form of National Parks. Amongst other things, the Sahara contains what Henri Lhote (1959) described as "the world's largest collection of prehistoric art". The size of this collection is almost beyond imagination. I do not know the original source of the figure, but it now seems agreed that the Sahara contains some ten million paintings and engravings, although I do not think anyone has actually got around to counting them! The importance of this collection is still not fully understood or appreciated. Indeed, until we have better dating, it is not inconceivable to suppose that in parts of the Central Sahara, such as Tassili-n-Ajjer and adjoining regions of southern Algeria and perhaps also in the Acacus and adjoining regions in Libya, the Neolithic revolution may predate that of Mesopotamia.

The Scale of Destruction

The tragedy of the Sahara is that this extraordinarily rich cultural and scientific heritage, so much of which seems to have survived over thousands of years the harsh vicissitudes of climate and other natural forces, has been subjected in the last two generations or so to extensive and largely irreversible damage. The scale and speed of this destruction cannot be overemphasised. There is scarcely a corner of the Sahara which has not been looted or vandalised, while in some areas, such as Morocco, it has been estimated that as much as 40 percent of the known rock art patrimony has been lost to looting or vandalism (Coulson 1999). The looting is not limited to rock art. Lithics and potsherds have been collected in their millions. It is generally estimated that some 2 million artefacts have been looted from the Tassili region of Algeria alone. Extensive areas of the Sahara have been subjected to what can best be described as systematic 'vacuuming' by professional looters to such an extent that the archaeological landscape of much of the Sahara has not been simply damaged, but 'sterilised'.

The Causes of Damage

The Sahara's rock art and associated archaeological sites and landscapes are vulnerable to degradation and destruction by a range of environmental and human agents (Barnett, this volume). The former should not be underestimated. Amongst the later, we can identify the actions of the indigenous populations, scientists working in both good and bad faith, photographers (professional and amateur) wishing to enhance the colour/texture of their subject matter, professional looters and 'collectors' (including archaeologists/ethnologists), bandits and the military, religious fanatics, local municipalities (public works and roads departments), oil and other mineral exploration and extraction companies, and many others, not least of which are tourists.

Before turning to tourism, which is the main concern of this paper, let me pass a few comments on the aforementioned.

Indigenous people

Where such sites are near centres of human settlement and occupation, material from the sites, especially stones that may include art panels, may be used for building houses, animal shelters, decoration, and the such like. Larocca (2003) describes such damage in parts of the Oued Draa and the Moroccan Anti-Atlas. Amongst the nomadic populations of the Sahara, rock shelters containing rock art may sometimes be reused as shelters and consequently damaged by camp fires and other human activity. Amongst many of these populations, notably the Tuareg and Toubou (Teda), Palaeolithic and Neolithic stone implements are frequently picked up and reused for multiple purposes. When I first lived amongst the Tuareg in the 1960s, I would invariably find various types of prehistoric grinding stone in daily use for grinding or working grain, fruits, animal skins and such like. Also, many such stone tools, especially hand axes, were believed to contain certain magico-religious properties and were often collected and closely guarded by women for magico-religious protective purposes.

Scientists

Several experiments undertaken by scientists to preserve the Sahara's rock art have resulted in damaging it. The best-known example is probably the use of synthetic resins, reputedly by UNESCO scientists, in the Tassili-n-Ajjer in or before 1968 (Keenan 2000, 2002). Five of the six experiments were undertaken on minor, relatively insignificant sites. Why one of these experiments (two areas covered) was undertaken on what is probably the most significant and best known of all the paintings in the entire Sahara remains a mystery. The painting concerned is the 'Great God' of Sefar (Keenan 2000, 288). Much damage has been inflicted on rock engravings by scientists attempting to make casts of them. Larocca (2003) has documented appalling damage inflicted by a team of Spanish archaeologists in Morocco. Another infamous case of damage to petroglyphs (Larocca 2003) caused by moulding occurred in Libya's Acacus Mountains in the 1980s when an Italian team, lead by the Castiglioni brothers, made replicas of engravings to exhibit in Italy (Castiglioni 1986). In spite of the Castiglioni brothers' condemnation by both the Libyan authorities and the archaeological community, the casts are still proudly displayed in Varese, together with a series of photographs taken during the application and removal of the thermosetting resin. A justifiable case for making replicas of rock art panels can be made when sites are under threat. That was the case at Dabous in western Air (Niger) where a team of conservationists, lead by Jean Clottes and supported by TARA (Trust for African Rock Art) and the Bradshaw Foundation, successfully made casts of the giant giraffe engraving. Casts of the 26-foot giraffe, available in aluminium and FRP resin, are being advertised for sale at $75,000. Diamond shaped casts of the head are available at $10,000. Profits from sales are reportedly being injected into rock art preservation projects, which is admirable. However, fear is being expressed in some quarters (Larocca 2003) that the commercialisation of petroglyphs

in this way may tempt less altruistic persons to make and sell mouldings of other well-known sites with inevitable risk of damage.

Photographers

Wetting and washing paintings, mostly by photographers to enhance their colour, has done immense damage to paintings. The moistening of paintings upsets the physical, chemical and biological balance of both the paint substances and the supporting rock. Henri Lhote (1958), probably the most widely read 'authority' on the Sahara's rock art, strongly advocated the 'washing' of paintings, with the result that hundreds of visitors to the Sahara, especially photographers, as well as guides, have followed his advice. The result is that visitors to the Tassili-n-Ajjer (Algeria) looking for the frescoes reproduced by Lhote now find that several are nothing more than a pale reflection of their former glory, while others have disappeared altogether (Keenan 2002).

Looters and 'collectors'

Millions of portable artefacts of the Sahara's cultural heritage have been looted. Vast regions of immense archaeological importance have been simply sterilised by systematic 'vacuuming' of artefacts. Hundreds (perhaps thousands) or rock art sites, many of supreme intellectual significance, have been vandalised. Many paintings and engravings have been removed, often hacked or cut from the rock face with chisels or chain saws. Graffiti and other forms of despoliation are rampant. Much of the blame for looting and vandalism lies with foreign (mostly European) tourists. Over the last two generations the Sahara's better-known rock art and associated archaeological sites have been visited by an ever-increasing stream of tourists, many of whom seem to have an almost insatiable lust to touch, hold and possess a part of the Sahara's prehistory. More serious than the 'innocent' tourist are the professional looters. These are professional operators, currently mostly Germans, who enter the Sahara with false-bottomed vehicles (and other devices) to scour archaeological sites for artefacts which are then sold into the global 'ethnic' market, usually via the internet and at considerable prices.

Two aspects of this looting are particularly serious. The first is that professional archaeologists and ethnologists who should know better have played a major part in this process. Many of the earlier archaeologists to explore the Sahara believed it was their right, indeed their professional job, to collect specimens for the Museums or other institutions which sponsored them. For instance, during Bagnold's first exploration of the Sarra Triangle in 1932, that "scrap of desert on the borders of Libya with the Sudan and Chad" (Kelly 2002, 67) the accompanying archaeologist, Dr Kenneth Sandford, an Oxford academic, was "kept busy collecting and sorting specimens for the museums back in Cairo, Khartoum, Oxford and Chicago". Saul Kelly (2002, 76-7) writes rather amusingly: "One can detect some impatience on Bagnold's part as, having extracted the cars from the soft sand patches with the aid of steel channels and rope ladders, the expedition was slowed down by Kennedy Shaw's and Sandford's constant search for the choicest specimens. The slight resentment felt by the archaeologists led them to christen their leader 'On-On Baggers'." France's best known and most celebrated 'Saharien', Henri Lhote (1959, 17), wrote quite

unashamedly about collecting cultural objects. In describing a passage south of the Ténéré, he wrote: "scattered about this prehistoric charnel-house was an abundant and magnificent stock of stone implements, many of which I collected … delicate arrow heads in flint, gauges (sic) for fishing nets, and also superb bone harpoons." While in the Tassili he admitted to encouraging Tuareg children to look around for arrowheads and other such objects for him. Lhote himself made one of the largest personal collections. As another 'saharien' once remarked: "What wasn't paid for by the *Musée de l'Homme* went to Lhote's own private collection" (Keenan 2002, 143). Many sites that were excavated by archaeologists were never recorded, with the excavated materials being simply 'looted'. Again, the worst offender was probably Lhote. The results of many of the sites that he excavated, both on the Algerian Tassili plateau and in the surrounding piedmont areas, perhaps numbering as many as eighty, have not been published, nor have the extensive remains been made available for analysis. That is in spite of persistent requests from his colleagues to do so and his many promises (Alimen *et al.* 1968, 423) "to make a general study of all the Tassili sites and the enormous number of remains that were collected during our different expeditions". Indeed, it is almost certainly true to say that no single human agent has contributed more to the destruction of the Sahara's archaeological record than Henri Lhote himself. In Lhote's defence, it has been put to me (Keenan 2002, 145) by an internationally recognised archaeologist that: "Lhote was by no means unusual in archaeology for taking credit for the discoveries of others or at least giving only minimal credit to his predecessors; that he did not set out deliberately to damage the art, nor to incite the public to do the same, in that it was standard procedure in those days to 'wash' rock paintings, as nobody knew any better, and that even if they had known of the potential damage, they would doubtless still have argued that it was worthwhile and necessary to wet the paintings just in order to make the best possible copy; and that Lhote was a collector, not an archaeologist or intellectual, whose amassing of a huge abundance of artefacts from the Sahara was by no means unusual but something that still goes on. In short, it may be argued that although Lhote had many faults, he was no worse than many other people of the time. Indeed, in his arrogance, self-aggrandisement, territoriality about his 'finds', his non-publication of excavations, and his collecting, he was fairly typical of his kind." These practices do still go on. In the last few years alone, professional archaeologists (or, in some instances, people claiming to be professional archaeologists) from France, Spain and Italy and elsewhere (Germans are awaiting arrest) operating in Morocco, Western Sahara, Algeria, Libya and Niger, have been arrested or charged for serious damage to or looting of rock art and associated antiquities.

The second serious aspect of this looting, which I shall talk about in more detail below, is that substantial local markets for such artefacts, although inherently 'illegal', are developing through much of the Sahara. In Morocco, an internal market for stolen/looted goods seems to have developed almost with the connivance of the state. In the Sahel countries and Mauritania, the paucity of the state's resources makes it difficult to stop such developments. In Algeria and Libya, there is a relatively strong regulatory environment which has made it difficult for local traders to develop such a market. The main point, however, to which I will return below, is that such markets cater mostly for the demand of tourists and are predicated on local conditions of

economic poverty and need and a lack of educational awareness of the long-term damage such markets are doing to both the local economy and the cultural heritage.

Vandalism and religious fanatics

What I have said so far would suggest that most of the damage to Saharan rock art and associated archaeological sites is of external agency. That was certainly the case until fairly recently, and probably still is today in the Sahelian countries, and perhaps also Libya, but probably not in either Morocco or Algeria, where an increasing amount of damage, in some parts the majority, is being committed by nationals of the countries concerned. In the Algerian Sahara, for example, most of the graffiti vandalism of rock art sites is in Arabic and being perpetrated by nationals from the north. Some are on holiday, many have been posted to Saharan regions as civil servants or military. Some of this action is being undertaken by religious zealots. These actions may be founded on ignorance, but they are also a manifestation of the disrespect that is often shown by peoples of the littoral for the prehistoric and indigenous cultures of the Saharan regions. In the Sahelian countries, where the main centres of population and government are in the south of the countries concerned (Mali, Niger, Chad), we see the geographical reverse of this pattern. Irrespective of motivation, such damage is the cause of increasing political tension in many parts of the Sahara, which central governments disregard at their peril.

Bandits and the military

Much of the central Sahara is now the domain of smugglers, arms traffickers, bandits and other outlaws. Several shelters containing rock art, in which such outlaws have 'holed up', have been damaged by bullets, presumably for amusement or in testing weapons. In many parts of the Sahara damage has been ascribed to the military, either in the form of their general disrespect for the environment and cultural heritage, or during the course of military action or manoeuvres. In the former Spanish Sahara, for example, Spanish soldiers did considerable damage to sites, not least through removing rock art panels and other artefacts as 'souvenirs'. A report undertaken on the liberated zone in 2002 (Brooks *et al.* 2003) describes more recent damage. However, most of the damage recorded by this expedition was thought to be caused by tourists and archaeologists rather than the military. The most damaged sites were those that had been studied by archaeologists from the universities of Gerona and Grenada (Brooks *et al.* 2003 and personal communication).

Local municipalities

There are several recorded incidents of local municipalities destroying rock art and associated archaeological sites in the course of building activity, road construction and the such like. Such damage is usually inflicted quite unwittingly and is the result of ignorance and lack of educational awareness by the authorities concerned.

Oil companies

Exploration for oil and gas has been undertaken in many regions of the Sahara, but with

the bulk of current output being restricted to Algeria and Libya. In Algeria, there are strict environmental controls and regulations, with both the national oil concern, Sonatrach, and foreign oil and gas companies at times being almost over-meticulous in conducting archaeological and environmental impact assessments of their operations. That, regrettably, has not been the case in Libya, where the British oil company, Lasmo (subsequently taken over by the Italian operative Agip-ENI) recently caused major archaeological and environmental damage to the Messak Settafet plateau (Anag *et al.* 2002). One positive outcome of the Lasmo affair, is hopefully that in future no oil company or national government in the Sahara (or elsewhere) will dare to countenance such reckless activity.

The Development of Tourism and the Management of Conservation

The biggest problem now facing Saharan countries in terms of the conservation of their cultural heritages is tourism. I should emphasise at the outset that the problem is not tourism *per se*, but the way in which the development of the tourism industry in the Sahara is managed.

Travel and Tourism is the world's largest industry accounting for 10 percent of world GDP. However, in the case of North Africa and the Sahara, we have an extraordinary situation. This is that the Sahara's two largest countries, namely Algeria and Libya, both of which abut the world's largest travel and tourism market, Europe, have two of the least developed tourism industries in the world. These two countries have two further salient features in common: (1) the economies of both countries are based almost entirely on hydrocarbons, which contribute some 98 percent of foreign exchange earnings. (2) The tourism industry in both countries, which as a potentially high foreign exchange earner could reduce both countries' dependence on hydrocarbons, has remained undeveloped for largely political reasons. In spite of these structural similarities, it is arguable whether the need to develop the tourism sector is the same for both countries. Unlike Libya, which has far higher per capita wealth than Algeria, Algeria is racked by poverty: some 30 percent of the population is unemployed and some 40 percent of the population is without satisfactory housing. The high labour intensiveness of tourism would therefore appear to make its development more attractive to Algeria than Libya, which suffers comparative labour shortages in the less skilled sectors of the economy.

However, while many developing countries have been seduced by the potential economic benefits of tourism, nearly all of them have now learnt that there can be irreversible 'downsides'. In both Algeria and Libya the potential 'upsides' and 'downsides' are extreme.

The Impact of Tourism

Tourists themselves are not necessarily agents of destruction. On the contrary, tourists and tourism can and must play a major role in the overall conservation management of sites. However, as an agency of destruction, tourism must be looked at in terms of both its direct and indirect actions and consequences. In terms of direct actions, we must distinguish between the actions and roles of tourist agencies and tourists themselves and also distinguish, as do the people of the Sahara, between foreign (European) and national tourists. We must also distinguish between the 'souvenir' hunting of tourists and the actions of professional looters who enter the Sahara in the

guise of tourists or tour operators. In terms of indirect actions we need to look especially at the development of various local markets and associated entrepreneurial and business activities.

Tourism agencies

In most towns of the central Sahara, tourism provides the only business and employment opportunities other than local commerce and the local or regional administration and associated government services. Indeed, with the exception of the hydrocarbons sector (which is not labour intensive) and a few other extractive enterprises, such as the much-reduced uranium mine at Arlit in northern Niger and the iron ore workings of Mauritania, tourism is the central Sahara's sole industry. Moreover, it is an industry with a low threshold of entry, requiring little more than access to a 4WD vehicle. Towns such as Tamanrasset, Djanet, Agades, Ghat, Timbuktu, etc. are literally swarming with 'wannabe' tourism agencies. Tamanrasset and Agades, for example, each have something in the order of a hundred such agencies, although no more than about half a dozen in each town are able to cater properly for the European market. With more agencies than there is business to sustain them, competition is not only acute, but literally 'cut-throat'. In some parts of the Sahara, notably Niger, hijacks of tourist have been ascribed to competing tourism agencies trying to embarrass each other. Such intense, largely unregulated competition results in dangerous cost-cutting, especially in vehicle safety and environmental protective measures. However, the most damaging action on the environment, is the pressure for tourist agencies to provide their clients with 'unique' trips. This often involves searching for 'unknown' rock art sites, which need not necessarily be damaging to the sites, and helping their clients to find and collect prehistoric stone tools, potsherds and so forth. Although it is illegal to remove such artefacts, there are very few agencies, which actively ensure that their clients restrict their desire for 'souvenirs' to photographs. Indeed, it is probably true to say that the majority of agencies not only search out such sites for their clients but actively help them collect such artefacts and then smuggle them out of the country. The result is that most of the best-known and accessible sites have been completely sterilised. And, as tourist numbers increase, so the scouring of the desert intensifies. For example, a reconnaissance of the most accessible terraces between the much-publicised Temet dunes and Air (Niger) in November 1992, which had been liberally covered with Palaeolithic and Neolithic tools and pottery as recently as 1998, revealed that they had been thoroughly scoured: not a single stone tool or potsherd could be found. The same reconnaissance revealed that most of the western margin of the Ténéré desert appeared to have been equally well scoured.

Foreign tour operators are by no means exempt from culpability for such damage. Indeed, some of the most severe damage to the cultural heritage of the Sahara is directly attributable to European tour operators. The two worst cases of recent times involved Italian and German operators. First: after the lifting of the embargo on tourism to Libya, a large number of predominantly Italian tour operators stormed the Acacus-Messak mountains of south-west Libya. Some 45,000 tourists are estimated to have visited the region between December 1999 and April 2000. The damage inflicted on the rock art of the region was immense: some forty rock art shelters are estimated to have been severely and irreversibly damaged in this orgiastic

catastrophe. Second: since the reopening of both Algeria and Libya to tourism in the late 1990s, at least one Munich-based tour operator has been regularly taking groups of tourists, using his own vehicles, to both countries to loot huge quantities of prehistoric stone tools and other such artefacts for subsequent sale via the internet.

Some idea of the potential profits to be made from such operations can be gleaned from the Acacus-Messak debacle. If we assume that each of the 45,000 tourists paid an average of £750 (€1,150), gross turnover was around £35 million (€50 million). If we assume the operators worked on a 20 percent margin, this gave a profit of around £7 (€10.5 million): not bad for a few weeks' work. In the case of the German operation, most artefacts sell for well over €100, with better specimens fetching nearer to €1,000.

Tourists – foreign and national

Although we have no empirical evidence, it is probably true to say that the vast majority of tourists are extremely respectful of the Sahara's environment and cultural heritage. However, as the above-mentioned devastation of the Acacus testifies, both tourists and tour operators, unless strictly regulated and controlled, can pose a major threat to the Sahara. Many tourists are still uneducated about both the Sahara's environment and its material cultural heritage. For instance, tourists visiting the Tassili after reading Henri Lhote's book (Lhote 1958) will quite reasonably believe that it is not harmful to wet rock paintings to enhance their colour. More see it as quite harmless to 'pick up stones' as souvenirs, especially when they see the same artefacts being sold by local people in the markets, shops, hotels and by the road side. Similarly, while most tourists give lip service to not leaving rubbish, an extraordinary amount – notably food tins, glass bottles (mostly alcohol) and plastic – despoils much of the desert. Litter has become a major problem on the Tassili-n-Ajjer plateau, while the Tassili-n-Ahaggar (to the SE of Tamanrasset) has become so littered that for the past two years a group of tourism agencies in Tamanrasset have organised an annual clean-up at their own expense.

While the above comments are directed predominantly at foreign (European) tourists, I am inclined to think that more damage is now being inflicted by national rather than foreign tourists. The Tuareg of Algeria distinguish between foreign and national tourists in almost 'racist' terms. They refer (Keenan 2003) somewhat derisorily to the *gens du nord*, that is Algerians from the north of the country, as *Chinoui/Chnaoui*, from the French *chinois* – Chinese. The explanation for calling them 'Chinese' is because "they are white and behave like foreigners". However, when they or Algerian emigrants living in France visit the Sahara as tourists, they are referred to as *Taiwan* because "they are like the cheap spare parts made in Taiwan, compared to the expensive, original, quality spare parts – namely European tourists." However, there is more to this distinction that mere purchasing power. Tuareg believe that northern Algerians are disrespectful of their culture and are now responsible for most of the degradation of the environment. While such sentiment is based partly on long-standing animosity towards les *gens du nord*, it also reflects a great deal of truth in that most of the graffiti and general despoliation of rock art sites and the surrounding landscape are inflicted by these people. Not surprisingly, such practices are doing much to exacerbate regional and political tensions. While similar

disrespect for the culture of the desert peoples, notably the Tuareg and Toubou, is found in the Sahelian states of Mali, Niger and Chad, I suspect that this distinction is less prevalent in Libya as a result of the Peoples' Revolution and the greater geographical proximity and the historical and cultural integration of the littoral and desert regions.

Professional looters

These people can only be counted as tourists in as much as they usually enter the Sahara as tourists or as tour operators. They are highly professional operators, using national borders for their convenience and keeping abreast of archaeological finds by reading archaeological research papers, picking up on published GPS data and so forth.

Entrepreneurs and local markets

Entrepreneurial activity associated with the tourism industry is extensive, ranging from charter airline services, through the hotel, restaurant and accommodation sector, foreign/local tour operators, transport – especially 4WD – services, etc. One of the major impacts, in terms of damage to the cultural heritage, is through the encouragement that the industry gives to local people to supply the tourism market with cultural artefacts, notably prehistoric stone implements. There is scarcely a settlement in the Sahara in which a local market selling such artefacts will not materialise within minutes of the arrival of tourists. The development of such markets, founded on ignorance of the damage they are doing to the local cultural heritage, are driven as much by poverty and the need for money as by the demands of the tourists. Indeed, I have witnessed tourists buying such objects in some of the most remote and impoverished corners of the Sahara simply because they feel that they should contribute to the alleviation of hardship, rather than for any desire to possess the items being sold. Further stimulating such markets are the traders, agents and 'collectors' in the main tourist centres who have developed networks to the most distant desert communities to provide them with a supply of such '*objets d'art*' for the *souks*, shops and hotel foyers of the tourist centres.

The Solution

Three points need to be understood:

1) Tourism can be a major contributor to the socio-economic development and betterment of the Sahara.

2) Socio-economic development, in the form of tourism, need not be at the expense of conservation. Indeed, the two can and must work hand in hand, for the economic future of the peoples of the Sahara lies not in the hydrocarbons sector, nor in exploiting the Sahara's subterranean water supplies, but in the long-term conservation of its unique physical environment and cultural heritage, which tourists will always pay to come and see. The key concept is 'environmentally sustainable development'.

3) The economic future of most Saharan communities is dependent on the conservation of their rich cultural heritages. When the oil has run out, the Sahara's museum of prehistoric rock art will still be receiving paying visitors.

How can this heritage be conserved?

I have highlighted the extent and speed of damage that can be inflicted by various agents, notably tourism, looters and vandalism. The first priority for all the countries of the Sahara is to ensure that they do not open the gates to tourism simply for the short-term goals of acquiring foreign exchange or to demonstrate that they are politically 'normal', nor until they have the requisite conservation and tourism management policies and structures in place. They must also arrest and prosecute with maximum speed and publicity the professional looters I have described above. This is not difficult: full details, including dates and routes of travel have been given to the authorities.

Once these measures have been taken, the countries of the Sahara must work together in exercising sufficient political will in two key directions: education and training and the greater involvement of local communities.

Education and training

A massive educational extension policy needs to be implemented in all Saharan countries, so that peoples at all levels are made aware of their cultural heritage, why its conservation is so important and how it can be effected. For example, people need to understand why it is important to conserve the total archaeological landscape, not simply the specific sites within it. As part of these educational initiatives, there is a need, in all Saharan countries and at all levels (national, regional, local), for training in the management of both conservation and tourism.

Involvement of local communities

No tourism or conservation strategy will work without the full participation and involvement of local peoples and communities. The first and last line of defence against the damage I have described in this paper lies in the hands of local communities. In the same way that Tuareg regard tourism as 'their industry', and must be allowed greater control of it, so political authorities must transfer much greater control to local communities. This is not easy for those countries, which have highly centralised, relatively undemocratic political systems. Nor is it easy for those countries in which 'corruption' has become almost endemic.

However, the solution, like the problem, must ultimately be both pan-Saharan and global. In the same way as looters have no regard for national frontiers, being in Libya's Ubari Sand Sea one week, Algeria's Tassili-n-Ajjer the next and Niger's Ténéré desert the week after, so the countries of the Sahara must work more closely together. Institutions such as the recently established *Fondation Déserts du Monde* may help in this regard. The Foundation was established by Algeria's Minister of the Environment in December 2002. Its main office is in Ghardaia (Algeria).

Responsibility for the successful implementation of the solution lies as much with the international community as it does with the national governments of the Sahara. The Sahara, like the Antarctic and Amazon Rain Forest, is a global heritage site. In the same way as the international community has played a major part in the Sahara's degradation, so it must take responsibility for its conservation. Such responsibility goes beyond the mere contribution of financial resources (which are important). It involves providing the encouragement, support and

the necessary expertise, and the transfer of skills in the form of conservation and management training.

The key to the future of the Sahara lies with Algeria and Libya, its two largest countries, and its mostly richly endowed both in terms of hydrocarbons and their cultural heritages, antiquities and environments. They are both in the rare position of having grossly undeveloped tourism industries. They therefore have the opportunity to become examples to the world of how environmentally sustainable tourism can be developed in such fragile environments. But, they also have the chance to 'get it wrong' and of being censured accordingly.

In short, the way in which tourism development is managed in these two countries over the next few years (and time is urgent) will determine whether the environmental catastrophe predicted and feared by many of the Sahara's local communities, and already under way, will be avoided.

Acknowledgements

I would like to acknowledge the Leverhulme Trust and the British Academy for their generous support in funding these two projects.

References

Alimen, H., Beucher, F. and Lhote, H. (with the collaboration of G. Delibrias). 1968. Les gisements néolithiques de Tan-Tartrait et d'In-Itinen, Tassili-n-Ajjer. *Bulletin de la Sociétié préhistorique française* 65: 421-56.

Anag, G., Cremaschi, M., di Lernia, S. and Liverani, M. 2002. Environment, Archaeology, and Oil: The Messak Settafet Rescue Operation (Libyan Sahara). *African Archaeological Review* 19.2: 67-73.

Brooks, N., di Lernia, S., Drake, N., Raffin, M. and Savage, T. 2003. The Geoarchaeology of Western Sahara: Preliminary results of the first Anglo-Italian expedition in the liberated zone. *Sahara* 14: 63-80.

Castilgioni, A., Castiglioni, A. and Negro, G. 1986. *Fiumi di pietra*, Varese.

Coulson, D. 1999. Ancient art of the Sahara. *National Geographic* 195.6: 98-119.

Keenan, J. 2000. The theft of Saharan rock art. *Antiquity* 74: 287-8.

Keenan, J. 2002. The Lesser Gods of the Sahara. *Public Archaeology* 2.3: 131-150.

Keenan, J. 2003. Ethnicity, regionalism and political stability in Algeria's Grand Sud. *Journal of North African Studies* (Special Issue), 8.4: 67-96.

Kelly, S. 2002. *The Hunt for Zerzura. The Lost Oasis and the Desert War*, London.

Larocca, A. 2003. Rock Art Conservation in Morocco. *Public Archaeology* 3.2: 67-76.

Lhote, H. 1958. *A la découverte des fresques du Tassili*, Paris. Translated 1959 as: *The Search for the Tassili Frescoes: The story of the prehistoric rock-paintings of the Sahara*, London.

22. The Natural and Human Essentials for Desert Tourism in South-West Libya.

By Thuriya Faraj al-Rimayh[1]

Abstract

This paper presents a general account of some of the main attractions of desert tourism in south-west Libya. Natural characteristics – landforms, flora, fauna, lakes and other desert phenomena – are reviewed, as well as the main archaeological and cultural heritage aspects: the Garamantian civilisation, oasis towns and rock art.

Introduction

The desert in Libya constitutes more than 90 percent of the land and is an important financial resource because of tourism. There are a number of tourist attractions and sites of high importance, ranging from splendid panoramic views to a wealth of prehistoric art, as well as ancient agricultural developments in oasis villages and some remarkable desert lakes. In addition to that there is an impressive local culture and folklore, especially in the oases and other desert towns.

This diversity in desert tourism in Libya offers a multitude of cultural and environmental opportunities for the entertainment of tourists. The gold to white sand of desert trails appeal to adventurous and sports-loving tourists as well as those who wish to explore for themselves the unknown and unexpected landscapes of the desert. There is plenty to interest those who fancy researching human cultures and ancient legacies, or who wish to study history and nature. The desert also presents a unique opportunity for photographers and for those who simply seek peace and tranquillity.

Libya is regarded as a country that has strived to diversify its economic assets, in terms of tourism, with the view to expand its foreign currency earnings instead of solely relying on oil revenues to fulfil its present and future economic and social projects. Therefore, desert-tourism is believed to be one of the most promising and important economic resources, especially for the southern regions of Libya. In order to make use of the potential for revenues from desert tourism, there must first be investment in it. For that reason, significant development efforts have now been geared to generate products relating to the desert, its scenery and local cultures.

It is worth mentioning that the desert region in south-west Libya is one of the best for desert tourism and a major attraction for many visitors from all over the world. It is believed to be attractive for immediate and short-term investments because of the richness of its cultural and natural heritage. Libya has what it takes to attract tourists to experience the people and locale of the desert.

[1]Researcher, Libyan Tourism Authority, Tripoli.

Natural Attributes

The area, which is the subject of our study, is distinguished for its moderate climate, warm in most months of the year especially during winter and spring as compared with countries in northern and western Europe, where most Saharan tourists come from. It is also noted for the variety of natural scenery, including spectacular mountain formations like the area of Akakus mountains as well as the Massak Sattafat and Massak Mallat. Desert rock formations are often highly sculpted by the wind to form rock columns, arches and tables and other exotic shapes. Further attractions include the many-coloured sand dunes of both the Dahan Murzuq and Dahan Ubari, and the stony surface of Hamada al-Hamara. In addition there are the oases, especially Ghadamis and Ghat, and those ones in the Wadi al-Hayat (al-Ajal) and ash-Shati. There are also some unique desert lakes such as the ones in the area of Ramlat al-Zalaaf, and the extinct volcanoes in the area of Waw an-Namus,

Oases are generally regarded as the most promising tourist sites in the desert because of their natural beauty, and their proximity to fossil waters because of their low-lying locations which meant certain vegetation and trees, especially palm trees, could grow there. Palm groves often still cover considerable areas of the oases. These oases are bordered by sand seas, with impressive dune formations. In some areas of the sand sea extant lakes offer attractive touristic landscapes, adding to the rare ancient towns and precious cultural legacies the area cherishes. Oases have always represented greenery amidst the desert and have over the ages offered water and food to their inhabitants, enabling them to engage in the diverse social and economic activities that produced a unique desert culture and traditions. Amongst the most important oases in the area were Ghadamis, Ghat, Murzuq and those ones in the Wadi al-Hayat and Wadi ash-Shati.

The sand dunes that cover a large area of the Libyan Desert are regarded amongst the most beautiful scenery in the world, full of revelations owing to the simplicity of their formation and their organised and precise order. Sand dunes takes various shapes, such as crescent, dome and star-like, rectiform, and linear (ridges). The sand dunes with their colourful and picturesque wavy surfaces also appeal to some tourists wishing to engage in their favorite sports such as walking, sand skiing, or trying out the therapeutic effects of hot sand baths. The best areas for such activities are to be found in south-west of Libya particularly in Dahan Ubari and Dahan Murzuq and the sand dunes in the vicinity of Ghadamis, which is in the forefront of tourist activities in the region.

The Ramlat al-Dwawda, a series of lakes in the Dahan Ubari in the Zalaaf area, are regarded as a prime desert tourist attraction too, because of the vast number of panoramic views framed by palm, bamboo and tamarisk trees at the lake edges, with huge dunes directly rising behind the lakes. Tourists have to undergo an interesting adventure to reach the lakes by driving over the sand dunes. The very existence of these lakes in the heart of the desert is a matter for thought and bewilderment for tourists and locals alike. The lakes of Gabr 'Awn, al-Mandara and Umm al-Ma' are amongst the eleven lakes in Ramlat al-Zalaaf which are the most famous for drawing tourists to the desert. The colour of some of those lakes is red because of crustacea living in them. Also there are migrant birds that have taken this unique environment as home, as well as some wolves, foxes and reptiles.

The desert mountains and plateaux attach extra splendour and fascination to the desert, and the most famous of all the mountains is the Akakus range in the southern-western corner, on the Libyan-Algerian border stretching north to the area of al-'Uwaynat, and towards the south to the southern part of Ghat along the valley of Wadi Tanzzuft. The Akakus is well-known for its caves and rock shelters bearing prehistoric rock art, both painted and engraved. But it is also characterised by its multi-coloured rocks. These lends a breathtaking magnificence to the many tilted shapes and eroded forms of rock formations, resulting from natural sculpture. Generally speaking the area of Akakus, with its valleys, intricate topography and its caves and rock shelters, is one of the most spectacular landscapes of Libya.

The mountains of al-Haruj al-Aswad are another example of natural beauty, especially their volcanic rocks and rounded topography. This area has the largest number of extinct volcanoes in Africa. The Waw al-Namus volcano with its associated lakes has been described by tourism experts and journalists as one of the most exotic locations in the world. Waw al-Namus is located in an isolated area of the desert 100 km to south of al-Haruj al-Aswad in the middle of Sarir Tibisti. The Waw al-Namus volcano is surrounded by ten pretty lakes in total, some of which contain fresh water springs and are encircled by palm trees, tall bamboo and tamarisks.

There are many dry valleys (wadis) in the Libyan Desert, reflecting a time of high rainfall in direct contrast with the current arid conditions. The area is one of the richest in fossil ground water and this is the crucial factor that has made parts of the area fit for human habitation over the ages. Water has contributed to the beauty and diversity of the natural environment (see al-Mahdi Bilkhayer, this volume) as a result of the spread of oases. Water supports both cultivated plants (such as those grown in oasis gardens, those used for medicine, palm trees, pasture, etc.) and other desert plants that attract researchers and conservationists.

There are also traces of camel caravan routes in the valleys and open desert areas, and some ancient towns. The most famous of those valleys in the south-west of the country are Wadi al-Shati and Wadi al-Hayat, which are both famous in the world of tourism of Libya because they were the homes for the Garamantian people that settled in the area and raised a fine civilisation, with many sites still providing evidence of their grandeur. In addition to those valleys are Wadi 'Utba, Wadi Barjuj and the valleys of the Akakus mountains. Also there are the valleys of Wadi Ayada, Wadi Afzajarn, Wadi Tshuniyat, and the Takhakhurri pass etc..

Other desert attractions are the Sareer and Hamadats (gravel and rock deserts) notably Sareer Tibisti, Hamada al-Hamara, Hamada Tanghrit. The rock formations produced by wind erosion of boulders of different shapes is a notable phenomenon of Hamadats and Sareer.

Moreover, the area of study possesses outstanding animal and plant forms that are able to survive in the harshest of climates, where there is a near total lack of water and hot temperatures year round. However, this particular area enjoys a surprising range of vegetation and green cover, despite its water deficiency – many trees such as Tamarisk and Acacia, a whole host of rare herbs. As for the wildlife, there are gazelles and antelopes in addition to many birds and insects. All these offer tourists and researchers a window into the desert environment and source for enjoyment to desert scholars and lovers.

The Libyan Desert is well known for its vastness, and it occupies a large part of the southern

band of the Great Sahara on the semi-equatorial line in Africa. Libya's geographical location as a caravan cross roads between equatorial south and moderate north. Here East Africa, the Nile and the Mediterranean cultures all influenced human civilisation.

The history of human settlement in those areas goes back to prehistoric times and this can be evidently seen in the rock engravings and drawings in mountain caves and valleys, and abundant stone (lithic) tools. The remains of ancient towns, palaces, castles and the scattered archaeological sites in the oases and valleys in the Libyan desert are in fact the remains of past civilisations that once populated the area such as the Garamantes and the Romans, who influenced many areas of the desert, together with the Arab Islamic civilisation. In general the prehistoric art, and oases civilisations and historic towns together constitute a unique cultural heritage and a vital source of tourism in the Libyan south, and the best example and corroboration is the declaration by UNESCO that the desert areas of the rock arts in Akakus and the old town of Ghadamis are World Heritage Sites.

Historic Oases Towns

Ghadamis

Ghadamis is one of the most important historic oases towns in Libya, and an outstanding and living example of mankind's solution to coping with the desert environment. This contributes to its touristic particularity and prospects and its World Heritage Site status. Ghadamis is considered one the most important population centres in the north-western corner of the Libyan desert, and this exceptional location made it a key desert gateway. Ghadamis has a long history as an important economic and cultural centre and this is manifested by its archaeology which goes back to the first millennium BC at least. Some of the discovered archaeology and inscriptions go back to pre-Roman times, and they are probably the remains of the another desert civilisation related to the Garamantes.

Travellers and historians have long appreciated the peculiarity of Ghadamis, with many features not found in other desert towns. The location of Ghadamis by an abundant spring and at the hub of a network of caravan routes has made it an important centre of oasis cultivation and trade, including slave-trading. The architectural design of the houses and mosques and the building materials used in the old city all all attractive factors to tourists. The old town also treasures the remains of earlier civilisations that have passed through Ghadamis, from the Romans to Islamic Arab to the Ottoman Turks rule. The most noted of the Roman touristic sites is the series of mortared rubble cores of tombs in the form of temples. Fragments of the relief sculpture and architectural elements (columns and capitals) are visible in the museum. There are also palaces and semi-palaces such as Bin Amiyr, Maqdul palace, and the Turkish fort, part of which is used as the Ghadamis local museum. The Ayn al-Faris spring is one of the most celebrated of all historic sites in the area, while the nearby Mujzem lake and the Ramla area are other tourist landmarks.

Ghat

Ghat and nearby villages are regarded as the southern centres for discovering the Akakus Mountain and the surrounding area, which enjoys a good natural setting with natural protection in Tanzufit valley, one of the natural corridors for caravans that gave Ghat its international fame throughout history and was famous as one of the trading centres in the desert and a link between Mediterranean and African towns south of the desert on the one hand and with eastern and western desert oases on the other. Ghat has been colonised since prehistory and its engravings and ancient paintings tell the story of human settlement and civilisation in the neighbouring mountains. Also to be admired is the traditional architecture of the old town of Ghat and of Ghat castle in the centre of the town. This is viewed as a distinguished architecture style.

Murzuq

Murzuq has been a population and trading centre for a long time, and was often used as a base by European travellers writing during the nineteenth and the beginning of the twentieth century, and it was known as a pivotal trading centre in the heart of the desert. Historians have given currency to many stories and legends that have made Murzuq an historic milestone that attracts tourists, and also considered it as a passageway to the east to Waw al-Namus and the western areas of Wadi al-Hayat (Wadi al-Ajal), the Akakus Mountains and Awinat. The old town of Murzuq, its walls and historic castle, standing houses and traditional mosque are phenomenal touristic attractions. Murzuq is also famed for its traditional handicrafts based on palm produce.

Archaeological Sites

The archaeology of Jarma is one of the living testimonies of the history of early Libyans in the area, and the name of Jarma emanated from the Garamates who lived in the area (see Mattingly, this volume). They were fearless and adventurous, and owned horses, chariots and weapons that helped them to control a large desert kingdom and to stand in the face of the Roman advance into the desert. Herodotus provided the first historical reference to the Garamantes in the fifth century BC, yet the first tangible appearance of human Garamantian settlements were on the escarpment hills along the southern side of the valley, of which the oldest at Zinkekra went back to the tenth century BC.

The archaeological sites in the Jarma area include Zinkekra mountain, with traces of early Garamantian habitation on its top and north slope and a number of rock engravings, revealing to us aspects of their life then. In addition to that there is a mausoleum encircled by a huge cemetery contains a large number of round graves with offering tables, and grave markers in the form of horns and hands. Another notable cemetery if the Royal necropolis south of old Jarma. The remains of old Jarma are surrounded by an oval defensive wall, bordered from outside by a moat. The well-preserved remains of late medieval and early modern buildings and a castle make this a very atmospheric site. The remains of the capital of the Garamantes lie beneath the

present Islamic city at old Jarma, of which one large central area has been unearthed.

A museum was opened recently near old Jarma with galleries presenting the prehistory, Garamantian culture and society, and Islamic traditional artefacts, in addition to archaeological and historic assets in the area of Jarma that enable it to be a tourist attraction. There are three main topographical units in the neighbouring areas, which are Bahr al-Rimal (sand sea) in the north, oases stretched along 150 km east to west, and the rocky escarpment and plateau (Massak Sattafat) in the south.

Prehistoric Art

The archaeology left by ancient people is the most important witness of the humid period that the desert went through in the ages of prehistoric engravings and paintings that have been found by the thousand in the mountainous areas in caves and valleys, particularly in the two areas of Akakus Mountains and Wadi Matkhandush (see Barnett, this volume). They also represent a universal human cultural heritage, and an attestation of wild animals and the natural vegetation richness that the area used to enjoy. The rock art in the area is distinguished by its fine quality, and is a good source of tourism in the area as well.

The valleys of the Akakus Mountains and the big caves that were formed by the work of natural erosion are amongst the most impressive areas worldwide for the preservation of prehistoric rock art. They were well chosen by the ancient artists to be the centre for this creativity. The valleys of the Akakus Mountains are actually the centre for prehistory arts in Libya, and are the most important of all centres in the southern flank in the Mediterranean and Europe area, and this area was duly declared a World Heritage Site.

The prehistoric rock art has for a long time now attracted all sorts of tourists and visitors. Whilst some are drawn simply by the gravity, beauty and artistic level of the rock art, others try to shed light on the society that produced it (see di Lernia and Merighi, this volume). The rock art needs to be understood in its social, ecological and historical context. The interpretation and analysis builds on whatever can be obtained in about the environment and the economic base, the ethnic origins, lifestyle and material culture.

Conclusion

Overall, the historical sources, the archaeological heritage, the rock art and the human landscapes of the Libyan Sahara constitute one of the most significant cultural resources for the study and enjoyment of deserts. The human components in an area known for its rich cultural heritage include traditions, practices, folklore, traditional industries. There is great diversity in social and cultural life related to geography and the long distances between oases to a certain extent. There are, for example, differences in traditions, practices and social system between Ghadamis and the oases of Wadi ash-Shati. Also, the variety and contrast of the ethnic origins in the area contributed to the production of diverse life styles, as in the case of the Tuareg, and this variety and contrast presents a source of excitement that attracts tourists of different ages and nationalities.

The touristic significance of south-west Libya is increasing and it has the capacity to become one of the world's premier environmental tourism industries, since it possesses a number of cultural and natural legacies of outstanding national and international worth. Some of these have already been enlisted in the the World Heritage List, such as the Akakus mountains, the old city of Ghadamis, which are treated as protected sites because they are considered as part of international human heritage in accordance with the international treaty for the protection of heritage sanctioned by UNESCO. Finally, these sites produce a compound tourist product, they cater for a variety of tourist needs and offer enormous potential for natural scenery, prehistoric art and archaeology. But these attractive natural habitats and cultural heritage sites need protection and resources need to be invested in the conservation and sustainable development of the resource if Libya is to enjoy long-term benefits from its desert tourism.

23. The Archaeological Park of the Acacus

By Mario Liverani[1]

Abstract
The natural environment and archaeological remains of the Tadrart Acacus and adjacent areas build up a complex so rich and coherent, that it has been acknowledged and listed (since 1985) by the UNESCO as one of the 'World Natural and Cultural Heritage Sites'. The task of preserving the area, protecting and restoring its most relevant features and monuments, and making the entire complex accessible to visitors is a duty for the Libyan Government, for the international agencies, and for the competent scholars. Various subjects share the juridical and moral responsibility concerning the various aspects of the entire problem.

Introduction

It is hardly necessary to reiterate here the many reasons for the uniqueness of the Acacus area. We can highlight, on the environmental side, the beautiful and impressive landscape of the Acacus range, complemented by the Messak plateau and the surrounding valleys and sand dunes. On the cultural side, we have at least to mention the prehistoric rock paintings of the Acacus (Mori 1998), the prehistoric engravings of the Messak (Lutz and Lutz 1995; van Albada and van Albada 2000; cf. Le Quellec 1998), the prehistoric sites in the mountain shelters (Barich 1987; Cremaschi and di Lernia 1998; di Lernia 1999; Garcea 2001) but also in the wadis and ergs, the funerary monuments of the Pastoral and Late-Pastoral periods (di Lernia and Manzi 2002), as well as the Garamantian citadels and castles (Liverani 2000; Mattingly *et al.* 2001) and the medieval or early-modern caravan cities at Jarma and Old Ghat. Every single item can find its counterparts elsewhere, yet not easily in comparable qualitative levels and amount. But the complex – the interaction between nature and culture, the scenario of the very beginnings of human artistic activity – is probably unique on a world-wide scale.

It proves almost impossible to list the various features of the natural and cultural heritage of the Acacus area without listing at the same time the damages they suffered in recent decades, and the perspectives for future danger. The Messak plateau has been cut across by oil prospectors through dozens and dozens of seismic lines (at 200 m interval) and bulldozer tracks (Fig. 23.1) – so invasive as to be clearly visible on satellite images (Kröpelin 2002, fig. 16). The sand dunes in the ergs (especially on the east side of the Acacus) are daily criss-crossed by the numberless paths of the tourists' four-wheel cars. The open-air prehistoric sites have been looted of the most diagnostic lithic artefacts by visitors and by commercial collectors. The original fauna of gazelle and *waddan* has totally disappeared because of futile gun-hunting. The original flora will also soon disappear, if every visiting group cuts down an acacia for a campfire at its night bivouac. The most accessible rock paintings are quickly fading away because of humidity intentionally or unintentionally brought in by tourists. And every year we notice some fragments of painting or

[1] Dipartimento di Scienze Storiche, Archeologiche ed Antropologiche dell'Antichità, University of Rome 'La Sapienza'.

Figure 23.1. Seismic lines for oil prospecting on the Messak plateau, cutting a Late Pastoral stone-covered tumulus.

engraving fallen down or cut away; and many new images and signatures added by local visitors in between the old ones. The medieval or early-modern caravan cities of Old Jarma and Old Ghat are falling down in ruins – and recent uncontrolled restoration activities are producing additional damages.

Protecting the Saharan Heritage

In our case, as in any other similar case, the protection of the environment and the cultural heritage is a task that everybody would easily subscribe to in principle, but that can find a practical and effective application only in two cases: either because the local and international public opinion is sufficiently aware and sufficiently powerful to stop looting and damages; or else because the local authorities become aware that the cultural heritage can be used as an economic resource. In my experience, the Libyan government, the local Fazzanese authorities, and the local communities in Ghat and Serdeles are well aware of their responsibilities toward the international public (and scholarly) opinion, and also well aware of the potential economic advantages of cultural tourism. In a few years, nothing will be left worthy of protection, and the Acacus would be better cancelled out from the UNESCO list.

Now, damage and deterioration have two sets of causes. On the one hand, it is the unavoidable effect of time passing, of natural causes, that most of the rock art has disappeared, with no

responsibility by the human community. On the other hand, during the last fifty years, and especially during the last ten years, serious damages have been produced by the suddenly increased human access and activity, against that part of the cultural heritage, which had survived the millennia of natural deterioration (Fig. 23.2).

First came the tourists, especially in the Acacus. Desert tourism, previously limited to a few (and risk-conscious) visitors, became in the early 1990s a mass affair, culminating with the *c.*45,000 tourists who visited the area in the winter/spring season of 1999-2000 (after the embargo had been removed). In the last two years a decline took place, because of the image of general political insecurity (especially after the Twin-Towers event).

Second and worse came the oil prospectors, especially in the Messak. After some years of unsuccessful research, a major oil deposit (among the biggest in Libya) was located by the LASMO Grand Maghreb Limited in 1997 in the very middle of the Messak Settafet, at the so-called 'Elephant Field' inside the license area NC174 (Fig. 23.1). Other oil companies (like Repsol in the erg of Ubari and Total in the ergs of Uan Kasa and Murzuk) have further enlarged the prospected area, and the risk now affects the Acacus itself.

The solution of protecting the area by excluding the tourists is both unjust and counter-effective in the long run. And the idea of stopping the oil companies is so foolish that it cannot be even imagined, not to say suggested. The area must be protected instead. But it should not be protected through excluding human access and economic exploitation. It should be protected through appropriate measures, regulating access and exploitation, and by facing up to both the natural and human causes of damage. In fact, desperate appeals for a protective intervention have been advanced in recent years by various scientific institutions or private persons, and were successful in stimulating the first official monitoring mission by international experts (including J.L. Le Quellec, S. Kröpelin and G. Anag) in 1999 (Le Quellec and Kröpelin 1999).

Modern technology, in addition to administrative measures, can contribute in a substantial way both to producing a detailed inventory (an 'archaeological map'), and to facing the general deterioration of the entire area and the specific damages in selected sites – both those produced by

Figure 23.2. New damage in the Uan Amil Cave, Acacus mountains. A part of the panel of a bovid has been removed with a chisel.

natural causes and by human activity. But restoration measures, carried on in individual sites or monuments, will prove ineffective unless preceded by a serious scientific study and unless framed in a general project of regional extent. The obvious tool to reach such a target, is the establishment of a large protected area, a 'Naturalistic and Archaeological Park of the Acacus and Messak' – or the Acacus only (more or less corresponding to the recently established Ghat province), since the Messak can be realistically considered as already lost forever and too badly pressed by the needs of oil exploitation. Examples of similar parks are not lacking, in Africa and elsewhere. Just a few miles from Ghat and the Acacus, across the Algerian border, the Tassili Park can provide a useful model in a similar environment with a comparable cultural heritage.

Our archaeological mission, the so-called 'Joint Italo-Libyan Mission in the Acacus and Messak', has been working in the area for fifty years, since the early discoveries by Fabrizio Mori on the prehistoric rock art of the Acacus. Accordingly, we are in charge (and we are the only mission to be officially in charge) of the archaeological works in almost the entire area under concern. Because of the scientific and moral (not legal) responsibilities ensuing from such a situation, we presented to the General Director of Antiquities and Museums of Libya, Ali Muhammad Khadduri, a general project suggesting the establishment of the 'Archaeological Park'. This happened five years ago (27th July 2000), but in the meantime no substantial progress seems to have been accomplished – at least to my official knowledge. Our project was gratefully received, at least in spoken words, not in formal documents. The guidelines of the projects have also been published (Liverani *et al.* 2000), so that they are accessible to every interested person or institution. It is also known that other projects have been (or are being) advanced by other institutions (in particular, by the UNDP, Tripoli branch) or private persons, and probably every project contains (or could contain) useful suggestions to be compared and evaluated in order to identify the most effective strategy. I am not personally interested that our project be given any priority. I am only interested that the Park be established as soon as possible. I am not interested in being appointed to any official committee, I am only interested that some competent person be appointed, and possibly that our mission be informed about what is going on, in order to coordinate efforts and interventions. I am a little bit surprised that the competence of the senior members of our mission has not been taken into account, that the enormous set of data assembled and classified by our mission during half a century of work has not been exploited, and that we have to collect information by hearsay and through indirect channels.

The Park project has also to take into due account the problem of oil surveying (and soon also of oil exploitation), especially as far as the Messak is concerned (see the excellent assessment by Kröpelin 2002). This is a different problem, yet the interference is clear, and probably the oil companies do not see the Park project as something positive, from their point of view. If this holds true, it is reasonable to foresee that no Park will be ever established. Previous experiences in other countries, however, demonstrate that some kind of agreement can be reached between the needs of oil exploitation and the needs of environment tutelage and cultural heritage. After all, in every country, the costs of the environmental risk and of the archaeological risk are considered

as a normal component (and a quite minor one, at that) in the general budget, whenever a road or an airport or any kind of building, or also any agricultural infrastructure or any urban planning, is coming into being. Our purpose is not to stop the economic enterprises, but to make them compatible with a reasonable protection of the natural and cultural heritage.

Our experience has been quite instructive, however, and worth of a short notice. Two years ago, we were invited to carry out an archaeological survey in the central Messak plateau (the general area of the Elephant Field) , in the strips of land where the GOSP, the asphalt road and the oil pipe had to be built. A parallel invitation was addressed to the British Mission under the direction of David Mattingly. The invitations came from the Department of Antiquities, and the operations were fully paid and efficiently supported by the LASMO oil company. We sent a team of various specialised persons, including geologists and archaeo-geologists, prehistorians, surveyors, anthropologists, rock art experts, all of then provided with the necessary (and rather sophisticated) equipment. The operation was quite successful, many sites and monuments (including funerary cairns and Old Libyan inscriptions) were located and studied, some of them were excavated (Anag *et al.* 2002). The results of the operation are being published in book form (Cremaschi and di Lernia forthcoming). The LASMO activities were neither stopped nor harmed in any way. After that operation, which provided the practical demonstration that a reasonable cooperation between archaeology and oil exploitation is in fact possible, our mission did not receive any further invitation for similar interventions in other areas, although other subjects were indeed invited: either isolated members of the Department of Antiquities (with no technical equipment) or foreign missions with no previous experience in that area – and they surveyed even an area (the *erg* Uan Kasa) that our mission had previously surveyed on its own charge! Once again, let me repeat that we are not interested in doing the entire work; we are interested that the work be done by teams including competent persons in the various fields of scientific activities involved, and with the necessary equipment, and ending in a scientific publications of the data. Otherwise the work is completely useless. And once again, I am rather astonished in realising that the competence accumulated – not by me, but by the senior members of our mission – during fifteen years of personal work, are not considered a valuable patrimony of knowledge about a cultural heritage in danger of being quickly destroyed.

Of course, our CIRSA is an Italian *research* institution, our task is to collect and analyse scientific data about the environmental change and cultural adaptations in the ancient Sahara, to the final end of reconstructing the ancient history of the area. In principle, we are not charged with the *tutelage* of the Libyan cultural heritage, a task that pertains to the Libyan Directorate of Antiquities. Whenever requested, we did provide our assistance, to the best of our competence and enthusiasm, and of our time and resources. Therefore we did present the Park project, and we did carry out the LASMO operation. If the Park is not established, and if the oil exploitation goes on without the necessary archaeological surveys, we cannot protest (nor even complain). But it would be totally unjust to hold us for responsible (even to a minor extent) for the deterioration of the cultural heritage.

Conclusions

Forgetting now our specific position, and going back to the Park project, I would end in an optimistic perspective. After all, in order to establish the Park, we need only three things: political will, resources and competence.

Political will pertains to the Libyan central government, possibly stimulated by the local authorities and communities, by the Libyan academic world, and by the international pressures. Without a strong political will by the Libyan government, the Park cannot be established, the entire discussion becomes futile, and no technical help by international agencies and by competent scholars can be of any use. The Libyan political will must be strong enough to overcome possible opposition (especially by the oil companies), and to locate the Park project at the top – and not at the very bottom – of the list of requests addressed to international agencies and to foreign states like Italy (e.g. under the label of compensation for damages produced during colonial dominance and war). As for a possible Italian engagement, we owe to the action of our Ambassador in Tripoli, Claudio Pacifico, if archaeology and especially the Acacus-Messak Park project will be given high priority and visibility in the Italo-Libyan agreement which is currently under negotiation. Unfortunately, the Anglo-American war operations against Iraq open now a negative scenario, with most resources being necessarily devoted to different priorities.

Resources should be provided in part by the Libyan government itself, and in part by external parties: either the international agencies or by foreign states or by the oil companies themselves. It is only too easy to suggest that the AGIP (which recently incorporated LASMO) could pay the huge compensation for the Messak damage by providing resources for the Park project. Yet such an idea, while so easily suggested, is much harder to accomplish: and in this way we revert to our first point, the Libyan political will.

The external financial support is necessary in order to establish the Park, while the inner Libyan resources are necessary in order to run the Park once it has been established. The total amount of the necessary resources is no doubt rather high, since the Park is a very large one. More precisely, it depends on the extent of the area to be included and on the extent of restoration work to be carried out. Just to provide an example: the Park can be established either including the architectural restoration of Old Ghat, or not. In the two cases, the cost is quite different. The project can include extensive restoration of the rock art (at least in the most famous sites, those included in the standard visitors' tours), or not, and also in this case the price becomes quite different.

It should to be clear, however, that an effective project should include a wide range of enterprises: the Park itself, the restoration of Old Jarma and Old Ghat, the archaeological Museum in Ghat, a 'Centre for Saharan Studies' to be located in Ghat, the restoration of rock art monuments, the restoration and arrangement of the major archaeological sites (such as the Jarma necropolis, or Aghram Nadharif), the improvement of communications (Ghat airport, asphalt roads), the repopulation of traditional flora and fauna, and an operative connection with the Tassili Park in Algeria. Only in this way can you build up a touring area strong enough to

attract a substantial amount of visitors, to put in motion private commercial activities, and to survive in the long run. Any one of the above sub-projects, carried out in isolation, is probably doomed to failure.

The last problem, competence, is the most easily solved. Competent persons are available in Libya and all over the world: the Libyan authorities have just to select the better ones and to pay them. Competent advisors are especially necessary in the phase of project-making, while the normal running of the Park (once established) becomes a matter a routine, to be entrusted to local officials under supervision of an international scientific committee.

Please – I am now directly addressing the Libyan authorities – decide immediately. Please, raise the funds as soon as possible. Please, build up the Park quickly. Otherwise, in a few years, nothing will be left worthy of protection for scientific study, for cultural memory, and for economic use.

References

Anag, G., Cremaschi, M., di Lernia, S. and Liverani, M. 2002. Environment, archaeology, and oil: The Messak Settafet rescue operation (Libyan Sahara). *African Archaeological Review* 19: 67-73.

Barich, B. (ed.) 1987. *Archaeology and Environment in the Libyan Sahara. The Excavations in the Tadrart Acacus*, Oxford.

Cremaschi, M. and di Lernia, S. (eds.) 1998. *Wadi Teshuinat. Palaeoenvironment and Prehistory in South-Western Fezzan (Libyan Sahara)*, Firenze.

Cremaschi, M. and di Lernia, S. (eds.). Forthcoming. *The Messak Settafet Rescue Operation (Libyan Sahara). LASMO N-FC 174 Concession Area,* AZA Monographs 5, Firenze.

di Lernia, S. (ed.) 1999. *The Uan Afuda Cave. Hunter-Gatherer Societies of Central Sahara,* AZA Monographs 1, Firenze.

di Lernia, S. and Manzi, G. (eds.) 2002. *Sand, Stones, and Bones. The archaeology of death in the Wadi Tanezzuft Valley (5000-2000 bp),* AZA Monographs 3. Firenze.

Garcea, E. (ed.) 2001. *Uan Tabu in the Settlement History of the Libyan Sahara,* AZA Monographs 2, Firenze.

Kröpelin, S. 2002. Damage to natural and cultural heritage by petroleum exploration and desert tourism to the Messak Settafet (Central Sahara, Southwest Libya), in *Tides of the Desert. Contributions to the Archaeology and Environmental History of Africa in Honour of R. Kuper* (Africa Praehistorica 14), Köln: 405-23.

Le Quellec, J.L. 1998. *Art rupestre et préhistoire du Sahara. Le Messak libyen*, Paris.

Le Quellec, J.L. and Kröpelin, S. 1999. *Rapport de la mission effectuée au Messak (Libye) du 10 au 17 juillet 1999.* Unpublished Report to UNESCO, Paris.

Liverani, M. 2000. Looking for the Southern Frontier of the Garamantes. *Sahara* 12: 31-44.

Liverani, M., Cremaschi, M. and di Lernia, S. 2000. The 'Archaeological Park' of the Tadrart Acacus and Messak Settafet (south-western Fezzan, Libya). *Sahara* 12: 121-40.

Lutz, R. and Lutz, G. 1995. *The Secret of the Desert. The Rock Art of the Messak Settafet and Messak Mellet, Libya*, Innsbruck.

Mattingly, D.J., Brooks, N., Cole, F., Dore, J., Drake, N., Leone, A., Hay, S., McLaren, S., Newson, P., Parton, H., Pelling, R., Preston, J., Reynolds, T., Schrüfer-Kolb, I., Thomas, D., Tindall, A., Townsend, A. and White, K. 2001. The Fezzan Project 2001: Preliminary report on the fifth season of work. *Libyan Studies* 32: 133-53.

Mori, F. 1998. *The Great Civilisations of the Ancient Sahara*, Roma.

van Albada, A. and van Albada, A.M. 2000. *La montagne des hommes-chiens. Art rupestre du Messak libyen*, Paris.

Theme 6

Historical and Documentary Studies

24. Libya and the Sahara in the History of Africa

By Michael Brett[1]

Abstract

The paper looks at the Sahara from two points of view: firstly, as an exceptionally barren region of Tropical Africa, in which a thin population has struggled to survive; secondly, as a barrier between the Mediterranean to the north and the Equatorial region to the south, which was overcome by trade. From both points of view the Libyan Sahara, centred on the Fazzan, played a crucial role. The Garamantes are the outstanding example of successful exploitation of the Saharan oases in Antiquity. But although they traded with Rome, there is no clear archaeological or written evidence of trans-Saharan trade before the 'golden age' of Islam created a substantial market for Sudanese gold and slaves, supplied by camel. The Sahara then became a central feature of the world economy, and the Fazzan the pivot of the route to the region of Lake Chad, but at the expense of the Garamantes. These were treated as enemies by the Muslim camel nomads who founded Zawila and developed the slave trade with the Bilad al-Sudan. The conversion of the Garamantes led to the appearance of an integrated agricultural and commercial society in the Fazzan, which eventually came under the rule of the Awlad Muhammad at Murzuq. But agriculture in the Fazzan was in retreat throughout the Islamic period, and prosperity depended increasingly on the trans-Saharan trade in slaves. When this was abolished in the nineteenth century, the Fazzan like the rest of the Sahara was marginal to the new world economy, and sank into poverty. Although oil and gas have now renewed the importance of the desert, its inhabitants have little part to play in their production, and the problem now is to benefit both them and their environment.

Introduction

The Sahara is a major feature of the climatic history of Africa, and thus of its human history as well. It is also a problem, since the sources for that history are thin. Climatically the Sahara has evolved from desert in the Late Pleistocene, to savannah in the first five thousand years of the Holocene, to desert again in the second: the last five thousand years. In the first, wet phase of the Holocene, the region saw the appearance of herding and farming to the north of the Tropic of Cancer, and of fishing and gathering to the south – a continuum of human occupation from the Equatorial forest to the Mediterranean and south-west Asia. That continuum was not entirely broken, but was certainly transformed, by the desiccation of the Holocene Dry. In the desert itself, as it developed on either side of the Tropic, a pastoral population turned from keeping cattle to sheep and goats, and to agriculture in the oases where the population was increasingly concentrated. To the south of the desert, as the lakes and swamps gave way to savannah in the Sudanic belt, the fishers and gatherers of the so-called Aquatic Civilisation turned to farming along the remaining watercourses, or on the dry grassland between. Both Sahara and Sudan thus came to form part of the present African whole, a continent described by Iliffe as an especially hostile region of the world, in which a thin population has struggled to colonise a harsh environment (Iliffe 1995, 1). By this reckoning, the Sahara and its peoples belong firmly with the lands and peoples to the south, rather than with the Mediterranean and

[1]School of Oriental and African Studies, London

Europe to the north. From a different and more familiar point of view, however, the formation of the desert created a formidable natural barrier to communication, effectively cutting off the lands to the south from the lands to the north, and allowing for the development of a distinct sub-Saharan civilisation. In this scenario, the accent shifts from subsistence to trade, as the means whereby the barrier, once established, was progressively overcome. The problem for the historian is to meld these two aspects into a single story.

In outline, this story runs as follows. The desiccation of the Holocene Dry left the Nile and the Red Sea as the only natural routes across the desert. To the west of the Nile, the concentration of the remaining population around the waterholes restricted the ways across the Sahara to those eventually followed by the camel caravans; but their development as trade routes across the desert had to wait, in the first place, for the establishment of the camel in the region as the pastoral animal of a newly pastoral population, in the course of the first centuries CE; and secondly for the 'golden age of Islam', in the second half of the first millennium, to create a substantial trans-Saharan market for Sudanese gold and slaves (Lombard 1975). The story is evident in the evolution of the written sources. These begin in Egypt around the beginning of the Holocene Dry, from which time they stretch progressively up the Nile and down the Red Sea to the Nilotic Sudan and Ethiopia; but they extend far across the desert to the west in the Islamic period, from 700 CE onwards. In the case of Nubia and Ethiopia, they culminate towards the end of Antiquity by documenting the establishment of Christianity, an event which marks the extent of Roman contact with sub-Saharan Africa in face of the Sahara to the west; but in the Central and Western Sudan, written sources only begin with the establishment of Islam, which marks the growing incorporation of these areas into a wider world. In this process of incorporation, the desert in between was converted from a frontier into a vast internal space. While it remained an obstacle to be overcome, its regular crossing was the framework for the evolution of an extraordinarily varied society in so small and sparse a population (Briggs 1960), with a central role in the intercontinental economy of the Islamic world. The fresh continuum of human occupation that came into existence between north and south lasted down to the late nineteenth and the beginning of the twentieth century, when an even wider world supervened, with drastic consequences. In the new framework of colonial partition, economy, society and government were all put on a different footing. It is ironic that political division, and the reduction of its population to small minorities in the states to north and south, have marginalized the desert as far as its inhabitants are concerned, at a time when petroleum has given the Sahara fresh importance in the world at large.

Pre-Islamic Activity

The outline itself is far from clear: the combination of agriculture, pastoralism and trade remains obscure, especially in the pre-Islamic centuries. The existence of trans-Saharan trade in the Classical period of Carthage, Greece and Rome has been a particular bone of contention; so, too, has been the closely related question of the presence of the camel in the desert for the purpose of such trade. Although the Classical sources offer tantalising suggestions of a land beyond the

desert where a great river, such as the Niger, flowed, such a land was evidently below the horizon of the Classical world. The lack of either clear literary or firm archaeological evidence for a significant trans-Saharan as distinct from a Nubian or Ethiopian presence in the population and affairs of the ancient world has led authors such as Robin Law to discount the assumption that the wealth of Carthage, and subsequently that of the three cities of Roman Tripolitania, must have derived to some considerable extent from trans-Saharan trade (Law 1967). Such a view is reinforced by the general absence, to date, of Classical traces in the archaeology of the Western and Central Sudan. But the idea that Herodotus in the fifth century BCE was describing a well-established route from Egypt to the Niger bend, which was investigated in the 1950s by Henri Lhote (Lhote 1973), has now been revived by Mario Liverani (Liverani 2000a/b), who postulates a caravan trade employing camels for the convoy of gold and slaves to the Mediterranean in the manner of the Islamic period, from the beginning of the Classical era.

For this conclusion, Liverani relies on the archaeological evidence of fortifications to the south of Ghat in the Wadi Tanizzuft, dating from the first centuries CE, and situated on the route he postulates to the Niger bend. For the use of the camel on such a route, he turns to the work of Brent D. Shaw (Shaw 1979), written to disprove the view that the wild camel of the Pleistocene had died out in North Africa and the Sahara, and that the domestic animal had been introduced via Roman Africa in Roman times – a view based, once again, on the absence of literary evidence for the camel as a common animal before the late Roman period. Shaw's contention, from a series of dateable camel bones, is that the wild camel had not died out, but had been domesticated with the onset of the Holocene Dry as a useful addition to the livestock of a pastoral and eventually agricultural population. Shaw certainly has a point; but he is not concerned with the question of trans-Saharan trade. Indeed, his argument that as a domestic animal, the camel in antiquity was always the last choice for transport, after horse, mule and donkey, and the last choice, after sheep and goats, for food, hide and hair, scarcely supports the idea of the camel caravan for the regular crossing of the Sahara before the coming of Islam. By the same token it begs the question of camel nomadism and its development in the desert, which Shaw, in rejecting the contention of Bulliet (Bulliet 1975) that the camel entered the Sahara from the south-east in the first centuries CE, fails to discuss. The question, on the other hand, is central to Bulliet's thesis, which is that the camel did so as a herd animal, with whose aid the desert was effectively repopulated by nomads from the first century CE onwards. His contention that the camel was introduced from Arabia across the Red Sea and the Nile to the south of Egypt rests on his proposition that the riding saddle of the camel in the Sahara derives from the riding saddle of Arabia – a different kind of evidence from Shaw's, but if true, then equally important. There seems in fact no reason why the two theses should not be compatible: domestication followed at a later date by the introduction and spread of camel nomadism. If, however, on the evidence of the Islamic period, we are going to make the presence of camel nomadism a condition for the development of regular long-distance movement and trade across the desert, we have to explain why such trade did not develop in the later Roman centuries, when such nomadism should have been in place.

The Garamantes and the Fazzan

To all these questions, the Libyan Sahara is central. Here, the desert funnels down from the Gulf of Sirt between the arms of the Tibesti massif to the east and the Ajjer highlands to the west to cross over into the lowlands that stretch towards Lake Chad. To the north of this pass, and about a third of the way across the desert from the Mediterranean, lie the oases of the Fazzan, in three long, parallel valleys running east and west. The Fazzan, with its mediaeval centre at Zawila and more recently at Murzuq in the southernmost line of oases, saw the beginning of the trans-Saharan trade of the Islamic world in the eighth century, when Berbers, newly-converted to Islam, undertook the regular supply of black slaves from the region of Lake Chad to the south. As Muslims, they entered into the mental world of Islam, centred in time and space upon the Prophet and the Holy Places of Mecca and Medina. Out of that world emerged a vast and varied literature, in which geography played no small part; historically, however, the time before the coming of Islam turned rapidly into myth and legend (Norris 1972). *Ubi sunt qui ante nos in mundo fuerunt*: "where are those who were before us in the world?" was a question more of sacred than secular history. Yet the predecessors of the mediaeval Muslims of the Fazzan were the Garamantes, the only Saharan people of Antiquity of whom we have substantial knowledge, thanks in the first place to the Classical sources, but in particular to the archaeological attention which those sources have attracted to the region. This prominence, we can now see, is not accidental; the Garamantes were as important in their time as they are to us (see Mattingly, this volume). They were a Saharan people in Iliffe's Africa, successfully adapting their way of life to a harsh environment through the exploitation of an ecological niche; but by their very success reaching out to the wider world within and beyond the desert. The answers that are emerging to the question of how they did so, and how subsequently they were transformed into the Muslims of the Middle Ages and the Arabs of modern times, must affect the answers to the questions regarding the Sahara as a whole.

While the Garamantes are situated by current research ever more firmly within the orbit of Rome beyond the imperial frontier (Wheeler 1955), they have been equally firmly placed within the history of Africa by the archaeologists of the Fazzan Project (Mattingly *et al.*, 1997-2002; 2003). Continuing the earlier work of Daniels (Daniels 1970), these have addressed in the first place the question of subsistence, to build up a picture of the population of the oases over the past three millennia in accordance with the current concern with the natural history of man on the continent (*cf.* Fleure 1951). Systematic excavation at Old Jarma/Garama, the Garamantian capital in the Wadi al-Ajal, the central valley of the Fazzan, together with extensive surveys of the region, have shown a population which around the middle of the first millennium BCE descended from the fortified heights of Zinkekra to unfortified settlements on the valley floor, where Mediterranean cereals were cultivated along with dates, grapes and figs. This agriculture was sustained by a growing network of foggaras or underground irrigation canals, which lasted up to and possibly into the Islamic period (see Wilson, this volume). By the first centuries CE, this society had developed to the point at which it had moved beyond mere subsistence. Garama was distinguished by impressive Roman-style architecture, a wealth of imported Roman goods, monumental tombs, and traces of considerable industry: iron, copper and salt working; textiles;

and carnelian beadwork. Such affluence spread beyond the Fazzan as far as the oasis of Ghat to the west (di Lernia *et al.* 2001; Liverani 2000b). It is clear that Garama did good business with Roman Tripolitania to the north, and equally probable that the Garamantians were well aware of their more remote neighbours to the south.

To what extent this prosperity was associated with trans-Saharan trade is nevertheless doubtful. It is difficult to believe that Herodotus could have been describing a well-established trade route through the Fazzan to the Niger bend at a time, in the fifth century BCE, when Zinkekra had only recently been abandoned for Garama, while Jenne-jeno, the future centre of trade and industry on the Niger, had barely been settled (McIntosh 1998). Liverani's most compelling piece of evidence is provided by the four Garamantian fortresses he has excavated to the south of Ghat, at the foot of the Tassili N'Ajjer, and a route across the mountain to the south-west. Dating from the first centuries CE, without, as yet, any trace of Garamantian-style agriculture in the oasis, they suggest an imperial extension of Garamantian power, with the control of trade in the direction of the Niger bend as a possible objective. But in the absence of further evidence for regular, commercial communication between the Classical world and the savannah to the south of the Sahara, we should perhaps think in terms of Saharan as distinct from trans-Saharan trade, that is, trade within the desert, and between the desert and its margin, not trade from side to side. Apart from the trade of the Fazzan with Tripolitania, we have a good example of such Saharan trade in the Western Sudan, where Tegdaoust (Awdaghust) in the desert of southern Mauritania resembled the Fazzan in its relationship to a centre of civilisation formed by Jenne-jeno and an incipient Ghanaian empire in and around the Inland Delta of the Niger (McDougall 1985; McIntosh 1998). This relationship reached its pre-Islamic peak in Late Antiquity, enabling the rapid development of the trans-Saharan gold trade in the Islamic period, as merchants from North Africa plugged into an existing cycle of exchange; but this peak coincided with the disappearance of Roman material at Garama, suggesting that the two cycles had nothing in common before the Islamic period. Little or no evidence exists for a similar cycle of trade in the Central Sudan around Lake Chad, reaching as far north as the Fazzan (Connah 1981), though the speed at which the trans-Saharan slave trade developed from the middle of the eighth century onwards suggests that there, too, it may have existed. It could indeed be the case that the Garamantians were drawing black slave labour from the south for their extensive irrigation and other works in the Fazzan, without necessarily supplying a Mediterranean demand. If so, the impression of the Garamantian Fazzan as a prosperous agricultural society which for some three hundred years shared in the general prosperity of Rome would be reinforced.

Zawila and Early Islamic Developments

From the fourth century CE onwards, however, the disappearance of Roman material at Garama signals the end of this advantageous relationship with the Mediterranean, and at the same time the beginning of social and economic change. Garamantian sites were progressively fortified, and although they continued to be occupied, a change of lifestyle from the middle of the first millennium CE seems indicated by the appearance of animal remains in dwellings of the later period. Cultural change is apparent from early in the Islamic period, when mosques replaced

temples, and old burial customs, in which standing stones and offering tables were placed in the Carthaginian manner at the grave, disappeared. At the same time the foggaras, the underground irrigation canals, fell into disuse, to be replaced by wells: a change which over the centuries was accompanied by a shrinkage of the cultivated area, and signs of increasing poverty down to the present day. These changes are all the more significant, since from the beginning of the Islamic period in the late seventh century CE, Garama in the central valley of the Fazzan was replaced as the principal city by Zawila at the eastern end of the southern line of oases. Strategically situated, unlike Garama, on the most practicable route across the desert to the region of Lake Chad in the south (Thiry 1995, 54), Zawila was remarkable not for its agriculture, but as the centre of the earliest trans-Saharan trade of which we have unequivocal evidence.

People of the Fazzan and the coming of Islam

The contrast with Garama is profound, and begins with the sources. Where archaeology has provided the material evidence for both the continuity of settlement and the discontinuity of culture in the Wadi al-Ajal down to the present day, the site of Zawila has yet to be thoroughly investigated in this way. On the other hand, it takes the place of Garama in the literature, following the change from Greek and Latin to Arabic. Reference to the Garamantians in the Classical literature peters out with a brief mention of their conversion to Christianity in 569 CE, following that of Awjila and Ghadames (Savage 1997, 120): evidence that while the economic connection with Rome (now Byzantium) may have subsided, the Fazzan remained within its sphere of knowledge and influence. But the Garamantians survive only briefly in the Arabic sources, with a reference to the conquest of Jarma, sc. Garama, and perhaps in the obscure folkname Q-r-m-tiyyun (Thiry 1995, 88, 175, 375). Thereafter the accounts of the Fazzan in the earliest Arabic works (the majority usefully translated, author by author, in Levtzion and Hopkins 1981), describe its inhabitants as Habasha, sc. "Abyssinians; Ethiopians", and their country as the first of the Bilad al-Sudan, "the Land of the Blacks".

This is not merely curious, since we might have expected them to be described, along with the rest of the peoples of the Libyan desert and North Africa, as Berbers; it is highly significant. Berber, in Arabic Barbar, that is, 'barbarian', was a loosely linguistic term for the non-Latin and non-Greek-speaking peoples of North Africa, which the Arabs had converted into a racial term for a branch of the human family in line of descent from Noah. As such it was applied from the beginning of the Arab conquest of North Africa in the seventh century to the speakers of the various Berber languages, of whom a minority was recognised as Christian, but the majority regarded as Muslim: that is, as pagans who had been obliged by the Arabs, in the absence of a recognisable faith such as Christianity, to profess the religion of their conquerors. As Muslims, they were thus incorporated into the Dar al-Islam rather than the Dar al-Harb, those unconquered regions of the world with whose inhabitants the faithful were, in principle, perpetually at war. This definition of a nation, only part of which had in fact been conquered and Islamised in this way, became the basis upon which the Berbers as a whole, in the highlands of North Africa and in the Western Sahara, were gradually drawn into the religion, the way of life, and the civilisation of Islam in the course of the next four or five hundred years (Brett 1978;

Brett and Fentress 1996; Brett 1999a). The artificiality of such a racial and religious classification is apparent in the case of the Norsemen who appeared on the coasts of Spain and Morocco in the ninth and tenth centuries, and who were classified as Majus or Zoroastrians, a 'people of the book' with whom peaceful negotiations could be conducted; and in the subsequent use of the same term for the Maguzawa, the non-Muslim Hausa. Indeed, there are early references to the unconquered Berbers as Majus, before the fiction of their Islamisation was finally established (Brunschvig 1986a, 111-13; 1986b). In the Fazzan, the same artificiality is apparent in the exclusion of the population from the category of Berber, and its designation as Habasha, that is, as a people identified with the Ethiopians, who may have been thought of as Christian, but were certainly considered to be beyond the pale of Islam, in the category of enemies who were yet to be conquered.

The source for the classification of the Fazzanis as Habasha is the opinion of the great jurist Malik ibn Anas in the middle of the eighth century, reported by his equally great successor Sahnun in the ninth (Brunschvig 1986b). Responding to a question about the identity of the Fazzanese, Malik would have answered that they were a race of Habasha, 'Abyssinians', who were only to be fought if they refused the invitation to submit. Brunschvig, who first drew attention to the passage, discussed the possibility that they were indeed 'Ethiopians' or Black Africans, citing the occasional description of the Garamantes as Aethiopians in the Classical literature, most recently by Isidore of Seville. But this discussion is rendered unnecessary by the logic of the statement, from which it appears that for Malik, 'Habasha' was a legal category like that of 'Majus': a vague racial term (Beckingham 1971) applied to a number of African peoples with whom the faithful were in principle, and in the case of the Fazzan in practice at war, a relationship which the jurist wished to regulate in accordance with Islamic law. In the light of this statement, Brunschvig is surely right to suggest that in the middle of the eighth century, the Fazzan of the Garamantes remained unconquered by the Arabs, despite the celebrated account by Ibn 'Abd al-Hakam in the ninth century of its conquest by 'Uqba ibn Nafi' in the seventh (Brunschvig 1986a and b, *pace* Thiry 1995, 80ff.). The statement, indeed, suggests that while these Habasha may have turned to Islam, perhaps as a protection against slave-raiding, they may never have been formally conquered, since the ninth-century al-Ya'qubi, who visited Zawila, describes a state of recurrent warfare between the people of the Fazzan and the Mazata, a people of the desert to the north. The impression is of a frontier zone on the borders of Islam, comparable to the situation in Morocco and the Western Sahara, where Islam, trade and holy war went hand in hand (Brett 1999a).

Muslim Zawila

Zawila, where al-Ya'qubi was a visitor, was by contrast clearly on the other side of this racial and regional frontier. Not only does he distinguish it clearly from the Fazzan (Thiry 1995, 89; more generally 77-93, 375-6; Savage 1997, 118-9); it is quite different in almost every way. Physically, it was unfortified before the late eleventh or twelfth century, perhaps not before the dynasty of the Banu al-Khattab was overthrown by conquest in 1172-3 (Edwards 2001). From its first appearance in the literature, moreover, it was a Muslim settlement of Muslim Berbers,

who participated in the great Kharijite revolt of these Berbers against their Arab rulers in the middle of the eighth century. At the centre of the revolt, which spread right across North Africa, were the Berbers whom the Arabs had recruited into their armies in the course of their conquest of North Africa and Spain (Brett 1978; 1999a, 58-9), which points to an origin for Zawila towards the end of the seventh century as a *misr* or garrison city like Qayrawan in modern Tunisia, founded on the frontier of the Fazzan as an outpost against the infidel. This solidarity with the rebels survived the attack on Zawila by the forces sent from Baghdad to recover the lost North African provinces, which achieved only partial success. The Zawilans recognised the breakaway Kharijite Ibadi Imamate of the Rustamids of Tahart in western Algeria (Savage 1997); and when that Imamate was overthrown at the beginning of the tenth century, Zawila became the seat of the Ibadi dynasty of the Banu al-Khattab, who ruled until the end of the twelfth (Thiry 1995, 356-73).

The Banu al-Khattab

The Banu al-Khattab were a family from the Hawwara and the Mazata, the very people who in the ninth century were at war with the people of the Fazzan; and their origin points to a second aspect of Zawila as a settlement of newcomers to the oases. Along with the Lawata, the Hawwara and Mazata were among the peoples from the deserts of Cyrenaica and Tripolitania from whom the Arabs had drawn their first recruits, and who went on to provide the Ibadi Imamate at Tahart with its followers in the northern Sahara. Unlike the Garamantes, they were nomadic rather than sedentary, pastoralists rather than agriculturalists (Savage 1997, 118-9; Thiry 1995, 377), and evidently in opposition to the Fazzanis in al-Ya'qubi's report of continual attacks upon the oases by the Mazata. On this reckoning, the Berbers who established themselves at Zawila not only came from the new world of Islam. They came from the world of the camel nomad, whose enigmatic origins go to the heart of the problem of trans-Saharan trade.

Zawila as entrepôt

Zawila's role in the trans-Saharan trade as it developed from the middle of the eighth century onwards is certainly its most prominent feature in the Arabic sources. It is most simply explained as a consequence of the Arab demand for slaves as tribute from the Berber peoples they conquered, which after the Berber revolt was supplied by the Berbers of Zawila with black slaves from the region of Lake Chad (Brett 1978; Brett and Fentress 1996, 89-90; Brett 1999b). In the interval, it seems only too likely that the supply was drawn from the Habasha of the Fazzan, irrespective of colour. The demand for such black slaves from such a source is new, unparalleled in the Roman world, or at least unsatisfied on this far-reaching scale. By the ninth century, it has brought the oases out of the isolation that is apparent in the archaeological sequence in the Wadi al-Ajal from the fourth century onwards. At the same time it has integrated them into the new world economy. Zawila, like Tahart at the other extreme of the Ibadi sphere in North Africa, has become the residence of merchants from Iraq and Iran; and the city has taken its place in the network of long-distance routes that by the ninth century ran from end to end of the Islamic world, and stretched down across the Sahara to the Bilad al-Sudan (Brett 1999b).

Origins of Trans-Saharan Trade

As a commercial centre closely associated with camel nomadism, Zawila is the key to the solution proposed by Bulliet to the problem of the origins of trans-Saharan trade. Following their appearance in the Sahara in the first centuries CE, camel nomads would not have entered into the symbiotic relations with settled societies enjoyed by the Arabs in the Fertile Crescent, but remained apart and hostile. "Only later, when trans-Saharan caravan trading developed on the initiative, surely, of merchants from the north, did the camel nomads of the Sahara experience a change in their status vis-à-vis settled society analogous to that which the Arabs had experienced centuries earlier" (Bulliet 1975, 140). Zawila, in that case, was not only the first result, but also the proof of how and when the change came about. The origins of trans-Saharan trade are nicely explained. So too is its absence in Antiquity despite the presence of the camel, both as a beast of burden and a herd animal: there was no such demand in the late Roman and Byzantine period to prompt supply.

Given a relatively late date for the establishment of camel nomadism in the Sahara, Bulliet's thesis is broadly acceptable. It is, nevertheless, unclear about the situation in Late Antiquity, and certainly optimistic about the subsequent relationship between nomads and sedentaries in North Africa and the Sahara. The beginning of fortification in the Fazzan in the late Garamantian period suggests that within the desert the relationship had indeed been one of hostility, and that the appearance of warrior nomads in the Sahara contributed to its isolation from the Mediterranean, as well as to the impoverishment of Roman North Africa. On the other hand, such nomads may have been instrumental in developing the routes to the south. It is possible that the Tuareg, the Berber nomads of the southern and central Sahara, take their name from Teraga, their word for the Fazzan. In the oasis of Abalessa, in the direction of the Niger bend from Ghat and the Fazzan, the fifth-century tomb called the tomb of Tin Hinan takes its name from the Tuareg tradition of an ancestral heroine who settled there. It is certainly that of a princess, adorned with gold and silver bracelets and provided with two Roman cups (Brett and Fentress 1996, 206-8). Just as the gold suggests a connection with Wangara, the 'island of gold' formed by the Inland Delta of the Niger, and the cups a distant relationship to the Mediterranean, so their location suggests an infrastructure of transportation ready to respond to the demand of the trans-Saharan world for gold. That readiness is attested by the rapidity with which the demand was supplied from the eighth century onwards, a rapidity which may be compared to the speed at which Zawila turned to the export of black slaves. It suggests that in the age of the camel nomad, the routes of the southern Sahara were already active in exchanges with the Sudan. If the Garamantians, as may seem likely, had used black slave labour for their intensive agriculture in the desert, we have a long-standing precedent which was followed in the mediaeval and modern period, when the supply of black slave labour to the Saharan oases was an integral part of the trans-Saharan trade, the internal in addition to the external demand ensuring its overall profitability (McDougall 1992).

Trans-Saharan slave trade

In the Islamic period, such a slave trade within the desert led to the formation of a stratified

Saharan society of noble Tuareg nomads ruling over servile cultivators, an extreme solution to Bulliet's problem of the relationship between nomads and sedentaries in North Africa and the Sahara (Briggs 1960). The categories were themselves fluid, with many nomads habitually forced out of the desert and into farming by poverty and oppression (Brett 1999d/e/f). Conflict in the Fazzan was not reduced but exacerbated by the coming of the Arabs and Islam, and prolonged into the ninth century by the incursions of the Mazata side by side with the growth of trade at Zawila. Islam in this situation played a dual role, on the one hand as a cause for war, on the other as a force for peace. As a force for peace, Islam is implicit in Bulliet's solution, underlying the commercial economy upon which his explanation rests. Its contribution is not simply a question of demand on the part of a newly prosperous Islamic state and society in the Near and Middle East. It concerns the organisation of supply, in general by Muslim communities such as the Ibadis, whose society stretched from Tahart to the Fazzan, but in particular by the Muslim merchants whose business this was. Whether they came from North Africa or from Iraq and Iran, these merchants were professionals whose literacy in Arabic and proficiency in Arabic numerals, the language and the arithmetic of the new civilisation, were essential to their success (Chaudhuri 1985). They relied, moreover, upon the Islamic law for the conduct of their affairs; contracts in accordance with its detailed provisions could be enforced from end to end of the Islamic world, while its principles governed their relations, as expatriates, with the non-Islamic rulers of the Bilad al-Sudan (Brett 1999c). While many such merchants came from North African tribal backgrounds, and frequently transported their goods in the course of tribal migrations, their specialisation distinguished them from their nomadic kinsfolk, and aligned them with the interests of government. The result of such developments within the Ibadi realm of Tahart can be seen at Zawila with the establishment of the dynasty of the Banu al-Khattab at the beginning of the tenth century.

Banu al-Khattab and Zawila
The arrival of the Banu al-Khattab transformed Zawila from a commercial city into a state at the centre of a commercial empire stretching northwards to the coast and south towards Lake Chad. To the north it was supported by Ibadi Berber tribesmen who practised agriculture as well as pastoralism in the manner of the Bedouin of Cyrenaica in recent times (Behnke 1980; Brett 2001, 244-5; Johnson 1973). In the Fazzan itself, the Fazzan of the Habasha, this dynasty of the nomadic Hawwara and Mazata appears to have overruled the previous antagonism to bring about a new order. At Garama and elsewhere in the Wadi al-Ajal, archaeology has clearly documented the continuity of occupation into the Islamic period, despite a blank in the record at Level V at Old Jarma itself, and some indication of a change in domestic ways of life. The appearance of mosques is a more obvious sign of cultural transformation. Still more significant is the reappearance of Garama/Jarma by name in the literature, together with Tasawa, 'little Jarma', across the mountain in the southern line of oases. In the twelfth century, the geographer Idrisi mentions them as the twin cities of the Fazzan, cultivating date palms, sorghum and barley by means of irrigation, in contrast to Zawila, the centre for travel to the Sudan, which despite its date palms, lives off imported commodities (Levtzion and Hopkins 1982, 120-2, 130). What

can perhaps be said is that after the revolution represented by the foundation of Zawila, first as a military and then as a commercial centre independent of Jarma/Garama and its agriculture in the Wadi al-Ajal, the old and the new grew together under the aegis of the Banu al-Khattab as the network of Saharan routes expanded (Brett 1999b), and a trade route developed in the direction of the Niger bend through old Garamantian territory via the old Garamantian outpost of Ghat (Thiry 1995, 376).

Newcomers of the Eleventh Century: Banu Hilal

From the eleventh century onwards, however, this equilibrium, if that is what it was between the old Garamantians and the new Zawilans, was upset by the spread of a fresh race of warrior nomads across North Africa. These were the Arab tribes of the Banu Hilal, who brought about a fresh revolution in the Berber world. The salient features of this revolution in North Africa are the progressive Arabisation and Islamisation of the rural population, resulting in large measure from the break-up of existing communities and tribes, and the formation of new populations under the dominion of warrior chieftains and the auspices of marabouts or holy men. It was a process driven by the insecurity of life in both the desert and the sown, from which sprang new categories of strong and weak, rich and poor, noble and ignoble, clerical and lay (Brett and Fentress 1996; Brett 1999d/e/f). To the north of the desert the process was governed by the efforts of the dynasties at Marrakesh, Fes, Tlemcen and Tunis to bring the country under their control. In the Sahara, such control was absent. As the contrast developed between the nomad and the cultivator, and between the warrior and the merchant, a fresh premium was placed on the role of religion. In the oases of the Mzab, a refugee population of Ibadi Berbers cultivated and traded under the rule of their clerics. Among both the Berber Tuareg and the Arab tribes that formed in the Western Sahara, a highly stratified society evolved in the desert and the oases under the rule of warrior nomads (Briggs 1960). Below them, however, literacy and commerce combined with saintliness and scholarship to produce other clans of nomads who specialised in both religious learning and trade with the Bilad al-Sudan.

North-South shift of influence

In the Fazzan the outcome was different. The influx of warrior Arabs in the eleventh and twelfth centuries put Zawila itself under siege, before the city was finally conquered in 1172-3 by the rogue Mamluk Qaraqush, leaving the service of Saladin in Egypt to carve out an empire for himself in the west. The Banu al-Khattab were exterminated, and the hold of the Ibadis on trans-Saharan trade was finally broken. Not only was the Islam of the Fazzan thus exposed to change, but also its Berber character. Elsewhere in the Ibadi world, the one depended on the other: conversion to Sunni Islam was followed by Arabisation (Brett and Fentress 1996), and it is unlikely that the Fazzan was an exception. The process, however, is lost to view. The vacuum left by the demise of the Banu al-Khattab was not filled until the middle of the thirteenth century, when the Fazzan was annexed by the rulers of Kanim, and the place of Zawila as the capital was taken by Traghan further to the west (Thiry 1995, 281, 378-9). The incorporation of the Fazzan into the Sudanic empire reveals the extent to which the balance in the Sahara

had shifted from north to south with the establishment of Islam in the Bilad al-Sudan, and a concomitant growth of its society and economy. The rise in Sudanese demand for imports from the Mediterranean and the Near East, greatly stimulated by the rise of the city-states of Hausaland, was coupled with the rise in the pilgrimage from the Bilad al-Sudan via Egypt to the Holy Places. The expansion of Kanim so far to the north was symptomatic of the achievement of Islam in thus drawing sub-Saharan Africa into its own wider, intercontinental world, in which the great desert had become, as it were, a second *mare nostrum*, 'our sea'.

Fazzan as part of Kanim

The nature and effect of Kanimi rule in the Fazzan, however, are obscure, as is its duration. It should have brought about a return to the happier days of the Banu al-Khattab. However, while trade, still probably through Zawila, may be expected to have revived and flourished after the years of disorder, the shrinkage of the cultivated area apparent in the archaeological record is likely to have been well advanced. Literary evidence confirms the disuse of the foggaras some hundreds of years earlier. Idrisi in the twelfth century states that at Jarma water was raised for irrigation by *khattara*, a device on the principle of the shaduf; previously we are told by al-Bakri that at Zawila, where foggaras would have been out of the question, it was raised by camel, presumably by the *saqiya* or horizontal wheel. The abandonment of the foggaras in the Wadi al-Ajal may have been simply because of a fall in the water table; but long periods of conflict in which control of the oases had moved away from the central agricultural area had surely undermined the previous ability of the population to undertake such collective works. While Idrisi's reference to Jarma and Tasawa, 'little Jarma', would suggest a measure of agricultural prosperity in the time of the Banu al-Khattab, today the ruins of Tasawa are buried in sand, the site abandoned for the modern village of the same name at some time before the sixteenth century. A critical event for the economy as a whole may have been the Black Death and its drastic effects around the Mediterranean from the middle of the fourteenth century onwards. Kanim itself was plunged into crisis in the second half of the century, and the continuation of its presence in the Fazzan is conjectural. Not until the sixteenth century does the outcome of the previous four hundred years become clear.

The Dynasty of Awlad Muhammad and the Shift from Zawila to Murzuq

The outcome, in the depths of the Sahara, was a dynastic state along Sudanese as well as North African lines. The dynasty was that of the Awlad Muhammad, which came to power perhaps as early as the end of the fifteenth century, and for whose history we at last have documentary evidence, thanks to the research of Habib El-Hesnawi (El-Hesnawi 1990). From this we can see for the first time the integration of the agricultural with the commercial and political economy of the region. The dynasty was probably of Moroccan origin, founded by a Sharif or descendant of the Prophet who was invited on the strength of his ancestry to put an end to the quarrels of the inhabitants – a good example of the role of the holy man in Saharan society. As monarchs, he and his successors built for themselves yet another capital at Murzuq still further west along the southern line of oases, the Wadi 'Utba, but at the same time took firm control of the Wadi

al-Ajal and the Wadi ash-Shati to the north. At Murzuq the Sultan ruled, with Sudanese titles and possibly in Sudanese fashion, through his relatives and slaves (El-Hesnawi 1990, 155-89). Below this level, however, government ran along lines familiar under the Hafsid dynasty at Tunis since the end of the thirteenth century. There, marabouts or holy men had taken peasant populations under their protection, and warrior Arab chiefs had been granted cultivated land together with lordship over its peasant occupants (Brett 1999d/e/f). The practice was continued by the Awlad Muhammad in the Fazzan, where the marabouts in particular formed a wealthy and literate class that became an indispensable arm of government. Integration was effected through taxation, which graded the population into taxpayers and tax receivers in the regime of a *makhzan*, 'a treasury state' that in accordance with North African practice, lived to tax and taxed to live in the name of justice: 'no justice without the army; no army without taxes; no taxes without wealth; no wealth without justice' (Brett and Fentress 1996, 154ff.; El-Hesnawi 1990, 174-89). Recipients of land grants and other benefits lived off the income from cultivators and herdsmen in a society of landlords and tenants, patrons and clients, villagers and headmen. It was an arrangement which encouraged the landholder to extend the area under cultivation, so that the Fazzan apparently enjoyed an agricultural revival (El-Hesnawi 1990, 175). But on the archaeological evidence, this was modest at best, and may have been illusory as the dynasty sought to stem the decline by fiscal inducements to cultivate.

Murzuq in the nineteenth century

The system was certainly durable: the Awlad Muhammad ruled the Fazzan down to the beginning of the nineteenth century, despite the determination of the Ottomans in Tripoli either to conquer the country or to assert their overlordship. With the incorporation of Egypt and most of North Africa into the Ottoman empire in the sixteenth century, the weight of political influence in the Libyan Sahara had returned to the north, where it remained throughout the eighteenth century with the establishment of the Qaramanli dynasty at Tripoli. Turkish imperialism, however, was accompanied by the heightened prosperity of the Ottoman world in a second, more modest, 'golden age' of Islam in the Mediterranean and Middle East. With the old empire of Kanim now resurrected as the empire of Borno, Murzuq profited from a steady demand for slaves in the Ottoman dominions, and a strong demand for Ottoman exports, including horses and firearms, in the Central Sudan. It was this commerce that sustained the economy of the Fazzan and the state of the Awlad Muhammad down to the crisis of the nineteenth century.

The crisis began the overthrow of the Awlad Muhammad by Yusuf Pasha Qaramanli, and the final annexation of the Fazzan to his Libyan empire. It was the start of a new era. The annexation of the Fazzan by Yusuf in 1813 was doubly significant, in that it was a step towards his greater ambition to create a Sudanese empire in the manner of Muhammad Ali in Egypt (Folayan 1979, 78-100): a sign of the way in which the political and military power and prestige of Europe was beginning to weigh upon Africa. At the same time his annexation coincided with the British attempt to cross the Sahara, and take control of the trans-Saharan trade through the Fazzan as the means to a great new commercial empire in Tropical Africa. It was also doubly ironic, since Yusuf's plans came to nothing, and in 1835 his dominions were reabsorbed into the Ottoman

empire as a mere province of Istanbul. Meanwhile British ambitions for the Fazzan centred on the abolition of the slave trade, the only worthwhile component of its traffic (Wright 1999). This was achieved in the middle of the century, at about the time the British discovered a far more economical way into the interior of West Africa from the mouths of the Niger, and hopes for the trans-Saharan route were abandoned. At that point 'the golden age of Islam' which had brought the Sahara into the world economy came finally to an end, and the Fazzan, which had played such a central role in its history, was left firmly in its place in Iliffe's Africa, that 'especially hostile region of the world'. At the end of a long history of indigenous colonisation, which had depleted its natural resources, it was reduced to poverty. European occupation in the twentieth century made little difference; but it is to be hoped that the region may now look forward to a brighter future with the development of the country as a whole in the new world economy of the twenty-first century.

References

Beckingham, C.F. 1971. Habash, Habasha in *The Encyclopaedia of Islam*, III.
Behnke, R.H. 1980. *The Herders of Cyrenaica*, Urbana, Chicago and London.
Brett, M. 1978. The Arab conquests and the rise of Islam in North Africa, in J.D. Fage and R. Oliver (eds), *The Cambridge History of Africa*, II, Cambridge: 490-544.
Brett, M. 1999a. The Islamisation of Morocco from the Arabs to the Almoravids, in Brett 1999g: I.
Brett, M. 1999b. Ifriqiya as a market for Saharan trade from the tenth to the twelfth century AD, in Brett 1999g: II.
Brett, M. 1999c. Islam and trade in the *Bilad al-Sudan*, tenth-eleventh century AD, in Brett 1999g: V.
Brett, M. 1999d. The way of the nomad, in Brett 1999g: X.
Brett, M. 1999e. Arabs, Berbers and Holy Men in Southern Ifriqiya, 650-750AH/1250-1350 AD, in Brett 1999g: XI.
Brett, M. 1999f. Ibn Khaldun and the dynastic approach to local history: the case of Biskra, in Brett 1999g: XV
Brett, M. 1999g. *Ibn Khaldun and the Medieval Maghrib*, Variorum Series, Aldershot.
Brett, M. 2001. *The Rise of the Fatimids. The World of the Mediterranean and the Middle East in the Fourth century of the Hijra, Tenth Century CE*, Leiden.
Brett, M., and Fentress, E. 1996. *The Berbers*, Oxford.
Briggs, L.C. 1960. *Tribes of the Sahara*, Cambridge, Mass., and London.
Brunschvig, R. 1986a. Ibn Abdalh'akam et la conquête de l'Afrique du Nord, in Brunschvig 1986c: XI.
Brunschvig, R. 1986b. Un texte arabe du IXᵉ siècle intéressant le Fezzan, in Brunschvig 1986c: XII.
Brunschvig, R. 1986c. *Études sur l'Islam classique et l'Afrique du Nord*, Variorum Series, Aldershot.
Bulliet, R. 1975. *The Camel and the Wheel*, Cambridge, Mass.
Chaudhuri, K.N. 1985, *Trade and Civilization in the Indian Ocean*, Cambridge.
Connah, G. 1981. *Three Thousand Years in Africa. Man and his environment in the Lake Chad region of Nigeria*, Cambridge.
Daniels, C.M. 1970. *The Garamantes of Southern Libya*, Cambridge.
Daniels, C.M, 1989. Excavation and fieldwork amongst the Garamantes. *Libyan Studies* 20: 45-61.
di Lernia, S., *et al.* 2001. Megalithic architecture and funerary practices in the late Prehistory of Wadi Tanezzuft (Libyan Sahara). *Libyan Studies* 32: 29-48.
Edwards, D.N. 1999. The archaeology of the southern Fezzan and prospects for future research. *Libyan Studies* 32:49-66.
El-Hesnawi, H.W. 1990. *Fazzan under the Rule of the Awlad Muhammad*, Sabha.
Fleure, H.J. 1951. *A Natural History of Man in Britain*, London.

Folayan, K. 1979, *Tripoli during the Reign of Yusuf Pasha Qaramanli*, Ile-Ife.

Iliffe, J. 1995. *Africans. The Story of a Continent*, Cambridge.

Johnson, D. 1973. *Jabal al-Akhdar Cyrenaica*, Chicago.

Law, R.C.C. 1967. The Garamantes and trans-Saharan enterprise in Classical times. *Journal of African History* 8: 181-200.

Levtzion, N., and Hopkins, J.D.F. (eds) 1981, *Corpus of early Arabic Sources for West African History*, Cambridge.

Lhote, H. 1973. *The Search for the Tassili Frescoes*, 2nd ed., London.

Liverani, M. 2000a. The Libyan caravan road in Herodotus IV.181-185. *Journal of The Economic and Social History of the Orient* 43: 496-520.

Liverani, M. 2000b. The Garamantes: a fresh approach. *Libyan Studies* 31: 17-28.

Lombard, M. 1975. *The Golden Age of Islam*, Amsterdam, Oxford and New York.

McDougall, E.A. 1985. The View from Awdagust: war, trade and social change in the southwestern Sahara from the eighth to the fifteenth century. *Journal of African History* 26: 1-30.

McDougall, E.A. 1992. Salt, Saharans and the trans-Saharan slave trade: nineteenth-century developments, in E. Savage (ed.), *The Human Commodity*, London: 61-88.

McIntosh, R.J. 1998. *The Peoples of the Middle Niger: the Island of Gold*, Oxford.

Mattingly, D.J., al-Mashai, M., Balcombe, P., Chapman, S., Coddington, H., Davison, J., Kenyon, D., Wilson, A.I. and Witcher, R. 1997. The Fezzan Project 1997: methodologies and results of the first season. *Libyan Studies* 28: 11-25.

Mattingly, D.J., al-Mashai, M., Aburgheba, H., Balcombe, P., Eastaugh, E., Gillings, M., Leone, A., McLaren, S., Owen, P., Pelling, R., Reynolds, T., Stirling, L., Thomas, D., Watson, D., Wilson, A.I. and White, K. 1998. The Fezzan Project 1998: preliminary report on the second season of work. *Libyan Studies* 29: 115-44.

Mattingly, D.J., al-Mashai, M., Balcombe, P., Drake, N., Knight, S., McLaren, S., Pelling, R., Reynolds, T., Thomas, D., Wilson, A.I. and White, K. 1999. The Fezzan Project 1999: preliminary report on the third season of work. *Libyan Studies* 30: 129-45.

Mattingly, D.J., al-Mashai, M., Balcombe, P., Barnett, T., Brooks, N., Cole, F., Dore, J., Drake, N., Edwards, D., Hawthorne, J., Helm, R., Leone, A., McLaren, S., Pelling, R., Preston, J., Reynolds, T., Townsend, A., Wilson, A.I. and White, K. 2000. The Fezzan Project 2000: preliminary report on the fourth season of work. *Libyan Studies* 31: 103-20.

Mattingly, D.J., Brooks, N., Cole, F., Dore, J., Drake, N., Leone, A., Hay, S., McLaren, S., Newson, P., Parton, H., Pelling, R., Preston, J., Reynolds, T., Schrüfer-Kolb, I., Thomas, D., Tindall, A., Townsend, A. and White, K. 2001. The Fezzan Project 2001: Preliminary report on the fifth season of work. *Libyan Studies* 32: 133-53.

Mattingly, D.J., Daniels, C.M., Dore, J.N., Edwards, D.N., Hawthorne, J.W.J. (with contributions by others). 2003. *The Archaeology of Fazzan*, vol. 1, *Synthesis*, London.

Norris, H.T. 1972. *Saharan Myth and Saga*, Oxford.

Savage, E. 1997. *A Gateway to Hell, a Gateway to Paradise. The North African Response to the Arab Conquest*, Princeton, NJ.

Savage, E. (ed.) 1992. *The Human Commodity. Perspectives on the Trans-Saharan Slave Trade*, London.

Shaw, B.D. 1979. The camel in Roman North Africa and the Sahara: history, biology, and human economy. *Bulletin de l'Institut Fondamental d'Afrique Noire*, 41, Series B: 663-721.

Thiry, J. 1995. *Le Sahara Libyen dans l'Afrique du Nord Médiévale*, Leuven.

Wheeler, M. 1955. *Rome Beyond the Imperial Frontiers*, London.

Wright, J.L. 1999. 'Nothing else but slaves': Britain and the Central Saharan slave trade in the nineteenth century, Unpublished PhD Thesis, University of London (SOAS).

25. Was the Libyan Sahara the Point of Origin for Ancient Egyptian Art and Scripts?

By Muhammad Ali Aissa[1]

Abstract

This paper reviews the interpretation of some Saharan rock art and assesses the linkage between the development of complex imagery and systems of writing. Contrary to the views expressed by early scholars (such as Henri Lhote) that some Saharan scenes reveal the artistic and religious influence of ancient Egypt, it is argued that the influence was in the other direction. Much of ancient Egypt's culture was built on Saharan/Libyan traditions, exemplified by rock art that antedates the pre-Dynastic and Dynastic periods of Nilotic civilization.

Introduction

In the Great Sahara where drought is now the common denominator, it is undoubtedly the case that during parts of the early Holocene era it rained torrentially. The landscape was covered by bushes and many rivers ran through it (Hugot 1980, 591-92). In appearance, the landscape was probably not dissimilar to savannah areas nowadays (Mori 1988, 33). Some modern sciences, such as geology, archaeology and the science of animals, concur with this picture, based on the evidence presented by geological, archaeological and faunal remains.

Around the start of the fourth millennium BC, the area headed for gradual desertification, with some inhabitants compelled to leave the area towards valleys and areas of greater water availability for the their lives and their animals. Some groups of them went northward in the direction of the Maghrib, starting from the Green Mountain all the way to the Atlantic occasion. Others went to the east towards the oases of Siwa, Dakhla, Kharja, Qaroun lake and Nile river (al-Nathuri 1981, 127). This paper explores the possibility that Saharan people were important contributors to the rich iconographic and written culture of ancient Egypt.

Saharan Iconography

The Great Desert of Sahara is viewed as one of the richest areas for rock art in the world, and its history at least goes back nine thousand years and continued until the first century AD. Scholars have categorised this art into five periods: equatorial animals, round heads, cattle herdsmen, horse, camel. Note that the classification was determined primarily on the basis of different kind of animals that have respectively lived in the area. Specialists have concluded that art of the first three periods preceded the arts of Dynastic Egypt by a number of centuries. It all represented and dealt with human and animals subjects.

Drawings of cows bearing discs between their horns are widespread in the Great Sahara and are regarded as earlier in history than the depictions of Egyptian deities, such as Hathor, that appeared in the culture of the Nile area. Also, the drawings of boats that were found in Wan

[1]Department of History, University of al-Fateh, Tripoli

Muhujjiaj in Acacus and in Aouenghet in Tassili are indistinguishable from those boats found engraved on the tombs of the Nile valley inhabitants during the early Dynastic period. The boats of the Great Sahara refer to the Cattle period, in other words before the appearance of funerary arts in the Nile valley (Ki-Zerbo 1980, 690; Mori 1988, 54).

This also applies to depictions of anthropomorphic figures with heads of animals and birds, which appeared in the Sahara at an early date well in advance of similar tendencies manifesting themselves in Nilotic art. It represents the worship of some animals, and this goes for the drawings that embodied hawks that were found in many places in the Great Sahara. Those images are much older than Egyptian hawks that became known in the pre-Dynastic period. Despite the smaller size of the Libyan hawk compared to the Egyptian ones, the desert hawk in Libya was the source for the symbolic appearance for the worship of the God Horus in the form of human body with a hawk's head in the area of Nile valley.

The Emergence of Writing

As for the first emergence of written script, it started, according to some researchers, by symbols imprinted by sharp instruments that humans used to decorate clay vessels, or to distinguish clay-made products from each other. Therefore, 'writing' can be traced to the Neolithic in terms of ideograms, patterns of drawings and engravings (Durant 1965, 131-32, 181-82).

Writing is the greatest human achievement that helped people to communicate with each other across time and space. Scholars in modern times have made classification for the different stages that writing has gone through, and image writing was the first of those stages, represented by simple pictures that expressed particular objects or concepts, such as hunting stories, some important events in their tribal and religious calendar that happened of great significance, and this type of inscription can be linked with the rise of prehistoric rock art (Jelinek 1982, 294-306).

A good example of an idiomatic depiction, dating to more than 12,000 years ago, was drawn on the walls of Lascaux cave in France (de Lumley 1984, 6, 7, 12). On it was depicted a wild bull and a man armed with a short spear. In the drawing we could clearly see that the hunter attacked the huge wild bull and stabbed it in its side with the short spear and the bull's intestines fell out and blood ran. Despite its deadly wound, the bull managed to hit back at the hunter and struck him down the ground (Vialou 1995, 4). This type of symbolism undoubtedly represents a form of a very early inscription, and though people in that period did not precisely use writing as it is now known. Because these images drawn by early man lacked consistency and coherency with each (Durant 1965, 157-70), they were limited to the extent they could communicate in a precise manner the needs, orders and nature of the daily lives and beliefs of people.

The Paintings from Jabbaren, Tassili

I believe early Libyans in the Sahara had the same intention behind some of their most repeated images. A good example concerns two paintings found in the area of Jabbaren in the Tassili mountains. Henri Lhote (1988, 67-74) named the first panel the "small gods with birds' heads",

and the second "sacrificial offering". Lhote argued that the two panels were drawn under the artistic influence of Nilotic civilisation, suggesting that those who made the paitings were either war captives or Egyptian traders who had reached the Tassili mountains, or perhaps Libyans who had lived for a period of time in ancient Egypt and when they returned to their homes in Tassili mountains brought with them the ancient Egyptians' art techniques (Lhote 1988, 72).

Lhote backed up his opinion by reference to the long history of recurrent wars between Libyans and Egyptians. It is clear from his statement that Lhote considered these paintings to have been identical to those in ancient Egypt, to the extent that he expected that the panels would have been accompanied with some Egyptian texts explaining the contents, as was the custom with early Egyptians when they decorated their tomb walls (Lhote 1988, 71).

I do not agree with Lhote's opinion and support the view of Bazama who rejected Lhote's names and explanations of these two particular panels (Bazama 1973, 214). Bazama argued instead that the persons drawn on the two panels are in fact all gods and not humans. There are clear similarities with the emergence of religion in pre-Dynastic Egypt and early Dynastic Egypt, when gods were associated with some of the animals and birds that were worshiped like the stork, frog, snake, fox, rabbit, cat, cattle and monkey.

I think that the Egyptian god Thoth evolved from a desert cult of the Great Sahara and the proof of that is found in the two images at Jabbaren. It is also worth mentioning that Thoth was the god of wisdom, knowledge and writing, he was also the god of moon in the form of the Ibis. This god was influential on a series of developments intimately connected with the rise of a golden civilization, such as the invention of writing, the recording of legal and historic events, and the delineation of calendrical time (Buzner 1992, 65-66), and to him accredited the division of the year in ancient Egypt to three seasons, and also dividing every season to four months, and every month is made up of thirty days, and to him attributed the addition of five days to every year which were dubbed the days of forgetfulness, and with that the year became 365 days (Bazama 1973, 196).

One of the most significant roles of the god Thoth was to weigh the hearts of the dead once they had been tried by the God Osiris. Returning to the two panels, we notice the presence of both male and female bird-headed figures, wearing what look like ancient Libyan and Egyptian clothes. Female garb consisted of long skirts and males wore loincloths to cover their private parts. There are also depictions of conical-shaped cups similar to those in pre-Dynastic Egypt. In addition, there is a boat similar to those depicted in ancient Egyptian tombs, and apparently used in transporting the dead to the afterworld. Lhote concluded that both scenes showed the influence of the ancient Egyptian art on them, and dated them to *c.*1200 BC (Lhote 1988, 71), though there is a circularity in the argument for assigning so late a date.

However, I firmly believe that the opposite is correct. That is to say that ancient Egyptian art only came to full maturity with the start of the Dynastic period and reached its peak with the end of the New Kingdom (3200-950 BC). Much of the rock art is older than this, so it was Egyptian art that was influenced by the Saharan art, and not the opposite. Depictions on the walls of ancient Egyptian tombs showing anthropomorphic figures with birds' heads were

in fact an artistic extension of an artistic tradition that appeared first in the Great Sahara. This can be verified by the exact correspondence of the scenes in ancient Egypt with those from the area of Jabbaren in the Tassili mountains.

We can compare the two images that Lhote called the first "sacrificial offering" with one in Tutankhamun's tomb near Luxor that represented the transfer of a dead woman by a boat to the afterworld accompanied by many Egyptian deities. One of these was Thoth who carried the dead and presented them to the God Osiris for a trial. It is unmistakable through the comparison that the subject matter is repeated in the two scenes, and this was manifestly evident by the existence of common denominators in the two drawings such as the ship, the many gods and the dead. Overall, the subject was almost identical and remained unchanged in the two panels, with the presence of a few differences that do not affect the unity of the theme in the two. One of the very few differences observed in the two scenes is the simple artistic representation on the 'offering' panel at Jabbaren, and the exactness in detail and abundance of decoration in the Tutankhamun painting.

This is understandable since the painting at Jabbaren is older than the Tutankhamun scene, so the earlier representation was simpler, and with passage of time and the development of civilisation, paintings of this sort reached a climax of perfection and complexity. Another difference concerns the placement of the figures in the Jabbaren panel where they were dispersed both in front of and behind the boat. Therefore, some of the figures could have been readying themselves to go aboard the boat, or have just come off it, whereas in the Tutankhamun panel they were all on board the boat.

Therefore, I conclude that the images from the Nile valley were only an extension to the repertoire established earlier in the Great Sahara. It is clear that those who painted the panels at Jabbaren were related to the people who later repeated the scenes in ancient Egyptian tombs after they had moved to the Nile valley to escape desertification in the Great Sahara. In the light of such facts, I suggest that the two panels at Jabbaren and other similar examples in the Sahara were not just images of gods or offering sacrifices but scenes that embodied symbolic meaning, which was the precursor to the use of hieroglyphic inscription that appeared in the Nile river area with the start of the Dynastic era (Bazama 1973, 214-17).

It is worth mentioning that writing was originally a mere collection of drawings representing a host of objects – things such as men, women and what they did in their daily lives, in addition to plants, flowers, animals, birds, buildings and furnishings. Such images only got to the coordinated stage of writing after a passage of many centuries.

Conclusion

There is no doubt that some aspects of the Jabbaren images still await to be decoded and interpreted, so that specialists can read and make sense of them. There are parallels here with what happened with the early study of ancient Egypt's hieroglyphic inscriptions in the Nile area. Therefore, we find ourselves confronted by ancient Libyan 'writings', which were later to underlie ancient Egypt's hieroglyphic inscription. The opinions and theories of many scholars have corroborated the fact that the languages of both ancient Libya and Egypt were of a common

source and ultimately the same origin. Oric Bates highlighted this fact when he confirmed that ancient Egypt's language, even in its early days, contained primary elements of Libyan origin and of an old and deeply-rooted nature (Bates 1970, 80).

The influence on the language of ancient Egypt by its Libyan counterpart, especially in its early roots, contributed to the lower pitch of ancient Egypt's language (Khushaym 1990, 132). Thereby, I am on the side of those scholars who believe that Nilotic civilisation belongs to one root and a single cultural tradition that emanated originally from the area of Sahara before it was struck by aridity (Mori 1988, 154; cf. also Abd-Aleem 1966, 6; al-Nathuri 1981, 127; Ki-Zerbo 1980, 690-691). That shows that Egypt was not only the gift of the Nile, as Herodotus once wrote, but the gift of the Sahara too.

Editorial note

The discussion of the Jabbaren imagery recorded by Lhote is further complicated by the fact that there is some doubt now about the authenticity of these paintings.

This is a somewhat abbreviated version of the Arabic version of this paper. Thanks are due to Faraj Najem for the translation.

References

Abd-Aleem, Mustafa Kamal. 1966. *A Study of the Ancient History of Libya*, [In Arabic], Benghazi.

al-Nathuri, Rashid. 1981. *The Grand Maghrib in Ancient Times; Historic, Cultural and Political Basis*, [In Arabic], Dar al-Nahdha al-Arabiya, Beirut.

Bates, O. 1970. *The Eastern Libyans*, reprinted edition, London.

Bazama, Muhammad Mustafa, 1973. *The History of Prehistoric Libya, vol. 1*, [in Arabic] The University of Libya, Benghazi..

Buzner, G. *et al.*, 1992. *Dictionary of Ancient Egypt*, (Arabic trans. by Ameen Salama) The General Egyptian Institute for Books, Cairo.

de Lumley, H. 1984. Premiers artistes derniers chasseurs de l'Europe, *Les dossiers d'archéologies* 87.

Durant, A. 1965. *The Story of Civilisation, Vol. 1,* (Arabic trans. by Zaki Najib Mahmud), The Arab League's Centre for General Cultural Affairs.

Hugot, H.J. 1980. The prehistory of the Sahara. In J. Ki-Zerbo (ed.), *UNESCO General History of Africa, volume 1*, Paris: 585-610.

Jelinek, J. 1982. *Encyclopédie illustrée de l'homme préhistorique*, Grund.

Khushaym, Ali Fahmi. 1990. *The Gods of Arab Egypt*, 2 Vols, [in Arabic], al-Jamhariya Bookshop, Misrata.

Ki-Zerbo, J. 1980. African Prehistoric art. In J. Ki-Zerbo (ed.), *UNESCO General History of Africa, volume 1*, Paris: 656-86.

Lhote, H. 1988. *À la découverte des fresques du Tassili*, Paris.

Mori, F. 1988. *Tadrart Acacus and prehistoric cultures in the desert*, (Arabic trans. Omar al-Baruni and Fuad Kab'azi), The Centre for the Study of Libyan Jihad, Tripoli.

Vialou, D. 1995. Art parietal et sociétes paléolithiques. *Dossiers d'archéologies*, 209.

26. The Libyan Fazzan, a Crossroads of Routes and a Thoroughfare of Arab and Berber Tribes.

By Professor H.T. Norris[1]

Abstract

The purpose of this paper is to select specific evidence and facts relating to the above theme. These have been selected from early Arabic historical and geographical texts. They will be interpreted in the light of more recent Arabic documents, principally from selected manuscripts, which have been written by Tuareg litterateurs in both Mali and Niger.

Introduction

Early Arabic historical and geographical texts indicate that the Libyan Fazzan played a crucial part in establishing permanent routes for the early Arab conquests which were launched in the direction of north-west and western Africa. These routes have subsequently been essential arteries for the growth of trade and for use by pilgrims between Barqa, Tripoli, Ghadamis, Zawila, Sijilmasa, Agades and Timbuktu. They also facilitated the short-lived expansion eastwards of the Saharan branch of the Almoravid movement in the eleventh century. These routes facilitated alliances and stirred up rivalries between Arab and Tuareg tribes and confederations and, at other times, have brought about intermarriage, cooperation, and literary and scholarly dialogue between both peoples. They have left a long-term mark upon the manner of life of these Saharan groups which has lasted until the present day.

Early Sources

The Arab conquest

Early sources look at the earliest expeditions of the Arab armies into southern Libya, principally the expeditions of Ibn Hudayj and 'Uqba b. Nafi' (or of 'Uqba b. 'Amir, following the tradition reported by Yaqut b. 'Abdallah al-Hamawi al-Rumi (571/1179-626/1229), in his Mu'jam al-Buldan (citing Ibn Hawqal, al-Bakri and al-Muhallabi). The identity of 'Uqba al-Mustajab has been a subject of dispute amongst Saharan scholars throughout the centuries.

Settlement of the Fazzan

These early sources have much to say about Arab settlement in the Fazzan, the development of Awjila, Zawila, Waddan, and sundry oases towards the west in the direction of Kawar and Tadamakkat (Agram/Es-Suq) and also southwards towards Jabal Tantana (Tassili of the Azgar), Takedda (Agades) and the massif of Tibesti. The settlements of the Ibadiyya merchants along this route are important.

[1]School of Oriental and African Studies, University of London

Contribution of Abu Abdallah al-Idrisi

Abu Abdallah al-Idrisi (548/1154) contributed greatly to our knowledge of the twelfth-century Fazzan and in particular to the regions which were the domain of the Azgar Tuareg. Today, these people are to be found in the frontier area between Algeria and the Libyan Fazzan and are centered in the town of Ghat. A route in the Sahara, which is mentioned by al-Idrisi, and by no other Arab geographer, linked Sijilmasa, in Morocco, to al-Bahnasa, in Egypt. This is of great relevance to those with an interest in the history of the alleged arrival of murabitun and sharifs, in Libya, by tradition, from the Saqiya al-Hamra region.

Tuareg, Berbers, the Fazzan and Beyond

The Azgar

Sir Francis Rennell Rodd (1926), a leading authority on the Tuareg, drew attention to the unique historical importance of the Azgar who appear to be descendants of the Lamta; Berbers who played an important part in the history of Libya dating back into Classical times. The Azgar were of a special interest to the authors of the earliest anthropological and descriptive studies published about the Tuareg, in general. H. Duveyrier's book (1864) *Les Touareg du Nord* followed his sojourn with the Azgar and is a classic study. Even today, the Azgar have been the least studied branch of the Tuareg people, despite the fact that Oric Bates (1914, 115) in his *The Eastern Libyans* remarked, that "Certain features of ancient Libyan government are clearly discernable in the constitution of the Azgar confederacy".

Libyan links beyond the Fazzan

From the Fazzan, Tuareg and Arab made their way south into the Sahara. The medieval town of Tadamakkat in the Adrir-n-Ifoghas had Libyan links through its Arab and Tuareg founders. An eighteenth-century history of the Kel Intasar of Azawad alleges that their ancestors migrated from Medina and from Egypt to the region of Timbuktu, via the oases of Tazerbu, in the Libyan Fazzan. Finally, the Ifoghas were an important presence from the area of Ghadamis to the Mali Adrar which can be seen in the legends of the wanderings of their holy man and founder, al-Ghazzali, westwards from the Libyan Sahara.

Much valuable source material remains to be mined to better understand the role of the Fazzan as a crossroads for Arab and Berber tribes and their contact with the Central Sahara.

Note

Due to restrictions on length, the full text of this article was published in *Libyan Studies*, the journal of the Society for Libyan Studies, vol 34 (Norris 2003). The above note is a précis of that article.

References

Bates, O. 1914. *The Eastern Libyans*, London.

Duveyrier, H. 1864. *Les Touareg du Nord*, Paris.

Norris, H. 2003. The Libyan Fazzan: a crossroads of routes and a thoroughfare of Arab and Berber tribes historically connected with the Murabitun. *Libyan Studies* 34: 101-20.

Rodd, F.R. 1926. *The People of the Veil*, London.

27. Snapshots from the Sahara: 'Salt', the Essence of Being

By E. Ann McDougall[1]

Abstract

It may not be immediately apparent why we should be looking at snapshots of Morocco, Mauritania and Mali in a collection of works devoted to Libyan culture and history. Nor why we should be focusing our viewfinder primarily on a moment in time, between the late seventeenth and eighteenth centuries, that is scarcely treated elsewhere among these papers. It is my contention, however, that this particular set of text-images reflects something essential about what it meant to 'be Saharan' at this particular moment of transformation, and that this 'essence' has relevance in other times and spaces. In this case, there is a relevance attached both to the specifics of Saharan salts and their industries, and to the dynamics of Saharan politics and their power configurations.

Introduction

Among the other papers here, for example, are references to the Garamantes' salt works at Jarma – an extensive industry about which we know something in archeological terms (Ziegert 1974), but little else with respect to its historical economic or political role (see Mattingly and Wilson, this volume). Also mentioned are the extensive salt works of Kawar, production sites known to have played an important role in the extension of political power by the Fazzan, under the leadership of both Jarma and of Zawila (Insoll, this volume). Knut Vikor's work on Kawar confirms this lengthy and significant period straddling the Islamisation of the Fazzan in which the Libyan region attempted in various ways to establish influence (if not hegemony) over this source of trans-Saharan trade revenue. Vikor would argue that the Fazzan-Kawar relationship survived centuries of transformation and strain, finally pulling apart only when influences from the south, from the rising states of Kanem and Bornu in sub-Saharan Africa, became dominant from about the thirteenth century (Vikor 1999, 140-8; 161-4). In short, both in terms of the specific questions raised by looking at salt in its cultural and commercial contexts, and the general ones emerging from images of political economies seeking to incorporate control over salt as a basis of power, the following set of 'snapshots' do indeed reflect something of the dynamics, if not the specifics, of moments in the history of the Fazzan.

Snapshot 1: The Legends of Ijil (*c.* Eighteenth Century)

A shepherd of the 'saintly' Kunta Choumad family of Wadan is 'led' by a giant lizard (*dzabe*) to the Ijil saline; it then disappears into the middle of the *sebkha* and the salt is discovered (Brosset 1933, 259-60). Some versions of this oral tale continue by saying that the Kunta chief, a highly respected *wali* (saint or *marabout* in French terminology) kept this a secret for a long time because the mine lay close to wells dug by another tribe (originally of southern Morocco), the Ahel Barikallah, and therefore by Islamic law 'belonged' to them (Berges n.d.). The wells are

[1]Department of History and Classics, University of Alberta, Edmonton (Canada)

indeed 10 km from the *sebkha*, although a 1949 report indicated that at that time, the part of the *sebkha* being exploited was only 4 km from the wells (D'Arbraumont 1949). Eventually, when his son became chief, he bought the wells, thereby gaining the right to exploit the surrounding lands and the resources lying beneath them. When the Ahel Barakallah discovered this deceit, they appealed to the local Emir to annul the purchase. The Kunta took the case to the Sultan of Morocco who in turn issued a certificate affirming that the deal had been made in good faith, and that the Kunta were indeed the new proprietors (Berges n.d.). A variation on this rendition has the Kunta immediately 'offering' the mine to the Sultan of Morocco and in turn receiving 'first rights' to exploit it – a document said to have been notable because it was written in red ink. Then the Kunta purchased the nearby al-Aiouj wells from the Ahel Barikallah, and dug additional ones at F'derick (d'Arbraumont 1949).

Berges draws liberally on Brosset. This account raises a complication, however: according to Brosset and d'Arbraumont it was the father of the current Kunta Choumad chief, Dah ould Choumad, who made the trip to Morocco, which would place the event in the late nineteenth century, at best. The document was said to have been lost in a great war (in which the Kunta were defeated) in 1900. There are a number of possibilities here with regard to interpretation: complete legend, a telescoping of events between the eighteenth and nineteenth centuries, a misunderstanding on Brosset's part of what was meant by '*père*' (it often refers to a relative of some unspecified generation in the past, not necessarily 'father' in the immediate sense) or a confusion between the moment of beginning exploitation (which may well have been in the eighteenth century) and that of dealing with the Moroccan Sultan and the Ahel Barikallah (which might well have corresponded to a time when the Ahel Barikallah were actually becoming quite wealthy and had dug numerous wells in the region and the Kunta were feeling their power being challenged) – namely, the nineteenth century. Their defeat at the hands of the Awlad Bou Sba (another tribe of southern Moroccan origin) at the end of the century and its association with the loss of the 'red inked paper' might indicate a moment of challenge to their claims to proprietorship over Ijil.

In both versions, the work of extracting the salt was delegated to the Agzazir, who some say were 'slaves' of the Kunta, others '*haratine*' or freed slaves, others merely 'clients' who had sought Kunta protection before the mine came under their proprietorship (d'Abraumont 1949; Bonte 1998, 41-7; Brosset 1933, 259; Leriche 1950, 144; Mahomoud Salem ould Bailla 1978). For d'Arbraumont and Brosset, the Agzazir were clients. Noted French ethnologist Albert Leriche called them *haratine* (freed slaves); Mahomoud Salem ould Bailla referred to his clan as 'slaves' of the Kunta – a term often used in Mauritania to actually mean *haratine*. Pierre Bonte has recently analysed a wide range of sources (oral and written) concerning the Agzazir and argues ultimately for either a *haratine* or at least 'lowly' social status, that gradually evolved as they moved from being dependent upon the Ida Ali clan of Shinqit to becoming dependents ('clients') of the Kunta. Bonte argues that the Agzazir were already salt workers *before* they came to live with the Kunta in Wadan (suggesting an Ida Ali involvement with, if not control over, exploitation prior to the Kunta 'takeover') and that it was their skills that helped them climb the social ladder and negotiate a more 'elevated' social relation with the Kunta – hence the

ambiguity and convenient lack of memory on the part of the Agzazirs regarding the origins of their involvement with Ijil and the Kunta (below).

Agzazir oral traditions retain almost no memory of this moment, although one I collected would locate it as early the beginning of the seventeenth century (Mahomoud Salem ould Bailla). He suggested that exploitation probably began some 350 to 450 years ago – but also claimed to know nothing of history. Kunta written traditions say only that the Kunta became the 'owner' of Ijil in 1766/67 (McDougall 1980, 98). An eighteenth-century dating is the most common across all the accounts, although some Kunta claim a fifteenth-century exploitation. And most confirm that possession remained with the same Kunta family, the Ahel Choumad, into the twentieth century (de Lartigue, 66). I discuss this in more detail elsewhere (McDougall 1980: 82-98; 1990, 249). The key issue is that the mine was clearly being exploited by the fifteenth century and is reported in Portuguese accounts but the Kunta is not likely to have been a fully autonomous tribe at that time; if it is true that the Kunta acquired rights to exploit Ijil in the eighteenth century, then they clearly did not 'discover' it.

That said, one French colonial account (itself based on oral information) argues that in fact the Kunta of Wadan possessed neither property nor use rights over the saline. This rendition maintains that Kunta claims to possession (and consequently, to taxation rights) derive from their close relations with the *jnun* or demons (s. *jinn*) who frequent the nearby Kedja (mountain) of Ijil. One Captain Laforgue was told in the early 1930s that the Kunta were "absolutely indispensable" intermediaries in obtaining permission to extract salt from the salines of the Kedia of Ijil – and the *jnun* were "the true masters of the *sebkha*" (Laforgue 1933, 410; quotation 423).

Snapshot 2: The Saharan Letters (I) (Late Seventeenth Century)

Letters from Mulay Ismail (Sultan of Morocco) to his son, al-Mamun Governor of Tafilelt and Dra'a, 1692, 1699 and n.d. (Mohamed al-Gharbi, 217-26; 227-36; 237-43).

In these three letters, al-Mamun is severely chastised by his father for mismanaging Saharan affairs. His incompetence is said to extend to all his duties; basically, he never follows his father's advice. His father's invocation of the proverb: "even a donkey learns from repetition" underscores Mulay Ismail's disappointment in his son (Mohamed al-Gharbi 323). He refers to the lands now governed by his son as the traditional 'heartland' of the empire, one whose resources, especially the caravans arriving regularly from the Sudan, should allow him to build up a significant power base. The letter continues:

> *"An effective governor would have written to the Arabs of al-Gebla [southern Mauritania] and of Teghaza [salt mine north of Timbuktu] and the Kings of Sudan and would have addressed all of these countries and planted spies in all of these directions such that you know every tribe and its intentions and every leader and his situation. And if you saw anyone of the Arabs of these areas go astray, you would bide your time, and then you would chose the right opportunity and take him to task wherever he might be. Had you done this all the Arabs would have come to respect and fear you and had you established yourself in that manner they would have sent presents to you and they would have come to visit you and you would have had the right or the ability to do to any of them near or far, what you wanted. And as a result everyone would know your name, and they would send delegations to wherever you are and your country would become prosperous, you would be able to make the caravan routes safe and [collect appropriate taxes]."*
> (Mohamed al-Gharbi 228, 9)

At this moment Mulay Ismail's concern was Teghaza, and the failure of his representative there to collect the required salt taxes. He gave explicit instructions as to what his son, al-Mamun, should say in the letter he was being ordered to send with the Sultan's emissary to the mine. He was to threaten the Tegaza agent with replacement unless the overdue taxes were delivered immediately, and he was to outfit Mulay Ismail's emissary with 20 of his own best camels… "[D]o not question why or to refuse this man anything", his father concluded (Mohamed al-Gharbi 241-3).

Snapshot 3: The *Nawazil* of Shinqit (Late Seventeenth Century)

Although compiled and recorded later by the *qadi* of Walata, this document consists of about 240 questions (and lengthy sub-questions) put to the learned Shinquit scholar Mohammed b. al-Mukhtar b. La'amech (d. 1696). The questions are posed by 'Saharans' positioned both near (the Adrar), and far (the Tagant, Timbuctu, Southern Morocco – the Wadi Nun) and the Sudan in general. One of the two largest groupings of questions, some 35, concerns commerce; half again of these are either directly related to salt transactions or use salt to illustrate the issue at hand. The Adrar and Hodh are the regional bases for several queries involving credit and transport costs. For example, if a man owning salt and a transporter owning camels fall out in the course of a journey to Zara (in this case over whether the route was too unsafe to continue), and the transporter continues, sells the salt as agreed upon, but is then robbed on his return voyage, how much does the merchant owe the transporter? Or … credit is extended in Shinqit to a merchant traveling to Zara (a southern salt market). The contract stipulates that payment is to be made in Shinqit on such-and-such a date. The date passes without payment. The salt owner encounters the merchant in Zara. Should the debt be paid in Zara, because the *time* is overdue, or should the owner wait until the merchant delivers the payment in Shinqit, because that is *where* payment was to be made? Other questions revolve around how to exchange different qualities of salt: what if you know the dimensions of salt bars but not the mine of origin; what if you know the mine but not the dimensions; what if one is bar salt and the other salt *en vrac* (loose or earth salt, like that of Tishit)? "What if the price of an *adila* (bar) of salt from Ijil and an *adila* from Aglil (Awlil) are equal, and if the people of the country (in which the salt is being sold) do not prefer one over the other? What if this situation pertains and the people do prefer one to the other but are not willing to pay more to have that which they prefer? What if the two salts are equal in quality but the people have a preference anyway?" And on it goes.

Another lengthy inquiry focuses on exchanging one *adila* for another, whether equality between them is to be judged purely by number or whether quality is to be taken into account, and whether one can give a bar of better quality for one of lesser? And yet another group of questions relates to the payment of *zakat*. The people of a country undertake commerce in *uroud* (moveable merchandise) and with the proceeds buy camels. Then they load the camels with salt and travel to the countries of the Sudan. Here, they sell the salt for grain and cloth and then return to their own people. They consume the grain, use the cloth, give presents and with what remains, they buy camels and salt or maybe just salt, and then they exchange the salt for cloth and on the cycle continues. "This is their habit and custom." There are some among

them who sell the salt for horses and slaves and they 'commercialise' these also. There are also among them those who sell the salt against gold and then they spend it (that which they gain in the process) to buy salt that they sell for grain and cloth and so it continues. The question goes on to say that from these transactions, people live or sometimes they spend part of the profit for consumption and invest the rest. Sometimes they spend even some of their capital to live. In this case, they borrow from someone. In the end, the question is asked "on what does one have to pay *zakkat?*". The question seems endless, but does ultimately ask "what in this case belongs to 'living' and upon which one *does not* pay *zakat*, and what belongs to capital [and profit] and *is* therefore subject to *zakat?*" (see McDougall 2001).

Snapshot 4: The Saharan Letters (II) (Second Half of the Eighteenth Century)
Letter from Shaikh Sidi al-Mukhtar al-Kabir (Kunta) to the Moroccan Sultan Sidi Muhammad b. Abd Allah (1757-1790) concerning Teghaza salt. (n.d.)

After a lengthy introduction, Sidi al-Mukhtar arrives at the heart of the matter. He alludes to earlier letters sent by the Moroccan sultan to his representative *Qaid* Abd el-Malek al Hayyuni, at Teghaza, letters that instructed him to collect the taxes owed by everyone extracting Teghaza's salt. 'Everyone' included the Kunta (of the Azwad, related to but distinct from the part of the clan residing in the Adrar). Sidi al-Mukhtar objects to this order: first, because his – a respected family of venerated *walis* – should not be required to submit to the authority of a mere *qaid* – a 'lay' person, uneducated and 'without value'); and second, because the sultan had no right to charge fellow Muslims for accessing salt. According to 'ancient traditions' (possibly *hadith*), he claims, water, fire, pasture *and salt* should be free to all.

Interpreting the Photos
These snapshots place us in different spatial, conceptual and focal positions. Temporally speaking, they move us across a short period of time, yet it is not insignificant that they do so. The late seventeenth-century texts show us more or less contemporaneous views of the Sahara but views that nonetheless present very different perspectives. Morocco is an integral part of both – one looking towards Ijil and the Adrar (Shinquit, Wadan), the other towards Teghaza and the Azwad. But while the former incorporates Morocco as part of its commercial boundaries, Shinqit serving as the 'centre', the latter view situates the Sahara in general (and in this case Teghaza in particular) as a geographically distant but economically central part of the Moroccan empire. There is an implicit conceptual competition but in real terms, both 'Saharas' coexisted. Indeed, as we see from the two texts dating to less than a century later, both Saharas actually intersected and indeed, overlapped. Morocco's influence, we find, is equally present at Ijil and Teghaza and by extension in the surrounding regions whose economic importance derives from these salts. Between the earlier and the later texts, the Kunta emerge in both regions as personifications of magical, religious and (increasingly) economic power – again, all tied to their connections to the salt industries. What is also evident in the earlier text, and implicit in the latter ones, is the integral role played by commerce with the Sudan. This commerce, in turn, revolves around the interregional salt trade.

Emergence of 'Saharan Power'

So, taken together, what do the snapshots reveal? Leaving aside the details each individually contributes to our 'picture' of Saharan history, collectively they reveal a complex interrelationship between the local-level role of magic in defining 'power' and that of Islam, which in serving as an intermediary between *jnun* and *sufi* groups like the Kunta, supported the emergence of specifically 'Saharan power'. It should be remembered that *jnun* represented both evil and good spirits; another saintly clan, the Tadjakant (generally believed to have been the clan from which the Kunta derived their origins) was believed to have relations with 'good' *jnun* through one of its most famous clerics, Sheikh Mohameden Fall (Laforgue 1933, 404, McDougall 2001). The Kunta here operated on various levels – 'communing' with local *jnun*, 'negotiating' the right to exploit Ijil, for example. Elsewhere, in the Azwad, Kunta were known for 'commanding' such non-muslim demons through more sophisticated access to the occult, access tied directly to their scholarly or 'saintly' knowledge. This was the same 'saintly' identity Sidi al-Mukhtar al-Kunti drew upon in juxtaposition to that of the *qaid* – who 'merely' represented the political power of the Moroccan sultan – in his attempts to gain exemption from the Morocco's taxation.

They also expose the extensive relationship between the developing culture of Islam and the salt trades (based on many different salts – Awlil (McDougall 1999), Ijil, Teghaza and Tishit (McDougall 1990, 250,1; 1999) are mentioned here). One set of contours can be traced from the perspective of the Kunta, clerics seeking to build their religious reputation in the context of competing clerical clans, entrenched indigenous families (and powers) and the ongoing struggle with Morocco's claims to both material and moral capital in the desert (as exercised in both the Adrar with respect to Ijil, and in the Azwad with respect to Teghaza) (McDougall and Nouhi forthcoming). Here, one can almost see the emergence of *this* Saharan Islamic culture negotiating over space and influence with that defined by Morocco. Both laid claim to the Sahara's material wealth – especially its salt mines and commerce, and both fought to define its spiritual identity. That said, the Saharan reality during most of the seventeenth and eighteenth century was that of a society in constant flux, varying as much in its self-perceptions as in the observations of those external to it (Bonte 1998).

Salt as a Tradable Commodity

A second set of contours can be discerned through the lens of the *nawazil*. It addresses commerce or a network of commercial relations, in early development. The concerns with 'equivalencies' between different salts being traded mirrored concerns expressed in more general terms of what commodities could be appropriately exchanged and whether Sudan measures unknown to Saharan merchants were 'acceptable'. Bel La'amech drew repeatedly on writings from the eighth century, notably a time of explosive growth for Islam, emphasising the *aada* or *'urf* 'the custom of the country', urging merchants to accept the measures and practices recognised by the Sudanese. Merchants were not only trading in unfamiliar territory, they were also dealing in unfamiliar commodities – as Bel La'amech noted, "salt is not in the *sharia*". There was nothing automatic about using salt as currency, about extending salt on credit, about arranging for salt

to be transported and sold on your behalf, about paying *zakat* – or not, about dealing with a variety of salts both in desert and desert-side markets – all had to be negotiated within religious and social cultures that were themselves of uncertain definition (McDougall 1999).

The *nawazil* suggests a further, albeit more speculative, influence for us to consider. The questions posed to Bel La'amech were for the most part submitted in writing and came from a very large geographical area. Indeed, one question related to the ethics of debt collecting in Wadi Nun on the part of an agent sent from Timbuktu. The fact that advice was sought from so far a field from a Shinqit cleric, and that in the course of many of his answers it became clear that Ijil salt was widely used as *the* measure of value and *the* norm for comparison, attests to an important emerging commercial culture. This culture was based on a shared understanding of what being a good Muslim and a good merchant meant as articulated by Bel La'amech (and later through interpretations by his disciples). And the markets where commonly held sets of 'ethical Islamic practices' were recognised and respected delineated its contours.

So if we put these snapshots, these static moments in time, together, what emerges is a glimpse of something that was in fact extremely dynamic. And we have only touched the surface here of what can be drawn out of this sequence of moments. What appears to have been a key catalyst was salt itself. All the memorable aphorisms refer to salt as the 'gold' of the desert, or remind us that "man can live without gold but not without salt" (Bovill 1933, citing *Cassiodorus*, 57). In the case of the Sahara, however, man could and did live without it – without directly consuming it, that is. It was the one place where the value of salt was not as food for human consumption. It acquired its consumption value – other than earth salts that were used as 'cures' or 'purges' for camels – in the sahelian regions to the south where sea salts either could not travel or did not store well, and where the only indigenous salts were locally-manufactured vegetable varieties (McDougall 1990, 231-7; Vikor 1999, 64-81).

Salt, at least certain layers of Ijil salt, were believed to bring (simultaneously) bad luck to the workers who dig it and the camels who carried it, while assuring prosperity to any woman who received it. Another was carried as a 'token' in the leather sack used for personal effects; it was believed to bring good fortune to the tent or dwelling where its owner resided. More generally, when handled appropriately, salt was said to be capable of destroying the power of the 'evil eye'; *jnun* were believed to be afraid of salt (Berges; Leriche 145-7). Salt, associated as it was with *jnun* (both 'good' and 'evil'), with powerful *sufi* clerics (who in turn could 'commune' with these *jnun* and who were regarded as one of three 'catagories' of people most susceptible to establish relations with *jnun* (Laforgue 1932, 443), with its Islamic commercial culture, and with its importance to the ultimate power of the Sultan, became in many ways a symbol of what it meant to be Saharan.

Conclusion

I conclude with a fifth and final snapshot, again at Ijil, this time set in some unknown 'past' but recounted during the 1930s. The 'ultimate power' is no longer the Moroccan Sultan but rather, the French colonial government. It is still 'power' of a questionable and negotiable nature.

Snapshot 5: The *Jnun* and the *Jadawil* (Ijil, Date Unknown)

In the practice of *jadwal* (magical charts) 'power' is associated with the written text (often worn on the body as an amulet) as well as with the 'quality' of the person who writes it and who can activate the force hidden ('coded') within. At Ijil, a tribe of non-Muslim *jnun* from the nearby mountain is interfering with normal salt production. The Kunta Ahel Chommad (Wada) as acknowledged 'possessors' of the mine, compose three, very particular *jadawil* in order to "clear them out [the *jnun*]" of the *sebkha*. The first of these was to protect salt workers (the Agzazir) against mischief – it was to be buried along the shore of the *sebkha* itself. The second and third were to be hidden in the mountain, the *Kedja d'Ijil*, where they would literally chase the demons away (Laforgue 1935, 21, 2). As expected, the Kunta magic – powerful and immediate – works. A French colonial administrator, recounting this event in 1934 noted, that "It must be believed that these amulets are effective, for the exploitation of the salt is today [still] very advantageous for the Kunta and their workers, the Agzazir of Adrar" (Laforgue 1932, 410; 423). Two years later (1936), a local French officer who wrote a full report on the subject of sorcery in the Adrar left us with thought-provoking reflection: "We are in the domain of the supernatural and everyone knows that domain is closed to the Europeans" *(*ARIM, E2 (1936). For more on this subject (McDougall 2001).

Acknowledgements

My sincere appreciation to Mohamed Lahbib Nouhi for acquiring the microfilm, translating the relevant sections and working through an analysis of them with me.

References

Published Sources:

Batran, Abdal-'Aziz Abdulah. 1971. *Sidi al-Mukhtar al-Kunti and the Recrudescence of Islam in the Western Sahara and the Middle Niger c.1750-1811.* Ph.D. Thesis, University of Birmingham.

Bovill, E.W. 1933. *Caravans of the Old Sahara,* London.

Brosset, Capt. D. 1933. La saline d'Idjil. *Bulletin du Comité de l'Afrique Français, Reneseigements Coloniaux* 43: 259-65.

de Lartique, R. 1897. Notice sur les Maures du Senegal et du Soudan: Apppendice II – Notes sur les carriers de sel et l'extraction du sel. *Bulletin du Comité de l'Afrique Francaise, Renseignements Coloniaux* No. 3 (juillet):41-72.

Laforgue, P. 1933. Les Djennouns de la Mauritanie saharienne: magicians, croyances et legends. *Bulletin du Comité d'Études Historiques et Scientifiques de l'Afrique Occidentale Française* XV 2-3: 400-25.

Laforgue, P. 1932. Les Djenoun de la Mauritanie Saharienne. *Bulletin du Comité d'Études Historiques et Scientifiques de l'Afrique Occidentale Française* XIV, 3: 433-52.

Laforgue, P. 1935. Les Djenoun de la Mauritanie Saharienne: rites magiques et djedoual. *Bulletin du Comité d'Études Historiques et Scientifiques de l'Afrique Occidentale Française* XVIII, 1:2-35.

McDougall, E.A. 1990. Salts of the Western Sahara: myths, mysteries and historical significance. *International Journal of African Historical Studies* 23 (2):221-51.

McDougall, E.A. 2001. The politics of sorcery and slavery: colonial 'reality' in central Mauritania (1910-1960), in C. Youé and T. Stapleton (eds), *Agency in Action in Colonial Africa: Essays in Honour of John Flint.* Basingstoke, England and New York.

McDougall, E.A. and Mohamed L. Nouhi, forthcoming. 'You have known power.' Zwaya development and the evolution of Saharan politics, 17th and 18th centuries, in M. Naimi, C. Lefebure , P. Bonte (eds) *L'ordre politique tribal au Maroc saharien et en Mauritanie*, Actes du colloque (Goulimine, November 1996), CNRS, Paris, I.R.S., Rabat.

Mohamed al-Gharbi, Rio Oro [Notes from…] (*As-supiya al-hamra wa wadi dhahab dar al Kitab*, Casablanca, s.d): 217-26; 227-36; 237-43.

Vikor, K.S. 1999. *The Oasis of Salt. The History of Kawar, a Saharan Centre of Salt Production* (Centre for Middle Eastern and Islamic Studies, Bergen Studies on the Middle East and Africa, Bergen).

Whitcomb, T. 1975. New Evidence on the Origins of the Kunta: I and II. *Bulletin of the School of Oriental and African Studies* 38: 403-17.

Ziegert, H. 1974. Salzverhüttung in der Sahara. *Der Anschnitt* 26.2: 28-32.

Unpublished (Archives, Manuscripts, Internet, Interviews):

Archives Republique Islamique de la Mauritanie, Nouakchott. Series E2 103. 1918-21 *Rapports Politiques – production des salines d'Idjil* (ARIM).

Archives Republique Islamique de la Mauritanie. 1936. E2 Rapport Politique. Rapport annual, sub-division Atar, Lt. Busquet (juillet), *Note sur la sorcellerie.*

Bel-La'amash al-Shanqiti, Muhammed b. al-Muktar (d.1696) [*Nawazil*] Ms. # 5742, *al-Khizana al-Hassaniyya* (Bibliotheque Royale, Rabat, Morocco): 94 pages (microfilmed).

Berges, Lt. n.d. *Salines: etude sur la Sebkha d'Idjil*, Departement de Géologie et des Minières, Nouakchott R.I.M.

Bonte, P. 1998. *L'emirat de l'Adrar. Histoire et Anthropologie d'une société tribale du Sahara Occidentale.* These de Doctorat d'État, Université de Paris VII.

D'Arbraumont, Capt. 1949. *Le sel en Mauritanie et au Soudan.* Centre d'Haute Etudes d'Asie Moderne (C.H.E.A.M.) #1609, Paris

"Islamonline": http://www.islamonline.net/surah/english/quran.shtml

* "al-Baqara": http://www.islamonline.net/surah/english/viewSurah.asp

* "al-Ikhlas": http://www.islamonline.net/surah/english/viewSurah.asp?hSurahID=80

* "*ayha 2*": http://www.islamonline.net/surah/english/Ayah.asp

Leriche, A. 1950. *Petites Notes sur la Sebkha d'Idjil,* Separata das Actas da 2a Conferencia International dos Africanistas Ocidentais Reunida, EM Bissau en 1947, Lisboa.

Mahomoud Salem ould Bailla. 1978. (Agzazir, born Atar 1926), F'Derick [Interview].

McDougall, E.A. 1999. *A Qadi from Shinqit and the Question of Salt: the nawazil of Mohammed b. al-Mukhtar b. La'amech (late 17th C.)* paper presented at the African Studies Association meeting

McDougall, E.A. 1980. *The Ijil Salt Industry and its role in the Pre-colonial Economy of the Western Sudan*, Unpublished Ph.D. thesis, University of Birmingham.

28. "An Unworn Carpet of the Earth": European Travellers in the Central Sahara, Eighteenth to Twentieth Centuries

By John Wright[1]

Abstract

The 'discovery' of the central Sahara, in the sense of its exploration by those competent and able to reveal it to the outside world, started in the late eighteenth century. The formation of the African Association in London in 1788 prompted several attempts to penetrate unknown inner Africa across the Sahara. Simon Lucas in 1788-89 never actually saw the desert, but he learned much about it from merchants in Misurata. Ten years later, Friedrich Hornemann reached Murzuq from Cairo, the first known European to do so.

After the Napoleonic Wars, the remarkable Consul-General in Tripoli, Colonel Hanmer Warrington, worked with the ruling Pasha, Yusuf Karamanli, to promote that town and the Sahara as Britain's natural gateway to inner Africa. The Ritchie-Lyon Mission to Fazzan (1818-20); The Bornu Mission (Denham, Oudney and Clapperton, 1822-25); and Major Alexander Gordon Laing's fatal journey to Timbuktu (1824-26), were all due to Warrington's efforts. British desire to end the trans-Saharan slave trade inspired the central Saharan travels of James Richardson (1845-46). Richardson was also the first leader of the Central African Mission of 1850-55, another of whose members was the great German explorer, Heinrich Barth. Yet by about 1860 it was clear that the Niger River offered Britain a better approach to inner Africa than the Saharan roads, which were accordingly abandoned to any other powers that cared to make use of them. The Germans Gerhard Rohlfs, Gustav Nachtigal, Erwin Von Bary and Moritz Von Beurmann were notable travellers in the central Sahara in the later nineteenth century, as also were the French explorers Henri Duveyrier and P.-L. Monteil. Italians began to study the central Sahara when it became a colonial territory after 1911.

All these European travellers have left valuable written and graphic material which still provides the essential foundation for many fields of study into the central Sahara, including its history, economy and society.

The Earliest Travellers

The Sahara, one of the greater natural wildernesses, and the largest hot desert, is hardly remote. For it starts only a few hundred miles from southern Europe, marking one edge of the Mediterranean world. Yet it is still little known to outsiders. If this is true now, when the adventurous can be persuaded to drive races or run marathons across it, to cycle through it or to balloon over it, how much deeper was that ignorance of the Sahara and all it contained in the late eighteenth century when the fresh British spirit of inquiry was stimulating a new Age of Discovery (for an introduction to historical travel writings on Libya, see Wright 2005). The desire of "rescuing the age from a charge of ignorance" was, after all, one of the main motives behind the founding of the Association for the Discovery of the Interior Parts of Africa (commonly known as The African Association) in London in 1788 (Hallett 1964, 42-71).

Natives of any place are naturally aware of their local geography, to a greater or lesser extent. But unless they are able and willing to share such local knowledge with the wider world, any place is open to 'discovery' by visiting strangers moved by the necessary intellectual curiosity

[1]Society for Libyan Studies, London

and other motives to travel into unknown regions. Such explorers then need to reveal their findings, within the context of contemporary geographical knowledge, to a wider public on their return home. For exploration has little practical purpose, beyond self-satisfaction, unless and until the explorer tells his tale to the world. Thus medieval European knowledge of China and further Asia remained shadowy until an account of Marco Polo's travels was published at the very end of the thirteenth century. The original Description of the World (*Divisament du Monde*) soon appeared in many western European dialects and languages. Renaissance Europe would probably have waited in vain for a recent first-hand account of inner Africa had Leo Africanus, a widely-travelled and inquiring Spanish Muslim, not been captured at sea by Christian corsairs in 1518 and taken to Rome, where he was persuaded to write up his Arabic travel-notes in accessible Italian. Leo's *La descrizione dell'Africa* appeared as the opening section of the first of the seven volumes of *Navigazioni e viaggi* published by the celebrated Venetian bookman Giovanni Battista Ramusio in 1550. It was later translated into many European languages, the English version being published by John Pory in London in 1600.

Early Modern Travellers

An early nineteenth-century view of the necessity for such reliable eye-witnesses for African exploration was expressed by the geographer W.M. Leake: "in ... Africa, nothing short of the ocular inquiries of educated men is sufficient to procure the requisite facts" (Leake 1832). For, as a contemporary popular geography complained, over fifty years after the founding of the African Association, "Europe scarcely knows a fiftieth part of interior Africa; beyond that, all is confusion and doubt" (Bell 1844, 288).

None of the dozen or so explorers sponsored by the African Association up to its merger with the Royal Geographical Society in 1831 penetrated Africa easily. Their main task was to establish the source, course and outlet of West Africa's greatest river, the Niger. The most successful was Mungo Park who on his celebrated first journey (1795-97) reached the Niger at Segu and corrected the crucial error about its direction of flow made by Leo Africanus three centuries earlier (Milanesi 1978). Among those who started their Niger quest from the north was Simon Lucas. In 1788-89 he managed to go only from Tripoli to Misurata, and failed even to reach Fazzan because of tribal unrest on the road. But he put his fluent Arabic to good use, gaining at Misurata a mass of new and valuable information on the African interior (Lucas 1810, 47-205; Mori 1927). Ten years later a young German, Friedrich Hornemann, travelled down the great pilgrim road from Cairo through Awjila to Murzuq staying some months at that oasis-capital of Fazzan and hub of central Saharan trade and communications. In 1799 he went up to Tripoli, forwarded a valuable travel report to London, and in 1800 left for the interior, where he disappeared (Bruce-Lockhart and Wright 2000, 2, n.6). Hornemann's journal of travel in Egypt and Libya was subsequently published in London in 1802 and in the *Proceedings* of the African Association (1820, Vol. II, 39-151; Bovill 1964, Vol.1, 58-107).

The Napoleonic Wars, and perhaps also the disastrous outcome of Mungo Park's second Niger expedition (1805-06) delayed the British Niger quest for over a decade. The most celebrated European traveller across the Libyan Sahara in the early nineteenth century was the Genoese

Dr Paolo Della Cella, who in 1817 went as surgeon with the army of the Bey of Tripoli into Cyrenaica (Della Cella 1819). Della Cella gave the first European eye-witness account of the Sirtica, but the Victorian bibliographer of North Africa, Sir R. Lambert Playfair, judged that, despite its "animated description", Della Cella's writing was superficial (Playfair 1889, 575).

The 'Heroic' Age of Saharan Travel

For a few years after the Napoleonic Wars, an apparent coincidence of interests between Great Britain, the Regency of Tripoli, and the resurgent Sultanate of Bornu on the far side of the desert led to a notable, if brief, upsurge in central Saharan exploration. This was the opening of the 'Heroic Age' of Saharan travel by Europeans. The British agent of this tripartite cooperation was the Consul General in Tripoli, Colonel Hanmer Warrington (Wright 2004). During his 32 years (1814-46) in the post, he never lost his conviction that the Regency and its trans-Saharan roads were Britain's natural gateway to Africa – the means to the geographical, scientific, diplomatic, commercial, evangelising and abolitionist penetration of the unknown inner continent. Tripoli's interests – not necessarily at all compatible with Britain's – were promoted by the ruling tyrant, Yusuf Pasha Karamanli. His need for more state revenues in the harsher post-Napoleonic economic climate could apparently only be met by increasing the trans-Saharan trade in black slaves (on which he levied taxes), to be achieved by the extension of Tripoli's power and influence right across the desert to the great slave reservoirs of Bornu and the Hausa states. Bornu was at the time led by the remarkable Shaikh al-Amin al-Kanemi, who in effect ruled on behalf of the Sultan. He came to see Britain as a more benign and promising partner than expansionist, slaving Tripoli, and he cautiously welcomed British travellers. The outcome of this tripartite coincidence of interests was three important British missions into the central desert between 1819 and 1826. Their prime objective was not the Sahara itself, but rather what lay beyond it, deep in inner Africa, and particularly the solution to the great geographical enigma of the Niger. The desert and the roads across it were regarded as necessary means to that end, but they were nevertheless observed and recorded as conscientiously as any other places British travellers visited, and they duly appeared on the new, updated editions of African maps (Arrowsmith 1834, includes detailed travellers' routes).

The Niger quest was resumed in 1818 where Mungo Park had left it twelve years before. The apparent coincidence of interests of the British, Tripoli and Bornu was officially recognised in London as a chance too good to miss, especially by John Barrow, Second Secretary to the Admiralty, who was becoming "the dominant personality in the field of African exploration", enjoying the confidence and support of the Colonial Secretary, Earl Bathurst (Bovill 1968, 40).

Ritchie and Lyon

In January 1818 a 29 year-old Scottish surgeon, Joseph Ritchie, was appointed temporary British vice-consul in Murzuq as a prelude to intended travel to the Niger at Timbuktu (Fleming 2001, 93). His travelling companion was a young naval officer, George Lyon. The expedition that finally left Tripoli in March 1819 had little success. Due to Ritchie's inept handling of the finances, the travellers were short of funds. They were marooned throughout the summer in

Murzuq – one of the most unhealthy Saharan settlements – and Ritchie sickened and died in November. Lyon managed to make a five-week tour of southern Fazzan, returning to Tripoli in March 1820. But he wrote a valuable and highly readable account of his travels, the basis of many future Fazzani studies (Lyon 1821).

The Bornu Mission

London was most of all impressed by Lyon's remarks on the eastward course of the River Niger after it left Timbuktu. According to Bornu traders in Fazzan, the river flowed through Lake Chad before joining the Nile south of Dongola. Bornu thus quickly replaced Timbuktu as the focus of Britain's Niger quest. The Empire of Bornu was then an obvious objective for explorers because it was the nearest Sudanese state to Tripoli and diplomatically the most approachable. The Bornu Mission of 1822-25 brought together three disparate and quarrelling members: Walter Oudney, an Edinburgh doctor and former naval surgeon; the well-travelled Scot, Lt. Hugh Clapperton, RN.; and an army lieutenant, Dixon Denham. Despite their differences, these three made a series of celebrated discoveries in the course of some three years. Even if they did not solve the Niger problem, they explored much of Lake Chad; they travelled widely in Bornu and other parts of the central Sudan; and after Oudney's death on the road, Clapperton in 1824 reached the great trading city of Kano and the Fulani capital at Sokoto. By the time Clapperton and Denham returned to Tripoli early in 1825, the central Sahara, Lake Chad and the central Sudan had been charted and were soon to be made known to the British public and the world at large. The mission had shown that the Sahara was not as formidable a barrier as had been feared, and that Europeans could safely travel the ancient road from Tripoli to Fazzan and Lake Chad (Bruce-Lockhart and Wright 2000, 40). A partial account of the mission was soon published (Denham and Clapperton 1826; Bovill 1964-6 Vols.II-IV). But only recently has the full story of the Clapperton's part in it been told with the publication of his long-lost travel journal, which throws much new light on the mission's exploration of the western Fazzan, in particular (Bruce-Lockhart and Wright 2000).

Alexander Gordon Laing

The third in this series of great British trans-Saharan expeditions intended to solve the mystery of the River Niger was the solo journey by the Scottish-born colonial official and traveller, Major Alexander Gordon Laing. He left Tripoli in July 1825, and reached Ghadames by a roundabout route in mid-September, the first known European to see that ancient centre of Saharan trade and communications. He left at the end of October for Timbuktu, which he reached via In Salah in Tuat on 18th August 1826, after being gravely wounded in an attack on the road. He was the first known European in that mysterious but celebrated city, a by-word for extreme remoteness, but which by the early nineteenth century had little of the intellectual and less of the commercial pre-eminence that Leo Africanus had witnessed three centuries earlier. Laing stayed five weeks in Timbuktu, but soon after starting his return journey to Morocco, he was attacked and killed. His journals and other papers disappeared with him – the cause of a prolonged

diplomatic impasse between Consul Warrington and the Pasha of Tripoli. Edward Bovill has edited Laing's surviving correspondence (Bovill 1964, Vol.I, 123-390; Monod 1977).

Other travellers

No British mission sent from Tripoli to look for the Niger on the far side of the desert had thrown much light on the problems of the river's course and outlet. These were solved in 1830 by Richard and John Lander, travelling inland from the Bight of Benin. By the time John Arrowsmith published his map of North Western Africa in 1834, the Sahara was etched with the fine lines of travel of the few Europeans who had penetrated it up to that time. Apart from these narrow paths of knowledge, the desert was still the same "wide extended blank" that it had been when the African Association was formed nearly fifty years earlier.

Meanwhile, other travellers had been busy elsewhere in the central Sahara. In 1817 the British naval officer and hydrographer, William Henry Smyth, trekked into the northern desert as far as Ghirza on Wadi Zem Zem to study the extraordinary Roman funerary monuments there (Smyth 1854). The brothers Frederick and Henry Beechey in 1821-22 sailed along the coast of the Sirtica (where the central Sahara meets the shores of the Mediterranean) from Tripoli to Cyrenaica, publishing a basic and richly illustrated topographical survey (Beechey 1828). The savant Jean Raymond Pacho (originally from Genoese Nice) spent the year from November 1824 on a journey from Egypt into unknown Cyrenaica. He visited the Marmarica, Bomba, Tobruk, Derna and the Jabil Akhdar (especially the ruins of Cyrene). He then went on to Ajdabiya and the important oasis of Awjila, the commercial cross-roads of the eastern Sahara. He finally visited Marada in the Sirtica before returning to Egypt through Awjila and Siwa (Pacho 1827-29).

For twenty years after the death of Major Laing, there were no further European expeditions through the central Sahara, although Britain did signal her diplomatic, commercial and abolitionist ambitions deep into the desert by opening vice-consulates at Murzuq in 1843 and at Ghadames in 1850. But British interest in the Saharan approach had waned with the deterioration of Anglo-Tripoli relations in the mid-1820s. Other factors were the final crisis and collapse of the Karamanli regime in Tripoli in 1835 and its replacement by direct rule from Constantinople; the start of the bloody Turkish war of reconquest (1836-58); and – following the Landers' success – the popular preoccupation with the Niger River route into Africa. But interest in the desert roads briefly revived in the 1840s with the emergence of slave trade abolition as an official and popular ideology in Britain; with the failure of the great abolitionist expedition up the Niger in 1841; and with old Consul Warrington's persistent promotion of the Saharan approach to inner Africa (Boahen 1972, 50-51; Temperley 1972, 50-61).

Richardson, Barth, Overweg

Thus the great anti-slavery agent James Richardson in 1845-46 went to Ghadames, Ghat and Murzuq to report at first hand on slavery and the slave trade (Richardson 1848). Convinced of the need to investigate the sources of the trade deeper into Africa, he then mounted the

celebrated Central African Mission of 1849-55. His travelling companions were two erudite Germans: the celebrated Dr Heinrich Barth (who had already made a remarkable journey from Tripoli to the Marmarica) and Dr Adolf Overweg. Starting from Tripoli in March 1850, the expedition crossed the central Sahara to Murzuq and Ghat and then went south-westwards through Tuareg country. Richardson died in Bornu in 1851 (Richardson 1853) but Barth made a series of outstanding journeys and discoveries in the central and western Sudan (Barth 1857). His travels, coinciding with the striking success of a fresh British attempt to open the Niger with steam power and the prophylactic use of quinine, had convinced Barth that Britain's best approach to inner Africa was, after all, by water and not across the desert:

"Steam power, quinine and in due course the breach-loading rifle, were to enable the British to exploit the interior of Africa via the Nigerian rivers system and to leave the Saharan approach to any other power that cared to make use of it" (Wright 1989, 69-70).

With the closure of the vice-consulates at Murzuq and Ghadames in 1860-61, Britain effectively withdrew from the central Sahara. It thus abandoned that arena after more than sixty years of pioneering, but ultimately disappointing, exploratory, diplomatic, abolitionist and commercial endeavour there.

Duveyrier, Rohlfs and Nachtigal

Others, notably German and French, took up the challenge. The young Frenchman Henri Duveyrier in 1859 (when he was only 19) began a two-year exploration of the country of the Aner Tuareg of eastern Algeria and western Libya, making important preliminary contacts. But the Libyan oases he visited – Ghadames, Ghat and Murzuq – were already known. His main (but biased and dangerously misleading) contribution to Saharan studies was his book on the Tuareg (who were misrepresented as largely benign) (Duveyrier 1864) and his writings on the Sanussi confraternity (who were shown as wholly malign) (Duveyrier 1884).

With the outstanding exception of the German Gerhard Rohlfs, most European travellers in the central Sahara from about 1860 onwards were no longer real pioneers, for many of them were covering ground and visiting places that were already known. Thus notable explorations and discoveries were more likely to be made beyond the desert, rather than in it. It therefore seems unreasonable to give scant notice to the great German explorer, Gustav Nachtigal. But the fact remains that his contribution to knowledge of the central Sahara was not particularly remarkable, at least up to the point when he went on a dangerous pioneering excursion into the Tibesti Mountains (now straddling the Libya-Chad frontier) in the late summer of 1869, making the first detailed studies of the Tebu people and their environment. But Nachtigal's reputation really rests on his great series of journeys into central and eastern Sudan (Fisher and Fisher 1971-88; Nachtigal 1879).

In 1853 another German, Dr Edward Vogel, had set out from Tripoli to follow up the Central African Mission; he eventually reached the Sultanate of Wadai in the eastern Sudan, where he was killed in 1856. Six years later Moritz von Beurmann left Benghazi in search of Vogel; he, too, was killed in Wadai.

The greatest European traveller of the central Sahara itself was Gerhard Rohlfs. He had

already travelled widely in Morocco and the Algerian Sahara before he started from Tripoli in 1865 to cross the desert via Fazzan and Lake Chad to Lagos in Nigeria. In 1869 he was back in Tripoli, travelling from there to Egypt through the oases of Awjila and Siwa. Four years later, at the head of a German scientific expedition, he tried to reach the remote and little-known oases of Kufra in the eastern Sahara, but was turned back by local hostility. In 1878, on a mission from the Kaiser to the Sultan of Wadai, he went from Tripoli to the oasis of Zalla, and then overcame some of the worst of the Libyan Desert to reach Kufra, the first European to do so. He had to withdraw quickly, returning home via Benghazi (Rohlfs 1874-5 and 1881). Rohlfs shared the British belief of the earlier nineteenth century that Tripoli was the most favoured point of departure for travel into the Sahara and Sudanic Africa; he also judged it to be the most promising Mediterranean terminus for the trans-Saharan railway planned from the 1870s onwards to link the emerging French empires in North and West Africa.

End of an Era – the Early Twentieth Century

By the time Erwin von Bary in 1876 travelled from Tripoli to Ghat (where he died), the broad lines of Tripolitanian and Fazzani geography had been laid down; but the Cyrenaican hinterland – apart from Rohlfs' brief excursions to Kufra – was barely known. The achievements of Rohlfs may nevertheless be said to mark the end of the 'Heroic Age' of Central Saharan travel and exploration: there were no more great geographical-scientific expeditions with diplomatic, political and commercial undertones, such as had penetrated the desert since the early nienteenth century (Mori 1927, 77). The Turkish authorities, increasingly anxious to maintain the integrity of their last remaining North African possessions in the face of European expansion, became more reluctant to authorise travel by foreigners anywhere in the interior. Nevertheless, the workings of the Sahara and its geography came to be more fully understood by travellers operating on a rather less adventurous scale than some of their bolder and less restricted predecessors. Thus P.-L. Monteil crossed the Sahara from Senegal to Lake Chad and so up to Tripoli in the early 1890s; but he added little of substance to existing knowledge of the central desert in his weighty book on his adventures (Monteil 1894). Nor really did the Swiss official in British colonial service, Hanns Vischer, who returned by the ancient caravan roads from Tripoli to his post in northern Nigeria about 1906, covering ground and places visited by European travellers many decades earlier (Vischer 1910). But the French geographer H.-M. De Mathuisieulx did in the early twentieth century manage to make some productive excursions into the desert hinterlands of both Tripolitania and Cyrenaica (Mathuisieulx 1912).

In the early twentieth century many Italian journalists and others interested in Turkish North Africa as a future Italian colony were active there, but they confined their reportage to the coast lands. Few Europeans other than Italians visited Libya and its Sahara in its early, troubled years as Italian possessions after 1911. But in 1920-21 the British traveller and writer, Rosita Forbes, accompanied the Oxford-educated Egyptian diplomat, Ahmed Mohammed Hassanein Bey, on a notable journey from Benghazi to Kufra (Forbes 1921); in 1923 Hassanein himself 'discovered' and put on the map the 'lost' oases of Arkenau and Owenat at the junction of the borders of Libya, Egypt and the Anglo-Egyptian Sudan (Hassanein Bey 1925). In the 1930s, British motoring adventurers from Egypt, notably Ralph Bagnold, traversed the Western Desert borders

of Libya in a series of pioneering car journeys during which the new techniques of motorised desert travel were tried and tested (Bagnold 1935; see Kelly, this volume).

During Libya's years as an Italian colony, Italian scientists and other researchers did much work on the basic characteristics of the central Sahara. Among these were Colonel Enrico de Agostini, who investigated the native peoples of Tripolitania and Cyrenaica (De Agostini 1917 and 1922-23); the great geologist Ardito Desio of Milan University (Desio 1950); and the archaeologists Pace, Sergio and Caputo (Pace *et al.* 1951).

By the Second World War the central Sahara had been the field of nearly 150 years of European travel and exploration. Some of it was subjected to even closer and more pressing scrutiny as a battlefield during the long (1940-43) North African campaigns, while from the mid-1950s onwards, the Sirtica and parts of Fazzan, in particular, were given yet closer attention by the international oil industry. As the war correspondent Alan Moorehead pointed out, no Second World War combatant had come "into the desert for conquest or loot" (Moorehead 1944). Foreign oilmen probing for the greatest source of wealth the central Sahara has so far yielded, have a quite different agenda, and they do not necessarily share or appreciate the desire of earlier generations of desert travellers simply "to tread an unworn carpet of the earth" (Hassanein Bey 1925, 269).

Bibliography

Arrowsmith, J. 1834. *North Western Africa,* London.

Barth, H. 1857. *Travels in North and Central Africa,* London, 5 vols.

Beechey, Capt. F.W. and H.W. 1828. *Proceedings of the Expedition to Explore the Northern Coast of Africa from Tripoli Eastward in 1821-22,* London.

Bagnold, R.A. 1935. *Libyan Sands. Travel in a Dead World,* London.

Bell, J. 1844. *A System of Geography, Popular and Scientific,* III(2): 288, Edinburgh.

Boahen, A.A. 1964. *Britain, the Sahara and the Western Sudan, 1788-1861,* Oxford.

Bovill, E.W. (ed.). 1964-66. *Missions to the Niger,* 4 Vols, Cambridge.

Bovill, E.W. (ed.). The Letters of Major Alexander Gordon Laing, 1824 - 1826, in Bovill 1964-66, I: 123–390

Bovill, E.W. 1968. *The Niger Explored,* London.

Bruce-Lockhart, J. and Wright, J. (eds.). 2000. *Difficult and Dangerous Roads: Hugh Clapperton's Travels in Sahara and Sudan, 1822-1825,* London.

Denham, D. and Clapperton, H. 1826. *Narration of Travels and Discoveries in Northern and Central Africa in the Years 1822, 1823 and 1824,* London. Reprinted as *Missions to the Niger II-IV,* Haklyt Society. 2nd series CXIX, ed. E.W. Bovill (see Bovill 1964-66).

De Agostini, E., 1917. *Le popolazioni della Tripolitania.* Tripoli.

De Agostini, E. 1922-3. *Le popolazioni della Cirenaica,* Tripoli.

Della Cella, P. 1819. *Viaggio da Tripoli di Barberia alle frontiere occidentali dell'Egitto fatto nel 1817,* Genoa. A subsequent edition was published by the Ufficio Storico of the Comando del Corpo di Stato Maggiore in 1912, Citta di Castello.

Desio, A. 1950. *Le vie della sete,* Milan.

Duveyrier, H. 1864. *Exploration du Sahara: Les Touareg du Nord,* Paris.

Duveyrier, H. 1884. La confrerie musulmane de Sidi Mohammed ben Ali Es-Senousi. *Societé de Géographie.* Paris.

Fleming, F. 2001. *Barrow's Boys,* London.

Forbes, R. 1921. *The Secret of the Sahara: Kufara*, London.

Hallett (ed.). 1964. Records of the African Association, 1788-1831. London. See Plan of the Association reproduced in *Proceedings of the Association for Promoting the Discovery of the Interior Parts of Africa*, 2 vols. London.

Hornemann, F. 1810. Journal of Frederick Hornemann. *Proceedings of the Association for Promoting the Discovery of the Interior Parts of Africa* 2:39-151.

Leake, W.M. 1832. Is the Quorra...the Same River as the Niger of the Ancients? *Journal of the Royal Geographical Society* 2: 1.

Lucas, S. 1810. Mr Lucas's Communications *Proceedings of the Association for Promoting the Discovery of the Interior Parts of Africa* 1:47-205.

Lyon, G. 1821. *A Narrative of Travels in Northern Africa in the Years 1818, 1819 and 1820,* London.

Hassanein Bey, A.M. 1925. *The Lost Oases,* London.

Mathuisieulx, H.-M. 1912. *La Tripolitaine d'hier et de demain,* Paris.

Milanesi, M. (ed.). 1978. *Giovanni Battista Ramusio, Navigazioni e viaggi*, 7 vols, Turin.

Monod, T. 1977. *De Tripoli à Tombouctou, le dernier voyage du Laing, 1825 -1826*, Paris.

Monteil, P.-L. 1894. *De Saint Louis à Tripoli par le Lac Tchad, etc.*, Paris.

Moorehead, A. 1944. *African Trilogy,* London.

Mori, A. 1927. *L'esplorazione geografica della Libia,* Florence.

Nachtigal, G. 1879. *Sahara und Sudan. Ergebnisse sechsjahriger Reisen Afrika,* 2 vols, Berlin. English edition: A.G.B. and H.J. Fisher, 1971-88. *Sahara and Sudan*, 4 vols, London.

Pace, B., Sergi, S. and Caputo, G. 1951. Scavi sahariani. *Monumenti Antichi* 41: 150-549.

Pacho, J.-R. 1827-29. *Relation d'un voyage dans la Marmarique, la Cyrenaique, et les oasis d'Audjelah et de Maradeh,* 2 vols, Paris.

Playfair, R.L. 1889. The Bibliography of the Barbary States, Part I: Tripoli and the Cyrenaica. *Royal Geographical Society, Supplementary Papers* II: 575, London.

Richardson, J. 1848. *Travels in the Great Desert of Sahara in the Years 1845 and 1846,* 2 vols, London.

Richardson, J. 1853. *Narrative of a Mission to Central Africa, 1850-51,* 2 vols, London.

Rohlfs, G. 1874-75. *Quer durch Afrika,* Leipzig.

Rohlfs, G. 1881. *Kufra: Reise von Tripolis nach der Oase Kufra,* Leipzig.

Smyth, W.H. 1854. *The Mediterranean. A Memoir Physical, Historical and Nautical,* London.

Temperley, H. 1972. *British Anti-Slavery, 1833-1870,* London.

Vischer, H. 1910. *Across the Sahara from Tripoli to Bornu,* London.

Wright, J. 1989. *Libya, Chad and the Central Sahara,* London.

Wright, J. 2004. Hanmer Warrington in *Oxford Dictionary of National Biography*, Oxford.

Wright, J. 2005. *Travellers in Libya,* London.

29. The Hunt for Zerzura: Exploration and War in the Libyan Desert, 1920-43

By Saul Kelly[1]

Abstract

The exploration of the Libyan desert by air and by car in the early twentieth century was at one level a series of pioneering attempts to overcome technical limits to desert research. It developed into a competitive academic quest for lost oases. In another way, though, it also foreshadowed the coming desert conflict of the Second World War. The results of the search for the lost oasis of Zerzura held practical implications for the conduct of the desert war and fate dictated that some of the key protagonists in that hunt were on opposing sides in that war.

Introduction

The Libyan Desert is the largest unbroken tract of natural desert in the world. It stretches for 1100 miles (1760 km). from the Nile in the east to the highlands of Ennedi, Erdi, Tibesti, Tummo and the Fezzan in the west, and over 1000 miles (1600 km). from El Fasher in the south to within 100 miles of the Mediterranean. Until the 1920s the knowledge possessed by Western geographers of the interior of the Libyan Desert was negligible. Although the position of the Kufra oasis (Fig. 29.1) had been fixed by the German explorer, Rohlfs, in 1879, the southern oases of 'Uwaynat and Merga were purely legendary, and their whereabouts vague. But in the space of five years (from 1923-7) the central portion of the Libyan Desert south of latitude 22° degrees, enclosed between the Darb al Arbain (the old slave road of forty days) in the east and the political boundary of the Chad province of French Equatorial Africa in the west, had been traversed by several journeys (by the Egyptian explorers Hassanein Bey and Prince Kemal el Din and the Sudan Political Officers Douglas Newbold and Bill Kennedy-Shaw). The three oases of which the Arabs had any recent or first hand knowledge had been found and accurately located. Only the legendary Zerzura oasis remained unfound (Kelly 2002, 2-12).

All through the Middle Ages Egyptian writers had spoken of a hidden oasis; the name of *Zerzura* – meaning probably 'oasis of the little birds' had been mentioned for the first time in the thirteenth century (Bagnold 1987, 268-69). The first European reference to Zerzura was in a book written in 1835 by an English traveller in Egypt, Sir Gardner Wilkinson. The latter had been told by the inhabitants of the Dakhla Oasis of an oasis lying west of the caravan route between the Farafra and Bahariya oases which was called Wadi Zerzura. This oasis was said to contain many palm trees, springs and rivers of an uncertain age. Wilkinson learnt from another source that three wadis, which were used for grazing, formed Zerzura. Wilkinson's account placed Zerzura somewhere in the Egyptian Sand Sea, so its non-discovery would not have been difficult to explain (Ball 1928, 253). But the truthful ring to Wilkinson's story was spoilt by the introduction of a second alternative position (favoured by Newbold and Dr Ball, the head of Egyptian Desert Surveys, though they later became more sceptical about it), roughly 400

[1]JSCSC, King's College, London

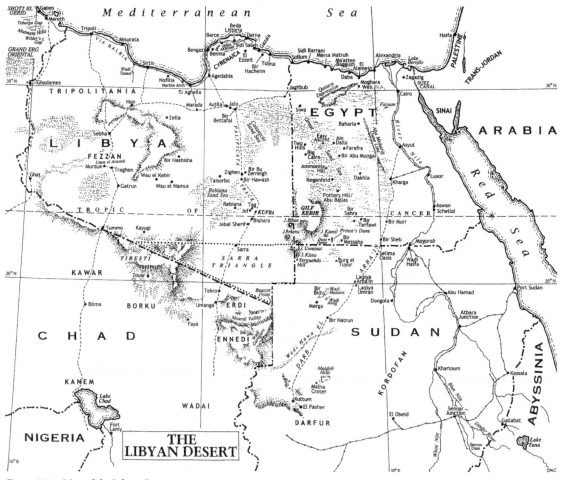

Figure 29.1. Map of the Libyan Desert.

miles (640 km) away to the south in the vast area between Dakhla, Selima and Merga. A third area, south-west of Dakhla and extending towards 'Uwaynat, was championed by the British traveller, W. J. Harding King.

The evidence consisted entirely of tales told by the Dakhla natives of incursions of 'black giants' from the south-west. There was no description of Zerzura itself and no mention of anyone having seen it. When in 1917 Ball discovered a large collection of old broken pottery jars marked with the tribal signs of the Tebu, and evidently meant for storing water, all by themselves at the foot of a hill 120 miles (192 km) south-west of Dakhla, not only did the existence of an old traffic by camel across the desert south-west of Dakhla become more likely, but the ability of human beings, Tebu or Arab, to reach Dakhla from the south-west was explained. At the same time, on the other hand, the depot of pottery almost ruled out the existence of any intermediate oasis on the route to 'Uwaynat, because if one had been there the expensive maintenance of a water depot more than a hundred miles from anywhere would have been pointless. Harding King, however, still stuck to his idea (Ball 1927, 120-21). Was he right?

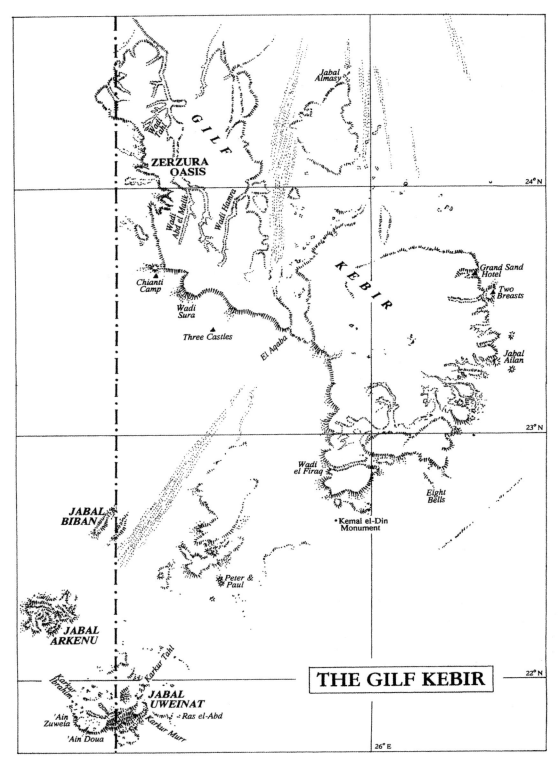

Figure 29.2. Map of the Gilf Kebir and Jabal ʿUwaynat.

In 1930 a new generation of explorers, the Royal Signals Officer Ralph Bagnold, Bimbashi Guy Prendergast of the Sudan Defence Force, Bill Kennedy-Shaw and Douglas Newbold of the Sudan Political Service, were sufficiently intrigued by the legend, after making the first motor crossing of the Great Sand Sea, to found the Zerzura Club, while downing iced beers in a Greek cafe in Wadi Halfa after they had returned to the Nile. Unlike most institutions resulting from a sudden impulse in a beershop, the Zerzura Club was to remain in being and was to assume a more serious aspect with the advent of great power rivalry into its proceedings (Kelly 2002, 17-25).

Wings over the Desert

Interest in the Libyan Desert, confined for long to Prince Kemal el Din, Dr Ball, and a few others, was now beginning to widen (as shown by articles in the British press). This was partly due to Bagnold's crossing of the Great Sand Sea and to the well-publicised desert rescue by another member of the Zerzura Club (Pat Clayton of the Egyptian Desert Survey) of Libyan refugees from Kufra, following its seizure by Italian forces in January 1931 (Clayton 1933, 259). But there was also the continued discussion in the Royal Geographical Society's journal as to the reality or otherwise of the unfound oasis of Zerzura. In particular the Gilf Kebir, an unexplored plateau between three and four thousand square miles in area southwest of the Great Sand Sea and hard-up against the Libyan border, now became an exceedingly interesting place (Fig. 29.2). It was apparently surrounded, except on the north sand-blocked side, by a single continuous vertical cliff over a thousand feet in height and quite inaccessible by car or camel. Pat Clayton had, after rescuing the refugees, and with only one day's spare petrol left, managed to sketch with a plane-table a stretch of 81 miles of the western cliffs of the Gilf, finding at their foot rock drawings, pottery and other evidence of occupation by Paleolithic man.

Deep rocky gorges issued through the walls of the Gilf indicating a tremendous rainfall at some period or other in the past. But what was there at the top? The obvious method of attack was from the air; and the first to take action was the Hungarian pilot and desert explorer, Count Ladislaus Almasy (Bagnold 1987, 205).

Almasy-Clayton Expedition 1932

Almasy had, perhaps, the most colourful background of all the members of the Zerzura Club. He was born in the castle at Borostyanko in Hungary (now Bernstein in Austria) in 1895 to a noble but not titled family, who dabbled in necromancy. An enthusiastic motorist and flier, he served in the Austro-Hungarian Army during the First World War, being decorated for gallantry. A confirmed royalist, he participated in the failed coup attempt in 1921 by the last Emperor of Austria-Hungary, Karl IV, to seize the throne of Hungary. By the early 1930s, after several trips to Egypt and the Sudan, Almasy had acquired a real passion for desert travel and, after talking to Prince Kemal el-Din, he had become fascinated by the Zerzura legend. He concluded that the three wadis of Zerzura, mentioned by Wilkinson, lay somewhere in the interior of the Gilf Kebir. Since these could only be spotted from the air, Almasy organised an expedition in 1932, with Pat Clayton, the veteran desert flier, RAF Squadron-Leader Penderel

and the young Naval Air Arm pilot, Sir Robert Clayton-East-Clayton, a happy-go-lucky, hard-swearing character, straight out of an Evelyn Waugh novel, who had just shipped his Gypsy Moth plane, Rupert, and his wife, Lady Dorothy, to Egypt (Kelly 2002, 36-57). Flying over the northern part of the Gilf Kebir, Almasy's party finally saw and photographed the Wadi Abd el Malik (wadi of the servant of the king) which contained live vegetation. Unfortunately they were not able to find a way up there from the desert plains. Sir Robert exclaimed in his diary: "Old man Wadi has beaten us! There is no more juice and it must be the return journey tomorrow. No wonder he is called the lost oasis." (Kelly 2002, 60; Rodd 1933, 254). But Almasy was sure that he had found one of Wilkinson's three wadis, and that the other ones existed nearby. It was a memorable expedition, nearly ending in disaster for Sir Robert, Penderel and Rupert, when they lost their bearings. At one point the party ran short of water and Almasy, against the advice of Clayton and the British High Commission in Cairo, took the two best cars and Arab drivers and drove to Kufra, leaving the others to continue their mapping. Before returning to the Gilf Kebir with water and Chianti, Almasy, unbeknown to the British members of his expedition, promised the Italian commandant at Kufra, Major Rolle, a map of their exploration of the great plateau.

With their water supplies replenished the Almasy-Clayton expedition finished its surveying work and returned to Cairo. But the deaths in swift succession of Almasy's patrons: Sir Robert, from a disease contracted in the desert, and Prince Kemal el Din, meant that the Hungarian explorer's second expedition had to be put off until the spring of 1933.

Ralph Bagnold 1932

In the meantime Ralph Bagnold's party (including Bill Kennedy-Shaw and Guy Prendergast), escorted by Penderel in his Vickers Valentia aircraft, undertook in the early autumn of 1932 their 6000-mile scientific and mapping expedition through the Libyan Desert. Their success was due in no small part to their development of the sun-compass for navigation, their use of a cooling water condensor and retention system for the cars and rope ladders and steel channels for 'unsticking' their vehicles from the sand. They encountered patrols of the Italian Army and Air Force at both the 'Ain Doua well at 'Uwaynat and Sarra Well. By "a quaint coincidence" the lone mountain of 'Uwaynat lay exactly on the corner of the southern and western boundaries of Egypt, with the water pool of 'Ain Doua being in the disputed territory between Egypt and Libya (Bagnold 1987, 225-26; Kelly 2002, 72). Sarra Well lay in the disputed triangle of territory between Libya and Chad. Both sides left the question of ownership severely alone, nor were any questions asked as to either party's reasons for being there, or what their future intentions were. But the commander of the Italian patrol at Sarra Well, Major Lorenzini, christened the 'Lion of the Sahara' by Fascist propagandists, said one thing that alarmed Bagnold: "The Nile at Aswan is only 900 kilometres from 'Uwaynat. If there was a war, what fun it would be to take a battalion to Aswan and seize the dam. What could you do?" (Bagnold 1990, 87; Kelly 2002, 75). In November 1932, following Bagnold's departure from the area and unbeknown to the British, the Italians made their own secret aerial and ground reconnaisance of the Gilf Kebir, just within the borders of Egypt. Primed by Almasy, the Italian Royal Air Force was eager

to familiarise themselves with the topography of this unknown corner of Egypt (Kelly 2002, 83-84). They too had become fascinated by the Zerzura legend, and were to all intents and purposes members of the Club. But they also had an ulterior motive, the expansion of Italy's African frontiers. For Mussolini had decided to pursue an aggressive foreign policy in order to create a new Roman empire in the Mediterranean and the Middle East. This was to pose a direct threat to the British Empire, whose main lifeline ran through Egypt and the Suez Canal.

Another Fashoda!

Desert exploration had become caught up in great power rivalry and the hunt for Zerzura had assumed a more serious aspect. Before Almasy could organise another expedition to the Gilf Kebir, he was anticipated by Pat Clayton who, on another desert survey expedition, managed in early 1933 to get into the Wadi Abd el Malik from the north by car, after making the first east-west crossing of the Sand Sea by a European (Clayton 1998, 53). On his way he had encountered some strange sights, including a lone Englishman walking along in the middle of the desert wheeling a single bicycle wheel with a milometer attached. The eccentric individual was none other than Orde Wingate (later of Chindit fame), who had set out with a camel caravan from Dakhla oasis in search of Zerzura. Wingate did not find Zerzura in the Sand Sea although, characteristically, he continued to believe it was there.

Clayton returned to the Gilf Kebir in March 1933 on another surveying expedition. This time he was accompanied by Lady Clayton-East-Clayton and Commander Dick Roundell, who had flown out to Egypt determined to finish the work of discovery that the late Sir Robert had begun the year before. After getting up the steep cliffs, Clayton's party conducted a survey of the top of the Gilf Kebir. But their descent nearly ended in tragedy when their brakes failed and the car and its occupants literally tobogganed down the steep slopes. Lady Dorothy and Dick Roundell discovered another Wadi, which turned out to be the Wadi Hamra—the Red Wadi. This was to be Lady Dorothy's last expedition. After her return to England she was killed in a flying accident at Brooklands (Kelly 2002, 86-89).

Pre-war strategies

At the same time that Clayton's expedition had been exploring the eastern side of the Gilf Kebir, Almasy's party (which included the ubiquitous Penderel and the Viennese anthropologist and journalist, Dr Richard Bermann) had been exploring the north-western side. When they put into Kufra for nearly a week to refit the cars and replenish their stores and water, Almasy and the other members of his party were keen to demonstrate their pro-Italian and pro-Fascist credentials to the Italian military by lavishing praise and admiration on Mussolini. But Almasy went further than the others. He revealed that he had been instructed by the Hungarian Fascist Prime Minister, Gyula Gombos, to give all possible help to Italy.

The alliance with Italy had been the cornerstone of Hungarian foreign policy since 1927, when a treaty of friendship and cooperation had been signed in Rome, and would continue to be so until the defeat of Italy in 1943. In accordance with his instructions from Gombos, Almasy had, as soon as he had reached Kufra, revealed to Capitano Fabri, the Italian Intelligence Officer,

that he had discovered a pass (the Aqaba) cutting through the Gilf Kebir "which enables one to cross it and to shorten the distance between Kufra and Dakhla enormously". Almasy said that even heavy lorries could drive through the pass. Almasy also gave Fabri a large British map of 'Uwaynat with the pass marked in pencil so that the Italian Air Force Intelligence Officer could clearly see for himself the connection between the wadis, which Almasy claimed formed the legendary Zerzura oasis. Almasy had also pointed out to Fabri on the map "that the English draw their boundary in the west along the 25th meridian to the 22nd parallel which includes the water of Auenat and even the well of Maaten Sarra. He said this was not just: 'Uwaynat and Sarra should belong to Italy and added smiling: 'when you negotiate boundaries be careful ... Auenat is too important to allow the English and the French to take it away from you'." (Kelly 2002, 93; RGS, WBKS papers, 1933 file). He promised that he would collect more information on the British attitude to the 'Uwaynat dispute, which he later passed, along with the report on his expedition and the maps showing routes and water wells from 'Uwaynat to the Nile, to the Italians through their Legation in Cairo.

The hunt continues…

As for the hunt for Zerzura, certain information that Almasy and Penderel received from a Tebu guide in Kufra convinced them that there was another wadi in the Gilf and that these three wadis could be the ones that Wilkinson had written of in 1835. So, after leaving Kufra, the party split in two, Penderel going to the northern side of the Gilf and Almasy and the rest of the party heading for the western side. Almasy visited the Giraffe 'Caves', containing the rock etchings of giraffes and lions which had been discovered by Clayton in 1931 (these engravings are in fact located on a rock face at a re-entrant in the Gilf Kebir at N 23° 36' 20.1", E 25° 13' 05.2"). He also traversed the Wadi el Melik, with its acacia trees and hundreds of small birds, which met the description of Zerzura as the 'Oasis of Small Birds'. Then Almasy, with one of the 'natives', made a reconnaisance on foot into the Gilf and discovered the last of the three wadis, Wadi Tahl (Wadi of Acacias). So Wilkinson's tale was true. There were verdant wadis in the Gilf Kebir.

And when he returned to the western side of the Gilf Kebir in late 1933 he discovered, near the Giraffe Caves and the three wadis the unmistakable pictures of swimmers which showed that there must have been a lake at some point in the past. He named the place Wadi Sura (Valley of the Pictures) This was further evidence that, in the past, the Gilf Kebir had been a fertile region, inhabited by man, thus giving foundation to the legends of 'cities' in the Libyan Desert. But had Almasy found Zerzura (Kelly 2002, 93-96; 104-05)?

The Italian threat to the Nile

While Almasy had been exploring 'Ain Doua and Wadi Sura, Mussolini's government, in talks with British diplomats in Rome, produced an old Ottoman map (the Turks had, up to their defeat in the First World War, claimed jurisdiction over Egypt, the Sudan and Libya) to substantiate their claim to a large chunk of the north-western Sudan, including 'Uwaynat and the Sarra Triangle. Not surprisingly the Foreign Office in London broke off the negotiations.

They realised that by claiming Sudanese territory up to Merga, almost opposite Dongola on the bend of the Nile that turns the most to the west, the Italians were attempting to establish themselves within a very short distance (roughly 300 miles / 480 km) of that river. The Foreign Office thought that whether the Italians object was to be within striking distance of the Nile irrigation works at Aswan or to make it possible to fly from Libya to their colony of Eritrea on the Red Sea without stopping, the net result was that the Italians were presenting the type of threat to the middle Nile and Egypt as the French had done on the upper Nile at Fashoda in 1898 (PRO, FO 371/17035, 1933).

Unbeknown to the British, when the Italians laid claim to a large chunk of the north-west Sudan they were already investigating the possibility of sending a strike force across the desert to the Nile at Dongola, Wadi Halfa and Assiut. Major Rolle, who was present at the Rome talks, had reported from Kufra in September that Almasy had told him that lorries could make their way from Jabal Kissu (to the south of 'Uwaynat) to Wadi Halfa, via the Selima oasis (Bagnold's expedition had demonstrated this in 1932). Almasy had also supplied the Italians with sketch maps of Bir Messaha and the wells around Merga, which would be vital for an Italian column making its way from 'Uwaynat to Kissu, Merga and on to Dongola (Kelly 2002, 104).

While 'Uwaynat and the Sarra Triangle was not regarded as being of supreme strategic importance to Britain, the British Chiefs of Staff pointed out to the Cabinet in January 1934 that their occupation by Italy would place a first class European power within 18 hours of the Nile by car. The Chiefs preferred to retain 'Uwaynat though they attached a higher priority to the retention of Merga. The Cabinet accepted the recommendation of the Chiefs of Staff that it was 'essential to put a check to Italian encroachments to the east and south' of 'Uwaynat (Kelly 2002, 106; PRO, CAB 51, 1934). On the instructions of the British government, the Sudan Defence Force rushed units to Merga and Kharkur Murr (at the south-east corner of 'Uwaynat, where it replaced an RAF detachment) to forestall any further Italian move into the Sudan.

While Italian and British forces were establishing their rival positions in the Jabal 'Uwaynat, who should arrive upon the scene but Almasy, accompanied by Baron Hansjoachim von der Esch (the nephew of the unscrupulous political intriguer, General von Schleicher, who was murdered on Hitler's orders in the Night of the Long Knives in June 1934). In March 1934 von der Esch was deputed by Almasy to survey the Gebel el Biban on Egypt's border with Libya. Von der Esch invited the Italian commander at 'Ain Doua, Capitano Parola, to accompany him. Meanwhile, Almasy surveyed Wadi Hamra, Wadi Abd el Melik and Wadi Tahl, before they met at 'Uwaynat and returned to Cairo via Bir Mesaha and the Kharga Oasis (Kelly 2002, 107-110).

Almasy felt that the hunt for Zerzura was nearly over. This seemed to be confirmed when in 1936 he tracked down an old Tebu camel rustler named Abd el Melik who gave an accurate description of the three wadis in the Gilf Kebir and confirmed that: "There are mountain sheep and foxes and many small birds in the valleys, and I believe that it was for this reason that the valley was called the Wadi Zerzura before" (Almasy 1937, 60). There can be little doubt that the three wadis in the Gilf Kebir were the truth behind the Egyptian legends of the 'Oasis of the Blacks'. Almasy had solved the problem of Wilkinson's oasis. But had Almasy found Zerzura, as he claimed in a paper read in his absence by Bagnold at the annual Zerzura Club dinner at

the Cafe Royal in London and in a book published that same year? Both Bermann and Bagnold were sceptical. Bermann thought it could lie among the great dunes of the Sand Sea to the north which had yet to be fully explored. He praised Orde Wingate for having in 1933 undertaken his march into the Sand Sea around 'Ain Dalla' in search of the lost oasis. He had found some valuable artefacts but not Zerzura (Bermann 1934, 463).

Bagnold had retired from the army in 1935 to concentrate on his study of *The Physics of Blown Sand and Desert Dunes*. But he had revisited the Gilf Kebir in 1938 and continued to think that Zerzura was "one of the many names that have been given to the many fabulous cities which the mystery of the great North African Desert has for ages created in the minds of those to whom it was hardly accessible; and that to identify Zerzura with any one discovery is but to particularise the general" (Bagnold 1937, 267; Kelly 2002, 111). Both Bermann and Bagnold thought the hunt for Zerzura would go on.

In the meantime the stand-off in the desert between Britain and Italy finally came to an end in July 1934. Mussolini, after learning of the British negotiating position from documents purloined by the Italian butler from the safe of the British ambassador in Rome, moderated his claim to Sudanese territory. It was agreed that the Sudan should cede to Italy the Sarra Triangle and 'Ain Doua. The Sudan was to keep the 'Ain Prinz spring at Karkur Murr, and Egypt was to retain the waterless northeast corner of 'Uwaynat. The Jabal 'Uwaynat had been divided between Italy on the western side and Egypt and the Sudan on the eastern. And it left the Italians with the best and most accessible water source in the Jabal 'Uwaynat. They were now in a position to use it as a stopover for planes flying from Libya to Eritrea, their colony on the Red Sea, or as a base for a land strike against the Nile barrages, which controlled the lifeblood of Egypt (Kelly 2002, 112-14). This was to be an ever-present threat after Mussolini declared in 1934 that: "We must have Egypt; we shall be great only if we can have Egypt!" (Kelly 2002, 108; Morewood 1985, 89).

The Zerzura Club Goes to War

It was to be another six years of flexing his military muscles on the Libyan frontier before Mussolini felt able to stake his claim to Egypt. Following Italy's declaration of war on a defeated France and an overexposed Britain in June 1940, Mussolini's dream of creating a new Roman Empire in the Mediterranean and the Middle East seemed about to be realised. The small British garrison in Egypt faced the daunting prospect of having to defend the Suez Canal, the lifeline of the British Empire, from attack by the half a million strong Italian Army in Libya. An equally strong Italian army in Eritrea and Ethiopia also threatened to overwhelm the Sudan, where there were only 2,500 British and 4,500 Sudanese troops, no tanks and hardly any artillery or aircraft. The British Commander-in-Chief, General Sir Archibald Wavell, knew that until reinforcements arrived, he would have to rely on bluff and his ability to move his small reserves rapidly and at the right moment between Egypt and the Sudan. And at any moment his communications through the Red Sea might have been disrupted by the Italian Navy and his vital artery along the Nile Valley by an attack from the west. This is what made the inner, Libyan, Desert of such importance. Wavell turned to Ralph Bagnold for advice.

The old desert explorer warned Wavell that the Italians were capable of launching from their base at 'Uwaynat a 500-mile (800km) raid (which would take them 36 hours) across the desert over excellent going to Aswan on the Nile. Once they had opened the sluice gates on the dam, Egypt would be flooded with disastrous effects for the defence of the country against Italy. A determined Italian force could also attack and take Wadi Halfa, wrecking the dockyard and the railway workshops, sinking any river steamers or barges and thus severing any communications between Egypt and the Sudan. There was a chance that an Italian force might move down into the Chad province of French Equatorial Africa from Kufra and further west at Murzuq, winning over the hesitant French and capturing Fort Lamy. This would also deprive the British of an essential link in the chain of airfields between Takoradi in British West Africa and the Sudan and Egypt, which ferried hundreds of aircraft to the Middle East after the Mediterranean route was severely restricted by Italy's entry into the war.

Bagnold's Boys
The British had no means of knowing what the Italians might be preparing in the far south. To find out, Bagnold proposed to apply the techniques he and the Zerzura Club had learned in the 1930s and to set up a small group of highly mobile patrols of lightly-armed desert-worthy vehicles, manned by specially-trained volunteers, which would get into the emptiness of Libya by the backdoor that only Bagnold and the Zerzura Club knew about (through the Great Sand Sea and around the Gilf Kebir) and track-read both of the routes leading south to Kufra. If they found no evidence of an impending Italian raid they would engage in a bit of "piracy on the high desert" (Kelly 2002, 135-36). Wavell jumped at the idea and issued an order that the desert explorer was to be given anything he needed from army stores. So the famous Long Range Desert Group (LRDG), 'Bagnold's Boys', was set up. It had carte blanche to make trouble for the Italians, and later the Germans, anywhere in Libya.

Bagnold sent out the word to his fellow British members of the Zerzura Club to meet him in Cairo. On the very day, 15th September 1940, that the Italians invaded Egypt going east along the Mediterranean coast, 300 miles (480 km) to the south, two LRDG patrols crossed the frontier going west into Libya. One patrol found no evidence of a planned Italian attack from 'Uwaynat on Aswan and Wadi Halfa, so it proceeded to engage in a little 'desert piracy', wrecking a convoy bound for Kufra and destroying unguarded aircraft and aviation fuel dumps at desert airstrips.

Meanwhile the other patrol, led by Pat Clayton, took a more southerly route across Libya and made contact with the French outpost at Tekro in Chad. Both patrols returned safely to Cairo, having covered 6000 miles (9600 km) in enemy territory without the loss of a single truck. These actions confirmed General Wavell's opinion that the LRDG was making an important addition to the anxieties and difficulties of the enemy. They were effectively disrupting any plan the enemy might have for launching a strike from Kufra and 'Uwaynat to the Nile. The War Office in London agreed, therefore, with Wavell's proposal to double the size of the unit.

In early 1941, the LRDG launched a joint attack with the Free French forces in Chad on the Italian military base at Murzuq in the south-western Libyan province of the Fazzan, in which

the Free French commander, Colonel d'Ornano, was killed and Pat Clayton was captured.

Soon after this raid the Italians decided to withdraw their garrison from 'Uwaynat. This strategic mistake deprived them, not only of a base to attack Wadi Halfa and Aswan on the Nile, but a sally-port to strike at Anglo-French lines of communication during the next phase of the operations in the Libyan Desert. By this time Wavell's offensive in the north had about cleared Cyrenaica of the enemy, and it was decided that for its future activities in Tripolitania the LRDG would need a base much further west than Cairo. The capture of Kufra on 1st March by Colonel Leclerc (subsequently Free France's most famous general) with a force no more numerous than the garrison, provided the new base to which the headquarters and three patrols of the now enlarged LRDG moved in April, in readiness for future operations (Kelly 2002, 141-56).

Almasy's war

The skill and boldness with which LRDG sought to divine enemy intentions in the desert was matched on occasions by the kommandos of the Brandenburger Regiment operating with the Afrika Korps. One such kommando, led by that other prominent member of the Zerzura Club, Count Ladislaus Almasy, managed in May 1942, in a daring operation (code-named 'Salam') across the desert and through the Aqaba pass in the Zerzura oasis, to convey Rommel's spies to Assiut on the Nile, from whence they made their way to Cairo (Kelly 2002, 192-219). Although the decrypts by the top secret Station X (the British Code and Cypher School at Bletchley Park) of the Abwehr hand cypher had belatedly alerted British Security Intelligence Middle East (SIME) to Almasy's secret desert crossing, the failure of Rommel's spies in Operation Kondor to establish contact with Afrika Korps HQ meant that nothing more was heard of them until SIME learnt by accident of their presence in Cairo from a German civilian internee and a highly placed Egyptian informer and rounded them up two months later, along with Aziz el Masri, Anwar Sadat, and others involved in the Free Officers' conspiracy (Kelly 2002, 220-32). For Almasy was more than a skilful desert traveller. His long residence as a Hungarian secret agent in Egypt before the war had led him to make contact with those Egyptian nationalists, such as the Chief of Staff of the Egyptian Army, General Aziz el Masri Pasha, who were prepared to conspire with the Axis powers in order to get the British out of Egypt. It was Almasy's acquaintance with Aziz el Masri and through him the Free Officers' conspiracy led by Anwar Sadat and Gamal el Nasser (both later Presidents of Egypt) that made the Hungarian Count such a pivotal figure in carrying out the strategy of the Abwehr (German Military Intelligence) towards Egypt during the war. Almasy was to be involved in several missions to try and spirit the Egyptian general out of Egypt and to use him as a rallying point for an Egyptian Legion, raised in Libya, which would march with Rommel to Cairo (Kelly 2002, 159-78).

LRDG/SAS 1942

The failure of the Kondor mission, in conjunction with the drying up of the messages from the US Military Attaché in Cairo (intercepted and decoded by the Italian and German Military Intelligence services), meant that Rommel was deprived of vital information on the strength

of the British defensive position at El Alamein, the last British bastion before the Nile. The last strategic chance for the Axis of Rommel's armour reaching the Nile, thereby destroying Britain's position as a world power and allowing the Axis occupation of the Middle East and the threatening of Russia's southern flank, vanished with Rommel's failure to break through at the first battle of Alamein in July 1942 and at Alam Halfa a month later (Kelly 2002, 232).

While Rommel remained at Alamein, he was continually harassed by LRDG/SAS patrols which, in three over-ambitious raids against Benghasi, Barce and Tobruk on the Cyrenaican coast sought and largely failed to disrupt his lines of supply. Undeterred, the LRDG/SAS operated on the southern flank of the Eighth Army, which began its advance following its defeat of Panzerarmee Afrika at Alamein in late October 1942. While the SAS undertook the shorter-range work against the Axis forces in Cyrenaica, the LRDG operated in Tripolitania. It was the LRDG that guided the 2nd New Zealand Division on its flanking marches around Rommel's positions at El Agheila and again at the Mareth Line. That was the end of its operations in Africa for the hilly country beyond Gabes in Tunisia was unsuitable for the LRDG to work in. The LRDG had, in cooperation with the regular forces of the Eighth Army, done its job of neutralising the threat to Egypt posed by the Axis forces and had occupied Italian Libya. Mussolini's dream of creating a new Roman Empire lay in ruins (Kelly 2002, 233-38).

End of the war

As the LRDG patrols had penetrated deep into Libya, ahead of the Eighth Army, the LRDG's commander, Guy Prendergast, and the Intelligence Officer, Bill Kennedy-Shaw, had looked for signs of their former Zerzura Club colleague, Almasy. All they found at Hon, the military headquarters of the Italian Sahara were traces of a 'Sonderkommando Dora', which appeared to be a similar organisation to the LRDG, a few German suncompasses and other special kit. Almasy had, in fact, returned to Budapest, where he set about writing a highly romanticised account of his time *With Rommel in Africa* (1943), a propaganda piece which dwelt on German successes up to Alamein rather than their defeats afterwards. But there are indications that Almasy sought to become a British double agent, while continuing as an Abwehr operative in the Middle East. He was involved in a top secret mission by the Luftwaffe special forces unit KG200 to Libya in 1943, which involved the setting up of an air strip in the Sirt Desert to act as a base for the subversion of the tribes in southern Tunisia (Kelly 2002, 238-48).

Epilogue

With the collapse of the Horthy regime and the Soviet occupation of Hungary in 1945, Almasy was arrested, tortured and tried by the newly-installed Communist regime on a charge of writing Fascist propaganda. He managed in January 1947, with the assistance of M.I.6. to escape to Austria and from there to Italy. A Soviet NKVD hit-squad tried to kill him during a high-speed car chase through the streets of Rome. He was saved by his friend the Duke de Valderano and M.I.6., who put Almasy on a flight to Egypt. His contribution to desert exploration was duly recognised in 1950 when he was appointed Director of the new Fuad 1st Desert Institute in Cairo. It must have given him a great deal of pleasure, and perhaps a touch of *schadenfreude*, as Director to welcome Bagnold and Clayton at the great party to publicise his work, which

was held in a vast tent in the garden of the Institute at Rue Sultan Hussein, Heliopolis, on the morning of 30th December 1950. Almasy should, however, be allowed his moment of fame and glory. For the following month he contracted amoebic dysentery and was invalided back to Europe. Almasy died on 22nd March 1951 and was buried in the cemetery at Salzburg. On his gravestone were inscribed the words 'Abu Raml' in Arabic, meaning 'Father of sand'. It was fitting that on the day that Almasy died, Clayton was in Tripoli on his way to the Fezzan to revisit the battle sites of the LRDG's most audacious raid ten years before. As for Ralph Bagnold, after the war he continued his researches on deserts, writing numerous papers and acting as a consultant to companies and governments abroad. It was with some satisfaction that when NASA's spacecraft was able to examine the landscape of Mars at close range, that Bagnold's seminal work on *The Physics of Blown Sand* was found to allow the sand-driving mechanism to be adapted to the very different and far more tenuous atmosphere of Mars. It also seemed to confirm Bagnold's judgement on Almasy's claim to have discovered Zerzura, that the hunt for evidence of past forms of life (in this case on Mars) will always go on as long as people are concerned to explore the uncharted wastes of the universe (Kelly 2002, 250-54).

References

Almasy, R.E. 1936. *Recentes explorations dans le désert Libyque*, Cairo.

Bagnold, R.A. 1937. The last of the Zerzura legend. *Geographical Journal* 89.3: 265-68.

Bagnold, R.A. 1987. *Libyan Sands*, London.

Bagnold, R.A. 1990. *Sand, Wind and War*, London.

Ball, J. 1927. Problems of the Libyan Desert. *Geographical Journal* 70.2: 105-28.

Ball, J. 1928. Remarks on lost oases of the Libyan Desert. *Geographical Journal* 72.3: 250-58.

Bermann, R.A. 1934. Historic problems of the Libyan Desert. *Geographical Journal* 83.6: 456-63.

Clayton, P. 1998. *Desert Explorer*, Cargreen.

Clayton, P.J. 1933. The western side of the Gilf Kebir. *Geographical Journal* 81.3: 254-59.

Kelly, S. 2002. *The Hunt for Zerzura: The Lost Oasis and the Desert War*, London.

Morewood, S. 1985. *The British Defence of Egypt, 1935-September 1939*. Unpublished Ph.D., University of Bristol.

Public Record Office (PRO), Kew. Foreign Office Political and General Correspondence, FO 371/17035/J2842/23/66, Peterson minute, 6 December 1933; Cabinet Office Records, CAB 51/1, COS 320, 26 January 1934.

Rodd, F. 1933. A reconnaissance of the Gilf Kebir by the late Sir Robert Clayton East Clayton. *Geographical Journal* 81.3: 249-54.

Royal Geographical Society, W.B. Kennedy Shaw Papers. Kufara 1933 File, Fabri to Comando delle Truppe. Benghasi, no.23, 23 April 1932.

Conclusions

30. Conference Resolutions and a Sahara Code for Libya

By David Mattingly,[1] Sue McLaren,[2] Elizabeth Savage,[3] Yahya al-Fasatwi,[4] Khaled Gadgood[5]

The following resolutions were drawn up as a result of discussion among the delegates at the conclusion of the two stages of the conference. There was general agreement that there is a need to reinforce existing conservation measures and to take further steps to mitigate the effects of modern development and resource exploitation (Figs 30.1-30.4). Following on from the conference, the organisers have been working with the British Council in Tripoli and interested Libyan National bodies to draw up a voluntary Code for the Sahara. The idea of the Code is that it should enshrine a few key conservation points of relevance to tourists, guides, workers (especially those involved in prospecting and extracting natural resources) and local inhabitants alike. Work on the Code is still ongoing with an important role being played by the British Council in Tripoli in collaboration with the EGA and the Academy of Graduate Studies. The draft version presented here must be considered provisional.

Figure 30.1. The Garamantian and early Islamic town at Qasr ash-Sharaba is typical of the vulnerable condition of ancient settlements in the desert; these sites can easily be damaged by vehicle tracks.

[1] School of Archaeology and Ancient History, University of Leicester
[2] Department of Geography, University of Leicester
[3] Sanders Research Associates, Great Gaddesden
[4] Biruni Remote Sensing Centre
[5] Environmental General Authority, Tripoli

Resolutions from the Tripoli Conference

1. The conference has celebrated the strengths of international scientific cooperation involving Libyan and European research on the natural resources and cultural heritage of the Sahara and points the way towards enhanced contacts and regular meetings in the future.

2. The conference recognises the vital importance of Libya's natural and archaeological resources for the Libyan economy, present and future, and its special importance for the communities in the southern desert region.

3. The conference recognises the important work on environmental, archaeological and heritage management in recent decades but we have identified new challenges in the twenty-first century. The conference sees new opportunities for active partnership between organisations involved in exploitation of the Sahara's resources and those involved in the conservation of its heritage.

4. We identify the need for a new structure of management of the processes of exploitation and conservation in particularly sensitive areas and suggest that the creation of archaeological or national parks should be further explored by the Libyan authorities.

Figure 30.2. Seismic survey for oil prospection is damaging to the environment and heritage of desert, cutting paths through the landscape as seen here on the Massak Sattafat.

Resolutions from the Fazzan Fieldtrip

1. The participants of the conference value the efforts of the different sha'abiyat to conserve the natural heritage of the Libyan Sahara and propose that they fully take into consideration the urban planning process and recommend that restoration programmes be put in place for important historic centres. We urge the adoption of public awareness programmes through education and media.

2. The participants advise the Libyan authorities to ensure that oil companies are obliged to take heritage and environment issues into consideration during their exploration and production processes and to contribute to funding, at a higher level than at present, for research, conservation and preservation. There should be common standards of industry practice in this regard.

3. The participants advise the development and establishment of national parks and protected areas across the Sahara which preserve and protect the ecosystem and the cultural heritage and which support programmes of research, conservation and tourism development and also advise that there be established a code of practice for all tourism operatives.

4. The participants value the cooperation in research between Libyan and EU counterparts in the field of Saharan studies and call for further strengthening of these academic links for the purpose of advancing the resolutions of this conference.

Figure 30.3. Abandoned oil test drill site on the Massak Sattafat. There is a need for systematic clean up.

The Saharan Code

1. Never waste water and keep the Sahara green.

2. Take only photographs and leave no rubbish behind you.

3. Use local vehicles and drivers.

4. Do not harm flora and fauna.

5. Do not disturb archaeological sites and artefacts.

6. Do not deface rock engravings and paintings and never wet rock paintings, as this destroys them.

7. Park your vehicles well away from sites of archaeological interest and natural beauty.

8. Never take artefacts, animals, rare plants and geological specimens from the Sahara – it is illegal.

9. Never buy antiquities or other rare items from the Sahara.

10. Report anyone who breaks the code and threatens the environment and heritage of the Sahara.

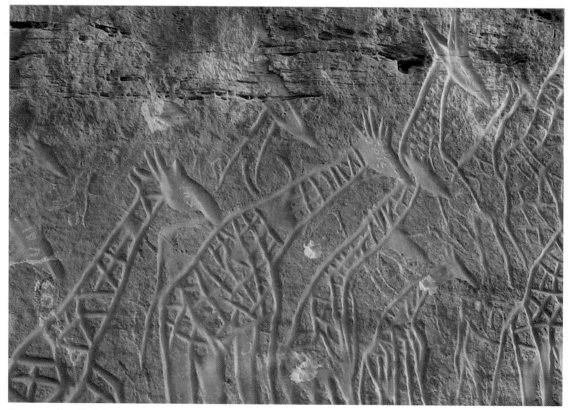

Figure 30.4. Bullet hole damage inflicted on large giraffe scene in Wadi Inhabeter between November 2004 and November 2005.

Appendix 1: Conference Programme

Sunday 15th December 2002 – al-Mahari Hotel, Tripoli

Opening Speeches and Messages: Dr Kaled Gadgood, Chairman of Organising Committee; H.E Mr Anthony Layden, British Ambassador to Libya; Dr Ehtuish Ehtuish, Secretary of Natural Resources, Environment and Urban Planning.

Plenary Lecture 1. Professor Amin Missallati (Chairman of Biruni Remote Sensing Centre, Tripoli, Libya) "Natural resources and the Saharan environment".
Plenary Lecture 2. Professor Graeme Barker (then University of Leicester, UK) "The archaeology and heritage of the Sahara".

Session 1: Natural Resources (oil, water, minerals, meteorites)
(Chairmen: Dr. Agil Berbar and Professor Tony Allan)

Professor J.A. Allan (School of Oriental and African Studies, University of London, UK) and Mr Salem al-Maiar (School of Oriental and African Studies, University of London, UK): "Managing Libya's scarce water resources in a world of changing technologies".
Professor Mike Edmunds (Department of Geography, University of Oxford, UK): "Libya's Saharan groundwaters".
Dr Mohamed Bashir el Baeji (Nuclear Research Centre, Libya): "Libyan meteorite impact craters: geological and economic importance".
Eng. Khalid al Ghwil, (Chairman, Libyan Water Co., Libya) "Underground water resources".
Dr Peter Turner (University of Birmingham, UK): "Geology and petroleum exploration in the Sahara desert".
Dr Yahya al Fasatwi and Professor Amin Missallati (Biruni Remote Sensing Centre, Libya): "Hydrocarbon seepage mapping of Libya using remote sensing techniques".

Session 2: Prehistory (Chairmen: Professor Cremaschi and Dr Mohamed Isa)

Dr Tim Reynolds (then Cambridgeshire County Council, UK): "The importance of Saharan lithic assemblages".
Dr Savino di Lernia and Francesca Merighi (University of Rome, Italy): "Transitions in the later prehistory of the Libyan Sahara, seen from the Acacus mountains". (Read by Ms Merighi)
Dr Tertia Barnett (Society for Libyan Studies, UK): "Libyan rock art as cultural heritage". (Read by Professor Mattingly)
Dr Kevin White (University of Reading, UK): "Lakes of the Edeyen Ubari and the Wadi al-Hayat".
Professor Ahmed al Hawat (University of Garyounis, Libya) and Professor Amin Missallati: "On the origin of the buried channel system of the Libyan desert: a significant groundwater resources".

Monday 16ᵗʰ December 2002

Session 3: Ecology and Environment (Chairmen: Dr Khaled Gadgood and Professor Graeme Barker

Dr Sue McLaren (University of Leicester, UK): "Late Quaternary environmental changes in the Fezzan, southern Libya: evidence from sediments and palaeogeomorphology".

Eng. Mohammed Suleimann Bil Kheir (Agricultural Research Centre, Libya): "Genetic origins of national plants in Hammada Zane Dahsa and Hammada Gharbiya".

Dr Nick Drake (King's College, University of London, UK): "Ancient climate change in the Sahara".

Eng. Abul Hamed Gneenis and Eng. Yousef Giubran (Biruni Remote Sensing Centre, Libya): "Forecasting the influence of the environment on urban distribution of people in the Libyan desert".

Professor Mauro Cremaschi (University of Milan, Italy): "The doors of old Ghat: tree rings of *Cupressus dupreziana* (south-west Fezzan, Libyan Sahara) as a source of palaeoclimatic information for the middle and late Holocene of the central Sahara".

Dr Annie Grant (then University of Leicester, UK): "Animal bones from the Sahara: diet, economy and social practices".

Dr Marijke van der Veen (University of Leicester, UK): "The archaeology of food and farming in the Libyan Sahara". (Read by Professor Barker)

Session 4: Historical Archaeology (Chairmen: Dr Abdullah Ahmed Al Mahmodi and Professor David Mattingly).

Professor David Mattingly (University of Leicester, UK): "The Garamantes: the first Libyan state".

Mr Ibrahim Al Azabi (Department of Antiquities, Libya): "Antiquities survey results of Ubari area".

Dr Andrew Wilson (University of Oxford, UK): "The spread of foggara-based irrigation in the ancient Sahara".

Mr Daoud Hallag (Archaeology Department, Shahat, Libya): "Comparison between ancient Libyan and Greek cultures".

Dr Faraj Mahmoud Arrashdi (University of Garyounis, Libya): "Tombs in the Libyan Desert".

Mrs Fawzia Taher El Kikli (Tripoli Education Authority, Libya): "Islamic architecture, its development and effect on the desert environment".

Dr Tim Insoll (University of Manchester, UK): "Islamic archaeology and the Sahara".

Session 5: Tourism, development and conservation (Chairmen: Dr Mohamed Bel Kir and Professor David Mattingly)

Ms Thuriya Faraj Al-Rimayh (Libyan Tourism Authority, Libya): "Desert tourism".

Mr Omar Gharsa (Administrative Control Authority, Libya): "Effect of civilised development on the urban heritage in desert settlements".

Professor Mario Liverani (University of Rome, Italy): "The archaeological park of the Acacus and Messak". (Paper read by Professor Cremaschi)

Dr Abdullah Ahmed Al Mahmodi (Department of Antiquities, Libya): "The antiquities of desert settlements of the Libyan Sahara".

Dr Jeremy Keenan (University of East Anglia, UK): "Tourism, development and conservation: a Saharan perspective".

Dr Yousef Shreak (University of Al Fateh, Libya): "Desertification and sustainable development".

Dr Abdul Gadder Abu Fayed (UNDP, Libya): "Conservation of Ghadames".

Saed Abu Hajar (University of Garyounis, Libya): "Rock art and tourism in Jabal Al Awynat area".

Session 6: Historical and documentary studies (Chairmen: Professor Ahmed al Hawat and Dr Elizabeth Savage).

Dr Michael Brett (School of Oriental and African Studies, University of London): "The history of the Sahara".

Dr Mohammed Ali Issa (University of al Fateh, Libya): "Was the Libyan desert the first place for art and writing before the Nile basin?".

Dr John Wright (Society for Libyan Studies, UK): "European travellers in the Central Sahara, 18th-20th centuries". (Read by Dr Savage)

Dr Ann McDougall (University of Alberta, Canada): "Salt and the Saharans: a study of culture rooting in materialist development".

Dr Agil Berbar (Libyan Centre for Historical Studies, Libya), "British parliamentary papers as a source of Libyan desert studies".

Professor Harry Norris (School of Oriental and African Studies, University of London): "The Libyan Fazzan as a crossroads of Arab and Berber tribes".

Dr Abdul Salam Shalouf (University of Garyounis, Libya): "Engraving in the desert".

Dr Saul Kelly (Kings College, University of London, UK): "The hunt for Zerzura: exploration and war in the Libyan desert 1920-43".

Plenary session (reports from session chairmen of individual sessions and report of initial conference resolutions).

Appendix 2: The Itinerary of the Fazzan Fieldtrip.

Monday 16th December.
Fly Tripoli to Sabha, welcome by Sabha sha'abiya, dinner and folk music

Tuesday 17th December.
Sabha (Plenary lecture at University of Sabha by Dr Habib al-Hesnawi, "The history of Fazzan").
Drive to Zuwila (reception by sha'abiya, tombs of Banu Khattab, kasbah and walled town (folkloristic dancing and exhibition), White Mosque).
Drive to Traghan (folk display).
Drive to Murzuq (Reception by Sha'abiya and folk dancing, overnight accommodation).

Wednesday 18th December.
Murzuq (historic centre).
Drive to Wadi 'Utba to visit Qasr ash-Sharaba ('lost' Garamantian and early Islamic city).
Drive along northern edge of Edeyen Murzuq and Wadi Barjuj, visit Mattendush (rock art of Messak Sattafet).
Drive to Jarma (sha'abiya reception at tourist camp by Qasr Watwat, with folk dancing/music, overnight accommodation at Jarma hotel).

Thursday 19th December.
Visit to Ubari Sand Sea (palaeolake with Palaeolithic and neolithic campsites).
Drive to al-Hatiyah (Garamantian pyramid tombs).
Drive to Tuwash (foggara and springlines).
Visit to Old Jarma (Garamantian to Islamic/early modern city), museum, Zinkekra (early Garamantian settlement, rock art and cemeteries).
Return to Jarma (plenary discussion and folk dancing, overnight accommodation at Jarma hotel)

Friday 20th December.
Flight from Ubari – Ghat (views of Wadi al-Ajal, Messak Sattafet, Erg Wan Kasa, Tadrart Akakus, Wadi Tanezzuft, west to Tassili).
Visits to Idinen (mountain of the Jinns), In Aghelashem (Late Pastoral and Garamantian elite burial site), Aghram Nadarif (Garamantian fortress), Old Ghat (Islamic/early modern caravan town), Old Birkit (Islamic/early modern caravan town).
Reception by sha'abiyat, folk dancing/
Late p.m. fly to Tripoli. Overnight at al-Mahari hotel, Tripoli.